OLD MASTER
PAINTINGS
IN NORTH AMERICA

OLD MASTER

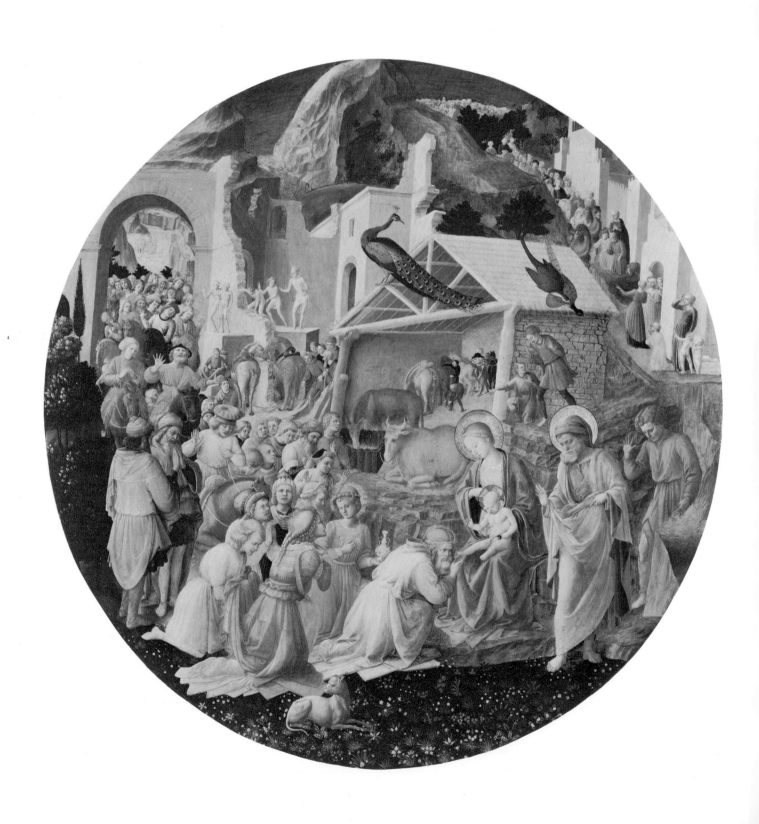

PAINTINGS IN NORTH AMERICA

Over 3000 Masterpieces
by 50 Great Artists

JOHN D. MORSE

ABBEVILLE PRESS • PUBLISHERS • NEW YORK

DEDICATION

To Edgar P. Richardson, who started me on this search.

To the memory of William R. Valentiner, who encouraged me to continue it.

To my wife Dorothy, former management consultant, without whose professional help it would never have been finished.

JDM

Library of Congress Cataloging in Publication Data

Morse, John D 1906—
 Old Master Paintings In North America

 Includes index.
 1. Painting—United States. 2. Painting—Canada.
I. Title.
N510.M63 1979 759.94'074'01 79-1056
ISBN 0-89659-050-X

CONTENTS

ACKNOWLEDGMENTS

WITHOUT THE GENEROUS COOPERATION of the more than one hundred museums who sent us information about their holdings, this revised, updated, and expanded edition of *Old Masters in America* (Rand McNally, 1955) would have been impossible. We thank all their staff members profoundly. Most heartwarming was the fact that the museum directors, curators, registrars, and other staff members made this considerable effort to share their treasures with artists, scholars, dealers, the traveling public, and with their fellow museums who are planning loan exhibitions. Specifically, we want to thank those many individuals who shared with us over the phone and by letter their knowledge about particular pictures and their pride in them.

Sources

THE TRUSTY ELEVENTH EDITION of the *Encyclopedia Britannica* proved as useful as ever. The venerable *Century Cyclopedia of Names* was indispensable. *Masterpieces of Art*, the official catalogue of the 1939 World's Fair, edited by W. R. Valentiner, was helpful, as was the catalogue, *Flanders in the Fifteenth Century: Art and Civilization*, published in 1960 jointly by The Detroit Institute of Arts and the Centre National de Recherches Flamands. Nathaniel Burt's *Palaces for the People* (Little, Brown, 1977) provided essential information about new museums, and the 1977 edition of the *Oxford Companion to Art* was a valuable source of updated information. *The Official Museum Directory*, published by the American Association of Museums, was, of course, constantly at hand for reference.

A number of museums have recently published exemplary catalogues and handbooks. Most useful among these were:

The Art Institute of Chicago, *The World of Art Library*, Series, Thames and Hudson, 1977

The Cleveland Museum of Art, Handbook, 1970

The Frick Collection, *Handbook of the Paintings,* 1971

Los Angeles County Museum of Art, *Handbook,* 1977

The Metropolitan Museum of Art, *Guide,* 1972

The Minneapolis Institute of Arts, *A Guide to the Galleries,* 1970. Also, *European Paintings in the Minneapolis Institute of Arts,* 1963

The Montreal Museum of Fine Arts, *Guide,* 1977

National Gallery of Art, *Brief Guide,* 1976

Memorial Art Gallery of the University of Rochester, *Treasures from Rochester,* 1971

Timken Art Gallery, San Diego, *European Paintings in the Timken Art Gallery,* 1969. Also, *European Paintings in the Collection of the Putnam Foundation,* 1977

Toledo Museum of Art, *European Paintings,* 1976

Wadsworth Atheneum, *The Netherlands and the German-Speaking Countries,* 1978

JOHN D. MORSE

DOROTHY W. MORSE

FOREWORD

THIS BOOK REALLY BEGAN IN 1950, when I was conducting my first party of American artists and teachers through the museums of Europe. As we stood enthralled before the famous masterpieces in Italy, Austria, Germany, Holland, Belgium, England, France, and Spain, I found myself referring again and again to equally fine if less famous paintings in New York, Boston, Philadelphia, Detroit, St. Louis, Kansas City, San Francisco, and a number of other American cities. The members of the party seemed surprised and delighted with this information, and urged me to put it in a book. This is a new, enlarged, and updated edition of that book, which appeared in 1955 after two more summers spent in European art museums.

When the first edition appeared, Edgar P. Richardson, then director of the Detroit Institute of Arts, wrote of it: "This book is the key to a new treasure of national wealth which did not exist fifty years ago, and which is steadily increasing." How that wealth has increased since 1955 is unfolded in the following pages.

In 1955, the one hundred museums surveyed listed 2162 paintings and some drawings by forty selected European old masters in their collections. In 1978, twenty-six museums (opened or reorganized since 1955) were added to the original 100. After some updating of the 1955 group and further research on the probable holdings of the newly selected group of twenty-six, it was decided that 120 museums should be surveyed for this 1979 edition. Altogether they have listed 2692 paintings and some drawings by the same forty old masters of the 1955 edition,

plus 406 paintings by the ten old masters added for this survey. This makes a total of 3098 works by the fifty old masters discussed and illustrated in this book. These works are in the collections of American and Canadian museums, which are ready and eager to welcome the ever-increasing number of art-loving tourists, both native-born and from abroad.

All the steps taken to arrive at these figures would be too laborious to detail, but readers of the book may find some of them interesting. Individual questionnaires were developed and mailed to the directors of the 120 museums selected, which included 94 of the 100 participating in the first survey. 106 museums completed their questionnaires and returned them with the information now contained in this book. Seven replied that they had no holdings, and one reported that it was selling its old masters and replacing them with moderns. All museums surveyed responded except six small museums, which presumably have no holdings in the group of fifty artists.

The questionnaires sent to the 94 participating museums of the 1955 edition included pasted excerpts from that edition listing the pictures they had named and the given attributions, dimensions, and dates, and asked for the updating of information resulting from 25 years of museum scholarship. Other pages provided space for old master acquisitions since 1955 and nominations for ten more artists to be added to the original forty. These ten were to be selected from the following list of twenty: Bonington, Bosch, Bronzino, Jan Brueghel,

Canaletto, Cranach, J.-L. David, Gericault, van Goyen, Hobbema, Hoppner, Ingres, Kalf, Lawrence, Le Nain, Magnasco, Memling, Morland, Turner, and van der Weyden. The ten selected will be found among those artists appearing in the Table of Contents. The questionnaires for new museums asked for holdings of the original old masters and nominations for the ten to be added. These figures were duly recorded as they came in from the museums, and the results were astounding.

Many pictures had been remeasured by the original participating museums, many deleted (one museum had a number marked "stolen"), many reattributed, and many added. For example, of the 31 Rembrandts listed by the Metropolitan Museum in 1955, 12 had been reattributed and 4 added, leaving today's total of 23 Rembrandts in the Metropolitan. But the total number of Rembrandts reported in this survey is 135 instead of the 117 listed in 1955. (The 1977 edition of the *Oxford Companion to Art* gives Rembrandt's total output as 600 paintings, 300 etchings, and 2000 drawings.)

On the delicate matter of attribution, the museums' attributions were followed in all cases, with the accepted variations where authorship is still under study: *studio of, workshop of, attributed to,* or a question mark *(?)* preceding the title of the work in the Index by Artist. "Follower of" and "school of" were ruled out. Drawings were not specifically invited, but were included at the discretion of each museum, where dimensions and dates (where known) were given.

What makes an "old master"? Why was Bosch chosen and not Jan Brueghel, why Bonington and not Bronzino, why Memling and not Magnasco? The second question is easier to answer than the first. It is simply that, in order to keep the book within readable limits, the list had to stop somewhere. I admire the paintings of Jan Brueghel, Bronzino, and Magnasco, but I—and I think most of my colleagues—admire Bosch, Bonington, and Memling more. Many will differ with these opinions. And it would indeed indicate a sorry state of conformity if this or any list were accepted as definitive.

Every reader can enjoy the game of making his own list of "old masters." There are many fine painters to choose from, a number of whose names are included in the Geographical Index. How to decide which belong to the arbitrary and mythical list of "old masters," and which are merely competent painters, is, of course, as individual a matter as listing the "great books" or "great symphonies."

But paintings have one quality about them that makes excellence more easily discernible than it is in either writing or music. A painting does not exist in time, as does a novel or a song. You can take it in all at once—and then look at it for as long as you like. With one glance you can see if the subject matter is original and interestingly presented. Then, more leisurely, you can admire its color, line, and form. Are the colors laid on boldly, with assurance, or are they hesitant, cautious, and muddy? Are the brush strokes strong and vigorous, like blades of healthy spring grass, or are they tired and droopy, like zinnias in September? Are the masses placed to lead your eye around within the picture, or are they stiff and static?

The illustrations and discussions of painters and paintings that follow are intended to stimulate this kind of independent judgment. I hope they succeed in doing that and thus increase the number of nominations for "Old Masters in America."

J.D.M.

Sarasota, Florida
December, 1978

Fra Angelico

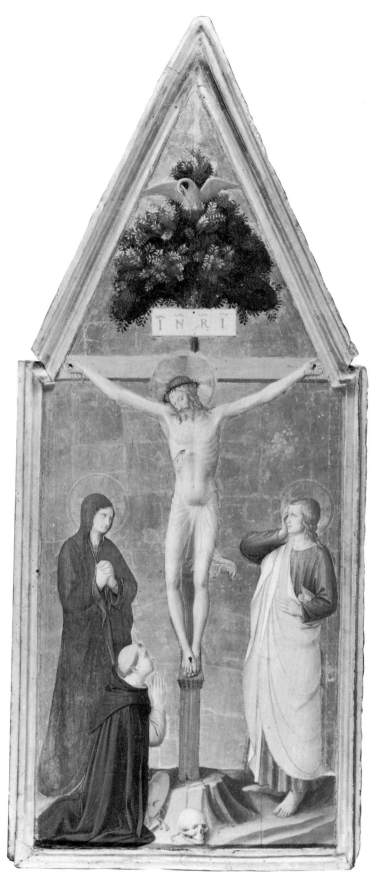

Fra Angelico • Crucifixion
Tempera on panel • 34 x 14¹/₄″ • Fogg Art Museum, Cambridge, Mass.
Hervey E. Wetzel Bequest Fund

Fra Angelico

1387—1455

Fra Angelico was born Guido di Pietro near the Tuscan village of Vicchio. He assumed the name of Fra Giovanni da Fiesole after entering the monastery of St. Dominic at Fiesole, in the hills above Florence. (The name of Angelico was given to him later.) In 1436, under the protection of Cosimo de' Medici, the order was moved to Florence, where, in the rebuilt monastery of St. Mark, Fra Angelico painted his most famous frescoes. Such was his renown, however, that he was constantly in demand elsewhere in Italy. In 1445 he was summoned to Rome by Pope Eugenius IV to help decorate the Vatican, and two years later he was invited to Orvieto to paint a Last Judgment in the cathedral. (It was completed by Luca Signorelli, who, along with Fra Filippo Lippi, was one of his collaborators. Fra Angelico also collaborated with Signorelli on the great *Adoration,* now in the National Gallery in Washington.) He died in Rome, where he was buried in the Church of Santa Maria sopra Minerva.

During Fra Angelico's lifetime, Geoffrey Chaucer, having visited Italy, returned to England to write the *Canterbury Tales;* Portuguese navigators discovered the Azores; the first book with movable type was printed in Europe. Such events marked the end of the Middle Ages outside Fra Angelico's cloister; inside it his paintings proclaimed the Renaissance. Both events and paintings reflect the increasing interest in this world and its reconciliation with the next, which was to be the chief preoccupation of the West for the next five centuries.

The most striking difference between Boston's *Virgin and Child* by Fra Angelico and the majority of pictures that were painted before it in Europe is the profusion of wild flowers in the background. The devotions of Fra Angelico embraced both worldly and heavenly beauty. He did not paint objects only as symbols, but as objects to be enjoyed for themselves. According to Bernard Berenson, he painted the first recognizable landscape in Italy—a view of Lake Trasimene.

The double rose which Giotto's Madonna holds in her hand, lovely as it is, remains a symbol, as Giotto's background of gold symbolizes her divinity. To Fra Angelico, the Madonna was no less divine in her garden of wild flowers; she was simply more of this world.

Yet he did not go so far as Raphael and place the Madonna and Child in a natural landscape. His background of flowers remains flat, like the flowers in medieval tapestry. The ones at the top of the picture are just as large as those at the bottom, instead of appearing smaller as they would in natural perspective. That Fra Angelico knew the laws of perspective is obvious from the way he drew the throne, and the fact that the heads of the angels in the background are smaller than the heads of the saints in front. The result is a curious, strangely satisfying combination of medieval and Renaissance viewpoints. The Madonna exists in convincing, worldly space, and yet she remains subtly aloof from the world.

Fra Angelico in America

Connecticut
HARTFORD, Wadsworth Atheneum
Head of an Angel, 6¾ x 5½

District of Columbia
WASHINGTON, National Gallery of Art
The Healing of Palladia by St. Cosmas and St. Damian, 14¼ x 18⅛, 1438-40 (Kress)
The Adoration of the Magi, 53⅞ x 54½, c. 1440-45 (with Fra Filippo Lippi) (Kress)
The Entombment, 35 x 21⅝, 1450-55 (attrib. to) (Kress)

The Madonna of Humility, 24 x 17⅞, c. 1430-40 (Mellon)

Massachusetts
BOSTON
Isabella Stewart Gardner Museum
The Death and Assumption of the Virgin, 23 x 14

Museum of Fine Arts
Virgin and Child with Angels, Saints, and Donor, 11½ x 11½

CAMBRIDGE, Fogg Art Museum, Harvard University
Crucifixion, 34 x 14¼

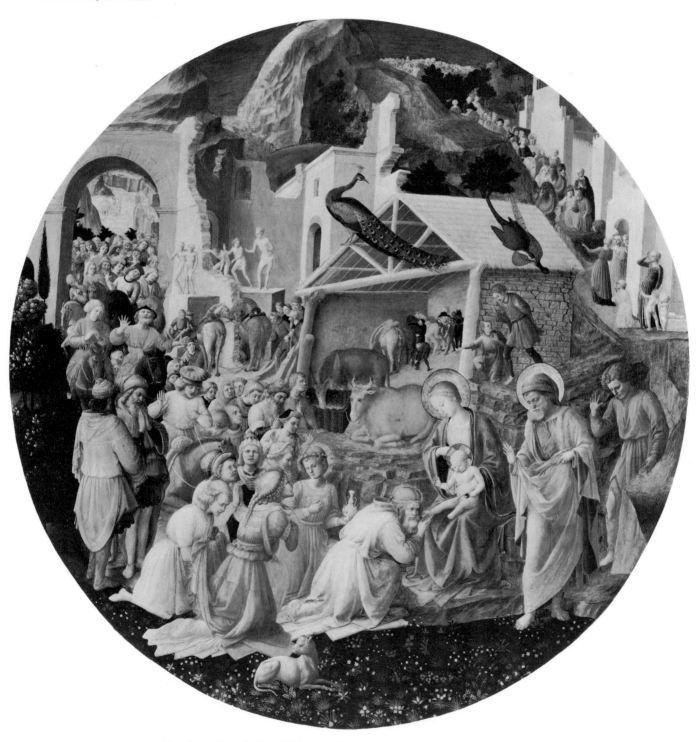

Fra Angelico & Fra Filippo Lippi • The Adoration of the Magi
Wood • 54" diameter • National Gallery of Art, Washington, D.C.
Samuel H. Kress Collection

12

Giovanni Bellini

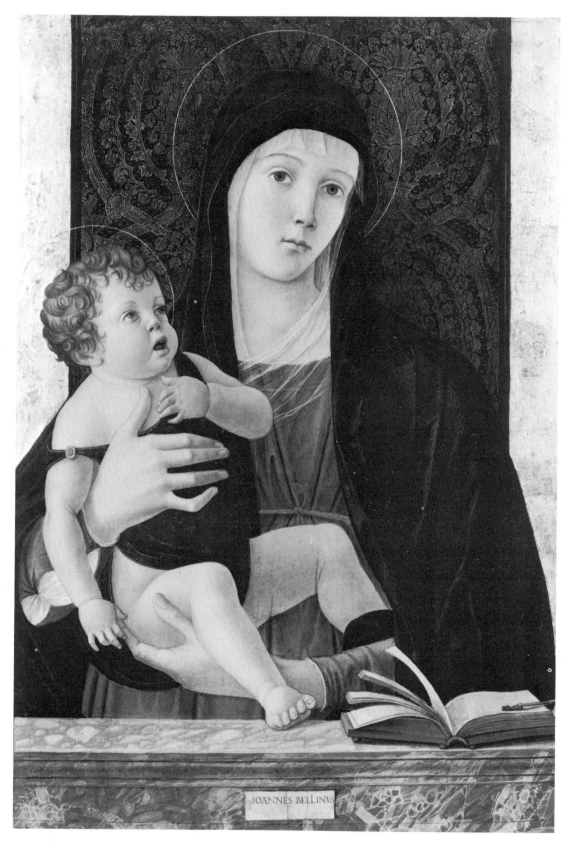

Giovanni Bellini • Madonna and Child
Tempera and oil on panel • *32½ x 23"*
Kimbell Art Museum, Forth Worth, Texas

Giovanni Bellini

1430/40–1516

Giovanni and Gentile Bellini were the sons of Jacopo Bellini, founder of the great Venetian school of painting. Both of his sons studied with him, and during their long painting careers in Venice they were both highly regarded. Giovanni, however, achieved fame not only as a great artist, but also as the teacher of Titian and Giorgione. For years he also held the coveted position of conservator of painting in the Doges' Palace, and at the height of his career he had more commissions than he could complete. He was one of the first Italian artists to paint in oil instead of tempera, after the technique was introduced into Venice from northern Europe about the year 1473 (see van Eyck).

With the paintings of Giovanni Bellini, the Renaissance came to full flower in Venice. To the men and women of the Middle Ages it had seemed fitting and proper to paint Biblical figures as rather austere symbols against a background of solid, celestial gold. Bellini painted them as human beings in warm, glowing colors against landscapes filled with birds and trees and buildings—all bathed in glorious Italian sunshine. To the eyes of the churchmen who commissioned him (as to ours today) these humanized figures were no less religious than the paintings of the Middle Ages—the Fra Angelico in Boston, for example, or the Giotto in the National Gallery. They simply reflected the changing point of view that came with the Renaissance. Europeans were discovering the world around them and finding it good. In Venice it was especially good.

At the time of Bellini's birth the population of Venice numbered 190,000, and its annual trade was computed by the Venetians at ten million ducats, with a profit of four million. Rent from Venetian houses amounted to half a million, and the salaries of about one thousand city employees ranged from seventy to four thousand ducats.

But there were other than money values in Venice, as every painting by Giovanni Bellini reveals. The story of Christ has never been painted with more love and devotion. It was also painted with a masterly skill, which is superbly illustrated in the *St. Francis in Ecstasy* in the Frick Collection. This painting demonstrates Bellini's extraordinary ability to paint a great number of interesting objects—rabbits, birds, donkeys, rocks, flowers, people, castles, etc.—in one picture and yet unify them into a single composition expressive of a central idea. He does it chiefly by the use of color.

These objects are held together in gentle harmony by the warm earth colors in which they are painted. They suggest the saint's love for all living things, just as the contrasting brilliance of the blue sky and pure white clouds above suggest his heavenly ecstasy. Many artists have painted the ecstasy of St. Francis. But it is safe to say that none has ever painted it better than Giovanni Bellini.

Sir Osbert Sitwell wrote of this picture: "probably the masterpiece of that painter, and among the most beautiful of all Venetian fifteenth-century work. . .Never was a picture more endowed with that holiness that attaches to all objects of beauty. Christianity speaks through every pagan leaf, and we are back in the lost world of ancient simplicity and understanding."

Giovanni Bellini in America

California

PASADENA, Norton Simon Museum of Art
Portrait of Joerg Fugger, 10¼ x 7⅞, 1474

SAN DIEGO, San Diego Museum of Art
Portrait of a Man, 30 x 23½

SANTA BARBARA, UCSB Art Museum, University of California
?Madonna and Child, 19¾ x 16 (Sedgwick)

District of Columbia

WASHINGTON, National Gallery of Art
Portrait of a Young Man, 12⅛ x 9¾, c. 1500 (Kress)
Madonna and Child in a Landscape, 29½ x 23, c. 1500 (with assistant) (Kress)
Portrait of a Young Man in Red, 12½ x 10⅜, 1480 (Mellon)
The Feast of the Gods, 67 x 74, 1514 (Widener)
Portrait of a Condottiere, 19¼ x 13⅞, 1480-90 (Kress)

Madonna and Child, 21 x 16¾, c. 1475 (Kress)
Orpheus, 18⅝ x 32, c. 1515 (Widener)
Portrait of a Venetian Gentleman, 11¾ x 8, c. 1500 (Kress)
St. Jerome Reading, 19¼ x 15½, 1505 (Kress)
Portrait of a Senator, 13¾ x 12⅛, c. 1475-80 (Kress)
Madonna and Child, 28¼ x 20⅞, c. 1480
An Episode from the Life of Publius Cornelius Scipio,
 29½ x 140¼, after 1506 (Kress)
Madonna and Child with Saints, 29¾ x 20, c. 1490 (Kress)

Georgia
ATLANTA, The High Museum of Art
 Madonna and Child, 37½ x 28¾, c. 1512

Louisiana
NEW ORLEANS, New Orleans Museum of Art
 Madonna and Child with St. John and St. Peter, 32⅞ x 47⅞,
 c. 1510 (with Catena) (Kress)

Maryland
BALTIMORE, The Walters Art Gallery
 Madonna and Child Enthroned with Saints and Donors,
 36⅛ x 59¹/₁₆

Massachusetts
BOSTON, Isabella Stewart Gardner Museum
 The Madonna and Child, 24 x 16¾

Michigan
DETROIT, The Detroit Institute of Arts
 Madonna and Child, 33⅜ x 41¾, 1509

Missouri
KANSAS CITY, The Nelson Gallery and Atkins Museum
 Madonna and Child, 29⅛ x 22¼ (Kress)

New York
NEW YORK CITY
 The Frick Collection
 St. Francis in Ecstasy, 49 x 55⅞,
 c. 1480

The Metropolitan Museum of Art
 Madonna Adoring the Sleeping Child, 28½ x 18¼
 Madonna and Child, 13⅜ x 10⅞ (workshop of) (Bache)
 *Madonna and Child with Sts. Peter, Margaret, Lucy, and
 John the Baptist*, 38¼ x 60½ (Bellini and workshop)
 (Bache)
 Madonna and Child, 35 x 28

Ohio
TOLEDO, The Toledo Museum of Art
 Christ Carrying the Cross, 19½ x 15¼, c. 1503

Oklahoma
TULSA, The Philbrook Art Center
 Portrait of a Bearded Man, 5⅜ x 4¼ (Kress)

Pennsylvania
PHILADELPHIA, Philadelphia Museum of Art
 Virgin and Child, 25⅝ x 17⅝ (attrib. to) (Johnson)

Texas
FORT WORTH, Kimbell Art Museum
 Christ Blessing, 23¼ x 18½, c. 1490-95
 Madonna and Child, 32⅜ x 22¾, c. 1475

HOUSTON, The Museum of Fine Arts
 Madonna and Child, 29¾ x 21½, c. 1475-80 (Straus)

Canada

Ontario
OTTAWA, The National Gallery of Canada
 Head of Christ, 20½ x 16, c. 1505
 ?*The Saviour*, 62¾ x 35, c. 1500?

Giovanni Bellini
The Feast of the Gods
Canvas • 67 x 74"
National Gallery of Art
Washington, D.C.
Widener Collection

16

Richard Parkes Bonington

Richard Parkes Bonington • View near Rouen
Oil on canvas • 21⁷/₁₆ x 33¹/₈ " • Taft Museum, Cincinnati, Ohio

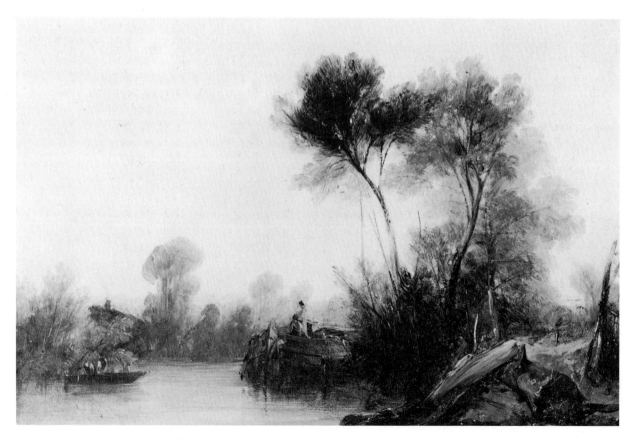

Richard Parkes Bonington • View on the Seine
Oil on millboard • 12 x 15³/₄ " • Virginia Museum of Fine Arts, Richmond

Richard Parkes Bonington
1802–1828

Richard Parkes Bonington was born in the English village of Arnold, near Nottingham, the son of a drawing master who encouraged the boy's early artistic efforts. In 1817 the family moved across the Channel to Calais, where Richard sketched street scenes and began experimenting with watercolors. He studied briefly at the Ecole des Beaux-Arts in Paris, and in 1820 entered the studio of Baron Gros, the Classicist and pupil of J.-L. David. Bonington established a reputation for watercolor landscapes when he exhibited his work at the Salon of 1822. In 1823 he began painting in oil which he exhibited at the so-called English Salon of 1824 held at the Louvre, where he first saw the paintings of Constable. At the Louvre he met and became friendly with Delacroix, who accompanied him to England in 1824 where they both sought out more of Constable's paintings, which were to influence Bonington greatly during the remainder of his short life. In 1826 he visited Italy, where he possibly contracted the tuberculosis that ended his life two years later, but not until he had completed a number of landscapes and Venetian scenes such as *A Procession on the Quay*.

After Bonington's death at the age of twenty-six, his friend Delacroix wrote the following about his work: "As a lad he developed an astonishing dexterity in the use of watercolors, which were in 1817 an English novelty. Other artists were perhaps more accurate than Bonington, but no one in the modern school, perhaps no earlier artists, possessed the lightness of execution which makes his works, in a certain sense, diamonds, by which the eye is enticed and charmed independently of the subject or of imitative appeal."

Delacroix's comments are particularly true of Bonington's English and French landscapes and coastal scenes, but they also apply to the few paintings he made on his trip to Italy. *A Procession on the Quay* in the Ball State University Art Gallery at Muncie, Indiana, is a fine example. There are several views of Venice and the area adjacent to the Piazza San Marco reproduced in this book (Canaletto; Guardi; Turner), and some of them sparkle with life. As we said of Guardi's paintings, they not only look like Venice, they *feel* like it. Bonington's *A Procession on the Quay* not only looks and feels like Venice; in Delacroix's words, "the eye is enticed and charmed independently of the subject or of imitative appeal."

This is a procession along the quay, or *molo*, beneath the Doges' Palace. Most artists would have named the procession—told us who the people are and where they are proceeding. Bonington saw a colorful pattern of brightly dressed people against a background of famous buildings under a blue and white sky. Red, white, blue, and gold are the chief instruments in this color orchestration—to adopt a musical metaphor. Its chord is sounded by the couple standing in the center of the picture. Her jacket is gold, his red under a red cap with a white feather in it. The brilliant red of the robed figures whom they are facing is made more billliant by the clear white robes of the figures beyond them and those coming over the white marble bridge, partially obscured by the gold banner. On the boat to the left a red-clad figure is hoisting a golden sail against a row of blinding white buildings down the canal, across from Santa Maria della Salute.

But all this color did not blind Bonington to the historic buildings he was also painting. His rendering of the fifteenth-century Doges' Palace is exact and meticulous, as are the two columns beyond it facing the Piazzetta and supporting a bronze lion, symbol of St. Mark, and a figure of St. Theodore, first patron of Venice. Beyond them is Sansovino's old library with its round arches, finished in 1584 and standing as firmly in Bonington's painting as it does today. Like all good works of art, this painting is an enticement to the mind as well as to the eye.

Richard Parkes Bonington in America

California
STANFORD, Stanford University Museum of Art
Vue de Rouen (drawing), 10⅛ x 7¾

District of Columbia
WASHINGTON, Corcoran Gallery of Art
On the Sea Coast, 10¾ x 14

Indiana
MUNCIE, Ball State University Art Gallery
A Procession on the Quay, 45½ x 64½, 1827

SOUTH BEND, Notre Dame University Art Gallery
Francois Ier and the Duchesse d'Etampes, 13¾ x 10½

Kentucky
LOUISVILLE, The J. B. Speed Art Museum
Greenwich (watercolor), 4½ x 7½, 1825

Massachusetts
BOSTON, Museum of Fine Arts
The Lover, 10¾ x 9
The Use of Tears, 15¼ x 12½
Fishing Village on the French Coast, 15¼ x 25½

CAMBRIDGE, Fogg Art Museum, Harvard University
Don Quixote, 7⅛ x 5⅛
Evening in Venice, 21¾ x 18¼
Cathedral of Notre Dame and Market Place of Caudebec-en-Caux, 37 x 47
Riva degli Schiavone and Doges' Palace, Venice, 24½ x 15½

NORTHAMPTON, Smith College Museum of Art
View of a Norman Town (unfinished), 36 x 45, c. 1827-28
The French Coast (watercolor), 6½ x 12⁵/₁₆

Michigan
DETROIT, The Detroit Institute of Arts
La Couseuse, 6⅞ x 4⅜

Missouri
KANSAS CITY, The Nelson Gallery and Atkins Museum
View in Boulogne, 18 x 24, 1824

New York
NEW YORK CITY, The Metropolitan Museum of Art
Mantes on the Seine, 15 x 20¾

Roadside Halt, 18¼ x 14⅞
Château of the Duchesse de Berri on the Seine, 14½ x 20⅝

Ohio
CINCINNATI, The Taft Museum
View near Rouen, 21⁷/₁₆ x 33⅛, 1826

CLEVELAND, The Cleveland Museum of Art
Battle of Crusaders (sketch), 5½ x 7¼

Oregon
PORTLAND, Portland Art Museum
Entrance to the Wey (watercolor), 3⅜ x 6½

Rhode Island
PROVIDENCE, Museum of Art, Rhode Island School of Design
Girl Writing a Letter, 8½ x 6½
Landscape (drawing), 6⅝ x 8⁷/₁₆, c. 1825

South Carolina
COLUMBIA, Columbia Museums of Art and Science
Trent River, 28½ x 44 (with Richard Parkes and James Holland)

Texas
FORT WORTH, Kimbell Art Museum
Lake Como, 7¼ x 6¾, 1826

Virginia
RICHMOND, Virginia Museum
View on the Seine, 12 x 15¾

Canada

Ontario
OTTAWA, The National Gallery of Canada
Landscape with a Wagon, 14⅞ x 20½, 1825

TORONTO, Art Gallery of Ontario
Dutch Fishing Boats (watercolor), 9⁷/₁₆, 182?

Quebec
MONTREAL, Montréal Museum of Fine Arts
View of the Seashore, 12¹/₁₆ x 15⁵/₁₆

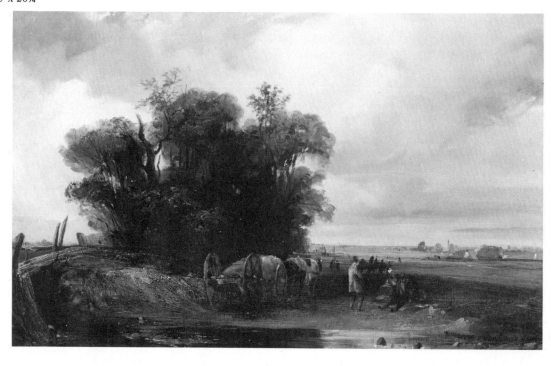

Richard Parkes Bonington
Landscape with a Wagon
Oil on canvas • 14½ x 20"
National Gallery of Canada
Ottawa, Canada

Hieronymus Bosch

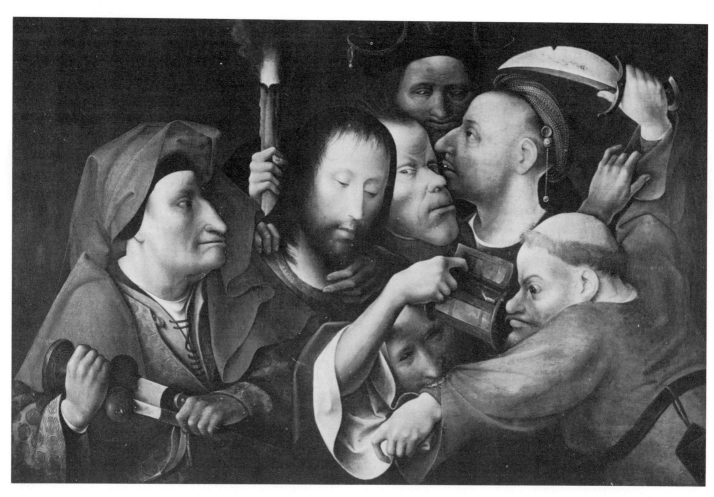

Hieronymous Bosch • Christ Taken Captive
Oil and tempera on panel • *20 x 32″* • *San Diego Museum of Art*

Hieronymus Bosch

c. 1450–1516

Bosch was born in the town of Hertogenbosch, from which he took his painting name and where he spent most of his life. It is the capital of the province of North Brabant in the Netherlands, about thirty miles southeast of Utrecht. Not much is documented about Bosch's early life except that as an orthodox Catholic he was a prominent member of the Brotherhood of Our Lady and that in 1480 he completed some panels for the Brotherhood's Church of St. John in Hertogenbosch, which his father, also a painter, had left unfinished. In the 1480s he married into a well-to-do family and inherited property which apparently gave him sufficient means to continue painting independent of patronage. Only about forty of his paintings are known to exist today (ten of them in American public collections), but the origin of their unique style remains a mystery. Nothing quite like Bosch's half-human, half-animal figures placed in weirdly realistic surroundings existed before or since—until the emergence of surrealistic painting (such as that by the Spaniard, Salvador Dali) in the twentieth century. In his own time Bosch's paintings were well received, especially in Spain, where Philip II collected a number of them which are now in the Prado.

In 1605 a Spanish friar, Brother José de Siguenza, wrote what is perhaps the most penetrating analysis yet to appear in print of the paintings of Hieronymus Bosch. "The divergence which exists between the paintings of this man and those of others consists in that the latter seek to paint men as they outwardly appear, but he alone has the audacity to paint them as they are inwardly."

Few writers on art have had the "audacity" to interpret the paintings of Hieronymus Bosch. No one can ever know exactly what he intended to communicate. We know that as an orthodox Catholic his work is built around the themes of temptation and redemption—the soul's perpetual exposure to the wiles of the evil one. We know the meaning of certain symbols in medieval theology: the crucifix symbolizes redemption; the egg represents both alchemy and sexual creation; the apple was the symbol of carnal pleas-ure, as in Adam and Eve. But to interpret these objects in modern terms is the dubious province of a psychiatrist, not an art historian.

However, the staff of the National Gallery in Washington, owners of Bosch's *Death and the Miser,* offer the following:

"Bosch has shown three stages in the life of a rich man. In his youth he has earned money fighting with sword and spear and guarded by armor and shield. Grown older, he tries to hoard his gains, while salamanders and rats carry away his treasure. Around his waist hangs the key to his strong box and his rosary, the key to his salvation. In the upper part of the picture, un-aware of death, he makes his choice. Which key will he use? The *Ars Moriendi,* or treatise on the art of dying, which probably inspired this paint-ing, suggests an optimistic outcome. But in the foreground a winged mannequin which has been identified as a self-portrait, smiles sardonically."

Hieronymus Bosch in America

California
SAN DIEGO, San Diego Museum of Art
Christ Taken Captive, 20 x 32, c. 1500

Connecticut
NEW HAVEN, The Yale University Art Gallery
Intemperance, 13⁵⁄₁₆ x 12⅛

District of Columbia
WASHINGTON, National Gallery of Art
Death and the Miser, 36⅜ x 12½, c. 1490 (Kress)

Massachusetts
BOSTON, Museum of Fine Arts
Ecce Homo, 28¾ x 23

New Jersey
PRINCETON, The Art Museum, Princeton University
Christ Before Pilate, 31½ x 41

New York
NEW YORK CITY, The Metropolitan Museum of Art
The Adoration of the Magi, 28 x 22¼

Pennsylvania
PHILADELPHIA, Philadelphia Museum of Art
Mocking of Christ, 20½ x 21¼ (Johnson)
Adoration of the Shepherds, 14¾ x 8⅞ (attrib. to) (Johnson)

Arrival of the Magi, 14¼ x 8⅜ (attrib. to) (Johnson)
Virginia
NORFOLK, Chrysler Museum at Norfolk
Temptation of St. Anthony, 16½ x 10½

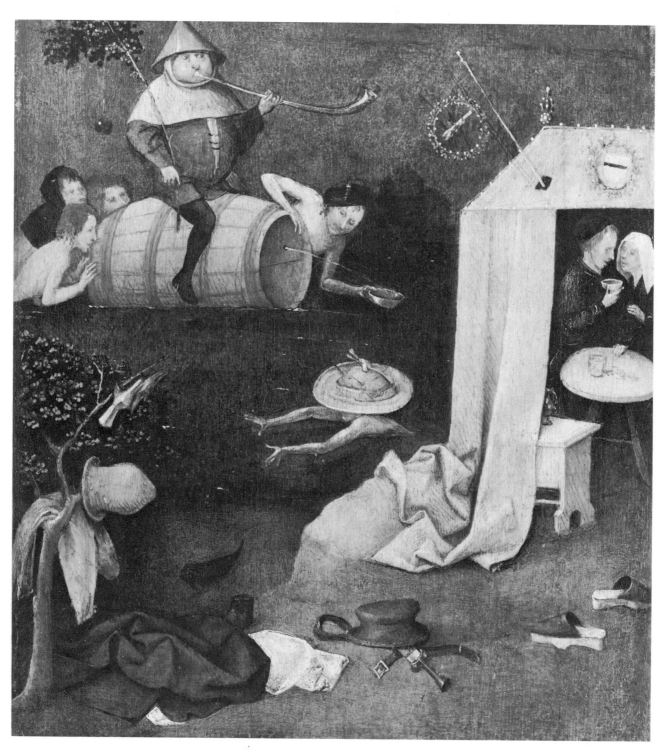

Hieronymous Bosch • Intemperance
Oil on wood • 14⅛ x 12⅜" • Yale University Art Gallery
The Rabinowitz Collection

Alessandro Botticelli

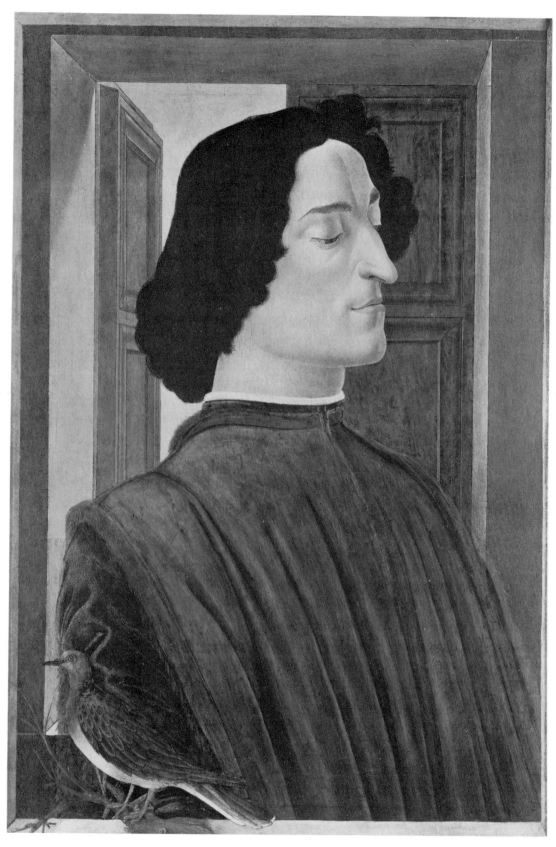

Botticelli • Giuliano de'Medici
Wood • 29¾ x 20⅝″ • National Gallery of Art, Washington, D.C.
Samuel H. Kress Collection

Alessandro Botticelli

1445–1510

Born Alessandro Filipepi, the son of a Florentine tanner, Botticelli probably took his painting name from an elder brother who, for some reason, apparently was called Botticello, or "little barrel." It may have been this brother who recognized young Sandro's talent and apprenticed him to Fra Filippo Lippi, the colleague of Fra Angelico. Botticelli achieved fame early as one of the foremost painters of the great Florentine school and was soon enjoying the patronage of the Medici family, for one of whose members he painted, when only thirty-four, the famous *Primavera,* now in the Uffizi Gallery. (Another painting that helped to establish Botticelli's reputation is the *Madonna of the Eucharist,* now in the Gardner Museum, Boston.) In 1481 Botticelli was summoned to Rome to help with the decoration of the Sistine Chapel, but after a year and a half he was back in Florence where, in his later years, he became a follower of Savonarola. In addition to portraits, frescoes, and altarpieces, he executed nearly a hundred drawings as illustrations for Dante's *Divine Comedy.*

The humanizing of the Christian story in art that came with the Renaissance is nowhere more beautifully illustrated than in Botticelli's painting of *The Adoration of the Magi* in the National Gallery in Washington. The original description of this famous scene appears in a single verse of St. Matthew 2:11:

And when they were come into the house, they saw the young child with Mary his mother, and fell down, and worshipped him: and when they had opened their treasures, they presented unto him gifts; gold, and frankincense, and myrrh.

During the Middle Ages this simple scene became embellished as follows in one of the official church handbooks of instructions for painters:

A house; the seated Virgin holds the Christ, blessing; the Three Magi offer gifts in boxes of gold; one, an old man with long beard and head covered, kneels, keeping his eyes turned toward the Christ, and with one hand he offers his gift, while with the other he takes hold of his crown. Second, very little beard; third should have no beard and, moreover, should belong to the Negro race. They look at each other, showing the Christ. On the right of the Virgin, St. Joseph should stand in an act of adoration. Outside the grotto a youth holds three horses by the bridle. In the distance, on a mountain, the Magi on horseback are returning to their own country with the escort of an angel.

In the 1480s, when Botticelli painted his *Adoration,* the Christian story had become even more familiar and more embellished. It was, in fact, so much a part of the daily lives of the people that Botticelli could present the Adoration, in all reverence, as though it had recently occurred on a hill just outside Florence. The principal characters are here, of course, and are easily recognized. But present also are a lot of interesting things not mentioned in either the Bible or in the medieval handbook.

Here is a fine Tuscan landscape, with hills, houses, trees, and a river—all in glowing sunlight. Here are several more horses than were last prescribed, each in its own attitude of grace. And here are many more people, each one a complete individual, wearing a different expression and a different robe. The citizens of Florence, too, are in adoration.

Equally important is the fact that these horses, hills, and people are painted with the flowing grace that makes Botticelli unique among artists. It is a vital grace, like that of the dancer Nijinsky. It appears in every line: in the gestures of the Madonna and Child, in the curving necks of the horses, in the feet of the kneeling figures. And it is always accompanied by color as surely placed and subtle and lovely as the line that carries it. Here is a high perception of harmony in nature, incomparably expressed. Here is great art and, therefore, in itself an act of adoration as pure as that of the magi.

Also in St. Matthew appears the verse (5:16):

Let your light so shine before men, that they may see your good works, and glorify your Father which is in heaven.

Alessandro Botticelli in America

Colorado
DENVER, The Denver Art Museum
Madonna and Child, 14 diam., c. 1485 (workshop of)

Connecticut
NEW HAVEN, The Yale University Art Gallery
Madonna with the Pomegranate, 32¾ x 21⅞ (studio of)

District of Columbia
WASHINGTON, National Gallery of Art
Madonna and Child, 29⅞ x 21⅞, c. 1470 (Mellon)
The Adoration of the Magi, 27⅝ x 41, 1481-82 (Mellon)
The Virgin Adoring Her Child, 23½ diam., c. 1480-90 (Kress)
Portrait of a Youth, 16¼ x 12½, 1483-84 (Mellon)
Giuliano de' Medici, 29¼ x 20⅝, c. 1476 (Kress)

Illinois
CHICAGO, The Art Institute of Chicago
Madonna and Child with Angels, 13⅛ diam., c. 1490

Massachusetts
BOSTON, Isabella Stewart Gardner Museum
The Tragedy of Lucretia, 32¾ x 70¼
Madonna of the Eucharist, 33 x 24¾

CAMBRIDGE, Fogg Art Museum, Harvard University
Magdalene at the Foot of the Cross, 28½ x 20¼

WILLIAMSTOWN, Sterling and Francine Clark Art Institute
Virgin and Child with St. John the Baptist, 34⅛ diam.,
 c. 1490

Michigan
DETROIT, The Detroit Institute of Arts
The Resurrected Christ, 18 x 11¾, c. 1480

New York
GLENS FALLS, The Hyde Collection
Annunciation, 7 x 10⁹/₁₆, 1472-80

New York City, The Metropolitan Museum of Art
The Last Communion of St. Jerome, 13½ x 10 (Altman)
Three Miracles of St. Zenobius, 26½ x 59¼

Ohio
CINCINNATI, The Cincinnati Art Museum
Judith with the Head of Holofernes, 11½ x 8½

CLEVELAND, The Cleveland Museum of Art
Madonna and Child with the Young St. John (tondo),
 26¾ diam.

Oregon
PORTLAND, Portland Art Museum
Christ on the Cross, 21⅞ x 15¾ (attrib. to) (Kress)

Pennsylvania
PHILADELPHIA, Philadelphia Museum of Art
Portrait of Lorenzo Lorenzano, 20 x 14⅜ (Johnson)
Life of the Magdalen, four predella panels, ea. 7¼ x 16¼
 (Johnson)

South Carolina
COLUMBIA, Columbia Museums of Art and Science
Adoration of the Child, 63½ x 54 (Kress)

**GREENVILLE, The Bob Jones University Art Gallery
and Museum**
Madonna and Child with Angels (tondo), 37 diam.

Canada

Ontario
OTTAWA, The National Gallery of Canada
The Christ Child and St. John Baptist, 14½ x 10, c. 1490-94
 (studio of)

Botticelli • Annunciation
Tempera on panel • 7 x 10⁹/₁₆" • The Hyde Collection, Glens Falls, N.Y.

Pieter Bruegel

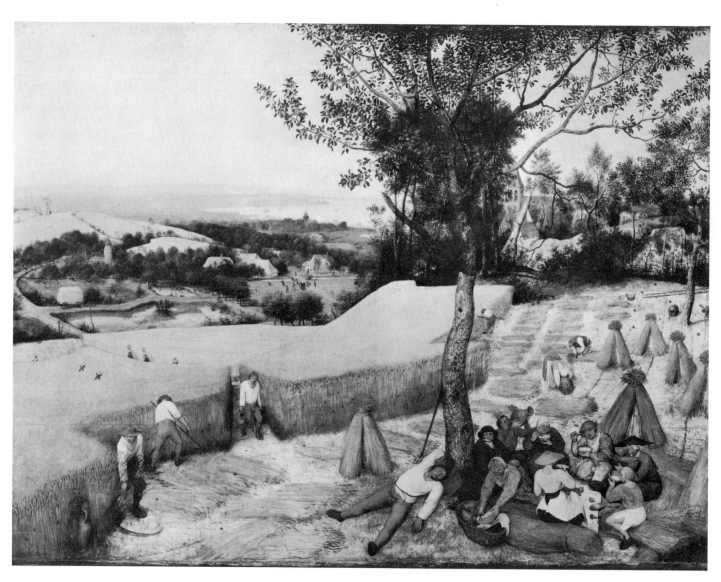

Pieter Bruegel, the Elder • The Harvesters
Oil on wood • 46½ x 63¼"
The Metropolitan Museum of Art, New York City
Rogers Fund

Pieter Bruegel

c. 1525–1569

Pieter Bruegel was born in a little town on the boundary line of present-day Belgium and Holland. Not much is known about Bruegel's life. The documents show that he went to Antwerp as a young man to study painting and that he became a member of the Antwerp guild of painters in 1551. The same year he made the conventional artist's trip to Italy (he was not impressed) and returned to Antwerp to marry the daughter of his teacher, Pieter Coeck van Aelst. He had two sons, Pieter and Jan, both of whom became painters. Jan, or "Velvet," Brueghel painted many of the fauna and flora details in Rubens's big pictures (New York, Sarasota) and achieved fame as a floral painter in his own right. Pieter the Younger chiefly copied his father's work, to the vast confusion of art scholars ever since.

Bruegel and Shakespeare had much in common. Each of these near contemporaries saw the extent of human vanity more clearly than it is given the rest of us to see, yet they remained undismayed by what they saw. The characters in their pictures and plays are never *entirely* villainous or *entirely* heroic. They are people: contradictory, complex, and wonderful.

In Detroit's *The Wedding Dance* Bruegel painted no less than 125 people, all gaily dressed and busily engaged in celebrating a wedding. In the hands of a lesser artist such an attempt would have resulted in complete confusion. Bruegel was great enough as an artist to create a delightful harmony out of what must have been actually a chaotic crowd.

The majority of the people in the picture are wearing scarlet jackets, dresses, trousers, or capes, yet so skillfully has Bruegel distributed these brilliant colors, balancing them with olive greens and blues, with accents of pure white, that they all blend together as handsomely as a bowl of ripe fruit. His use of line is even more skillful. Although one's impression is that of vast activity, Bruegel has actually let only seven couples do the dancing, and it is they who form the basic composition. This basic design is a triangle, whose lower points are the musician at the right and the bystander at the left, and whose apex is the joined hands of the farthest pair of dancers. All the other lines in the picture are subtly related to this central triangle, giving unity to the composition.

The story of Detroit's acquisition of *The Wedding Dance* superbly illustrates the fascination of art-historical detection. Another version of the painting, labeled "Pieter Bruegel the Elder," was hanging in the Antwerp Museum when Dr. William R. Valentiner, then director of the Detroit Institute of Arts, discovered this one at a sale in London. It was called a copy by Pieter the Younger.

After careful study, Dr. Valentiner decided that he was looking at the original and that Antwerp had the copy. Strong in his conviction, he cabled Detroit, and bought the London "copy." He then had it cleaned and boldly hung it as the original, letting the chips fall where they might. They fell heavily. But one by one his fellow art historians came to agreement, and in 1935 he was completely vindicated when the Detroit *Wedding Dance* was invited to an international exhibition in Brussels as the original.

Pieter Bruegel in America

California
SAN DIEGO, Timken Art Gallery, San Diego
Parable of the Sower, 28⅞ x 40¼, 1557

Maine
BRUNSWICK, Bowdoin College Museum of Art
Waltersburg (drawing), 10½ x 12¾

Massachusetts
BOSTON, Museum of Fine Arts
Combat Between Carnival and Lent, 14¼ x 25

CAMBRIDGE, Fogg Art Museum, Harvard University
An Alpine Landscape (drawing), 17¾ x 12

NORTHAMPTON, Smith College Museum of Art
Mountain Landscape with Four Travelers (drawing),
5½ x 7⁷/₁₆, 1560

Michigan
DETROIT, The Detroit Institute of Arts
The Wedding Dance, 47 x 62

New York
NEW YORK CITY
The Frick Collection
The Three Soldiers, 8 x 7, 155(?)8

The Metropolitan Museum of Art
The Harvesters, 46½ x 63¼

Pennsylvania
PHILADELPHIA, Philadelphia Museum of Art
Unfaithful Shepherd, 24¼ x 33⅞ (composition attrib. to)
(Johnson)

Washington
SEATTLE, Seattle Art Museum
Dancing Peasants, 16⅛ x 14⅛

Pieter Bruegel, the Elder • Parable of the Sower
28⅞ x 40¼" • Timken Art Gallery, San Diego, California

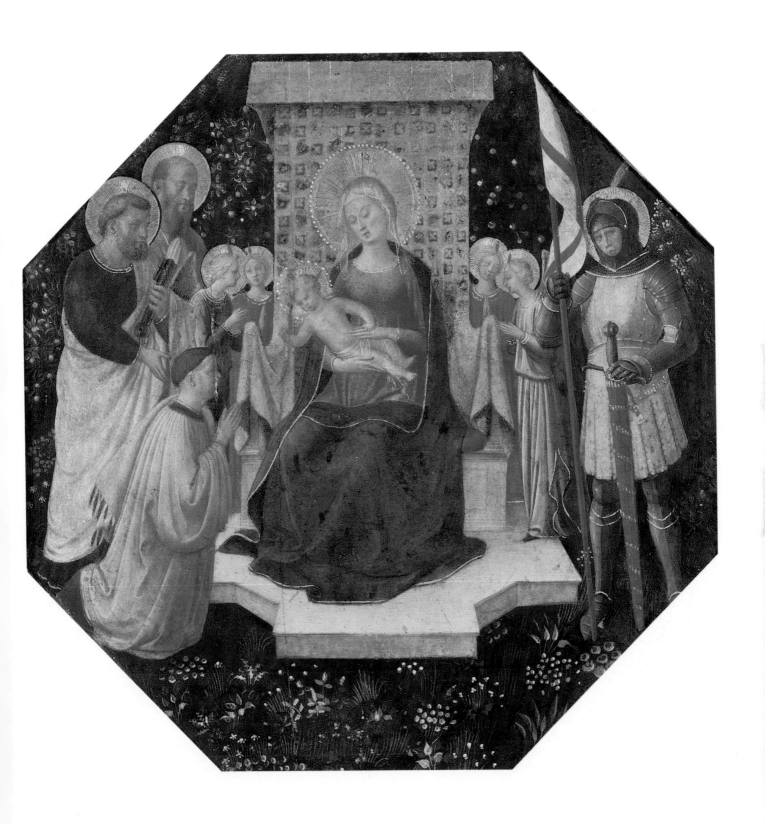

Fra Angelico • Virgin and Child with Angels, Saints and Donor
Tempera on panel • 11½ x 11½" • Museum of Fine Arts, Boston

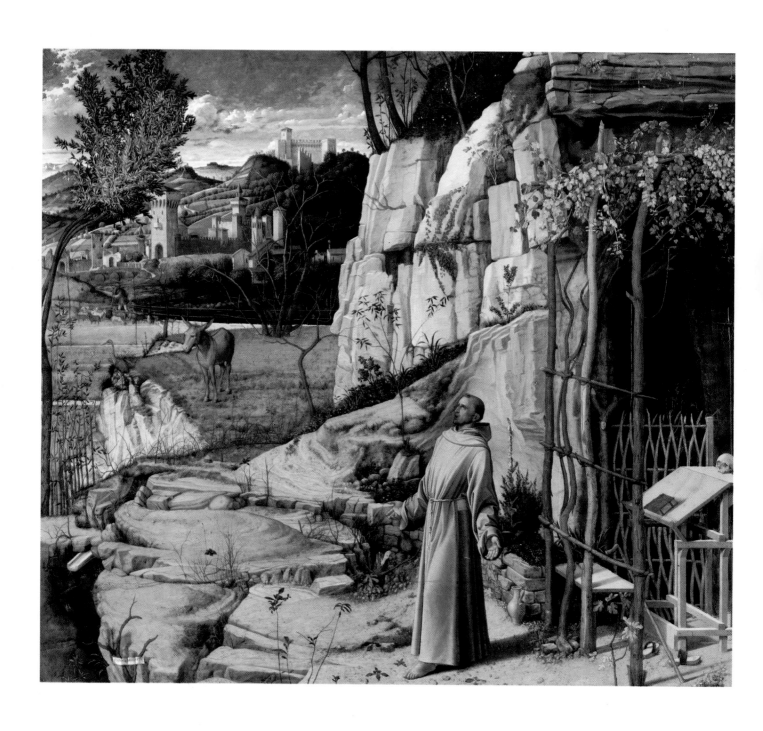

Giovanni Bellini • St. Francis in Ecstasy

Oil on canvas • *49 x 55⅞″* • *The Frick Collection, New York*

Richard Parkes Bonington • A Procession on the Quay
Oil on canvas • 45½ x 64½″ • Ball State University Art Gallery, Muncie, Indiana

Hieronymus Bosch • Death and the Miser

Oil on canvas • 36⅜ x 12½ '' • National Gallery of Art, Washington, D.C. • Samuel H. Kress Collection

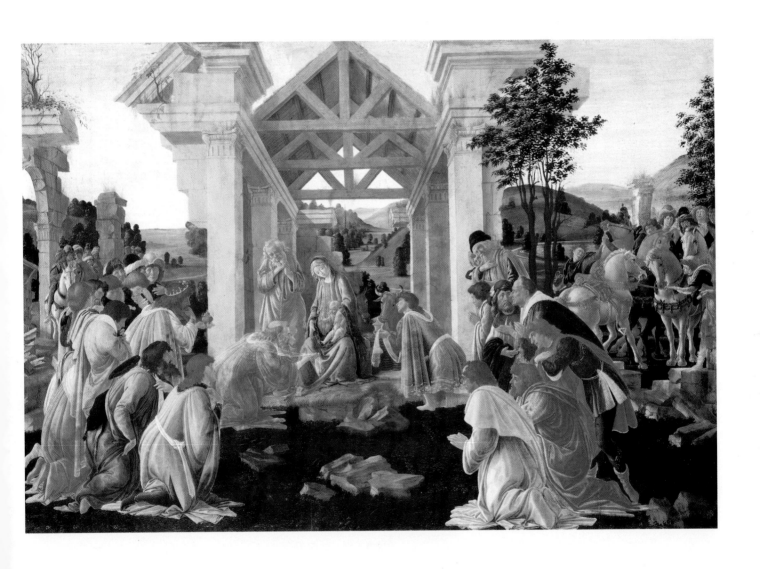

Botticelli • The Adoration of the Magi
Panel • 27⅝ x 41" • National Gallery of Art, Washington, D.C. • Andrew W. Mellon Collection

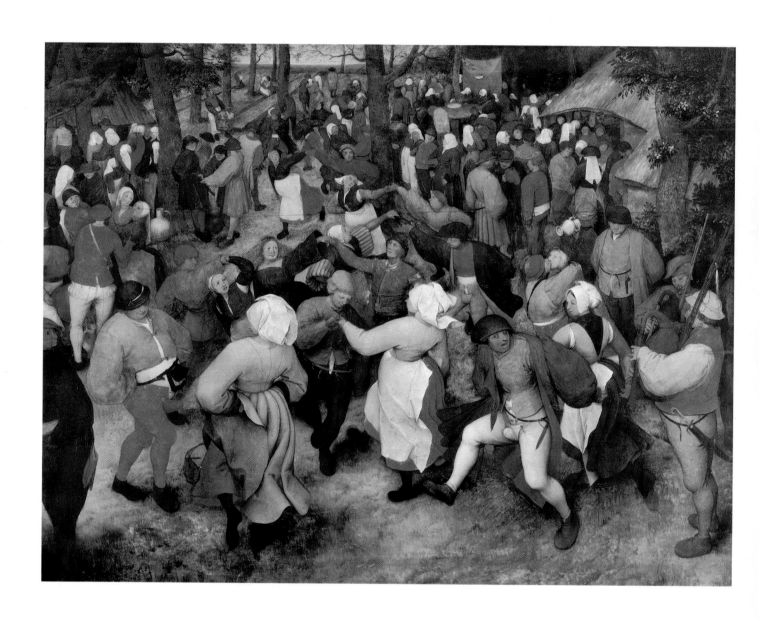

Pieter Bruegel, the Elder • The Wedding Dance
Oil on canvas • 47 x 62" • Detroit Institute of Arts

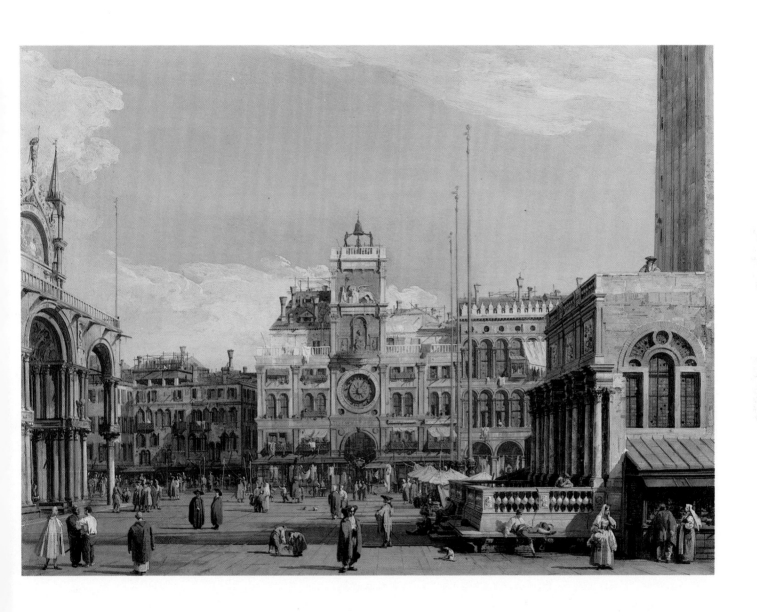

Giovanni Antonio Canal, called Canaletto • The Clock Tower in the Piazza San Marco, Venice
Oil on canvas • 20¾ x 27¾"
William Rockhill Nelson Gallery of Art, Kansas City, Missouri • Nelson Fund

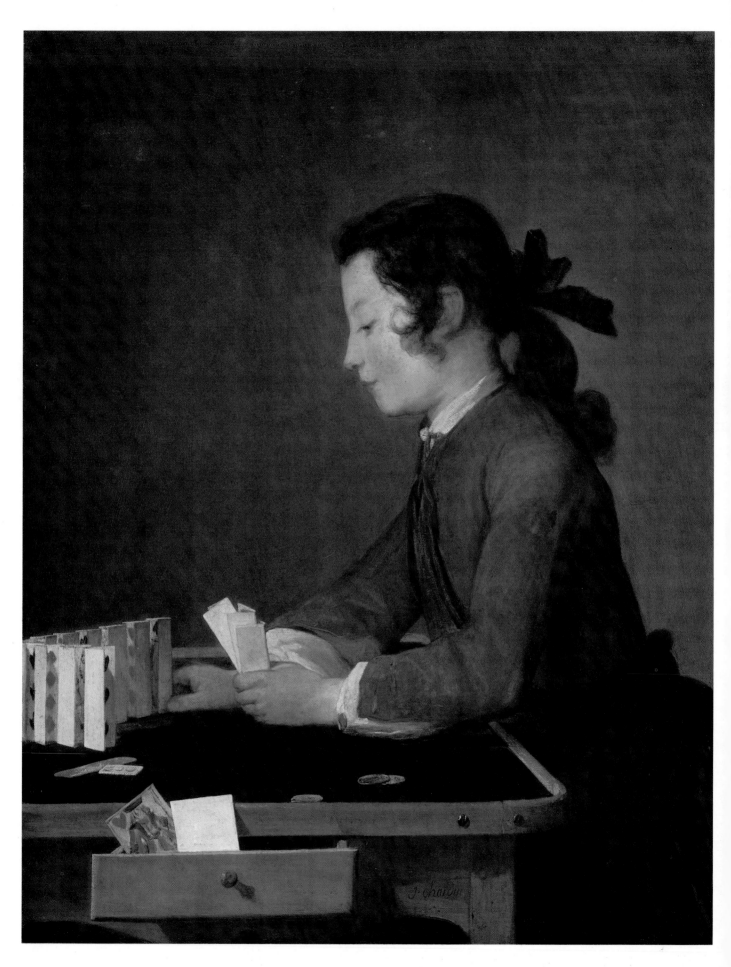

Jean-Baptiste-Siméon Chardin • The House of Cards

Oil on canvas • 32⅜ x 26" • National Gallery of Art, Washington, D.C. • Andrew W. Mellon Collection

Canaletto

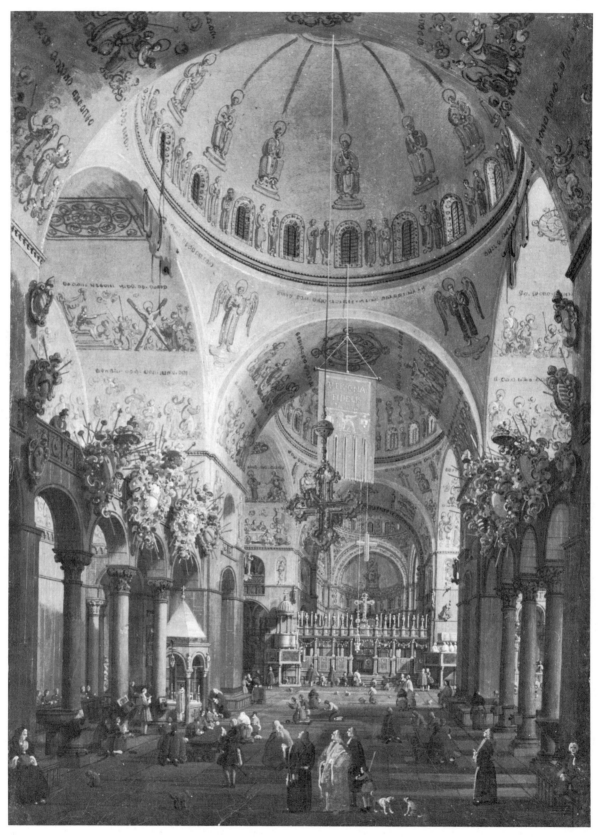

Giovanni Antonio Canal, *called* **Canaletto** • St. Mark's Cathedral
Oil on Canvas • *17³⁄₈ x 12³⁄₈ ″* • *The Montreal Museum of Fine Arts*
Bequest of Miss Adaline Van Horne

Canaletto

1697—1768

Canaletto was born in Venice as Giovanni Antonio Canale, the son of a theatrical scene painter who took young Antonio to Rome in 1716 to help him with theatrical commissions. There Antonio began making topographical views *(veduti)*, which he continued to produce back in Venice after 1720, when his name first appears on the roster of Venetian painters, and where his skill at painting views of the city brought him many wealthy English clients. His friendship with these clients and his agent, Joseph Smith, Venetian consul, induced him to visit England in 1745, where he made a number of drawings and paintings in the style which he had perfected in Venice. (A drawing of *St. Paul's Cathedral* is in Buffalo.) In 1755 Canaletto returned to Venice and, except for two more brief trips to England, painted there happily and profitably until his death. To expedite production of his *veduti,* Canaletto made good use of the *camera obscura,* a dark box (or even a room) with a tiny hole on one of its sides through which light from a brightly lit scene enters and forms an image on a screen exactly like the image on the ground glass of a modern camera. The lines of buildings or trees can then be accurately transferred to canvas and painted. The principle of the *camera obscura* was known to Aristotle and to a number of Italian artists, including Leonardo. The first written account of it appeared in Italy in 1558 with the publication of *Magia Naturalis* by Giambattista della Porta. We will never know exactly in which paintings Canaletto used the *camera obscura.* But we do know that, with or without it, he painted hundreds of pictures that delight us today.

Changing taste in art is dramatically illustrated in the comparative popularity of Canaletto and Guardi. During his lifetime, Canaletto was Italy's most sought-after artist. In 1763 King George III of England bought fifty-four of his paintings and 143 drawings. His contemporary, Guardi, after painting all his life in Venice, died penniless there in 1793.

With the coming of the Romantic movement in the nineteenth century, this situation reversed itself. Canaletto's objective, naturalistic views lost favor to Guardi's subjective, imaginative landscapes, just as the poetry of Pope lost favor to that of Byron, and the music of Mozart was played less often than that of Wagner. This change in taste is still with us today. There are seventy-eight paintings by Guardi listed in this book, and only forty-one by Canaletto. Fifty years from now these figures might be reversed again. In the meantime, here is Canaletto's superb painting of the Clock Tower in the Piazza San Marco in Venice, done before 1740 and acquired by the Nelson-Atkins Gallery in Kansas City, Missouri.

The picture was painted for the eighteenth-century tourist trade. Venice was the high point on the Grand Tour taken by all Europeans who could afford it, and the Piazza San Marco was a place where thousands of them could gather at one time to tell each other tales of their travels—and possibly buy a picture like this one for a souvenir.

The Clock Tower was popular because it could be easily climbed; much went on inside it; and it commanded a view of the entire Piazza to its right, as well as the Piazzetta in front with crowds of gaily dressed citizens and tourists on the pavement below. Canaletto has painted them in a lively manner, in contrast to his firm, architectural rendering of the buildings.

Canaletto has only suggested the Campanile and Basilica, while making the Clock Tower the focal point of his painting. Two bronze Moors strike the hours on the bell at the top. Below them is a third-century winged lion of gilt copper which Venetian traders brought from Constantinople. Next is a gilt Madonna standing between two doors which open to emit and receive worshipping magi. And finally comes the great blue and gold clock, still functioning today as it was when Canaletto painted it.

Canaletto in America

Alabama
BIRMINGHAM, Birmingham Museum of Art
View of the Grand Canal, Venice, 24 x 39¾ (Kress)

California
MALIBU, The J. Paul Getty Museum
View of the Arch of Constantine with the Colosseum in Background, 32¼ x 48, 1742-43

PASADENA, Norton Simon Museum of Art
Piazzetta, Venice, 29½ x 46½

SAN DIEGO, San Diego Museum of Art
Bacino de San Marco, 33½ x 52, c. 1747-50

Connecticut
HARTFORD, Wadsworth Atheneum
Landscape with Ruins, 28¾ x 21⅞
View of Venice, Piazza and Piazzetta San Marco, 26 x 40½

District of Columbia
WASHINGTON, National Gallery of Art
View in Venice, 28 x 44, c. 1740 (Widener)

Illinois
CHICAGO, The Art Institute of Chicago
Ruins of a Courtyard (drawing), 11½ x 8⅛
Portico with Lantern, 19⅜ x 23, c. 1745
The Terrace, 19⁵⁄₁₆ x 23, c. 1745

Indiana
INDIANAPOLIS, Indianapolis Museum of Art
View of the Piazzetta San Marco Looking South, 21⅛ x 23¼, c. mid-1730s

Maryland
BALTIMORE, The Baltimore Museum of Art
Capriccio: Architecture in Ruins, 41½ x 41, c. 1755 (Jacobs)

Massachusetts
BOSTON, Museum of Fine Arts
The Grand Canal, Venice, 15 x 23½

CAMBRIDGE, Fogg Art Museum, Harvard University
View of Piazza San Marco, Venice, Facing the Basilica, 30 x 46¾, c. 1730-35

SPRINGFIELD, The Springfield Museum of Fine Arts
Farmhouse on the Venetian Mainland, 5¾ x 7½ (Gray)
Villa and Ruins by a River, 5¾ x 7½ (Gray)

WORCESTER, Worcester Art Museum
Capriccio: A Circular, Domed Church, 17¼ x 28¹⁄₃, 1740

Michigan
DETROIT, The Detroit Institute of Arts
The Piazza of St. Mark, Venice, 29¾ x 46¾

Minnesota
MINNEAPOLIS, The Minneapolis Institute of Arts
Grand Canal from Palazzo Flangini to Palazzo Bembo, 24⅛ x 36⅜

Missouri
KANSAS CITY, The Nelson Gallery and Atkins Museum
The Clock Tower in the Piazza San Marco, Venice, 20¾ x 27¾, before 1740

ST. LOUIS, The St. Louis Art Museum
Capriccio: An Island in the Lagoon with a Pavilion and a Church, 20⅛ x 27

New York
BUFFALO, The Albright-Knox Art Gallery
Distant View of St. Paul's Cathedral (drawing), 11 x 20⅜

NEW YORK CITY, The Metropolitan Museum of Art
Venice: The Piazzetta, 51½ x 51¼
Venice: Santa Maria della Salute, 18¾ x 31¼

North Carolina
RALEIGH, North Carolina Museum of Art
Capriccio: the Rialto Bridge and the Church of S. Giorgio Maggiore, 66¹³⁄₁₆ x 45⅝

Ohio
CINCINNATI, The Cincinnati Art Museum
The Arch of Septinius Severus, 20¾ x 27⅞

CLEVELAND, The Cleveland Museum of Art
View of the Piazza San Marco, Venice and the Piazzetta looking towards S. Giorgio Maggiore, 53⅝ x 91½

DAYTON, The Dayton Art Institute
The Pantheon, 24¼ x 38¼, c. 1720

TOLEDO, The Toledo Museum of Art
View of the Riva degli Schiavoni, 18½ x 24⅞, late 1730s

Oklahoma
TULSA, The Philbrook Art Center
View of Dresden from the Right Side of the Elbe, 37⅛ x 49⅛ (Kress)

Rhode Island
PROVIDENCE, Museum of Art, Rhode Island School of Design
Venetian Scene, 20¼ x 32⅞

South Carolina
COLUMBIA, Columbia Museums of Art and Science
View of Venice, 26½ x 32¾

Tennessee
MEMPHIS, The Brooks Memorial Art Gallery
Canal Grande at San Vio, 44⅜ x 63⅜

Texas
FORT WORTH, Kimbell Art Museum
Venice: The Grand Canal at Santa Maria della Carita, 18¼ x 25, c. 1726-30
The Molo, Venice, 24½ x 39⅞, c. 1735

HOUSTON, The Museum of Fine Arts
View of Venice, Entrance to the Grand Canal, 19½ x 29, 1720 (Blaffer)
The Grand Canal: Southwest, 19½ x 28¾ (Blaffer)

Washington
SEATTLE, Seattle Art Museum
Bacino di San Marco, 49½ x 80¼, c. 1730

Canada

Ontario
OTTAWA, The National Gallery of Canada
St. Mark's and the Clock Tower, Venice, 52 x 65
The Vegetable Market and San Giacometto di Rialto, 46¾ x 50¾, c. 1740-46

TORONTO, Art Gallery of Ontario
The Bacino di S. Marco from the Piazzetta, 19⅛ x 32½

Jean-Baptiste-Siméon Chardin

Jean-Baptiste-Siméon Chardin • Knucklebones
Oil on canvas • 32 x 25½" • The Baltimore Museum of Art

Jean-Baptiste-Siméon Chardin
1699–1779

Jean-Baptiste-Siméon Chardin was born in Paris and died there eighty years later after a quiet, uneventful life spent in painting the things he loved and saw around him. Perhaps the most eventful incident of his career was his first recognition as an artist when he painted an advertising sign (a man wounded in a duel being treated by a surgeon) for a doctor. He studied with the historical painter Pierre Jacques Cazes and was admitted to the Academy in 1728, where for twenty years he held the position of treasurer. Chardin exhibited regularly thereafter in the Salon, where his still-life paintings and scenes of ordinary middle-class family life created no great excitement. But they were often purchased by such discerning collectors as Prince Joseph Liechtenstein of Vienna, from whose collection the National Gallery acquired Chardin's *Attentive Nurse.*

The French author André Siegfried once pointed out that when the average Frenchman is holding one hand over his heart, the other is clutching his pocketbook. He was speaking of the dualism in French character that art historians have always found fascinating. It explains how Fragonard and Chardin could live and paint so differently in the same century: one so elegantly and the other so factually; one so grand and the other so simple. The grand manner and quiet realism have always existed side by side in French art, as Siegfried maintains they do in French character. In the seventeenth century Claude and Poussin were no more popular than Georges de la Tour and the brothers Le Nain (San Francisco, Detroit). In the nineteenth century the paintings of Delacroix and Daumier found equal favor.

Chardin, who was born in Paris and lived there all his life, was no less "French" than Fragonard because he painted the things he saw around him every day and painted them realistically. He also painted them with great sensitivity and with a subtlety of color unequaled in all of French art.

America is fortunate in owning many examples of this quiet master. We have two versions of his painting of boys blowing soap bubbles (New York, Washington), a subject unique with Chardin. And in Washington is the only American-owned version of *The House of Cards,* an engaging subject which Chardin painted several times.

Like all Chardin paintings, this picture is arresting and charming because the subject is so very ordinary that it is unusual. No other artist would have thought of painting it. Chardin's gift was seeing the unusual in the usual and painting it with all the logic of Claude or Poussin.

The eye of the boy building his house of cards is exactly midway between the left and right sides of the canvas. Placed in the upper half of the picture, it is the apex of a pyramid on which the whole composition is built. The color, too, is carefully planned. The green felt of the table provides a firm base for the delicately contrasting browns, reds, and blues.

With this solid foundation established, Chardin could afford to leave a few objects lying strewn about, such as the coins on the table and the cards sticking out of the half-open drawer. These give his painting an air of casualness. But the reason we want to look and look again is that, in addition to the charm of immediacy, the painting has the enduring, formal appeal of all great French art.

Jean-Baptiste-Siméon Chardin in America

California

PASADENA, Norton Simon Museum of Art
Dog and Game, 75¾ x 54¾, 1730
Pair of Still Lifes, 15¾ x 12⅜

SAN DIEGO, San Diego Museum of Art
The Monkey Antiquarian, 17½ x 12⅞

SAN FRANCISCO, The Fine Arts Museums of San Francisco
La Charmeuse, 25⅝ x 21¾

Connecticut
HARTFORD, Wadsworth Atheneum
Still Life—The Kitchen Table, 16½ x 13, 1732

District of Columbia
WASHINGTON
Corcoran Gallery of Art
?Woman with Saucepan, 18½ x 15 (Clark)

National Gallery of Art
The Attentive Nurse, 18¼ x 14½, c. 1739 (Kress)
Kitchen Maid, 18¼ x 14¾, 1738 (Kress)
The House of Cards, 32⅜ x 26, c. 1735 (Mellon)
Still Life with Game, 19½ x 23⅜, c. 1760-65 (Kress)
Soap Bubbles, 36⅝ x 29⅜, c. 1740
The Young Governess, 23 x 29¼, c. 1739 (Mellon)
Still Life with a White Mug, 13 x 16¼, c. 1756

The Phillips Collection
A Bowl of Plums, 17¾ x 22½

Illinois
CHICAGO, The Art Institute of Chicago
The White Tablecloth, 37⅞ x 48¾, c. 1737

Indiana
INDIANAPOLIS, Indianapolis Museum of Art
Vegetables for the Soup, 12¼ x 15⅝

MUNCIE, Ball State University Art Gallery
La Serinette, 19 x 16½

Kentucky
LOUISVILLE, The J.B. Speed Art Museum
Triumph of Cupid, 10⅜ x 24¾

Maryland
BALTIMORE, The Baltimore Museum of Art
Knucklebones, 32 x 25½, c. 1738-39 (Jacobs)

Massachusetts
BOSTON, Museum of Fine Arts
A Kitchen Table, 15½ x 18½, 1733
The Teapot, 13 x 16, 1764

CAMBRIDGE, Fogg Art Museum, Harvard University
Portrait of Jean-Jacques Bachelier (pastel), 21⅝ x 17⅝, 1773

SPRINGFIELD, The Springfield Museum of Fine Arts
Still Life (oval), 60 x 38, 1764 (Gray)

WILLIAMSTOWN, Sterling and Francine Clark Art Institute
Cooking Pots and Ladle with a White Cloth, 15⅜ x 12⅛,
 c. 1728-30
Kitchen Utensils and Three Herrings or Whitings, 15⅜ x 12⅛,
 c. 1728-30

Michigan
DETROIT, The Detroit Institute of Arts
Still Life with a Dead Hare, 28½ x 45½, 1760
Still Life/Kitchen Still Life, 6⅝ x 8¼

Minnesota
MINNEAPOLIS, The Minneapolis Institute of Arts
The Attributes of the Arts, 44 x 56½, 1766

Missouri
ST. LOUIS, The St. Louis Art Museum
The Silver Goblet, 16⅞ x 19, c. 1760

New Jersey
PRINCETON, The Art Museum, Princeton University
Attributes of the Painter, 19¾ x 33⅛
Attributes of the Architect, 19¾ x 33⅛

New York
NEW YORK CITY
The Frick Collection
Lady with a Bird-Organ, 20 x 17, 1751
Still Life with Plums, 17¾ x 19¾, 1758

The Metropolitan Museum of Art
Still Life: The Silver Tureen, 30 x 42½
A Boy Blowing Bubbles, 24 x 24⅞

North Carolina
RALEIGH, North Carolina Museum of Art
Kitchen Table with a Ray Fish, 15¾ x 12

Ohio
CLEVELAND, The Cleveland Museum of Art
Still Life with Herrings, 16⅛ x 13¼

OBERLIN, The Allen Memorial Art Museum, Oberlin College
Still Life with Rib of Beef, 16 x 13¹/₆, 1739

Pennsylvania
PHILADELPHIA, Philadelphia Museum of Art
The Hare, 24⁷/₁₆ x 31½, c. 1757

Virginia
NORFOLK, Chrysler Museum at Norfolk
Les Prunes, 16½ x 12¾

Canada

Ontario
OTTAWA, The National Gallery of Canada
La Pourvoyeuse, 18⅜ x 14¾, 1738
La Gouvernante, 18⅜ x 14¾, 1738

TORONTO, Art Gallery of Ontario
Un Bocal d'Abricots, dit un Dessert (oval), 22½ x 20, 1758

Claude

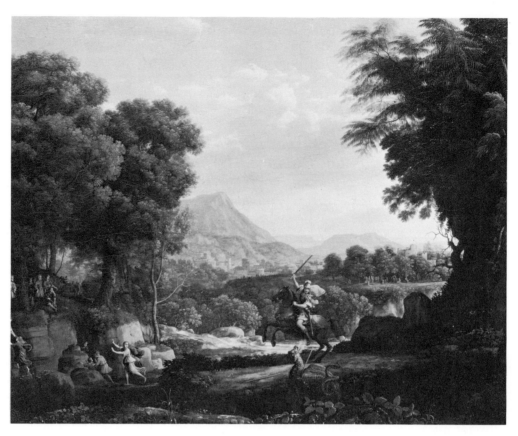

Claude Lorrain • St. George and the Dragon
Oil on canvas • 44 x 58¼″ • The Wadsworth Atheneum, Hartford, Conn.
Ella Gallup Sumner and Mary Catlin Sumner Collection

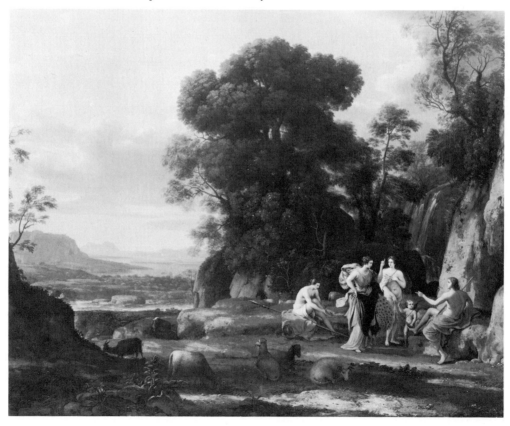

Claude Lorrain • The Judgment of Paris
Canvas • 44¼ x 58⅞″ • National Gallery of Art, Washington, D.C.
Ailsa Mellon Bruce Fund

Claude
1600–1682

Claude Gelée, called Claude of Lorraine, was born of poor parents in the village of Chamagne, in Lorraine. Left an orphan at the age of twelve, he worked briefly in the wood-carving shop of his brother at Freiburg. Next he traveled rather aimlessly in Italy, seeking employment. In the Roman studio of a landscape painter named Tassi he seems suddenly to have found himself. He began studying nature with the eye of a naturalist, often remaining outdoors observing and sketching from sunrise to sunset. After a brief visit to his native province in 1625 and further travel in France, he returned to Rome. His painting soon earned him the protection of Pope Urban VIII, and his future was assured. He remained in Italy for the rest of his life and died in Rome a highly respected artist and a wealthy man.

The typically French paintings of Claude are more logical than emotional, more classic than romantic. In its whole conception, his *Roman Campagna near Tivoli* is calm, serene, and measured. No storm threatens. Nature is completely under Claude's control. On top of the hill, the Roman ruins of Tibur (now Tivoli) suggest the ancient days of classical splendor. The appeal of this picture, which is primarily intellectual and formal, is totally different from that of a landscape by Ruisdael. Its composition, in fact, is based on a design equation first solved by Euclid—the golden section.

With the golden section, the Greeks attempted to divide a given line into its most agreeable proportions. They recognized that a line divided exactly in the center produced mere symmetry—usually dull and uninteresting to the eye, whether in a garden, a house, or a painting. The division should be either to the left or to the right of center, and Euclid determined just how far it should be. Here is his solution:

AB is the given line. *G* marks the golden section on it. To find this proportion, Euclid bisected the line *BD* of the square derived from the given line. The bisection is point *E*. The line *EA* created the arc *AF*. *F* is the arc's point of intersection on the extended line of *DB*. The square constructed from line *BF* established point *G*, which is approximately five-eights of the length of the given line. This is the proportion of the golden section.

It can, of course, be measured from either the right or left side of the center point on the given line. For *Roman Campagna near Tivoli* Claude chose the left side and followed the golden section exactly, not only for the right and left side proportion, but also for the up and down proportion.

The line of the horizon is divided just left of center by the vertical tree in the group of three on the hillside and the red-clad figure below. The red-clad figure is the *G* of our given line. The horizon line observes the same proportion in relation to the top and bottom of the picture; it is just below center. The focal point is where the horizon meets the vertical axis of the tree and the red-clad figure, and it is here the eye falls immediately. This off-center position encourages the eye to continue exploring *Roman Campagna near Tivoli,* but with a pleasure derived more from its formal, logical design than from its content.

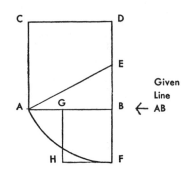

51

Claude in America

California
LOS ANGELES, University of Southern California, University Galleries
Classical Landscape, 28½ x 38

PASADENA, Norton Simon Museum of Art
Landscape with Piping Shepherd, 26 x 37½, 1635

SAN DIEGO, Timken Art Gallery, San Diego
Pastoral Landscape, 40 x 52, 1646-47

SAN FRANCISCO, The Fine Arts Museums of San Francisco
River Landscape, 21¾ x 31¾

Connecticut
HARTFORD, Wadsworth Atheneum
St. George and the Dragon, 44 x 58½, 1646

NEW HAVEN, The Yale University Art Gallery
A Pastoral Landscape, 15½ x 21

District of Columbia
WASHINGTON, National Gallery of Art
The Herdsman, 47¾ x 63⅛, c. 1655-60 (Kress)
Landscape with Merchants, 38¼ x 56½, c. 1635 (Kress)
The Judgment of Paris, 44¼ x 58⅞, 1645-46

Illinois
CHICAGO, The Art Institute of Chicago
Landscape with Sacrificial Procession, 40 x 50, 1673

Indiana
BLOOMINGTON, Indiana University Art Museum
Landscape (drawing), 7¾ x 7¾, 1660-65

MUNCIE, Ball State University Art Gallery
L'Amour et Psyche, 37¼ x 61 (attrib. to)

Massachusetts
BOSTON, Museum of Fine Arts
Seaport at Sunset, 46½ x 58¼, 1649
The Mill, 24 x 33½, 1631
Parnassus, 38½ x 53

CAMBRIDGE, Fogg Art Museum, Harvard University
A Wooded Hillside (drawing), 7¹⁄₁₀ x 10½
The Arch of Constantine (drawing), 3¾ x 6

WELLESLEY, The Wellesley College Museum, Jewett Arts Center
?Landscape (drawing), 4 x 4

WILLIAMSTOWN, Sterling and Francine Clark Art Institute
Landscape with the Voyage of Jacob, 28 x 37⁷⁄₁₆, 1677
Rest on the Flight into Egypt (oval), 12¹¹⁄₁₆ x 14¹⁵⁄₁₆, 1646

Michigan
DETROIT, The Detroit Institute of Arts
Seaport at Sunset, 16⅛ x 20⅝, 1643
Evening, 30¾ x 45½, 1631

Missouri
KANSAS CITY, The Nelson Gallery and Atkins Museum
Landscape with a Piping Shepherd, 22 x 28½
The Mill on the Tiber, 20 x 27

ST. LOUIS, The St. Louis Art Museum
Villagers Dancing, 38⅛ x 57½, c. 1650

Nebraska
OMAHA, Joslyn Art Museum
Rest on Flight to Egypt, 30 x 36¼, c. 1640

New York
ELMIRA, Arnot Art Museum
Ulysses Discovering Himself to Nausicaa, 40 x 29

GLENS FALLS, The Hyde Collection
Parnassus, 7¼ x 9½, 1634

NEW YORK CITY
 The Frick Collection
 The Sermon on the Mount, 67½ x 102¼, 1656

 The Metropolitan Museum of Art
 Landscape with an Artist Drawing, 22¾ x 32
 Pastoral Landscape—The Roman Campagna, 40 x 53½
 The Trojan Women Setting Fire to Their Fleet, 41⅜ x 59⅞
 The Ford, 29¼ x 39¾, 1650
 Sunrise, 40½ x 52¾

POUGHKEEPSIE, Vassar College Art Gallery
A Clump of Trees (drawing), 7 x 5¼

North Carolina
RALEIGH, North Carolina Museum of Art
Landscape with Herdsman near Tivoli, 30 x 40

Ohio
CINCINNATI, The Cincinnati Art Museum
Artist Studying from Nature, 30¾ x 39¾

CLEVELAND, The Cleveland Museum of Art
Roman Campagna near Tivoli (Italian Landscape), 40 x 54
Landscape with Rest on the Flight into Egypt, 80¾ x 59½

OBERLIN, The Allen Memorial Art Museum, Oberlin College
A Harbor Scene, 39⅝ x 53

TOLEDO, The Toledo Museum of Art
Landscape with Nymph and Satyr Dancing, 39¼ x 52⅜, 1641

Pennsylvania
PHILADELPHIA, Philadelphia Museum of Art
Landscape with Cattle and Peasants, 42 x 58½, 1629 (Elkins)

Texas
FORT WORTH, Kimbell Art Museum
A Pastoral Landscape, 22½ x 32⅜, 1677

HOUSTON, The Museum of Fine Arts
Pastoral Landscape with Rock Arch and River, 37¾ x 52⅞, c. 1630

Virginia
RICHMOND, Virginia Museum
Battle on a Bridge, 41 x 55

Canada

Ontario
OTTAWA, The National Gallery of Canada
Landscape Composition with St. John the Baptist Preaching (drawing), 9¾ x 12½
The Temple of Bacchus, Evening, 37½ x 48, c. 1645-50
Study of Tall Tree with Man Climbing (drawing), 11⅛ x 8⅝
The Ponte Molle (drawing), 7⅜ x 12¼
Landscape with Trees, Figures, and Cattle (drawing), 10 x 7¾

TORONTO, Art Gallery of Ontario
Coast View with the Embarkation of Carlo and Ubaldo, 36½ x 54½, 1667

John Constable

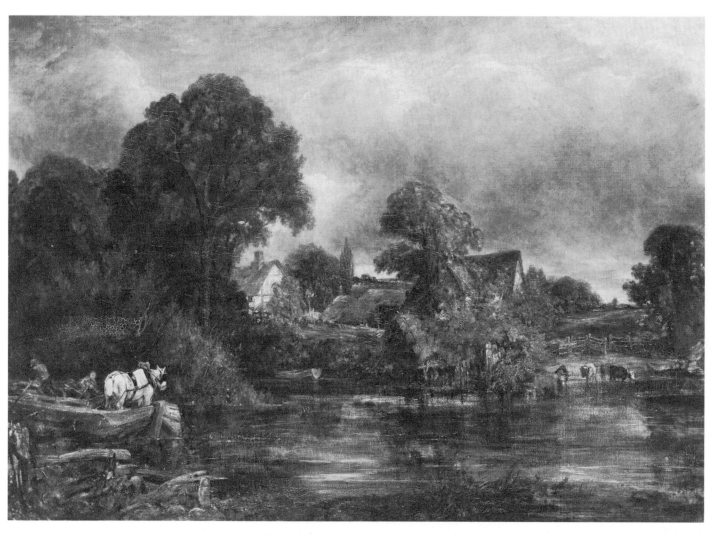

John Constable • The White Horse
Canvas • 50 x 72″ • National Gallery of Art, Washington, D.C.
Widener Collection

John Constable
1776–1837

John Constable was born in Suffolk, England, where he spent most of his life except for a few years studying and painting in London. He was the son of a prosperous miller, who consented to his enrollment at the Royal Academy in 1799. In 1802 he exhibited his first picture, but it was not until 1819 that he was admitted to the rank of associate at the Academy, and it was ten years later before he was voted a full Academician. In 1816, after the death of his father left him with an income, he married Maria Bicknell, who died in 1827. In the meantime, his celebrated *Hay Wain* (now in the National Gallery, London) had received great acclaim in France, where it was exhibited at the Louvre, and his *White Horse* (now in the Frick Collection, New York) had won a gold medal at Lille. Constable always enjoyed less popularity at home than abroad, where in many ways his style of painting anticipated French Impressionism.

Like Vermeer two hundred years earlier in Holland, John Constable was a painter who saw more color in nature than most of his contemporaries. He, too, saw color in shadows, though it is most unlikely that he ever saw a painting by Vermeer. His unconventional approach to landscape painting kept him from becoming a full Academician of the Royal Academy until he was fifty-three years old. The more conservative members of the Academy were upset by his brilliant, broken color and his great slashing strokes that made the English air vibrate excitingly.

Constable loved nature as passionately as his contemporary, William Wordsworth. He once wrote, "The sound of water escaping from mill dams, willows, old rotten planks, slimy posts and brickwork, I love such things. These scenes made me a painter."

And just as nature herself has many moods, Constable varied his style. He could accommodate his bolder style to the wishes of a patron without losing his integrity. Americans can find a beautiful example of this flexibility in New York, where two versions of his famous *Salisbury Cathedral* are on view a few blocks from each other. One is at the Frick Collection and the other is at the Metropolitan Museum.

The painting in the Frick Collection is one of the last of seven versions which Constable painted during six years in an effort to please Bishop John Fisher. "I must beg of you," wrote the bishop in 1822, "either to finish the first sketch of my picture, or to make a copy of the small size. I wish to have a more serene sky."

We do not know which version the bishop was referring to, but it could have been the version in the Metropolitan, for there the sky is certainly more tumultuous than the one at the Frick, and the trees are painted in the free, colorful manner that has made Constable's work so acceptable to twentieth-century eyes. Apparently, however, Constable was able to satisfy both himself and the bishop, for at one stage of the prolonged work he wrote to a friend: "It was the most difficult subject in landscape I have ever had on my easel. I have not flinched at the windows, buttresses, etc., but I have still kept to my grand organ colour, and have, as usual, made my escape into the evanescence of chiaroscuro."

These words were not written of the Frick version, which was completed after the bishop's death, but they describe it. It is full of color in small, surprising places: red roses in the foreground; red, yellow, and blue in the clothing of the tiny figures near the cathedral; a blue parasol; purple in the grass. And through it all glows the wonderful Constable air, apparently serene enough for the bishop, (though he did not see the finished work) but excitingly full of sunlight and shadow.

55

John Constable in America

Alabama
BIRMINGHAM, Birmingham Museum of Art
Landscape in Sussex, 9½ x 14¾

California
SAN DIEGO, San Diego Museum of Art
Landscape (sketch), 12 x 17¼ (attrib. to)

SAN FRANCISCO, The Fine Arts Museums of San Francisco
Arundel Mill, 16 x 10¾, c. 1810

SAN MARINO, The Huntington Art Gallery
View on the Stour near Dedham, 51 x 74, 1822
Salisbury Cathedral, 25 x 30, 1823
The Artist's Sisters, 15 x 11½, c. 1815
Hedgerow and Pond (drawing), 10¾ x 13⅛, 1798

STANFORD, Stanford University Museum of Art
Cloud Study (drawing), 3⅝ x 5½

Connecticut
HARTFORD, Wadsworth Atheneum
Weymouth Bay, 13½ x 20⅜, c. 1819

NEW HAVEN, The Yale University Art Gallery
Hampstead Heath, 12⅞ x 19¾

Delaware
WILMINGTON, The Delaware Art Museum
Flatford, Suffolk, 13 x 17½

District of Columbia
WASHINGTON
Corcoran Gallery of Art
Near Arundel, 12½ x 15

National Gallery of Art
The White Horse, 50 x 72, 1819(?) (Widener)
A View of Salisbury Cathedral, 28¾ x 36, 1820-30 (Mellon)
Wivenhoe Park, Essex, 22 x 39¾, 1816 (Widener)

The Phillips Collection
English Landscape, 9½ x 12½
On the River Stour, 24 x 31

Georgia
ATLANTA, The High Museum of Art
Landscape, 24 x 18½

Illinois
CHAMPAIGN, Krannert Art Museum
A View on the Stour Estuary Opposite Mistley, 14 x 19½, 1813

CHICAGO, The Art Institute of Chicago
Stoke-by-Nayland, 49½ x 66⅜, 1836
Landscape with Cottages, 6 x 11¾, c. 1820
Hampstead, Stormy Sky, 18 x 24⅛

Indiana
INDIANAPOLIS, Indianapolis Museum of Art
Lock on the Stour, 29¾ x 24¾
Barge on the Canal, 27¾ x 35½ (attrib. to)

MUNCIE, Ball State University Art Gallery
Hampstead Heath, 10 x 12½
Windsor Castle, 15½ x 20¾
George Garrard, A.R.A., 28 x 24 (attrib. to)

Louisiana
NEW ORLEANS, New Orleans Museum of Art
Clouds, 12⅝ x 19½, 1821-22

Maryland
BALTIMORE, The Baltimore Museum of Art
Rugged Cliff and Drifting Clouds, 7½ x 4½ (Lucas loan)

Massachusetts
BOSTON, Museum of Fine Arts
A Sea Beach, 26 x 39½
Weymouth Bay, 22 x 30¼
The Stour Valley and Dedham Church, 21¾ x 30¾
Portrait of a Lady, 8⅞ x 8½ (attrib. to)

CAMBRIDGE, Fogg Art Museum, Harvard University
Evening (drawing), 8¾ x 12¾
Landscape, Flatford Mill (drawing), 6⅛ x 9¼

NORTHAMPTON, Smith College Museum of Art
View near Dedham, 13½ x 16½, 1808-12

WILLIAMSTOWN, Sterling and Francine Clark Art Institute
Malvern Hall, 21⁵/₁₆ x 30¾, 1821

WORCESTER, Worcester Art Museum
Sophia Lloyd and Child, 26⅝ x 32, 1806

Michigan
DETROIT, The Detroit Institute of Arts
Coast Scene near Brighton, 12⅞ x 20, 1824-26
View of Norwich, 9¼ x 13
Glebe Farm, Dedham, 18¼ x 23½

MUSKEGON, Hackley Art Museum
Sandpits at Hampstead, 14¾ x 24¾

Mississippi
LAUREL, Lauren Rogers Library and Museum of Art
River Scene, 14¼ x 11½

Missouri
KANSAS CITY, The Nelson Gallery and Atkins Museum
The Dell in Helmingham Park, 44⅝ x 51½, 1826

ST. LOUIS, The St. Louis Art Museum
Osmington Bay and Portland Island, 10 x 14
"The Leaping Horse" (View on the Stour), 18⅛ x 25, c. 1819

Nebraska
OMAHA, Joslyn Art Museum
The Lock, 45 x 54½, 1824

New Hampshire
MANCHESTER, The Currier Gallery of Art
Dedham Mill, 21½ x 30½, c 1820

New York
NEW YORK CITY
The Frick Collection
Salisbury Cathedral from the Bishop's Garden, 35 x 44¼, 1826
The White Horse, 51¾ x 74⅛, 1819

The Metropolitan Museum of Art
Tottenham Church, 20½ x 18⅛
Mrs. James Pulham, Sr. (Frances Amys, c. 1766-1856), 29¾ x 24¾
View at Stoke-by-Nayland, 14¼ x 11⅛
Salisbury Cathedral from the Bishop's Garden, 34⅝ x 44

ROCHESTER, Memorial Art Gallery of the University of Rochester
View of Dedham, 9½ x 12½

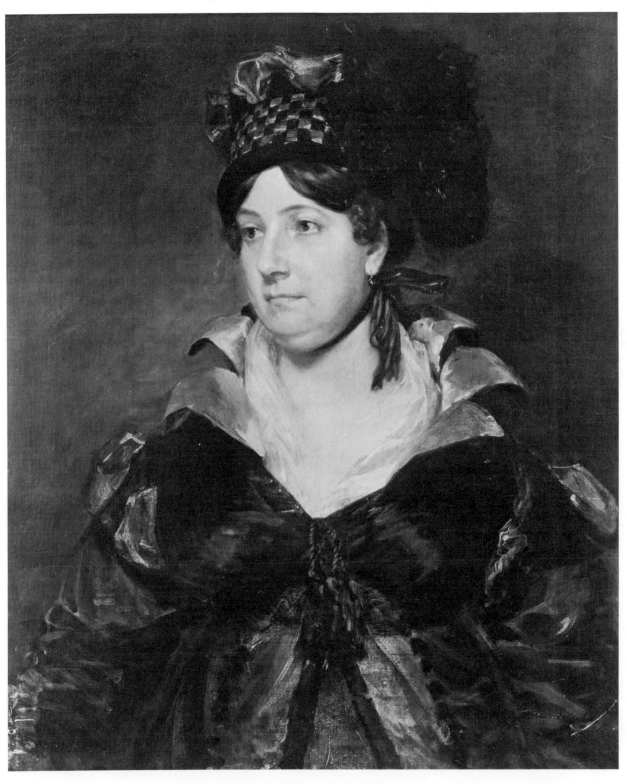

John Constable • Mrs. James Pulham, Sr.
Oil on canvas • *29¾ x 24¾"* • *The Metropolitan Museum of Art, New York City*
Gift of George A. Hearn

North Carolina
RALEIGH, North Carolina Museum of Art
The Old Mill at Suffolk, 11¾ x 10¼

Ohio
CINCINNATI
 The Cincinnati Art Museum
Waterloo Bridge, 21¾ x 30¾, 1824

 The Taft Museum
Dedham Mill, 23⅞ x 35

CLEVELAND, The Cleveland Museum of Art
Branch Hill Pond, Hampstead Heath, 23⅞ x 30¹¹⁄₁₆

COLUMBUS, Columbus Museum of Art
William Fisher, 12¼ x 10⅝, 1823

TOLEDO, The Toledo Museum of Art
Arundel Mill and Castle, 28½ x 39½, 1837

Pennsylvania
PHILADELPHIA, Philadelphia Museum of Art
The Lock, Dedham, 55¾ x 48, c. 1823-24 (McFadden)
Hampstead Heath: Storm Coming Up, 24½ x 30½, c. 1831
 (McFadden)
The Dell at Helmingham, 30½ x 38½ (McFadden)
Dell Scene, 27⅞ x 36 (Johnson)
Chain Pier, Brighton, 13 x 24 (attrib. to) (Johnson)

Rhode Island
PROVIDENCE, Museum of Art, Rhode Island School of Design
Thatched Cottage Seen in Bright Sunlight (drawing),
 7¼ x 8⅞, c. 1800-10
Brighton Beach (drawing), 6⅛ x 11¾, 1824-28
Portrait of Mrs. Edwards, 29⅞ x 25

Trees, 20¼ x 15
Waterloo Bridge from Left Bank (drawing), 4⅜ x 7
The Thames from Windsor Castle (drawing), 7¼ x 14¹³⁄₁₆,
 1802
The Dorset Coast (drawing), 3½ x 4⅝

South Carolina
COLUMBIA, Columbia Museums of Art and Science
The River, 12 x 16⅛

Virginia
RICHMOND, Virginia Museum
The Ponds at Hampstead Heath, 24½ x 30¼

Canada

British Columbia
VANCOUVER, Vancouver Art Gallery
Herne Bay (sketch), 8 x 12¾

Ontario
OTTAWA, The National Gallery of Canada
A View of a Suffolk Church (drawing), 3¾ x 3¾
East Bergholt Church (drawing), 4⅝ x 4
East Bergholt Church (watercolor), 17¼ x 13¾, 1805
Beach Scene with Fishing Boat (drawing), 3¾ x 5⅜
Salisbury Cathedral from the Bishop's Grounds, 29½ x 36½,
 c. 1823
St. Martin's Church, Salisbury (drawing), 4½ x 8¼

TORONTO, Art Gallery of Ontario
Scene in Helmingham Park, Suffolk, 36¼ x 28¾

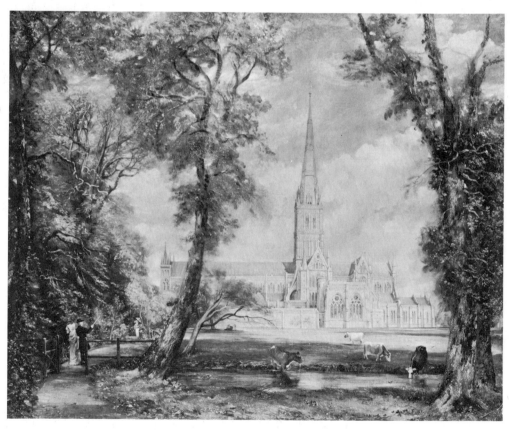

John Constable • Salisbury Cathedral from the Bishop's Garden
Oil on canvas • *34⅝ x 44"*
The Metropolitan Museum of Art, New York City
Bequest of Mary Stillman Harkness

Jean-Baptiste-Camille Corot

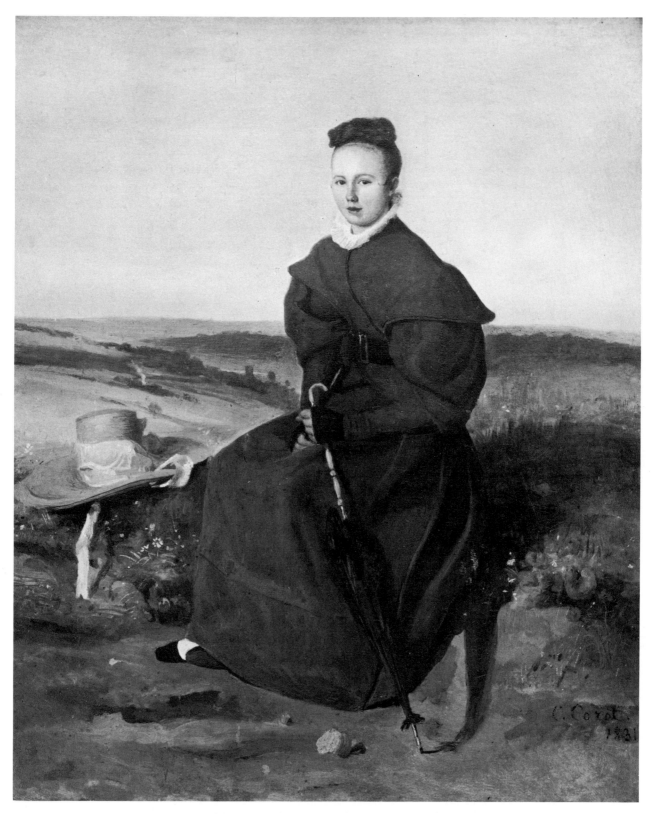

Jean-Baptiste-Camille Corot • Mademoiselle du Puyparlier
Canvas • *21³⁄₈ x 18¹⁄₁₆"*
Sterling and Francine Clark Art Institute, Williamstown, Mass.

Jean-Baptiste-Camille Corot
1796–1875

Jean-Baptiste-Camille Corot was born in Paris of a well-to-do family who, after educating him at Rouen, apprenticed him to a linen draper. He was twenty-six before his father consented to his becoming an artist. For a time he studied with Victor Bertin, artist member of a famous French journalist family, but he always preserved his independent approach to the problems of painting. During the years 1825-28 he traveled in Italy, and returned for short visits in 1834 and 1843. Corot exhibited at the Paris Salon for the first time in 1827 and regularly thereafter. From then until his death he painted prodigiously, producing both landscapes and figure paintings which found ready buyers in Europe and America. (This book lists 239 works by Corot in 64 museums in 29 states, the District of Columbia, and Canada.) Noted for his charities, such as providing the aging Daumier with a cottage, one of Corot's last acts was to give a sum equivalent to ten thousand dollars to the poor of Paris.

Corot was the last of the European old master painters. But in one important way he anticipated the modern movement in art which began in Paris during the decade of 1870-1880 with the exhibitions of the Impressionists. Renoir, Monet, Pissaro, and their fellow Impressionists were primarily interested in capturing the effect of sunlight on canvas with pure colors. In this respect they were super-realists; their paintings were a refinement of the realistic approach to nature. But their kind of realism marked a break with the conventional, representational realism of the day, and set artists to thinking in terms of form and color—*apart from* representation. Nearly fifty years before, Corot had shown a similar preoccupation with painting the effect of light and shade, not only as a means of achieving realism, *but as an end in itself.*

Lionello Venturi, the critic and art historian, quotes Corot as follows: "In preparing a study or a picture it has seemed to me very wise to begin by indicating the most vigorous values (supposing the canvas is white) and to continue by following in the right order up to the highest values. I should begin by setting up twenty numbers, from the most vigorous dark tone to the highest light tone. In this way your study or picture would be set up in the proper order. This order should in no wise trouble the draughtsman or the colorist. Always the mass, the whole, that which has struck us first. Never lose the impression that has moved us first."

During his long career, in which his art passed through several styles, ending with the silvery landscapes that are so popular in America, Corot's many paintings reflected these words in varying degrees. But seldom were they better illustrated than in a picture he painted as a young man in Italy, *The Bridge of Narni* in the National Gallery of Canada, Ottawa. It is one of the illustrations in this book which in interesting to look at upside down (see Daumier) because of Corot's preoccupation with "vigorous dark tone" and "highest light tone." It is also a stunning view of the old bridge over the Nera River at Narni, forty-three miles north of Rome.

The Bridge of Narni has the immediate appeal of place. It makes you want to find the spot right away and walk down this road, perhaps sitting for a while on one of those sun-warmed rocks, talking to the people and admiring the green of the hillsides, the blue of the distant water, and the white clouds. But what produces this feeling is not only the faithful representation of a place. The picture is arresting, exhilarating in itself. Its carefully planned darks and lights, moving through gray rocks, brown slopes, and green trees, force your attention in much the same way that a dramatic thundercloud forces it—simply as forms and colors, quite independent of subject matter.

Jean-Baptiste-Camille Corot in America

Arizona
TUCSON, The University of Arizona Museum of Art
L'Allée des Rêves, 12¼ x 9¾

California
LOS ANGELES
Los Angeles County Museum of Art
Seine and Old Bridge, Limay, 18¼ x 24, 1870-72

Wooded Landscape with Cows in a Clearing, 16½ x 11¾, c. 1860

University of Southern California, University Galleries
Le Lac, 26 x 32, 1873-74

PASADENA, Norton Simon Museum of Art
Young Woman in Red Bodice, 18¼ x 14½, 1868
Rebecca at the Well, 19⅝ x 29⅛, 1839
Site in Italy, 21 x 32, 1839
View of Venice, 18½ x 27, 1834

SAN DIEGO
 Timken Art Gallery, San Diego
Man Fording a Stream, 14¼ x 24½
A Bend in the River with Houses and Poplars, 12¾ x 9, c. 1850-55

 San Diego Timken Art Gallery
View of Volterra, 62¾ x 47½

SAN FRANCISCO, The Fine Arts Museums of San Francisco
View of Rome, 8⅝ x 15, 1826-27
St. Angelo, View of Rome, 8⅝ x 15, 1826-27

Colorado
DENVER, The Denver Art Museum
La Femme à la Pensée, 19 x 16

Connecticut
HARTFORD, Wadsworth Atherneum
Castel Sant' Elia, 7⁹⁄₁₆ x 11⅜, 1826
Rouen from the Hill of St. Catherine, 10⅜ x 16½, 1833
L'Eglise à Lormes, 13½ x 18, c. 1842
Bord de la Seine, 16¼ x 29⅜, c. 1845

NEW HAVEN, The Yale University Art Gallery
Dance of the Nymphs, 19⅞ x 31½, 1865-70
The Harbor of La Rochelle, 19⅞ x 28¼, 1851

District of Columbia
WASHINGTON
 Corcoran Gallery of Art
Dance Under the Trees by the Lake, 22 x 31½ (Clark)
Dance of the Nymphs, 32½ x 46³⁄₁₆ (Clark)
Le Bateau au Clair de Lune, 25 x 32¹¹⁄₁₆ (Clark)
La Chaumière aux Sureaux, Normandie, 18¼ x 22¼ (Clark)
Bacchante with a Tambourine, 22¼ x 39¾ (Clark)
Remembrance of Terracina, 26 x 32 (Clark)
The Lake of Terni, 24 x 35½ (Clark)
Ville d'Avray: The Birch Tree, 21 x 31½ (Clark)

 National Gallery of Art
Gypsy Girl with Mandolin, 25 x 20, 1868-71
Agostina, 52¼ x 37⅜, 1866 (Dale)
The Eel Gatherers, 23¾ x 32, c. 1860-65 (Frelinghuysen)
Forest of Fontainebleau, 69 x 95½, 1830-33 (Dale)
A View near Volterra, 27⅜ x 37½, 1838 (Dale)
Italian Girl, 25⅝ x 21⅝, 1872 (Avalon Foundation)
The Forest of Coubron, 37¾ x 30, 1872 (Widener)
Rocks in the Forest of Fontainebleau, 18 x 23¾, 1860-65 (Dale)
The Artist's Studio, 24⅜ x 15¾, 1865-68 (Widener)
View near Epernon, 12¾ x 21, 1850-60 (Widener)
River Scene with Bridge, 9⅞ x 13⅜, 1834
Madame Stumpf and Her Daughter, 41¾ x 29¼, 1872

 The Phillips Collection
View from the Farnese Gardens, Rome, 9½ x 15¾, 1826
Portrait of a Woman, 15½ x 12¾, 1865-70
Genzano, 14½ x 22⅜, 1843
Civita Castellana, Plains and Mountains, 8⅝ x 13⅞, 1826-27

Georgia
ATLANTA, The High Museum of Art
Un Ravin du Morvan (Environs de Lormes), 18 x 18¾, c. 1840-45
Farm Scene, 18½ x 15, c. 1840-50

Illinois
CHICAGO, The Art Institute of Chicago
Interrupted Reading, 36½ x 25¾, c. 1870
View of Genoa, 11⅝ x 16⅜, 1834
Monte Pincio, 10⅝ x 16, 1840-50
Bathing Nymphs and Child, 32 x 40, 1855-60
Just Before Sunrise, 13 x 21½, c. 1865-70
Wounded Eurydice, 22 x 16¼, 1868-70
Arleux-Palluel, the Bridge of Trysts, 23½ x 28½, 1871-72
Souvenir of Italy, 31½ x 25½, 1855-60

Indiana
INDIANAPOLIS, Indianapolis Museum of Art
Ville d'Avray: Woodland Path Bordering a Pond, 19¾ x 24⅛
Villeneuve-Les-Avignon, 10¼ x 16¾
Souvenir d'Italie, 15¼ x 19¾

MUNCIE, Ball State University Art Gallery
Environs de Ville d'Avray, 31 x 33 (attrib. to)

Iowa
DES MOINES, The Des Moines Art Center
Village of Avray: Pond and Cabassud House, 18¼ x 21¾, 1855-60

Kentucky
LOUISVILLE, The J. B. Speed Art Museum
Un Lavoir à Marino, 11 x 17, 1827

Louisiana
NEW ORLEANS, New Orleans Museum of Art
Woodland Scene, 14¼ x 23½, 1870-73

Maine
BRUNSWICK, Bowdoin College Museum of Art
The Pond, 16¼ x 19⅜

Maryland
BALTIMORE
 The Baltimore Museum of Art
Thatched Village, 14⅝ x 18½, 1864 (Lucas loan)
View Toward Paris, 18¼ x 24¼, 1864 (Lucas loan)
Shepherds of Arcadia, 31 x 35⅝, c. 1872 (Epstein)
The Artist's Studio, 16 x 13, 1865-70 (Cone)
The Bridge, 7¾ x 10¼ (Lucas loan)
Environs de Ville d'Avray, 12¾ x 16 (Lucas loan)
Study of a Landscape, 8⅞ x 12 (Lucas loan)
The Crown of Flowers, 25½ x 17, c. 1865-70 (Eisenberg)

 The Walters Art Gallery
Early Spring, 21⅝ x 15⅝, c. 1855-65
St. Sebastian Succoured by Holy Women, 101⅝ x 67, 1853

Massachusetts
BOSTON
 Isabella Stewart Gardner Museum
Noonday, 16¼ x 21

 Museum of Fine Arts
Girl with a Pink Shawl, 26¼ x 21¾
Farm at Recouvrières (Nièvre), 18 x 27
Old Beech Tree, Fontainebleau, 21 x 18
Old Man in Corot's Studio, Rome, 13 x 9
La Bacchanale à la Source: Souvenir de Marly-le-Roy, 32 x 36
Venice, the Piazzetta, 6 x 9

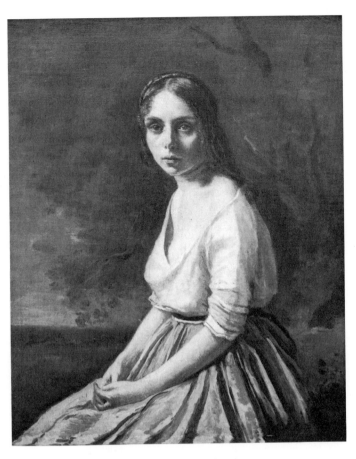

Jean-Baptiste-Camille Corot
Girl in a Pink Skirt
Canvas • 18⅞ x 15⅜''
Sterling and Francine Clark Art Institute
Williamstown, Mass.

Jean-Baptiste-Camille Corot
At Ville d'Avray
Oil on canvas • 21½ x 14½''
The Taft Museum, Cincinnati, Ohio

Souvenir of a Meadow at Brunoy, 35 x 45
Nymphs Bathing, 36 x 28
Dante and Virgil Entering Inferno, 101 x 66
Pond at Sunset, 14 x 20
François Rude, 13 x 9
Forest of Fontainebleau, 35 x 51
Ville d'Avray, 10 x 18
Ophelia, 27 x 18
Sin, near Douai: Children Playing, 13 x 18
The Laurel Gatherers, 20 x 14
Souvenir: The Banks of the Saône, 16 x 21
Morning near Beauvais, 14 x 16
The Turn in the Road, 24 x 19
An Italian Hill Town, 6 x 11

CAMBRIDGE, Fogg Art Museum, Harvard University
Henry Leroy as a Child (drawing), 10¾ x 9⅞
Ville d'Avray (drawing), 7¹/₁₆ x 10¹³/₁₆

NORTHAMPTON, Smith College Museum of Art
Town on a Cliff, 6⅞ x 15⅛, c. 1827-28
Jumièges, 12 x 15½, c. 1829-30
La Blonde Gasconne, 15¾ x 11⅞, c. 1850
Dubuisson's Grove at Brunoy, 18 x 21½, 1868

SPRINGFIELD, The Springfield Museum of Fine Arts
View near Naples, 27¾ x 43, 1841 (Gray)

WELLESLEY, The Wellesley College Museum, Jewett Arts Center
Montigny-les-Cormeilles, 10 x 13, c. 1832

WILLIAMSTOWN, Sterling and Francine Clark Art Institute
Apple Trees in a Field, 16 x 23¾
The Bathers of the Borromean Isles, 31 x 22⅛, c. 1865-70
The Castel Sant'Angelo, Rome, 13⁷/₁₆ x 18⁵/₁₆, 1835-40
Dunkerque: Fishing Boats Tied to the Wharf, 9¼ x 14³/₁₆, 1829-30
Girl in a Pink Skirt, 18⅞ x 15⅝, 1845-50
Louise Harduin (formerly Mlle. du Puyparlier), 21⅜ x 18¹/₁₆, 1831
Meadow with Willows, Montlhéry, 13¾ x 8¹¹/₁₆, 1850-70
A Road by the Water, 15¾ x 25⁹/₁₆, 1865-70
Washerwomen in a Willow Grove, 15 x 18⅛, 1871

Michigan
DETROIT, The Detroit Institute of Arts
Fontainebleau, La Vallée de la Solle, 15 x 18¼
Young Girl with a Mandolin, 22 x 15
Gathering Fruit at Mortefontaine, 26 x 16½

MUSKEGON, Hackley Art Museum
L'Etang aux Vlils, 18 x 15

Minnesota
MINNEAPOLIS, The Minneapolis Institute of Arts
Le Printemps de la Vie, 41 x 29, 1871
Silenus, 97½ x 70½, 1838

Mississippi
LAUREL, Lauren Rogers Library and Museum of Art
Landscape near Paris, 13½ x 17

Missouri
KANSAS CITY, The Nelson Gallery and Atkins Museum
The Villa of the Parasol Pine, 17 x 25
The Grove of Willows, 16¼ x 24, 1865-72

ST. LOUIS, The St. Louis Art Museum
Girl with Mandolin, 20¼ x 14½, 1860-65
The Beach, Etretat, 14 x 22½
Landscape, 13½ x 24¼, c. 1855-60

Nebraska
OMAHA, Joslyn Art Museum
River Scene, Château-Thierry, 22½ x 13⅜, 1855

New Hampshire
MANCHESTER, The Currier Gallery of Art
Grez-sur-Loing: Bridge and Church, 12¼ x 25, c. 1850-60

New York
BUFFALO, The Albright-Knox Art Gallery
Italian Monk Reading, 15¾ x 10¾

NEW YORK CITY
The Brooklyn Museum
Landscape (drawing), 9⅜ x 14⅝, 1860-68
L'Albanaise, 29⅜ x 25⅝, 1872
Ville d'Avray, 20¾ x 32¼, 1865
Jeunes Filles de Sparte, 16½ x 29½, 1868-70

The Frick Collection
Ville d'Avray, 17¼ x 29¼, c. 1860
The Boatman of Mortefontaine, 24 x 35⅜, 1865-70
The Lake, 52⅜ x 62, c. 1861
The Pond, 19¼ x 29, c. 1868-70

The Metropolitan Museum of Art
Lake Albano and Castel Gandolfo, 9 x 15½
Hagar in the Wilderness, 71 x 106½
Italian Landscape, 5 x 10⅝
The Destruction of Sodom, 36⅜ x 71⅝ (Havemeyer)
Village Street—Dardagny, 13½ x 9½
Sibylle, 32¼ x 25½ (Havemeyer)
A Wheelwright's Yard on the Seine, 18¼ x 21⅞
Portrait of a Child, 12⅝ x 9¼ (Havemeyer)
Reverie, 19⅝ x 14⅜ (Havemeyer)
Girl Weaving a Garland, 16½ x 11¾ (Havemeyer)
Bacchante by the Sea, 15¼ x 23⅝, 1865 (Havemeyer)
Boatman Among the Reeds, 23½ x 32
The Ferryman, 26⅛ x 19⅜ (Altman)
The Sleep of Diana, 76 x 51½, 1868
Ville d'Avray, 21⅝ x 31½
Woman Reading, 21⅜ x 14¾
Woman Gathering Faggots at Ville d'Avray, 28⅜ x 22½
River Landscape with Two Boatmen, 16 x 12⅞
A Lane Through the Trees, 24 x 18 (Altman)
The Gypsies, 21¾ x 31½, 1872
The Letter, 21½ x 14¼ (Havemeyer)
Bacchante in a Landscape, 12⅛ x 24¼ (Havemeyer)
The Muse—Comedy, 18⅛ x 13⅞ (Havemeyer)
Environs of Paris, 13½ x 20¼
A Pond in Picardy, 17 x 25 (Altman)
Mother and Child, 12¾ x 8⅞ (Havemeyer)
Honfleur: Calvary, 11¾ x 16⅛
Monsieur Lemaistre (died 1888), 15⅛ x 11⅝

POUGHKEEPSIE, Vassar College Art Gallery
Woodland Scene, 9¾ x 7½
Near Ville d'Avray, 15¼ x 8½

ROCHESTER, Memorial Art Gallery of the University of Rochester
Entre Coubron et Montfermeil, Sous Bois, 13¾ x 17½, 1871-72

Ohio
CINCINNATI
The Cincinnati Art Museum
Mantes, Fisher and Goatherd with Cathedral and Bridge, 15⅝ x 21¼
Ruins of the Château of Pierrefonds, 29½ x 42
Outskirts of Igny, 13½ x 21¼
Château Thierry, 7⅛ x 13⅛
Don Quixote, 74 x 54
Landscape with Tower, 18¾ x 22¼
The Lake, 22⅞ x 25¼
Village of Coubron, 18¼ x 24¼
The River's Curve, 13 x 18½
Landscape, 17¾ x 23⅝

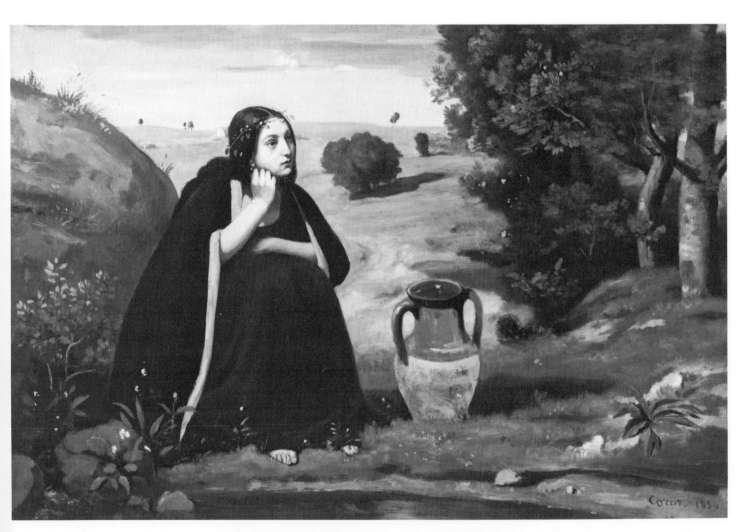

Jean-Baptiste-Camille Corot • Rebecca at the Well
Oil on canvas • *19⅝ x 29⅛''*
The Norton Simon Foundation, Los Angeles

La Rochelle, 27 x 38
Le Tournant de la Seine à Port Marly, 32¾ x 52, 1872
Portrait of Captain Faulte du Puyparlier, 25½ x 21½, 1829
 (with Georges Rodrigues)
La Maison Blanche de Sèvres, 28½ x 23¾
The Large Oak with Three Peasants, 19¾ x 24¹/₁₆ , c. 1860-65
Landscape, 20¼ x 20¼

The Taft Museum
The Brook, 24¼ x 15¼, c. 1865-70
At Ville d'Avray, 21½ x 14½, c. 1860-70
Le Soir, 35½ x 43⅜ c. 1855-60
Souvenir de Riva: Evening Glow, 24½ x 36¼, c. 1865-70
Les Environs de Paris, 20¼ x 39½, c. 1865-70

CLEVELAND, The Cleveland Museum of Art
Willows, 14½ x 17½, 1871
Ville d'Avray: Peasant Cutting Reeds in a Swamp, 23 x 39,
 c. 1865-70
The Roman Campagna, 38¼ x 53¼, 1826-27

COLUMBUS, The Columbus Museum of Art
View of St. Lo, 14⁵/₁₆ x 10¼ (Schumacher)
Chaumières au Bord de L'eau, 11 x 16, 1865-70

TOLEDO, The Toledo Museum of Art
Canal in Picardy, 18⅜ x 24¼, c. 1865-71

Oregon
PORTLAND, Portland Art Museum
Landscape, a Boy Sketching, 10¼ x 14
The Ponds of Ville d'Avray, 17¾ x 29⅛

Pennsylvania
PHILADELPHIA
The Pennsylvania Academy of the Fine Arts
Dance of the Nymphs, 25½ x 34½
Landscape, 13¾ x 18

Philadelphia Museum of Art
Hilly Seacoast, 10 x 14 (Johnson)
Lake Geneva, 10¼ x 13⅞ (Johnson)
Environs de Gruyères, 17 x 23¼ (Johnson)
Ville d'Avray, 23¼ x 31½ (Johnson)
Douai, House of Alfred Robaut, 21¾ x 19¾ (Johnson)
Houses in the Village of St. Martin, 16⅛ x 12⅝, 1860-65
The Ferry, 17¾ x 24, 1865-72
Pensive Young Brunette, 9½ x 7½, 1845-50
Nemi—Les Bords du Lac, 23¾ x 36¹/₈ (Johnson)
Mur (Côtes-du-Nord), 13 x 21⅞ (Johnson)
Mother and Child on Beach, 14⅞ x 18⅛ (Johnson)
Ville d'Avray, 10¾ x 11½ (Johnson)
Mother Protecting Her Child, 20 x 14½
Gipsy Girl at the Fountain, 22¾ x 16⅞, c. 1865-70 (Elkins)
House and Factory of M. Henry, 33 x 41, 1833 (Wilstach)
Architectural Study, 12¾ x 9 (Wilstach)
The Fisherman, 19½ x 30, 1865-70
Canal in Holland, 15⅜ x 20¼, c. 1854
Château Thierry, 8⅞ x 13⅛, 1855-65

READING, The Reading Public Museum and Art Gallery
Landscape, 11 x 9
Summer Idyll, 25½ x 21

Rhode Island
PROVIDENCE, Museum of Art, Rhode Island School of Design
Landscape with Farmhouses (drawing), 8⅝ x 12
Intérieur d'un Chalet de L'Oberland Bernois, 10¼ x 14⅛,
 1850-55
Riverbanks at Ville d'Avray, 12½ x 18, 1871-73
Honfleur, Le Vieux Bassin, 11¾ x 16¾, 1822-25
Landscape with Cottage, 12¼ x 16¾

Tennessee
MEMPHIS, Brooks Memorial Art Gallery
Little Morvan Village, 6 x 13½

Texas
DALLAS, Dallas Museum of Fine Arts
Palluel, Batelier Dans le Marais, 10 x 22, 1871 (Munger)

FORT WORTH, Kimbell Art Museum
View of the Ville d'Avray, 22¾ x 38½, c. 1865-70
Orpheus Singing his Lament for Eurydice, 16½ x 24, c. 1865-70

**SAN ANTONIO, San Antonio Museum Association, Witte
Memorial Museum**
La Muse du Soir, 14¾ x 11¾

Virginia
NORFOLK, Chrysler Museum at Norfolk
Landscape in a Thunderstorm, 53¼ x 38½, 1856

RICHMOND, Virginia Museum
Les Bords d'Un Canal Aux Environs de Rotterdam, 11¾ x 18⅛
Le Rappel des Vaches, 19⅞ x 29¼
Le Chevrier en Vue du Golfe, 25 x 31, 1870

Washington
SEATTLE, Charles and Emma Frye Art Museum
Zuydcotte Près Dunkerque, 15½ x 18½, 1873

Wisconsin
MILWAUKEE, Milwaukee Art Center
Le Mont Ussy, 16½ x 21½, 1850 (sketch)-1872

Canada

Ontario
OTTAWA, National Gallery of Canada
Landscape-Marécages Boisés avec Trois Vaches (drawing),
 11⅝ x 16¾, c. 1871
The Fisherman, 7½ x 9½
Palestrina (drawing), 7½ x 6½
Street at Auvers, 16¼ x 9½, c. 1860-65
The Bridge of Narni, 26¾ x 37¼, 1827
Le Pont de Narni (drawing), 11¹⁵/₁₆ x 18⅜

Quebec
MONTREAL, Montreal Museum of Fine Arts
L'Ile Heureuse, 73 x 55½

Gustave Courbet

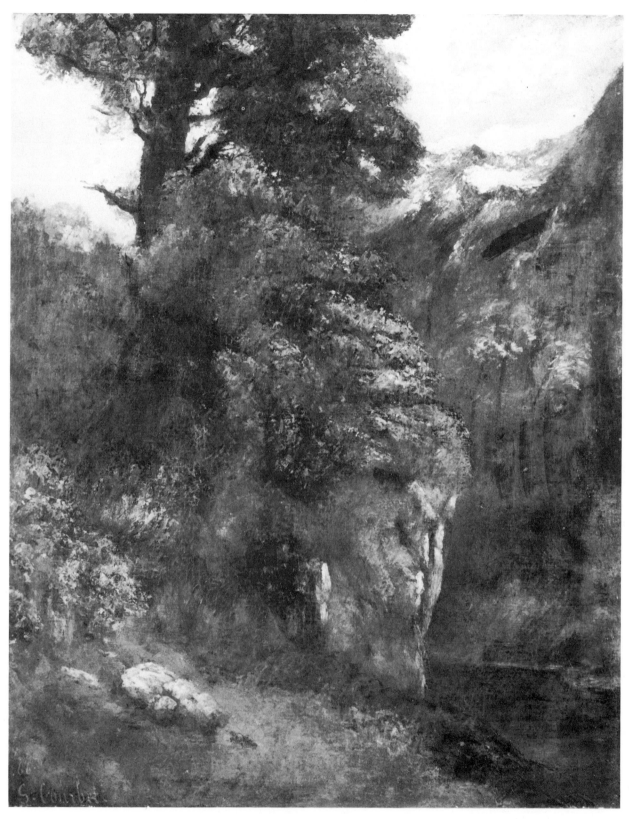

Gustave Courbet • The Glen at Ornans
Oil on canvas • *32⅛ x 25⅞''*
Yale University Art Gallery • *Gift of Duncan Phillips*

Gustave Courbet

1819–1877

Gustave Courbet was born at Ornans in the eastern French department of Doubs. At its capital city, Besançon, he studied theology briefly, but abandoned it in 1839 to begin painting in Paris. He was an independent thinker in aesthetics, politics, and religion, and his first paintings were rejected by the Salon; it was ten years before his unconventional realism began to receive acclaim. Critical and financial success followed quickly, and in 1870 Courbet became a national figure when he refused to accept the cross of the Legion of Honor from Napoleon III. Soon after he became a member of the Commune the following year, the painter directed the destruction of the triumphal column in the Place Vendôme. With the fall of the Commune, Courbet was tried and sentenced to pay the cost of restoring the column. He escaped to Switzerland, where he spent the remainder of his life in exiled poverty, still painting as he pleased. "Painting," he said, "is an art of sight and should therefore concern itself with things seen; it should, therefore, abandon both the historical scenes of the Classical school and poetic subjects from Goethe and Shakespeare favored by the Romantic school." When once asked to include angels in a painting for a church, he replied, "I have never seen an angel. Show me an angel and I will paint one."

Gustave Courbet was a rebel in art as well as in politics. He called a spade a spade and a nude a nude, and was the first important artist to abandon the pretense of giving names like Venus and Adonis to nude figures to make them acceptable to society.

Calling nude figures Venus and Adonis did not make them less nude, but it made them respectable. Courbet, however, simply titled his painting *Woman with a Parrot*. This raises an important question: What is the difference between Courbet's painting and the nude girl on the barbershop calendar?

The definitive answer to this question would take a book in itself. But we might at least approach it by noting that the girl on the barbershop calendar has never been replaced by a reproduction of a nude by Titian, Rubens, Courbet, or any other great artist. The reason is that the calendar artist paints nudity as an end in itself—to be exploited. The masters painted not only their frank sensual delight, but also their sense of wonder before the marvelous organism of the human body.

The woman in Courbet's painting is lying on a dark green couch, with her rich brown hair cascading over the white cover, and her luminous flesh superbly contrasted against its cool tones. The wonderful curves of her body are contrasted with the angular lines of the parrot's stand; they are repeated in the parrot's wings. The woman is frankly nude. But she is not *displaying* her nudity, like the girl on the calendar. She is not even conscious of it. She is perfectly natural; so was Courbet; and so are we. We are as natural as the boy at the Art Students League of New York who, at a party, met a model he had been painting all summer. Seeing her with clothes on, he fell in love at once and promptly married her.

Gustave Courbet in America

California
**LOS ANGELES, University of Southern California,
University Galleries**
Jura Landscape, 22 x 24

PASADENA, Norton Simon Museum of Art
Forest Pool, 30 x 36, 1865
Stream of the Puits-Noir, 39 x 59, 1868

Cliffs at Etretat, 25¾ x 32, 1869
Marine, 19¾ x 24, 1866
Portrait of Henri Rochefort, 26½ x 21, 1874
Pears and Primroses on a Table, 23½ x 28¾, 1871

SAN DIEGO, San Diego Museum of Art
The Silent Pool, 22⅝ x 28⅛

SAN FRANCISCO, The Fine Arts Museums of San Francisco
Portrait of His Sister, 12⅝ x 9¾
Landscape in Jura, 28½ x 36

Colorado
DENVER, The Denver Art Museum
Landscape in Snow, 13⅜ x 27¼

Connecticut
HARTFORD, Wadsworth Atheneum
A Bay with Cliffs, 14¹⁵/₁₆ x 18¹/₁₆
Self-Portrait (drawing), 11½ x 8¾, 1847

NEW HAVEN, The Yale University Art Gallery
The Glen at Ornans, 33¼ x 27, 1866
Hunter on Horseback, 47 x 37¾
Landscape with Waterfall, 36¼ x 32

District of Columbia
WASHINGTON
Corcoran Gallery of Art
Landscape, 19⅞ x 24½
Ornans, 16½ x 19⅜

National Gallery of Art
The Promenade, 33⅝ x 28½, 1866 (Dale)
Portrait of a Young Girl, 23¾ x 20½, 1857 (Dale)
A Young Woman Reading, 23¾ x 29¼, 1868-72 (Dale)
The Stream, 41 x 54, 1855
La Grotte de la Loue, 38¾ x 51⅜, c. 1865

The Phillips Collection
Rocks at Mouthiers, 30 x 46, c. 1850
The Mediterranean, 23 x 33, c. 1854-60

Florida
WEST PALM BEACH, Norton Gallery of Art
Still Life, 20 x 24, 1871
Palette of the Artist, 9½ x 13½

Illinois
CHICAGO, The Art Institute of Chicago
Mère Grégoire, 50¾ x 38¼, 1855
The Brook of Puits-Noir, 18 x 22, c. 1855
Beach at Deauville, 36⅛ x 25⅞, 1865
An Alpine Scene, 23⅞ x 28½, 1874
The Rock of Haute Pierre, 31½ x 39½, c. 1869

Indiana
INDIANAPOLIS, Indianapolis Museum of Art
The Dark Cove, 22¾ x 29

SOUTH BEND, Notre Dame University Art Gallery
Landscape with Rocks, 16 x 13

Iowa
DES MOINES, The Des Moines Art Center
The Valley of the Loue, 36½ x 58¾, c. 1865

Kentucky
LOUISVILLE, The J. B. Speed Art Museum
The Artist's House, La Dent de Jaman, 19¾ x 24

Louisiana
NEW ORLEANS, New Orleans Museum of Art
Landscape, 21 x 25, 1867

Maryland
BALTIMORE, The Baltimore Museum of Art
The Grotto, 25¼ x 31⅛, 1860-64 (Cone)

HAGERSTOWN, The Washington County Museum of Fine Arts
Landscape, 18 x 21½

Massachusetts
BOSTON
Isabella Stewart Gardner Museum
A View Across a River, 18 x 22

Museum of Fine Arts
The Quarry, 83 x 71
Mixed Flowers in a Bowl, 23½ x 19¼
Forest Pool, 61¾ x 44¾
Reclining Nude, 41¼ x 56¾

CAMBRIDGE, Fogg Art Museum, Harvard University
Peasant Girl Standing by a Pump (drawing), 18¾ x 15⅜
Portrait of the Artist with a Pipe (drawing), 7¼ x 5⅜

NORTHAMPTON, Smith College Museum of Art
The Preparation of the Dead Girl, 74 x 99, 1850-55
Portrait of M. Nodler, The Elder at Trouville, 36¼ x 28¾, 1865
Normandy Coast Scene, 8½ x 16, 1865-70

SPRINGFIELD, The Springfield Museum of Fine Arts
Castle of Chillon, 34½ x 45, 1873 (Gray)
Portrait of M. Nodler, the Younger, 36 x 28½, 1866 (Gray)

WILLIAMSTOWN, Sterling and Francine Clark Art Institute
Seascape, 13⅜ x 9⁷/₁₆
The Seaweed Gatherers, 21⁵/₁₆ x 25¾

Michigan
DETROIT, The Detroit Institute of Arts
Bather Sleeping by a Brook, 32 x 25½, 1845
The Mountain Hut, 24¼ x 19¾

Minnesota
MINNEAPOLIS, The Minneapolis Institute of Arts
Portrait of Mme. Robin, La Grandmère, 36 x 28¾, 1862
Deer in the Forest, 51½ x 38¼
The Castle at Ornans, 32⅛ x 46

Missouri
KANSAS CITY, The Nelson Gallery and Atkins Museum
Portrait of Jo, 25½ x 21¼
Low Tide, 17½ x 24¾

ST. LOUIS, The St. Louis Art Museum
The Valley of Ornans, 23¹¹/₁₆ x 33⁹/₁₆, 1858
The Greyhounds of the Comte de Choiseul, 35 x 45¾, 1866
Portrait of a Woman, 50 x 39½, 1853-54

Nebraska
OMAHA, Joslyn Art Museum
Coast Scene—Approaching Storm, 21¾ x 15½, c. 1867

New York
BUFFALO, The Albright-Knox Art Gallery
The Source of the Loue, 39½ x 52, c. 1864

ELMIRA, Arnot Art Museum
Mountain Stream, 35 x 28

GLENS FALLS, The Hyde Collection
Waterfall at Ornans, 15⅞ x 21⅜

NEW YORK CITY
The Brooklyn Museum
The Silent River, 28⅛ x 43, 1868
Le Rocher Isolé, 25½ x 32
La Vague, 25¾ x 34¾

The Metropolitan Museum of Art
Les Demoiselles de Village, 76¾ x 102¾
Louis Gueymard as Robert le Diable, 58½ x 42
Lady in a Riding Habit (L'Amazone), 45½ x 35⅛ (Havemeyer)
Alphonse Promayet (died 1872), 42⅛ x 27⅝ (Havemeyer)

Gustave Courbet • Portrait of M. Nodler, the Elder, at Trouville
Oil on canvas • 36¼ x 28¾''
Smith College Museum of Art, Northampton, Massachusetts

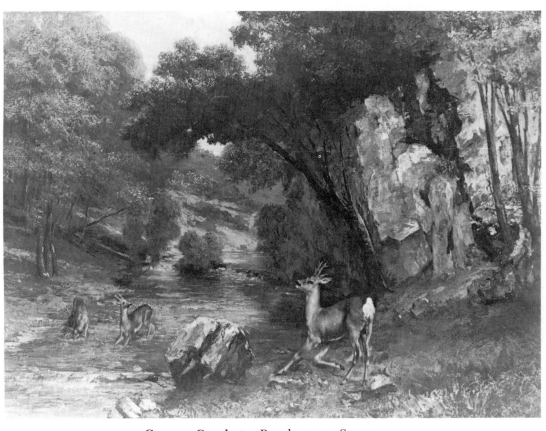

Gustave Courbet • Roedeer at a Stream
Oil on canvas • 38⅜ x 51⅛'' • Kimbell Art Museum, Fort Worth, Texas

Hunting Dogs, 36½ x 58½ (Havemeyer)
Madame Auguste Cuoq (Mathilde Desportes, 1827-1910),
 69½ x 42½ (Havemeyer)
Madame de Brayer, 36 x 28⅝, 1858 (Havemeyer)
The Deer, 29⅜ x 36⅜ (Havemeyer)
The Source of the Loue, 39¼ x 56 (Havemeyer)
Torso of a Woman, 29½ x 24 (Havemeyer)
The Source, 47¼ x 29¼ (Havemeyer)
Monsieur Suisse, 23¼ x 19⅜ (Havemeyer)
After the Hunt, 93 x 73¾ (Havemeyer)
The Brook of the Black Well, 19⅝ x 23⅞ (Havemeyer)
Landscape, 23⅜ x 28¾
Portrait of Jo (La Belle Irlandaise), 22 x 26, 1866
 (Havemeyer)
Marine–The Waterspout, 27⅛ x 39¼, 1870 (Havemeyer)
Pond in the Valley, 20¾ x 25½
Portrait of a Man, 16¼ x 13⅛ (Havemeyer)
The Young Bather, 51¼ x 38¼, 1866 (Havemeyer)
Woman with a Parrot, 51 x 77, 1866 (Havemeyer)
The Woman in the Waves, 25¾ x 21¼, 1868 (Havemeyer)
Calm Sea, 23½ x 28¾, 1869 (Havemeyer)
A Boat on the Shore, 25½ x 32
The Sea, 20 x 24
A Brook in the Forest, 19⅞ x 24⅛
The Hidden Brook, 23⅜ x 29¾

ROCHESTER, Memorial Art Gallery of the University of Rochester
The Stone-Breaker, 17½ x 21½

Ohio
CINCINNATI, The Cincinnati Art Museum
Sunset, Vevay, Switzerland, 25¾ x 32
A Gorge in the Jura, 18 x 22
The Forest in Winter, 27½ x 43

CLEVELAND, The Cleveland Museum of Art
Madame Boreau (La Dame au Chapeau Noir), 31⅞ x 24⅜,
 1863
Grand Panorama des Alpes (or La Dent du Midi), 59⅜ x 82¹¹/₁₆,
 c. 1875 (unfinished oil on canvas)

COLUMBUS, Columbus Museum of Art
Marine, 18¼ x 21¾, 1860 (attrib. to) (Howald)
Les Remouleurs, 34¾ x 40⅞, c. 1850

OBERLIN, The Allen Memorial Art Museum, Oberlin College
Castle of Chillon, Evening, 25½ x 31¹³/₁₆

TOLEDO, The Toledo Museum of Art
The Trellis, 43¼ x 53¼, 1862
Landscape near Ornans, 35 x 50⅛, 1864

Oregon
PORTLAND, Portland Art Museum
The Violincellist, 45 x 35, 1847
Stormy Sea, 15½ x 22⅜
Autumn, 28⅞ x 23¾

Pennsylvania
PHILADELPHIA
The Pennsylvania Academy of The Fine Arts
Great Oak of Ornans, 35 x 44, 1864
Mayor of Ornans, 37¼ x 29½

Philadelphia Museum of Art
Head of a Woman with Flowers, 21¾ x 18¼, 1871
Source of the River, 21⁵/₁₆ x 25½, 1873
Une Dame Espagnole, 32 x 25¾ (Johnson)
Château Chillon, 23½ x 28¾ (Johnson)
La Vallée, 25¾ x 32 (Johnson)
Marine, 17 x 25¾ (Johnson)
Willows and Brook, 16⅞ x 24 (Johnson)
Landscape at Ornans, 32 x 37½, c. 1855 (McIlhenny)
La Vague, 29¾ x 59⅝ (Wilstach)
View of Ornans, 18⅝ x 22¼ (Wilstach)
Fringe of the Forest, 34½ x 45⅜, c. 1856
Reclining Nude, 18¼ x 21¾, 1868
The Waves, 12¾ x 19, c. 1870
Apples and a Pear, 9½ x 12⅞, 1871

READING, The Reading Public Museum and Art Gallery
Spring Landscape, 15½ x 23

Rhode Island
PROVIDENCE, Museum of Art, Rhode Island School of Design
Landscape with a Mill near Ornans, 18⅜ x 24¼, 1869
 (attrib. to)
Jura Landscape, 25 x 30, 1869
Landscape, 8¾ x 12¾

Texas
DALLAS, Dallas Museum of Fine Arts
La Mer Ourageuse, 22 x 36, c. 1869-70

FORT WORTH, Kimbell Art Museum
Roedeer at a Stream, 38 x 51¼, 1868
Study for Man with a Pipe, 18¼ x 13¾, 1845

Virginia
NORFOLK, Chrysler Museum at Norfolk
Foresters, 46¾ x 30½, c. 1858

RICHMOND, Virginia Museum
Landscape with Figure, 21½ x 28¾

Wisconsin
MILWAUKEE, Milwaukee Art Center
Portrait of Clement Laurier, 39⅜ x 31¾, 1855

Canada

Ontario
OTTAWA, The National Gallery of Canada
Les Cascades, 38½ x 59½
Les Rochers, Etretat, 36 x 45, 1866
La Femme aux Gants, 24⅞ x 20½
Dans le Bois: Neige, 23½ x 29

TORONTO, Art Gallery of Ontario
Ste. Pelagie, Still Life with Fruit and Garlic, 6 x 28, 1871
Woman Painted at Palavas, 23¼ x 19, 1854

Québec
MONTREAL, Montréal Museum of Fine Arts
The Brook of the Black Well, 25 x 32 (attrib. to)

Claude • Roman Campagna near Tivoli (Italian Landscape)
Oil on canvas • 40 x 54" • The Cleveland Museum of Art • Mr. and Mrs. William H. Marlatt Fund

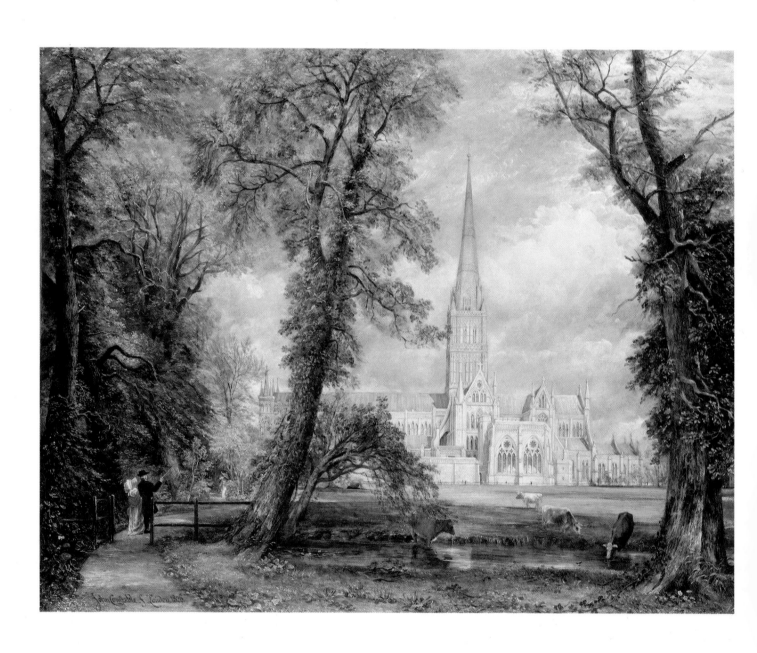

John Constable • Salisbury Cathedral from the Bishop's Garden
Oil on canvas • 35 x 44¼" • The Frick Collection, New York City

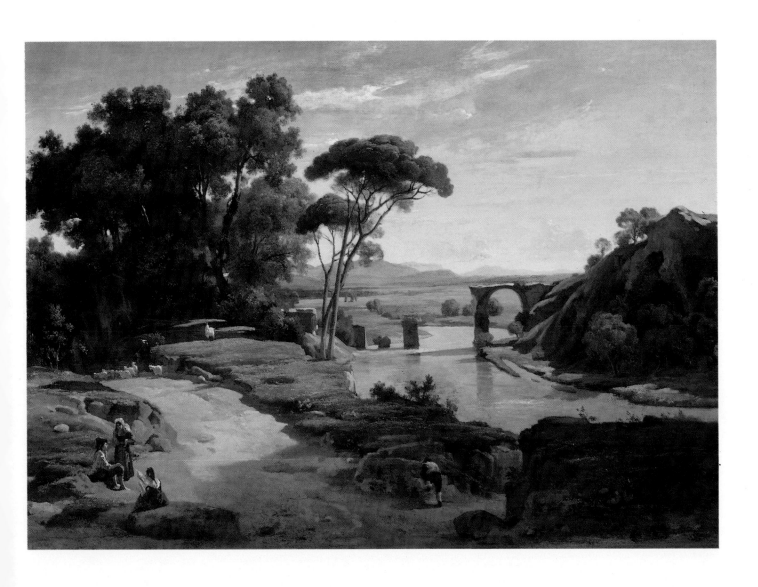

Jean-Baptiste-Camille Corot • The Bridge at Narni
Oil on canvas • 26¾ x 37¼" • The National Gallery of Canada, Ottawa

Gustave Courbet • Woman with a Parrot
Oil on canvas • 51 x 77" • The Metropolitan Museum of Art, New York City
H.O. Havemeyer Collection

Lucas Cranach the Elder • The Stag Hunt

Oil on panel • 45¾ x 66¾ " • The Cleveland Museum of Art • John L. Severance Fund

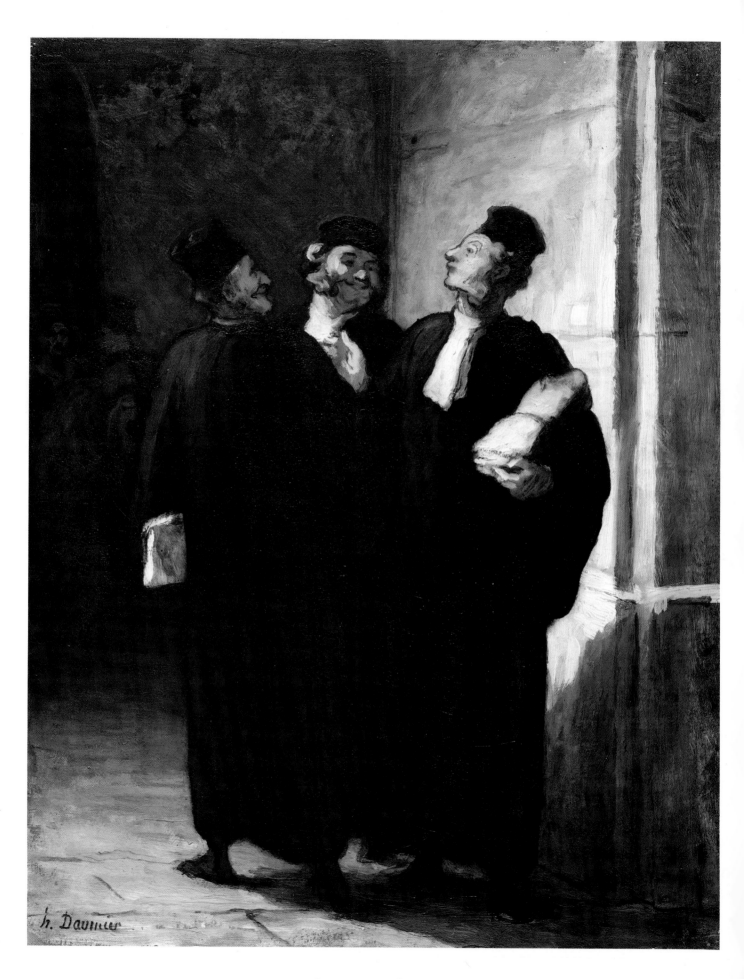

Honoré Daumier • Three Lawyers

Oil on canvas • 16 x 13″ • The Phillips Collection, Washington, D.C.

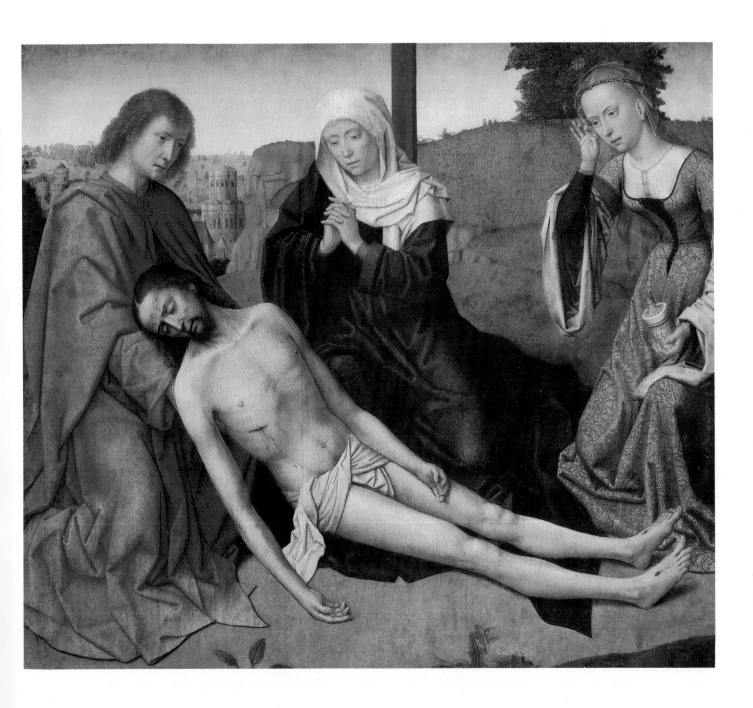

Gerard David • Lamentation at the Foot of the Cross
Oil on panel • *21½ x 24½"* • *The Art Institute of Chicago*
Mr. and Mrs. Martin A. Ryerson Collection

Jacques-Louis David • Napoleon in His Study

Oil on canvas • *80¼ x 49¼ ″* • *National Gallery of Art, Washington, D.C.* • *Samuel H. Kress Collection*

Lucas Cranach

Lucas Cranach the Elder • The Judgment of Paris
Oil and tempera on panel • 20 x 14⁵/₁₆″ • The St. Louis Art Museum

Lucas Cranach
1472–1553

Lucas Cranach was born in the German duchy of Franconia in the town of Kronach, from which he took his painting name. His father was Hans Maler, an artist who probably taught his son the rudiments of the painting craft. Not much is known about Cranach's early career, but it is documented that he owned·a house in Gotha, fifty miles from his birthplace; that he married Barbara Brengbier, the daughter of a burgher of that city; and that she bore him three sons, John, Hans, and Lucas. It is also recorded that in 1504 he was invited to Wittenberg in Saxony by Frederick the Wise, elector of that German kingdom, who named him court painter the following year. As court painter he was active in several branches of his profession. He painted portraits, hunting scenes, Biblical and classical subjects, and altarpieces, made engravings on copper, and drew designs for coins produced by the electoral mint. He also owned a press on which he printed his engravings. When Frederick the Wise died in 1525, Cranach continued to work for his successors, William and John. During this period Cranach met and became friends with Martin Luther, who had enrolled at the university in Wittenberg in 1508 and whose portrait Cranach and his sons were to paint many times before Luther's death in 1546. Cranach himself died at Weimar seven years later.

Cranach painted *The Stag Hunt* for John Frederick the Magnanimous, elector of Saxony, who built the castle of Hartenfels shown in the background. The castle still stands on an island in the Elbe River in the town of Torgau, twenty-six miles southeast of Wittenberg. According to the town records, the castle was not finished in 1540, when Cranach painted this picture, so the assumption is that he imaginatively used architectural drawings for his model.

John Frederick, who commissioned the painting (which hung in the castle for generations), is pictured in the left foreground holding a crossbow, while the attendant at his side prepares another arrow. The youth shown with them is perhaps one of John's sons, John Frederick II of Gotha or John William of Weimar. The elector's wife, Electress Sibylle, stands at the extreme right with a group of ladies-in-waiting, also holding a crossbow in preparation for a shot at the stags which have been chased into the stream by dogs and hunters dressed in the yellow and black livery of John Frederick's attendants.

Other persons and happenings in this sixteenth-century painting are yet to be identified by its present owner, the Cleveland Museum of Art. In the meantime we are free to explore the picture wonderingly. Who is the couple standing in the boat? Is that a boar or a bear being pursued by dogs and a man with a spear in the glade above them? What kind of horn is the horseman blowing in the center of the picture?

These are fascinating speculations for us today, although they would not have intrigued Michelangelo, who was alive when this picture was painted. Michelangelo held north European painting in low esteem. He called it "anecdotal and sentimental. . . innocent of artistic body and vitality."

Cranach's *Stag Hunt* may lack the formal qualities that Michelangelo demanded in painting, but it is certainly not innocent of vitality. Nor is it entirely without form. The stream winds through the picture, holding together the various happenings and pointing toward the castle for which the picture was painted. The colors are distributed interestingly over the basic green of the landscape, which sparkles with the whites of the many active animals. Turned upside down (a test for any picture), it is a pleasing arrangement of line, color, and tone. Right-side up again, it is a fascinating record of one aspect of life in sixteenth-century Germany.

Lucas Cranach in America

California
PASADENA, Norton Simon Museum of Art
Adam and Eve, ea. 75 x 27½, 1530

SAN FRANCISCO, The Fine Arts Museums of San Francisco
Portrait of a Lady of the Saxon Court as Judith, 31½ x 22

Connecticut
HARTFORD, Wadsworth Atheneum
The Feast of Herod, 31½ x 46
Frederick the Wise, 5⅜ x 5⅝
John the Faithful, 5⅜ x 5⅝
Diana and Acteon, 19½ x 28¾, c. 1520

NEW HAVEN, The Yale University Art Gallery
The Crucifixion with the Converted Centurion. 23⅝ x 16, 1538

District of Columbia
WASHINGTON, National Gallery of Art
Portrait of a Man, 22⅜ x 15⅛, 1522
Portrait of a Woman, 22⅜ x 15, 1522
The Crucifixion with Longinus, 20 x 13¾
The Nymph of the Spring, 19 x 28⅝

Georgia
ATLANTA, The High Museum of Art
Portrait of a Man, 22½ x 15¼

Illinois
CHICAGO, The Art Institute of Chicago
The Crucifixion, 47¹¹/₁₆ x 32½, 1533-38(?)
Eve Tempted by the Serpent, 42⅜ x 14⅜, c. 1530

Indiana
INDIANAPOLIS, Indianapolis Museum of Art
Crucifixion, 30 x 21½, 1532.(Clowes)

Kentucky
LOUISVILLE, The J. B. Speed Art Museum
Portrait of a Young Noblewoman, 22⅜ x 19⅝

Massachusetts
BOSTON, Museum of Fine Arts
The Lamentation, 15 x 10½, c. 1515

Michigan
DETROIT, The Detroit Institute of Arts
Legend of St. Christopher, 16½ x 11
Adam and Eve, 22⅜ x 13¾, 1528
Madonna and Child with Angels, 46 x 31⅝

MUSKEGON, Hackley Art Museum
Portrait of Martin Luther, 28½ x 22⅛, 1537
Portrait of Katherine von Bora, 28⅜ x 22

Minnesota
MINNEAPOLIS, The Minneapolis Institute of Arts
Madonna and Child with Grapes, 22⅜ x 13¾

Portrait of Moritz Buchner, 16 x 10¾
Portrait of Anna Buchner, 16 x 10¾

Missouri
KANSAS CITY, The Nelson Gallery and Atkins Museum
The Three Graces, 17⅞ x 14¹/₁₆, 1535
The Last Judgment, 28½ x 39⅛, 1520-25
Portrait of a Bearded Man, 19½ x 14, 1538

ST. LOUIS, The St. Louis Art Museum
Judgment of Paris, 20 x 14⁵/₁₆

New Jersey
PRINCETON, The Art Museum, Princeton University
Venus and Amor, 40 x 14¾, c. 1518-20

New York
NEW YORK CITY
The Brooklyn Museum
Lucretia, 23 x 15¾

The Metropolitan Museum of Art
Portrait of a Man with a Rosary, 18¾ x 13⅞
Samson and Delilah, 22½ x 14⅞
The Martyrdom of St. Barbara, 60⅜ x 54¼
The Judgment of Paris, 40⅛ x 28
Judith with the Head of Holofernes, 35¼ x 24⅜
John, Duke of Saxony, 25⅝ x 17⅜

Ohio
CINCINNATI, The Cincinnati Art Museum
St. Helena, 16 x 10⅝

CLEVELAND, The Cleveland Museum of Art
The Stag Hunt, 45¾ x 66¾ (with assistance of Lucas Cranach, the Younger)

COLUMBUS, Columbus Museum of Art
Melancolia, 46⅞ x 32¾, 1528

TOLEDO, The Toledo Museum of Art
Sts. Catherine, Margaret, and Barbara, 48½ x 22, c. 1515-20

Oregon
PORTLAND, Portland Art Museum
Madonna and Child with St. Catherine, 28½ x 22

South Carolina
GREENVILLE, The Bob Jones University Art Gallery and Museum
Salome with the Head of John the Baptist, 22¼ x 13
Abner Stabbed by Joab, 21⅜ x 38⅜

Washington
SEATTLE, Seattle Art Museum
The Judgment of Paris, 25 x 16½, c. 1516-18

Honoré Daumier

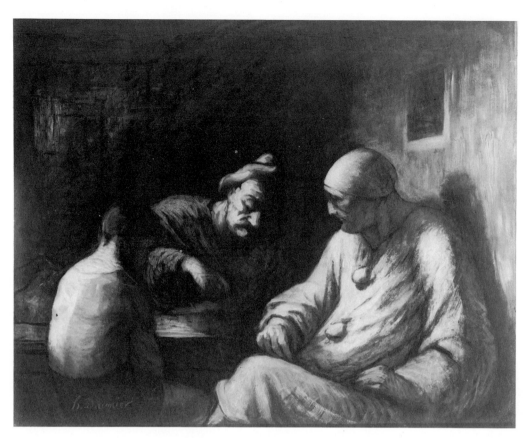

Honoré Daumier • Mountebanks Resting
Oil on canvas • 21¼ x 26″ • The Norton Simon Foundation, Los Angeles

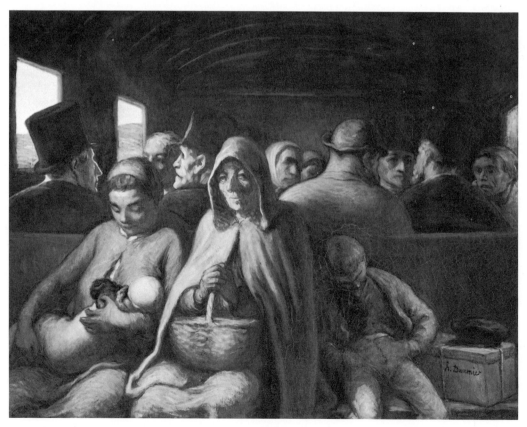

Honoré Daumier • The Third-Class Carriage
Oil on canvas • 25¾ x 35½″ • The National Gallery of Canada, Ottawa

Honoré Daumier
1810–1879

Honoré Daumier was born in Marseilles, the son of a glazier who did not approve of his son's youthful interest in art. In 1816 the Daumier family moved to Paris, where Honoré was first apprenticed to an attorney and then to a bookseller. He found the bookstore more congenial than the law office, for there he could look at pictures, and soon he was studying lithography on the side. Before long he was supporting himself by making plates for music publishers and illustrations for advertisements. When the comic journal *La Caricature* was founded in 1830, during the reign of Louis Philippe, Daumier joined its staff and began the series of satirical lithographs for which he is famous. One of them, depicting Louis as "Gargantua swallowing bags of gold extorted from the people" brought him a six-months jail sentence in 1832. After the discontinuance of *La Caricature* in 1835, Daumier worked for its successor, *Charivari,* producing for it and other journals the astonishing total of nearly four thousand lithographs. All this time he had been painting, but it was not until a year before his death that his work in oil was acclaimed. He spent his last years in a cottage provided by Corot.

The great popularity of Daumier's satirical cartoons eclipsed his work as a painter during his lifetime and obscured the fact that he was a great artist. One reason for this underestimation of Daumier was, of course, the fact that he never had a chance to exhibit his paintings, in which his true power is revealed. Another is that, beginning with Cézanne in the 1880s, the balance between form and content in painting began to be readjusted after a long emphasis on content alone. It is no accident that Daumier's *Three Lawyers* was acquired by the Phillips Collection in Washington, self-described as "A Collection of Modern Art and Its Sources." In his work Daumier achieved a wonderful balance of form and content.

The immediate appeal of the *Three Lawyers* is its engaging satire. Here are types we recognize—people whose self-importance inevitably makes us smile. They happen to be lawyers; they might have been doctors, artists, musicians, or people of any profession. We smile with pleasure at their posturing. This is the picture's content. But consciously or unconsciously we are also enjoying the purely visual pleasure which the picture holds for us—like an arrangement of flowers, a full shelf of books, or a fine automobile. This is the picture's form. To test its excellence, turn the page upside down.

Now, without any thought of content, the picture is still visually interesting. Your eye goes round and round inside it, clockwise. This activity begins with the bright yellow light at lower left, moves up and across to the right corner, and there pauses to explore the pool of yellow-green with its accents of subtle color. Then it moves in toward the dark center. Here it changes pace and jumps from one patch of white to another, contrasting each with the dark blue-blacks that form the hard core of the picture's design, which can be enjoyed from any angle because it is *good* design.

Honoré Daumier in America

California
PASADENA, Norton Simon Museum of Art
Mountebanks Resting, 21¼ x 26, 1870

SAN DIEGO, San Diego Museum of Art
Sortie du Théatre, 13⅛ x 16⁵/₁₆, c. 1865

STANFORD, Stanford University Museum of Art
The Augean Labors of Hercules (drawing), 13⁹/₁₆ x 10⁵/₁₆
Man with a Stick (recto) and *Studies of Heads* (verso)
(drawings), 10¹¹/₁₆ x 7⁹/₁₆

Connecticut
HARTFORD, Wadsworth Atheneum
The Mountebanks Changing Place (wash and drawing), 14¼ x 11
Head of a Man (drawing), 6½ x 4¾

District of Columbia
WASHINGTON
Corcoran Gallery of Art
Browsing at the Print Dealer's, 12¾ x 9 (Clark)
A L'Hôtel Drouot, 9½ x 7¼

Dumbarton Oaks, Harvard University
Buste de Femme, 15¾ x 12½

National Gallery of Art
Advice to a Young Artist, 16⅛ x 12⅞, after 1860
Hippolyte Lavoignat, 18¼ x 15, c. 1860 (Dale)
French Theater, 10¼ x 13¾, c. 1857-60 (Dale)

The Phillips Collection
For the Defense (drawing), 9 x 14
On a Bridge at Night, 10½ x 8½
The Painter at His Easel, 13⅛ x 10¼
The Uprising, 24½ x 44½
Two Sculptors, 11 x 14
To the Street, 10¾ x 8½
Three Lawyers, 16 x 13
The Strong Man, 10½ x 13¾
The Family (drawing), 6¾ x 7½, c. 1855

Illinois
CHICAGO, The Art Institute of Chicago
Two Lawyers, 5¼ x 5¾, c. 1860
The Three Judges (watercolor), 11¾ x 18⅜
Fatherly Discipline (drawing), 10 x 7⅞
The Print Collector, 16⅝ x 13, c. 1857-63
Street Musicians, 10⅛ x 12⅝

Iowa
DES MOINES, The Des Moines Art Center
The Reader, 13½ x 10, c. 1863

Kentucky
LOUISVILLE, The J. B. Speed Art Museum
The Gossips,. 5½ x 4¾

Maryland
BALTIMORE
The Baltimore Museum of Art
In the Theatre Boxes, 9½ x 12⅛ (Lucas loan)

The Walters Art Gallery
First Class Carriage (drawing), 8⅛ x 11¾
The Amateurs (drawing), 12¾ x 12¼
Second Class Carriage (drawing), 8 x 11⅞
Third Class Carriage (drawing), 8 x 11⅝
The Omnibus (drawing), 8⅜ x 11⅞
The Lawyers (drawing), 13¾ x 12
The Loge, 9½ x 12⅛ (Lucas)

Massachusetts
BOSTON, Museum of Fine Arts
The Horsemen, 23½ x 33½
The Man on the Rope, 44½ x 28½
The Triumphant Advocate, 23½ x 17¾

CAMBRIDGE, Fogg Art Museum, Harvard University
Scapin et Géronte, 13¼ x 10⅛
The Print Amateurs, 13 x 9½
Le Couple Chantant, 22 x 18
The Butcher (drawing), 13 x 9½
Two Lawyers Conversing (drawing), 10¹/₁₆ x 6½

NORTHAMPTON, Smith College Museum of Art
Three Heads (drawing), 4⅜ x 6¾, 1865

WILLIAMSTOWN, Sterling and Francine Clark Art Institute
An Artist, 13⅞ x 10⅝
The Print Collectors, 12⁵/₁₆ x 15¹⁵/₁₆

Michigan
DETROIT, The Detroit Institute of Arts
The First Bath, 9⅞ x 12¾

Minnesota
MINNEAPOLIS, The Minneapolis Institute of Arts
The Fugitives, 15¼ x 27

Mississippi
LAUREL, Lauren Rogers Library and Museum of Art
?Le Lutteur de Foire, 14¾ x 18

Missouri
KANSAS CITY, The Nelson Gallery and Atkins Museum
Exit from the Theater, 12¼ x 15¼

New York
BUFFALO, The Albright-Knox Art Gallery
Salle d'Attente, 12⅛ x 9½, 1850s
Laundress on the Quai d'Anjou, 11¼ x 7¾, c. 1861

NEW YORK CITY
The Brooklyn Museum
Head of Old Lady in Profile (drawing), 3 x 2⅝
Study of Heads (drawing), 3⅞ x 6¼

The Metropolitan Museum of Art
The Third-Class Carriage, 25¾ x 35½ (Havemeyer)
Don Quixote and the Dead Mule, 9¾ x 18⅛
The Drinkers, 14⅜ x 11
The Laundress, 19¼ x 13

Ohio
CINCINNATI, The Cincinnati Art Museum
Orchestra Stalls, 23¹³/₁₆ x 33¼

CLEVELAND, The Cleveland Museum of Art
The Troubadour, 32¾ x 22⅛

TOLEDO, The Toledo Museum of Art
Children Under a Tree, 21⅞ x 18½

Pennsylvania
PHILADELPHIA, Philadelphia Museum of art
The Print Collector, 13 x 10 (Wilstach)
Le Malade Imaginaire, 10¼ x 13¼ (Elkins)

Rhode Island
PROVIDENCE, Museum of Art, Rhode Island School of Design
Les Amateurs de Peinture (drawing), 4½ x 5
Don Quixote and Sancho Panza (watercolor), 5⅝ x 10¾
Parental Admonition (drawing), 7¾ x 6¾
Study of Two Old Men (drawing), 4³/₁₆ x 4¹⁵/₁₆

Texas
HOUSTON, The Museum of Fine Arts
A Group of Lawyers, 7 x 8¾, c. 1860 (Beck)

Virginia
NORFOLK, Chrysler Museum at Norfolk
Portrait of Madame Daumier, 12½ x 10½

Canada

Ontario
OTTAWA, The National Gallery of Canada
A l'Audience (drawing), 5¼ x 9¾
L'Evasion, 43½ x 28½
Le Wagon de Troisième Classe, 26¾ x 36¼, c. 1864

Québec
MONTREAL, Montréal Museum of Fine Arts
Nymphs Pursued by Satyrs, 51¾ x 38¼
At the Opera (drawing), 5½ x 7½
The Critics (watercolor), 14 x 7¾

Gerard David

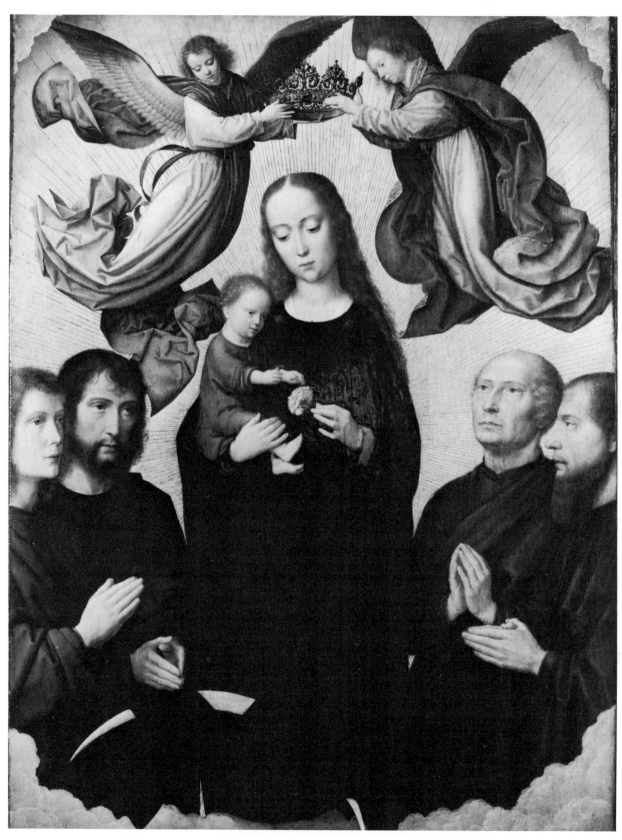

Gerard David • Virgin and Child with Saints and Donors
Oil on oak panel • 27⅞ x 21¼"
The Norton Simon Foundation, Los Angeles

Gerard David

c. 1450–1523

Gerard David was born at Oudewater, Holland, and after some years of study, presumably in Haarlem, joined the painters' guild of St. Luke in Bruges in 1484. There he studied and copied the work of Jan van Eyck (Detroit, New York, Philadelphia, Washington), married the daughter of the dean of the goldsmith's guild, and became dean of his own guild in 1501. He was regarded as a leading citizen of Bruges, where he died and was buried in the Church of Our Lady. For some reason, however, only a few of David's works remained in Bruges. They became scattered all over the world, and it was not until a number of them were recalled to his native city in 1902 for an exhibition of Flemish painting that his genius became universally recognized.

Gerard David was the last of the great Flemish artists to paint in the tradition of realism that began with Jan and Hubert van Eyck. Being Gothic, its emphasis was on content rather than form, on facts rather than theories. It grasped eagerly at the new Renaissance interest in the affairs and objects of the real world, but it was not guided by the Greek and Roman cultures to which the Latin painters of Italy responded so naturally. Michelangelo did not think highly of Flemish painting.

"It is an anecdotal and sentimental art," he wrote, "which aims only at success and obtains it easily, not by values of painting, but by the subject matter. . . . But, although some people delight in it, in truth it is done without reason or art; it lacks rhythm or proportion; it shows no care in selecting or rejecting; it is innocent of artistic body and vitality . . ."

Being a Latin, and a contemporary of David, Michelangelo was bound to find fault with such paintings as the *Lamentation at the Foot of the Cross* in the Art Institute of Chicago. With a perspective of four hundred years, we can agree with him on some points and disagree on others. It is not true, for example, that this painting "shows no care in selecting or rejecting." David could have painted many more objects in it: birds, flowers, animals—all of which would have diverted attention from the main theme. But David carefully "selected" other objects to make his painting expressive: the gay dress and alabaster box to characterize Mary Magdalene; the rich blue robe of the "other Mary"; and the warm red robe of St. John, bringing into sharp contrast the dead body of Christ.

As for "rhythm or proportion," it is true that any Italian master would have been more concerned with formal problems of design. On the other hand, the straightforward, almost rugged, simplicity of this picture seems especially appropriate to the subject. Its emotional impact is immediate. Its appeal is as enduring as the story of the Passion of Christ.

Gerard David in America

California
PASADENA, Norton Simon Museum of Art
Virgin and Child with Saints and Donors, 27⅞ x 21¼

SANTA BARBARA, UCSB Art Museum, University of California
Deposition, 12½ x 9¾ (Sedgwick)

District of Columbia
WASHINGTON, National Gallery of Art
The St. Anne Altarpiece, 94 x 38 x 28 x 28, c. 1500-10 (Widener)
The Rest on the Flight into Egypt, 17¾ x 17½, c. 1510 (Mellon)

Illinois
CHICAGO, The Art Institute of Chicago
Lamentation at the Foot of the Cross, 21½ x 24½, c. 1511

Michigan
DETROIT, The Detroit Institute of Arts
The Annunciation, 13½ x 9, c. 1490

Missouri
ST. LOUIS, The St. Louis Art Museum
The Annunciation, 11 diam.

New York

NEW YORK CITY

The Frick Collection
Deposition, 56⅛ x 44¼, 1510-15

The Metropolitan Museum of Art
The Nativity, with Donors and Sts. Jerome and Vincent (triptych);
center, 35¼ x 28; wings, ea. 35¼ x 12⅜ (Bache)
*Adoration of the Shepherds; St. John the Baptist; St. Francis
Receiving the Stigmata* (triptych); center, 18¾ x 13½; wings,
ea. 18 x 6½
Christ Taking Leave of His Mother, 6⅛ x 4¾ (Altman)
The Annunciation, 30 x 24
The Crucifixion, 21 x 15
Virgin and Child with Four Angels, 24⅞ x 15⅜

Ohio

CLEVELAND, The Cleveland Museum of Art
The Nativity, 33⁹/₁₆ x 23½

Toledo, The Toledo Museum of Art

Three Miracles of St. Anthony of Padua: a. *The Drowned Child
Restored to Life*, 21¹¹/₁₆ x 12⅞, c. 1500-10; b. *The Mule Kneeling
Before the Host*, 22⁷/₁₆ x 13⅜, c. 1500-10; c. *St. Anthony Preach-
ing to the Fishes*, 21⅞ x 12¹³/₁₆, c. 1500-10

Pennsylvania

PHILADELPHIA, Philadelphia Museum of Art
Virgin and Child Enthroned, 39¼ x 25¾ (Johnson)
Pietà, 34⅝ x 25½ (Johnson)

South Carolina

GREENVILLE, The Bob Jones University Art Gallery and Museum
The Crucifixion, 39 x 30⅝
The Risen Christ, 15⅞ x 13⅜

Virginia

NORFOLK, Chrysler Museum at Norfolk
Christ on the Cross with Sts. John the Baptist and Francis,
25¾ x 16¼ (loan)

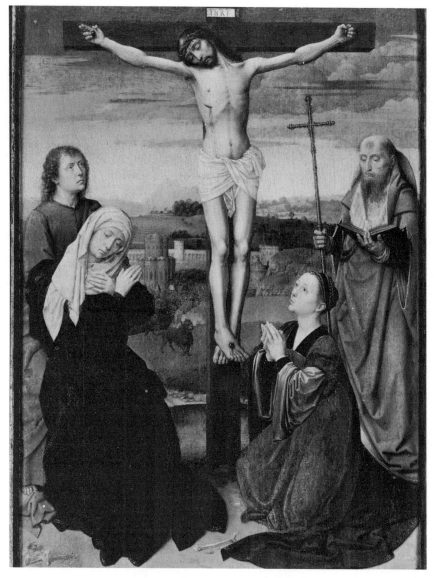

Gerard David • The Crucifixion
*Tempera and oil on wood • 21 x 15" • The Metropolitan Museum of Art,
New York City • Rogers Fund*

Jacques-Louis David

Jacques-Louis David
Portrait of Mr. Cooper Penrose
Oil on canvas • 51 x 38"
Timkin Art Gallery, San Diego, California

Jacques-Louis David • Self-Portrait
Canvas • 19 x 15"
North Carolina Museum of Art
Raleigh, North Carolina

Jacques-Louis David

1748–1825

Jacques-Louis David was born in Paris, the son of a merchant who was killed in a duel when Jacques was nine years old. He attended the Collège des Quatres Nations, where he studied the classics and revealed a talent for drawing. Through his guardian, Jacques was admitted to the studio of François Boucher, the fashionable boudoir decorator and painter, friend of Mme Pompadour and teacher of Fragonard. But Boucher, recognizing that young David was more interested in the classics than in his own style of elegant eroticism, sent him to Joseph-Marie Vien, the pioneer of Neoclassical art in France. Vien took David with him to Rome in 1776, where the young artist steeped himself in the realities of the classics he had studied in college, while establishing himself as a painter of both historical pictures and portraits. Back in Paris after 1780, David, although active in the revolutionary movement, became painter to King Louis XVI, who commissioned him to paint an historical picture. The artist spent the year 1784-85 again in Rome, where he painted what was to become one of his most famous pictures, *The Oath of the Horatii,* now in the Louvre. (A smaller version of it is in the Toledo, Ohio, Museum of Art.) Returning to Paris, David continued teaching and painting. When a Parisian lady persuaded him to paint a sacred picture with Christ as the subject, the lady protested that the Savior looked more like the Roman consul Cato than Christ. David replied, "There is no inspiration for Christianity now." During this period, David also continued his political activities. Elected to the National Convention in 1792, he voted for the death of the king, who was guillotined the following year, making way for David's next patron, Napoleon Bonaparte. But with the return of the Bourbons in 1814, David was exiled as a regicide and spent the remainder of his life in Brussels, still one of the most influential artists in Europe.

This picture was painted in 1812 while Napoleon was in Paris planning his next campaign after the disaster of Russia. (Waterloo was still three years away.) He is shown standing at his desk, with its Empire chair pulled back, and supporting his sword.

The scattered papers, including the scroll entitled CODE (his famous promulgation in 1804 of the first code of French civil law), the candles burning low, and the clock showing twelve minutes after four indicate that Napoleon has been at work all night. On first seeing the finished portrait, the emperor is reported to have said, "You have understood me, David. By night I work for the welfare of my subjects, and by day I work for their glory."

David understood Napoleon's annoyance with his small stature, as well as the craft of painting. He has pictured the Little Corporal on a canvas six feet, eight inches high, letting his subject almost fill it, although Napoleon is known to have been an unusually short man. All of the surrounding objects emphasize height: the clock, the wall decoration, the books in the adjoining library.

In addition to these elongational devices, David has shown the emperor looking *down* at his working painter and at us.

David's portraits (San Diego, Indianapolis, New York) are more colorful than his historical paintings such as *The Oath of the Horatii* in the Louvre and Toledo, Ohio. Here he has painted Napoleon in the uniform of the Grenadiers de la Garde Imperiale. The gold epaulettes of the general harmonize warmly with the glowing Empire furniture, a style designed by David himself with Napoleon's architects. The red lining of the coat also adds warmth, and its rich blue is repeated in the desk cover. The green of the lampshade is echoed in the carpeted floor. The silver insignia of the Legion of Honor (which Napoleon instituted in 1804) recurs in the belt of the sword scabbard and in the emperor's stockings.

The portrait is signed and dated on the rolled-up print on the floor. It was commissioned by a British peer, the Marquess of Douglas, for his collection of full-length portraits of European royalty, and came to the National Gallery in Washington with the Samuel H. Kress Collection in 1961.

Jacques-Louis David in America

California
SACRAMENTO, E. B. Crocker Art Gallery
Funeral of a Warrior (drawing), 10⅞ x 60

SAN DIEGO, Timken Art Gallery, San Diego
Portrait of Mr. Cooper Penrose, 51 x 38

SAN FRANCISCO, The Fine Arts Museums of San Francisco
La Bonne Aventure, 24¼ x 29½

Connecticut
HARTFORD, Wadsworth Atheneum
The Lictors Bring Back to Brutus the Bodies of His Sons,
27¹³/₁₆ x 35¾

District of Columbia
WASHINGTON, National Gallery of Art
Napoleon in His Study, 80¼ x 49¼, 1812 (Kress)
Madame David, 28¾ x 23⅜, 1813 (Kress)

Illinois
CHAMPAIGN, Krannert Art Museum
Achilles Displaying the Body of Hector at the Feet of Patroclus,
44½ x 57¼ (attrib. to)

CHICAGO, The Art Institute of Chicago
Mme Pastoret and Her Son, 52⅜ x 39⅜, c. 1791-92
Portrait of Madame Buron, 25⅝ x 21½, 1769

Indiana
INDIANAPOLIS, Indianapolis Museum of Art
Portrait of a Man in Military Costume, 18½ x 15¼

Massachusetts
CAMBRIDGE, Fogg Art Museum, Harvard University
Portrait of Emmanuel J. Sieyès, 37½ x 28½, 1817

NORTHAMPTON, Smith College Museum of Art
Two Women (drawing), 5¹¹/₁₆ x 7⅞

Warrior and Kneeling Woman (drawing), 7 x 4⁹/₁₆
Mother and Child at the Feet of Tatius (drawing), 5¼ x 6⅝

Nebraska
OMAHA, Joslyn Art Museum
Jupiter (drawing), 7¹¹/₁₆ x 5⁷/₁₆

New York
BUFFALO, The Albright-Knox Art Gallery
Portrait of Jacques-François Desmaisons, 36 x 28½

NEW YORK CITY
The Frick Collection
Comtesse Daru, 32⅛ x 25⅝, 1820

The Metropolitan Museum of Art
Antoine-Laurent Lavoisier (1743-1794) and His Wife (Marie-
Anne-Pierrette Paulze, 1758-1836), 102¼ x 76⅝
*Jeanne Eglé Desbassayns de Richemont (1776-1855) and Her
Daughter, Camille (1799?-1804)*, 46 x 35¼
General Etienne Maurice Gérard, Marshal of France (1773-1852),
77⅝ x 53⅝
The Death of Socrates, 51 x 77¼

North Carolina
RALEIGH, North Carolina Museum of Art
Self Portrait, 18⅛ x 15¾

Ohio
CLEVELAND, The Cleveland Museum of Art
Cupid and Psyche, 72½ x 95⅛, 1817

TOLEDO, The Toledo Museum of Art
The Oath of the Horatii, 51¼ x 65⅝, 1786

Texas
DALLAS, Dallas Museum of Fine Arts
Nude Study, 25¼ x 31⅝, 1780

Jacques-Louis David • The Oath of the Horatii
Oil on canvas • *51¼ x 65⅝''*
The Toledo Museum of Art, Toledo, Ohio • *Source: Edward Drummond Libbey*

Eugène Delacroix

Eugène Delacroix • Paganini
Oil on canvas • *17¹⁵⁄₁₆ x 11¹⁄₂″* • *The Phillips Collection*

Eugène Delacroix

1798–1863

Ferdinand-Victor-Eugène Delacroix was born at Charenton-St. Maurice, near Paris. The son of an ardent revolutionary, Eugène upset the world of art as his father had helped overturn a government. After a brief period of study with Pierre Guérin and at the École des Beaux-Arts, he exhibited his first important canvas in 1822 and at once became the recognized leader of the Romantic movement in painting—opposed, sometimes violently, by the Classicists of the Academy. In 1825 he visited England, where he renewed his acquaintance with Bonington, whom he had met at the Louvre and who had introduced him to English watercolor painting. Delacroix's favorite author was Byron, whose poems supplied him with many painting subjects. But where Byron had found his own inspiration a few years earlier in Spain, Italy, and Greece, Delacroix went in 1832 to Morocco. There the exciting, colorful life of the Arabs gave him material for many of his later paintings. He did not stay long, however, and was soon back in Paris, where he spent the remainder of his life. With his rich imagination, he found subject matter everywhere, and his enormous energy enabled him to complete a number of murals for public buildings, including the Chambre des députés and the Luxembourg library.

When Delacroix painted *The Return of Christopher Columbus,* now in the Toledo Museum of Art, the Western world was fed up with revolutions and wars. The year was 1839, and the politicians' promises of better things to come seemed far from realization. In their disillusionment, both Europeans and Americans sought to turn their eyes away from distressing reality to any other world but this one, including the world of the imagination. The result was the Romantic movement, described by the French critic Paul Jamot as "an immense lyric and dramatic poem, sung by thousands of voices." The chief literary voice of the Romantic movement was that of Byron, Delacroix's favorite author. Delacroix himself was its painter.

The titles of the Delacroix paintings in America reveal his search for romantic subject matter: *The Abduction of Rebecca, Lioness Devouring a Rabbit, Medea Slaying the Children of Jason, Jesus on the Lake of Genesareth, The Return of Christopher Columbus.* Ten years before Delacroix painted *The Return of Christopher Columbus,* Washington Irving had published in London his *History of the Life and Voyages of Christopher Columbus.* The same year it was painted (1839), Alexander von Humboldt had published in Paris another account. Here was material made to order for Delacroix. The accounts told of triumphal processions, rich and strange spoils from the newfound lands: gold, cotton, curious arms, Indians whom the explorer had brought back for baptism.

All these exotic items—and more—are included in the painting in the Toledo Museum. Yet the picture is not cluttered. By skillfully leaving large areas of plain yet glowing color, such as the pale blue of the steps, the rich red of the drapes behind Ferdinand and Isabella, and the severely black-and-white robes of the priest at the right, Delacroix has managed to give the impression of splendid activity while keeping it under complete control. The subject is romantic. The painting has movement. It also has the order and design of all great art.

Eugène Delacroix in America

California
LOS ANGELES, Los Angeles County Museum of Art
St. Sebastian, 14½ x 20
Henry IV Giving the Regency to Marie de Medici, 34¾ x 45⅝, 1835

PASADENA, Norton Simon Museum of Art
The Sultan of Morocco, 25⅝ x 21⁹⁄₁₆, 1856

SAN FRANCISCO, The Fine Arts Museums of San Francisco
Halte de Cavaliers Arabes près de Tanger (watercolor), 6½ x 10¼

STANFORD, Stanford University Museum of Art
Three Views of Reclining Figure (recto) and *View of a Lion* (verso) (drawings), 9½ x 14¹¹⁄₁₆

Connecticut
HARTFORD, Wadsworth Atheneum
Turkish Women Bathing, 36¼ x 30½, 1854
Mameluke Horseman, 12¾ x 16⅛, c. 1835
Tiger Drinking, 9¾ x 15½, (1835)?

NEW HAVEN, The Yale University Art Gallery
Ravenswood and Caleb (drawing), 10¼ x 8½

District of Columbia
WASHINGTON
Corcoran Gallery of Art
Tiger and Serpent, 13 x 16¼ (Clark)

National Gallery of Art
Columbus and His Son at La Rábida, 35⅝ x 46⅝, 1838 (Dale)
Arabs Skirmishing in the Mountains, 36⅜ x 29⅜, 1863 (Dale)

The Phillips Collection
Paganini, 17¼ x 11½, c. 1832
Horses Coming Out of the Sea, 19¾ x 24, 1860
Hercules and Alcestis, 12⅛ x 19½, 1862

Hawaii
HONOLULU, Honolulu Academy of Arts
La Justice de Trajan, 25¼ x 21, 1858

Illinois
CHAMPAIGN, Krannert Art Museum
Intérieur d'un Couvent de Dominicains, à Madrid ("L'Amende Honorable"), 23⅞ x 29, c. 1831-33

CHICAGO, The Art Institute of Chicago
Arab Rider Attacked by Lion, 18 x 14¾, 1849
Combat Between the Giaour and the Pasha, 23¾ x 28, 1827 (loan)
The Lion Hunt, 30¹⁄₁₆ x 38¾, 1861
Tiger Resting, 18 x 15, c. 1830-40
Wounded Lioness, 13⅛ x 22⅛, c. 1830-40

Maryland
BALTIMORE
The Baltimore Museum of Art
Perseus and Andromeda, 17 x 13¼, 1847 (Cone)
The Lamentation over Christ (after van Dyck), 8¼ x 12⅛ (Lucas loan)

The Walters Art Gallery
Christ on the Sea of Galilee, 23½ x 28⅞, 1854
Christ on the Cross, 31½ x 25¼, 1846
Marphise, 32¼ x 39¾, 1852

Massachusetts
BOSTON
Isabella Stewart Gardner Museum
The Crusader, 15½ x 11¼

Museum of Fine Arts
The Lion Hunt, 35½ x 47, 1858
The Entombment, 63½ x 51½, 1848
Christ on the Sea of Gennesareth (sketch), 9 x 12

CAMBRIDGE, Fogg Art Museum, Harvard University
Le Giaour et le Pacha, 32 x 25½, 1856
Christ Walking on the Waters (pastel), 12½ x 9½
Man Leading a Horse (drawing), 7¾ x 10⅛
Portrait of Frédéric Villot (drawing), 13⅛ x 9⅜

NORTHAMPTON, Smith College Museum of Art
Boissy d'Anglas à la Convention, 16 x 21¼, c. 1831
Socrates and His Genius (drawing), 7⅞ x 6¼, 1833

WILLIAMSTOWN, Williams College Museum of Art
Lion (drawing), 7 x 10½
Horses and Horsemen (drawing), 9 x 11¾

Minnesota
MINNEAPOLIS, The Minneapolis Institute of Arts
La Côte Barbaresque, 32 x 41, 1853
The Fanatics of Tangiers, 38⅝ x 51¾

Missouri
ST. LOUIS, The St. Louis Art Museum
The Capture of Weislingen, 28⅞ x 23½, 1853

Eugène Delacroix • Interior of the Dominican Convent at Madrid
Oil on canvas • 27⅞ x 29" • Kannert Art Museum, University of Illinois, Champaign
Gift of Mr. and Mrs. Merle J. Trees

Eugène Delacroix • The Lion Hunt
*Oil on canvas • 30 x 38½" • The Art Institute of Chicago
Potter Palmer Collection*

Nebraska
OMAHA, Joslyn Art Museum
Entombment (after Rubens), 28 x 21

New Jersey
PRINCETON, The Art Museum, Princeton University
The Death of Seneca, 13¾ x 17¼

New York
BUFFALO, The Albright-Knox Art Gallery
Street in Meknès, 18¼ x 25⅜, 1832

NEW YORK CITY

The Brooklyn Museum
Lioness Devouring a Rabbit (drawing), 9 x 14½
The Disciples at Emmaus, 22⅞ x 19⅛, 1853
Desdemona Maudite par son Père, 16 x 13, 1839

The Metropolitan Museum of Art
The Abduction of Rebecca, 39½ x 32¼, 1846
Christ on Lake Gennesareth, 20 x 24, 1853-55 (Havemeyer)
George Sand's Garden at Nohant, 17⅞ x 21¾
Basket of Flowers, 42¼ x 56
Scene from Hamlet, 10¾ x 7⅛

POUGHKEEPSIE, Vassar College Art Gallery
Fortitude (watercolor), 11⅝ x 9⅜, 1840
Tribute Money, 17¾ x 13½
Studies after Italian Renaissance Paintings (recto) and *Studies for "Mephisto"* (verso) (pen and brown ink on paper), 12 x 7⅞
Studies of Algerians (drawing), 7 x 5½
Study for the Tribute Money (drawing), 10 x 6¾

Ohio
CINCINNATI, The Cincinnati Art Museum
Medea Slaying the Children of Jason, 43½ x 33

CLEVELAND, The Cleveland Museum of Art
Arabs Resting, 19½ x 24, 1858

COLUMBUS, The Columbus Museum of Art
Caesar Before the Body of Pompey, 14 x 16 (attrib. to) (Schumacher)
Odalisque, 13¼ x 15⅝ (attrib. to) (Schumacher)
Etudes de Chiens (Whippets) (drawing), 8¾ x 13

OBERLIN, The Allen Memorial Art Museum, Oberlin College
Beheading of St. John the Baptist, 13 x 16⅝

TOLEDO, The Toledo Museum of Art
The Return of Christopher Columbus, 33½ x 45½, 1839

Oregon
PORTLAND, Portland Art Museum
Jesus on the Lake of Gennesareth, 17¾ x 21⅝

Moroccan Lion Hunt (drawing), 4 x 6⅝

Pennsylvania
PHILADELPHIA, Philadelphia Museum of Art
Horses at the Fountain, 29 x 36½, 1862 (Wilstach)
L'Amende Honorable, 50 x 62½, 1831
Christ on the Sea of Galilee, 19 x 23, c. 1853
Flowers and Fruit, 43 x 56½ (Johnson)
Dahlias, 19¾ x 13 (attrib. to) (Johnson)

Rhode Island
PROVIDENCE, Museum of Art, Rhode Island School of Design
Arabes en Voyage, 21¼ x 25⅝, 1855
Battle Scene with Fleeing Horse (drawing), 8⅞ x 13
Arab Rider Resting (drawing), 5½ x 8½, c. 1829
Crouching Lioness (drawing), 8⅞ x 19½
Leaf from a sketchbook with studies for lithographs of antique medals (drawing), 7⅝ x 12 1/16, c. 1825
Studies after Dürer's woodcut, "The Death of the Virgin" (drawing), 10 1/16 x 6⅝
Studies from the Male Nude (drawing), 14 x 9 1/16
Study for the second version of the "Entry of the Crusaders into Constantinople" (drawing), 9⅞ x 14¾

Virginia
NORFOLK, Chrysler Museum at Norfolk
Le Boeuf Ecorché, 36¼ x 28½ (loan)
Arab Horseman Giving a Signal, 22 x 18¼ (loan)

RICHMOND, Virginia Museum
Amadis De Gaule, 21½ x 25¾

Washington
SEATTLE, Seattle Art Museum
Studies of a Lioness (drawing), 7¾ x 11¾, c. 1831
Landscape of Tangiers (watercolor), 4⅛ x 8½, c. 1832

Wisconsin
MILWAUKEE, Milwaukee Art Center
Arab Encampment, 15 x 18¼, 1839

Canada

Ontario
OTTAWA, The National Gallery of Canada
Othello and Desdemona, 20 x 24½, 1847-49
Crucifixion (drawing), 9¾ x 6 11/16
A Sheet of Figure Studies (drawing), 9⅞ x 13⅞

TORONTO, Art Gallery of Ontario
The Fanatics of Tangiers, 18½ x 22, 1857

Albrecht Dürer

Albrecht Dürer • The Virgin and Child with St. Anne
Tempera and oil on canvas • 23⅝ x 19⅝″ • The Metropolitan Museum of Art,
New York City • Bequest of Benjamin Altman

Albrecht Dürer
1471–1528

Albrecht Dürer was born in Nuremberg, the son of a goldsmith who had migrated to Germany from Hungary. At first apprenticed in his father's shop, he showed such talent for drawing that the elder Dürer sent him to the studio of Michael Wolgemut, painter and woodcutter, where he stayed three years. In 1490 he started on his *wanderjahre,* which took him to various parts of Germany and across the Alps to Venice. In 1494 Dürer returned to Nuremberg and married Agnes Frey, whose dowry of two hundred guilders helped him to set up his own shop with a printing press and journeymen. Dürer was again in Venice in 1505-6, and in 1520 he took his wife with him on a trip to the Netherlands. In both places the wide distribution of his prints had made him a celebrity, and he was urged to stay. But he returned to Nuremberg with his wife and spent the remaining years of his life there, continuing with his painting, printmaking, and writing. He died childless.

The difference between the Gothic tradition of northern Europe and the Latin tradition of the south (England combines the two) is clearly revealed in the pictorial arts. Compared to the formal, logical designs of most French, Italian, and English portraits, those of Germany are intense, personal, real—as in this *Portrait of a Clergyman* by Albrecht Dürer. Here there is no landscape background, as in Gainsborough's *Blue Boy* or Lawrence's *Pinkie*—no accessories, as in Titian's *Man With a Falcon.* Here is a directly painted picture of a man. He is an unknown clergyman whose portrait remained in Dürer's collection when his brother Andrea inherited it on his death and sold it to a Nuremberg collector, from whose collection it eventually passed to the art market and finally to the National Gallery in Washington.

"I therefore hold," wrote Dürer, "that the more exactly a picture resembles men, the better that work will be." But of course by "exactly" resembling men Dürer meant much more than copying surface details. He knew his anatomy thoroughly. The bone structure beneath the clergyman's skin is clearly understood, and his cloak rests on very firm shoulders, evidence that Dürer knew what he was talking about when he wrote his *Four Books on Human Proportion* and *Treatise on Measurement.* The same knowledge and talent is evident in his many engravings and woodcuts, on which his reputation largely rests.

One of the best known of these woodcuts is *The Four Horsemen of the Apocalypse,* which can be seen on request in many museum print departments, as can various etchings, engravings, and prints by many of the old masters discussed in this book. Dürer published this print himself in 1498, as one of fifteen woodcuts illustrating the Biblical account of the Revelation of St. John. The four horsemen—war, famine, pestilence, and death—were very real in Europe at the time, and they are no less real in this print. With the skill that he learned as an engraver in his father's goldsmith shop, with the extraordinary imagination that had excited the envy of his Italian contemporaries, and with the deep religious emotion that ruled his life, Dürer has presented these four scourges as though they might come roaring out of the clouds at any moment.

He has presented the "four horsemen" with a compositional technique which he may have learned in Italy, plus his own love of realistic detail. The Italians call the technique *contrapposto,* or the placing of one mass against another to give coherent form and movement to a work of art. Here it takes the form of an X, with the central horsemen at its crux. His right arm holding the scales is one upper arm of the X; the upraised sword of the next horseman is the other. The lower arms of the X are suggested by the line of the horses reaching from lower left to upper right and the horses' legs pointing toward the figures at lower right, one of whose legs starts a diagonal that ends with the lightning bolts entering the picture at the upper left-hand corner.

With this unifying composition established, Dürer has everywhere lavished his love of realistic detail: the nails in the horses' hooves, the harness, the jewels of the bishop's miter in the mouth of a Gothic beast. And below it all he has drawn his famous signature, an A around a D.

Albrecht Dürer in America

California
SACRAMENTO, E. B. Crocker Art Gallery
Nude Woman with a Herald's Wand (drawing), 12 x 9½, 1498

District of Columbia
WASHINGTON, National Gallery of Art
Portrait of a Clergyman, 16⅞ x 13, 1516 (Kress)
Madonna and Child, 19¾ x 15⅝, 1496-99; reverse: *Lot and His Daughters* (Kress)

Massachusetts
BOSTON, Isabella Stewart Gardner Museum
Man in a Fur Coat, 19¾ x 12⅝

CAMBRIDGE, Fogg Art Museum, Harvard University
Susanna of Bavaria (drawing), 15⅞ x 11⁹/₁₆
Lamentation (drawing), 11⅜ x 8¼

New Jersey
PRINCETON, The Art Museum, Princeton University
Woodblock for "Holy Family and Hares," 15¹¹/₁₆ x 11⅛, c. 1497

New York
NEW YORK CITY, The Metropolitan Museum of Art
The Virgin and Child, 11 x 7⅜, 1516 (attrib. to)
The Virgin and Child with St. Anne, 25⅝ x 19⅝, 1519 (Altman)
Salvator Mundi, 22⅞ x 18½

Rhode Island
PROVIDENCE, Museum of Art, Rhode Island School of Design
Buttercups, Red Clover, and Plantain (watercolor), 11⅞ x 8½ (attrib. to)

Washington
SEATTLE, Seattle Art Museum
Madonna and Child (drawing), 7¼ x 5¼, 1512-14

Canada

Ontario
OTTAWA, The National Gallery of Canada
A Nude Woman with a Staff (drawing), 9¼ x 3¾

Albrecht Dürer • Madonna and Child
Wood • 19¾ x 15⅝"
National Gallery of Art, Washington, D.C.
Samuel H. Kress Collection

Anthony van Dyck

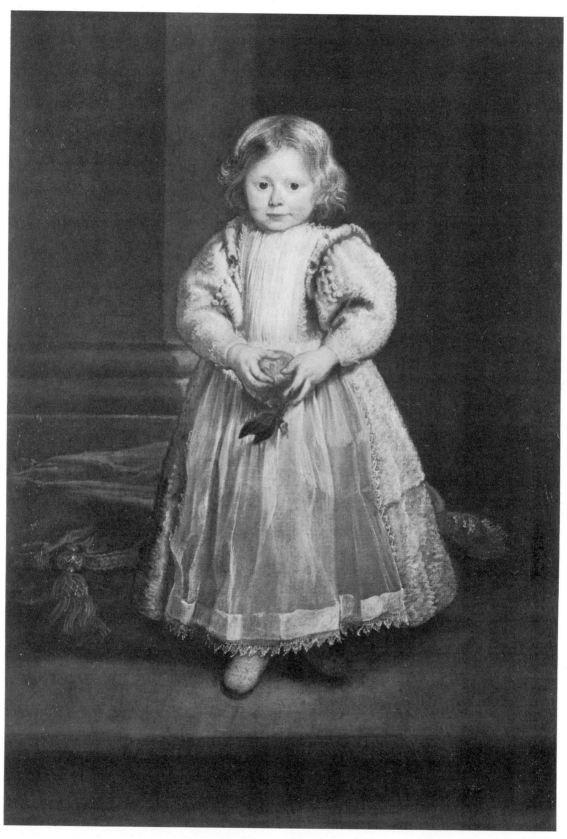

Anthony van Dyck • Clelia Cattaneo, Daughter of Marchesa Elena Grimaldi
Canvas • 48⅛ x 33⅛″ • National Gallery of Art, Washington, D.C. • Widener Collection

Anthony van Dyck

1599–1641

Anthony van Dyck was born in Antwerp, the son of a wealthy silk merchant. Little is known of his early education, but apparently he showed a precocious talent, for when he was ten years old he was apprenticed to the painter Hendrick van Balen. Nine years later, in 1618, he more than justified his parents' hopes by being admitted to the Antwerp guild of painters. Almost immediately he became one of the favorite and most valued assistants of Rubens, who probably helped him get to England in 1620. Here at the age of twenty-one he painted a portrait of James I and became a court favorite. The Earl of Arundel gave the dashing young artist letters to Italy, where he spent the years 1621-28 painting portraits of members of the great families. During the next few years he was back in Antwerp, competing with Rubens for religious painting commissions. In 1632 van Dyck returned to London, was knighted the same year by Charles I, and was named "painter in ordinary" to the King, with a pension of two hundred pounds and a studio in Blackfriars. During the nine remaining years of his life he painted more than 350 portraits, quite possibly working himself to death. To the great annoyance of his current model, Margaret Lemon (she reportedly bit his painting hand), van Dyck finally married Lady Mary Ruthven, who bore him one daughter eight days before he died. To a natural daughter in the Netherlands he left four thousand pounds.

Van Dyck established the fashionable portrait. His predecessors (Titian and Tintoretto in Italy) and his contemporaries (Hals, Rubens, and Rembrandt in the Netherlands) painted people so that they looked important. Van Dyck painted them so that they looked not only important, but fashionable. Rembrandt's portraits would dignify the editorial page of any modern newspaper; van Dyck's would add elegant vitality to its society pages. Rembrandt's sitters are people one would *like* to know; van Dyck's are people one *should* know. Such a lady is the Marchesa Elena Grimaldi, wife of Marchese Nicola Cattaneo, of Genoa, whose portrait by van Dyck hangs in Washington.

The marchesa in this portrait is not notable for her richness of character (though van Dyck could paint that, too), but for her unassailable aristocracy. She has the absolute confidence that makes all democrats a little angry—and a little uneasy. As a member of the Cattaneo family, she very likely possessed this confidence, but if she did not, van Dyck gave it to her. He provided it not only with the obvious device of having a Moor in attendance on her, but with his whole magnificent conception of the portrait.

The body of the Marchesa forms a pyramid. Her erect and lovely head, outlined against the cherry-colored parasol, is the apex of this pyramid—the focus of attention. Every line in the picture leads to it. On the left, the marble balustrade points upward to her. A line extended from it touches her aristocratic nose. The strongest rib of the parasol parallels this line, and its handle starts the downward slope of the right side of the pyramid. This right-hand slope is repeated in every gesture of the Moor and in the splendid gown of the Marchesa herself. She is indeed as imposing and impregnable as an Egyptian pyramid. Professor Frank Jewett Mather said of this painting: "My heart does not speed its beat before it, but my hat comes off and stays off."

Anthony van Dyck in America

California
LOS ANGELES
Los Angeles County Museum of Art
Portrait of Mary Villiers, Duchess of Richmond and Lenox, with Her Dwarf, 83 x 48

University of Southern California, University Galleries
St. John, 30¼ x 24

SACRAMENTO, E. B. Crocker Art Gallery
Lamentation over Christ (drawing), 8 x 10

SAN DIEGO, San Diego Museum of Art
Portrait of Queen Henrietta Maria, 41½ x 33½, c. 1637

SAN FRANCISCO, The Fine Arts Museums of San Francisco
Portrait of Duchess of Croy, 47 x 39¼

Connecticut
HARTFORD, Wadsworth Atheneum
Portrait of Robert Rich, Second Earl of Warwick, 98 x 52
The Resurrection of Christ, 45 x 37¼

NEW HAVEN, The Yale University Art Gallery
Portrait of Ferdinand Bouschot, 27½ x 23
The Apostle Matthew, 25⅛ x 18⅝

District of Columbia
WASHINGTON
Corcoran Gallery of Art
Charles Lewis, Elector Palatine, 46½ x 40 (studio of) (Clark)
Charles, Lord Herbert, 46¾ x 40 (studio of) (Clark)

The National Collection of Fine Arts, Smithsonian Institution
Portrait of Marchesa Lina Cattaneo, 16⅝ x 12½ (Gellatly)

National Gallery of Art
Paola Adorno, Marchesa Brignole Sale, and Her Son, 74½ x 55, c. 1625 (Widener)
The Assumption of the Virgin, 46½ x 40¼, c. 1627 (Widener)
Susanna Fourment and Her Daughter, 68 x 46¼, c. 1620 (Mellon)
Marchesa Balbi, 72 x 48, 1622-27 (Mellon)
Philip, Lord Wharton, 52½ x 41⅞, 1632 (Mellon)
Clelia Cattaneo, 48⅛ x 33⅛, c. 1623 (Widener)
Henri II de Lorraine, Duc de Guise, 80⅝ x 48⅝, c. 1632-40
The Prefect Raphael Racius, 51⅝ x 41⅝, c. 1625 (Widener)
Portrait of a Flemish Lady, 48⅜ x 35½, 1618-21 (Mellon)
Filippo Cattaneo, 48⅛ x 33⅛, c. 1623 (Widener)
Marchesa Elena Grimaldi, 97 x 68, c. 1623 (Widener)
Giovanni Vincenzo Imperiale, 50 x 41½, 1625 (Widener)
Lady d'Aubigny, 42 x 33½, c. 1638 (Widener)
Isabella Brant, 60¼ x 47¼, 1621 (Mellon)
Dona Polyxena Spinola Guzman de Leganes, 43⅛ x 38⅛, c. 1632
Saint Martin Dividing His Cloak, 13⅝ x 9⅝, c. 1620

Florida
SARASOTA, John and Mable Ringling Museum of Art
St. John the Evangelist, 16 x 13

WEST PALM BEACH, Norton Gallery of Art
The Madonna in Glory, 53¼ x 57¾

Illinois
CHICAGO, The Art Institute of Chicago
Helena Tromper Du Bois, 39 x 31⅞, c. 1631

Indiana
INDIANAPOLIS, Indianapolis Museum of Art
Portrait of a Genoese Nobleman, 29 x 24
The Triumphal Entry of Christ into Jerusalem, 59½ x 90¼

Kentucky
LOUISVILLE, The J. B. Speed Art Museum
The Martyrdom of St. Sebastian, 75 x 56⅝
Duchess of Southampton, 29⅞ x 23¼

Maryland
BALTIMORE
The Baltimore Museum of Art
Portrait of Frederick Henry, 45 x 38, 1628 (Jacobs)
Rinaldo and Armida, 93 x 90, 1629 (Epstein)

The Walters Art Gallery
Madonna and Child, 49⅝ x 45⅛

Massachusetts
BOSTON
Isabella Stewart Gardner Museum
A Lady with a Rose, 39 x 30½

Museum of Fine Arts
?Gentleman with an Armillary Sphere, 49 x 42
Margareta de Vos, 20½ x 17
Peeter Symons, 45 x 37½
Rinaldo and Armida, 44 x 57 (studio of)
Anna Maria de Schodt, 71¾ x 47¼
Princess Mary, 59 x 42, 1641

PITTSFIELD, The Berkshire Museum
The Duke of Richmond and Lenox, 84 x 46½

WILLIAMSTOWN, Sterling and Francine Clark Art Institute
Ambrogio da Spinola (oval), 26½ x 22⅛, c. 1620

Michigan
DETROIT, The Detroit Institute of Arts
Portrait of the Marchesa Spinola, 42 x 32½, 1622-27
Portrait of the Earl of Downe, 45 x 35⅞
Jan Wildens and His Wife, 47 x 60, c. 1618-20
A Family Group, 44 x 63½, 1634-35
Portrait Sketch of Lucas van Uffel, 12 x 9¼, 1622-27
Portrait of a Man, 14¾ x 10½, 1628-32
Martyrdom of St. George, 9¼ x 7, 1627-32

Minnesota
MINNEAPOLIS, The Minneapolis Institute of Arts
The Betrayal of Christ, 55⅞ x 44½

Missouri
KANSAS CITY, The Nelson Gallery and Atkins Museum
Portrait of a Man, 45½ x 35¾

ST. LOUIS, The St. Louis Art Museum
Portrait of a Goldsmith, 44¾ x 36

Nebraska
OMAHA, Joslyn Art Museum
Portrait of a Flemish Lady, 33½ x 41¾, 1627-32

New York
ELMIRA, Arnot Art Museum
?Head of Charles II when a Boy, 13 x 15½

GLENS FALLS, The Hyde Collection
Portrait of Jan Woverius, 18 x 12½, c. 1634

NEW YORK CITY
The Frick Collection
Paola Adoro, Marchesa de Brigole Sale, 90⅞ x 61⅝, 1622-27
Marchesa Giovanna Cattaneo, 40⅜ x 34, 1622-27
Ottaviano Canevari, 51¼ x 39, c. 1627
Frans Snyders, 56⅛ x 41½, c. 1620
Margareta Snyders, 51½ x 39⅛, c. 1625
James, Seventh Earl of Derby, His Lady and Child, 97 x 84⅛, 1632-41
Anne, Countess of Clanbrassil, 83½ x 50¼, 1636
Sir John Suckling, 85¼ x 51¼, 1632-41

The Metropolitan Museum of Art
The Marchesa Durazzo, 44⅝ x 37¾ (Altman)
Portrait of a Lady, 49 x 38
Portrait of a Man, 41¾ x 28⅝
Lucas van Uffele (1583?-1637), 49 x 38⅝ (Altman)
Thomas Howard, Second Earl of Arundel (1585-1646), and His Grandson, 96¼ x 55½ (workshop of)
St. Rosalie Interceding for the Plague-Stricken of Palermo, 39¼ x 29
Self-Portrait, 47⅛ x 34⅝ (Bache)
Robert Rich, Second Earl of Warwick, 81⅞ x 50⅜ (Bache)

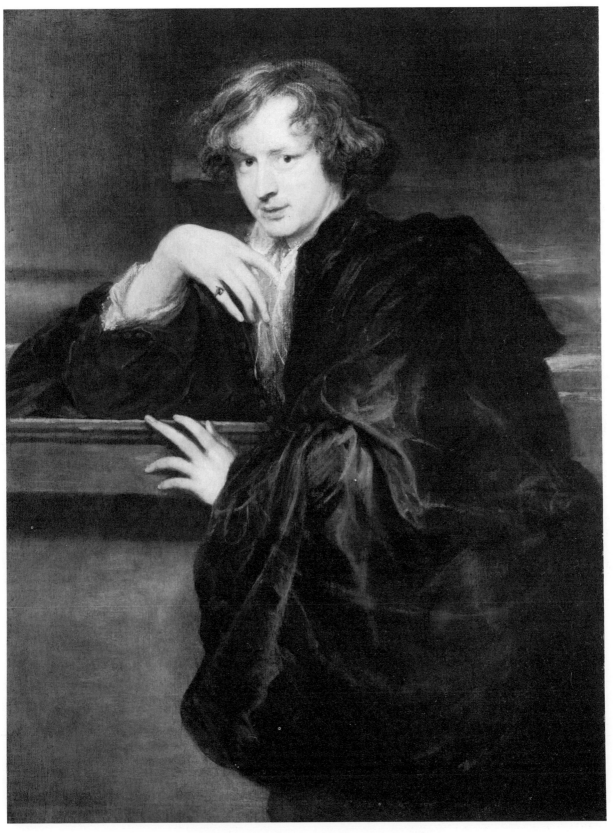

Anthony van Dyck • Portrait of the Artist
Oil on canvas • 47 x 33½" • The Metropolitan Museum of Art, New York City
The Jules S. Bache Collection

James Stuart, Duke of Richmond and Lennox (1612-1655),
85 x 50¼
The Virgin and Child, 25¼ x 19½
The Three Eldest Children of Charles I, 50⅛ x 58¼ (workshop of)
Study Head of a Young Woman, 22¼ x 16⅜
Virgin and Child with St. Catherine, 43 x 35¾

ROCHESTER, Memorial Art Gallery of The University of Rochester
Portrait of a Man in Armor, 40 x 32¼ (Eastman)

North Carolina
RALEIGH, North Carolina Museum of Art
Mary Villiers, Duchess of Lennox and Richmond, 94 x 58¼
Bacchanalian Procession, 60 x 87
Portrait of Erycius Puteanus, 29½ x 26⅜
Henry, Prince of Wales, 94 x 58¼

Ohio
CINCINNATI
The Cincinnati Art Museum
A Member of the Balbi Family, 52¼ x 47¼

The Taft Museum
Paolina Adorno, Marchesa di Brignole, 89¼ x 58¼

CLEVELAND, The Cleveland Museum of Art
A Genoese Lady with Her Child, 85¾ x 57½

COLUMBUS, Columbus Museum of Art
Donna Polyxene Spinola, Marchesa de Leganes, 72¼ x 44¾
(Howald)
Christian Bruce, Countess of Devonshire, 83¼ x 51½, c. 1632
Head of a Bearded Man (drawing), 13 x 10¹/₁₆

OBERLIN, The Allen Memorial Art Museum, Oberlin College
Portrait of a Man, 29 x 24¼, 1615-16

TOLEDO, The Toledo Museum of Art
Portrait of a Man, 41½ x 33, c. 1630

ZANESVILLE, Zanesville Art Center
Adoration of the Shepherds, 23 x 19, c. 1629

Rhode Island
PROVIDENCE, Museum of Art, Rhode Island School of Design
Christ Bearing the Cross (drawing), 7⅞ x 6⅝
Study of Figure with Arm Outstretched (drawing), 10¾ x 15¾
Lamentation of Christ (drawing), 8⅝ x 7

South Carolina
GREENVILLE, The Bob Jones University Art Gallery and Museum
Madonna and Child, 20⅝ x 16¼
Mother of Sorrows, 46⅞ x 37⅛
Man of Sorrows, 32⅛ x 25⅝

Tennessee
MEMPHIS, The Brooks Memorial Art Gallery
Portrait of Henrietta Maria, 25 x 20

Texas
DALLAS, Dallas Museum of Fine Arts
Countess of Oxford, 41½ x 32½ (Munger)

FORT WORTH, Kimbell Art Museum
Self-Portrait, about age 15, 14⅜ x 10⅛, c. 1614
Portrait of a Cavalier, 28¾ x 21⅞, 1634

HOUSTON, The Museum of Fine Arts
?*Portrait of Charles Louis,* 40½ x 32½, 1637 (Straus)
?*Portrait of a Man with a Beard (Jaspor de Charles de
Neuwenhove of Waes),* 39¼ x 29½ (Blaffer)

Virginia
NORFOLK, Chrysler Museum at Norfolk
Martyrdom of St. Sebastian, 74½ x 65¾, c. 1623

RICHMOND, Virginia Museum
Lady Mary Villiers, Duchess of Richmond, 41⅜ x 33
Marchesa Caterina Durazzo Adorno, 47 x 37¼

Wisconsin
MILWAUKEE, Milwaukee Art Center
Portrait of a Woman, said to be Lady Margaret Tufton,
45¹⁵/₁₆ x 37⅜, after 1632

Canada

Ontario
OTTAWA, The National Gallery of Canada
Christ Blessing the Children, 51½ x 78½, c. 1618
Expulsion from Paradise, 7½ x 6¾, c. 1620

TORONTO, Art Gallery of Ontario
Daedalus and Icarus, 44½ x 33½, c. 1620
Michel Le Blon, 30¾ x 24, c. 1630-35

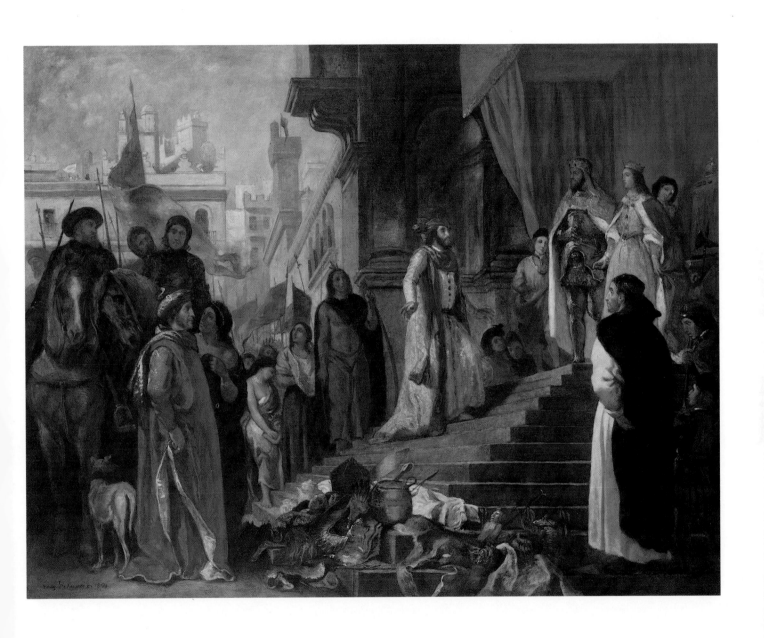

Ferdinand-Victor-Eugene Delacroix • The Return of Christopher Columbus
Oil on canvas • *33½ x 45½"* • *The Toledo Museum of Art* • *Gift of Thomas A. DeVilbiss*

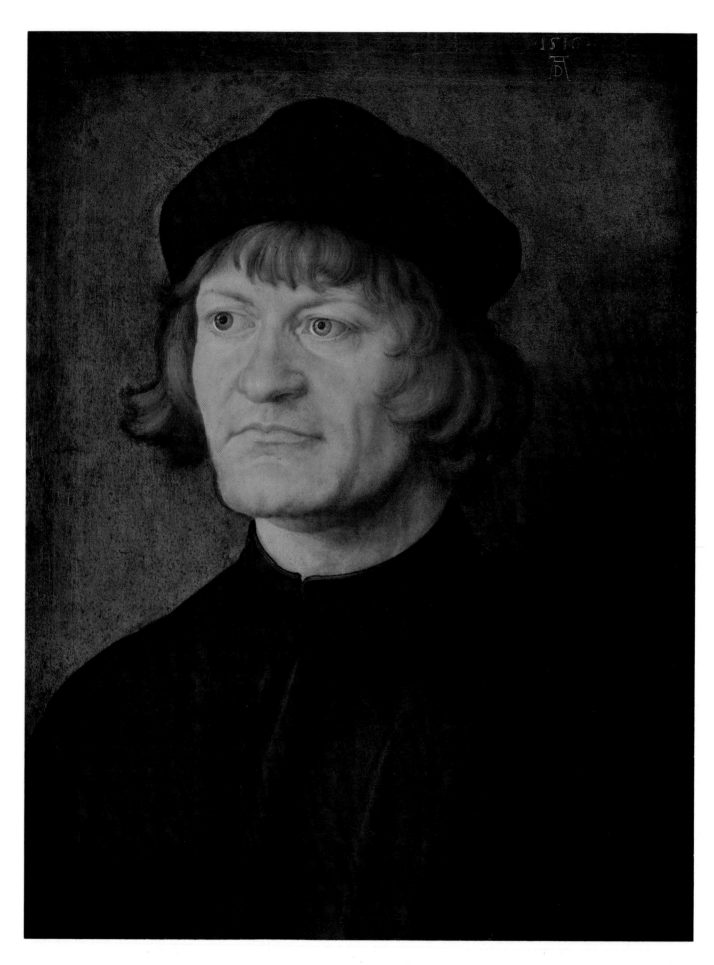

Albrecht Dürer • Portrait of a Clergyman
Parchment on canvas • 16⅞ x 13" • National Gallery of Art, Washington, D.C.
Samuel H. Kress Collection

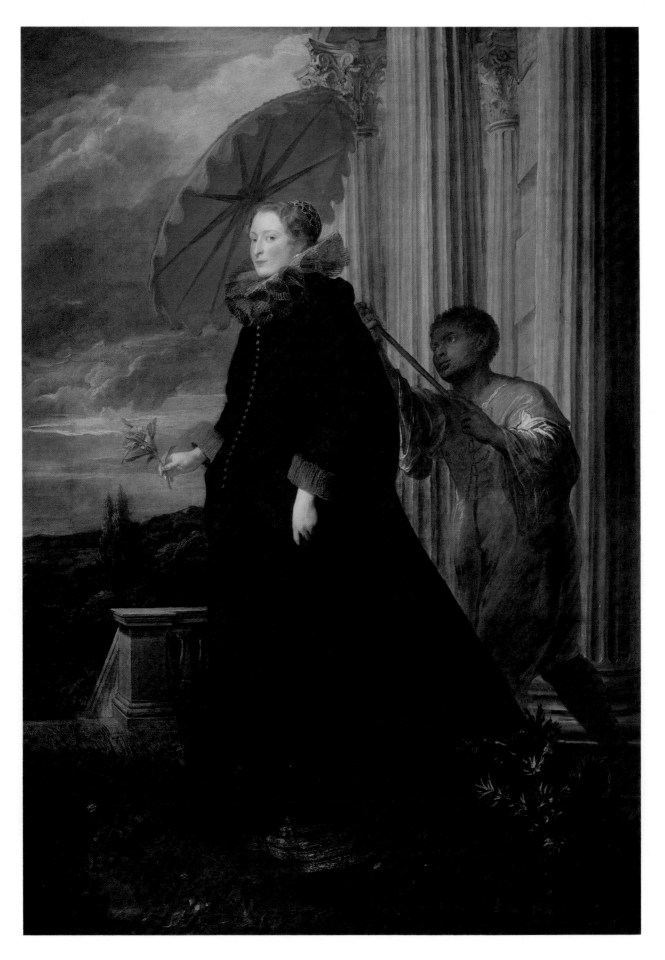

Anthony van Dyck • Marchesa Elina Grimaldi

Oil on canvas • 97 x 68″ • National Gallery of Art, Washington, D.C. • Widener Collection

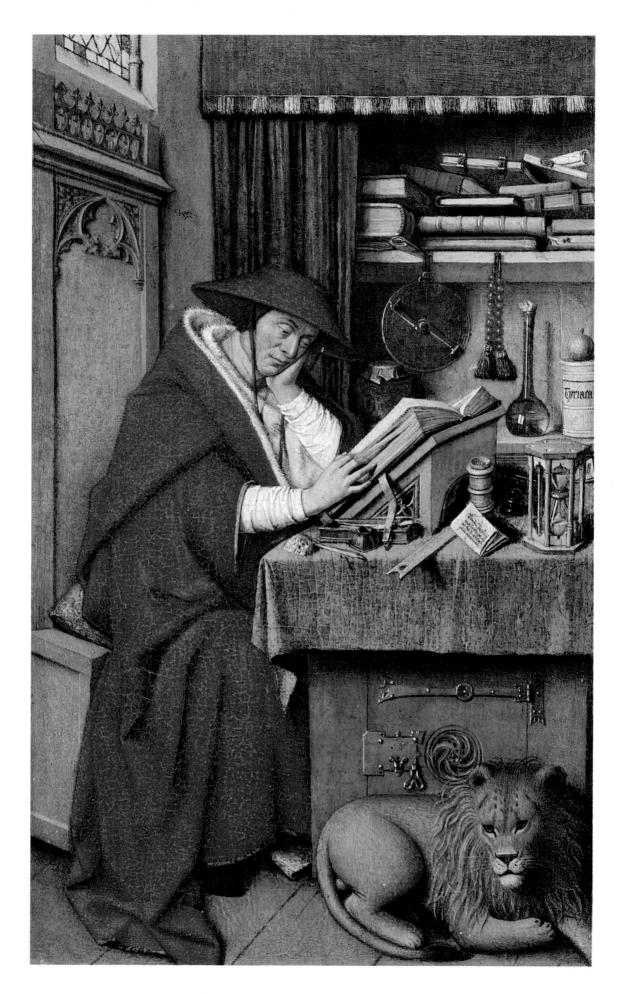

Jan van Eyck • St. Jerome in his Study

Tempera on panel • 8⅛ x 5¼ ″ • Detroit Institute of Arts

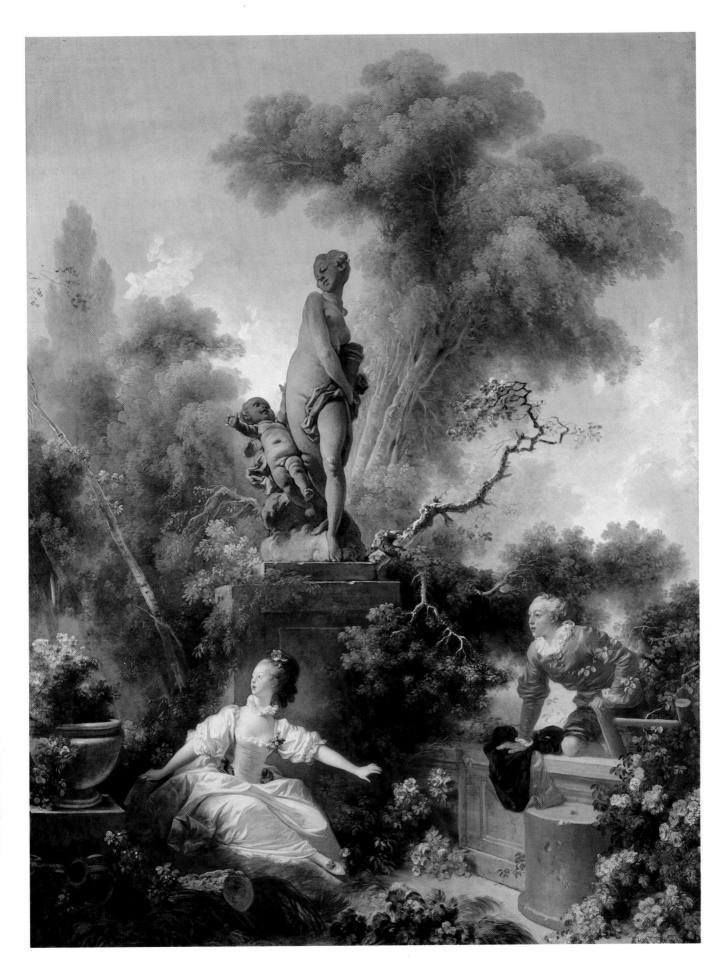

Jean-Honoré Fragonard • The Meeting
Oil on canvas • 125 x 96″ • The Frick Collection, New York

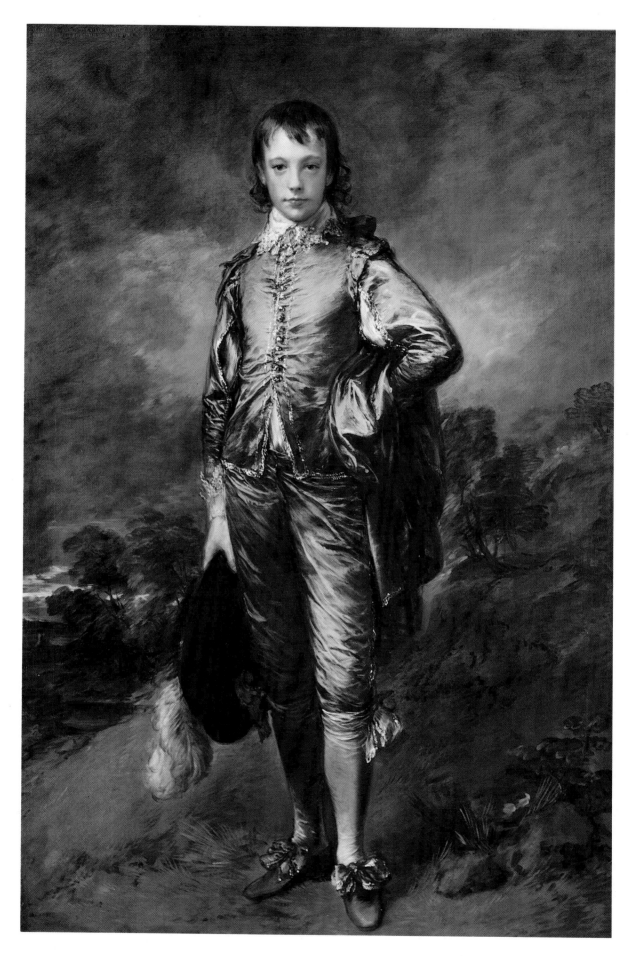

Thomas Gainsborough • The Blue Boy
Oil on canvas • *70 x 48"* • *The Huntington Art Gallery, San Marino, California*

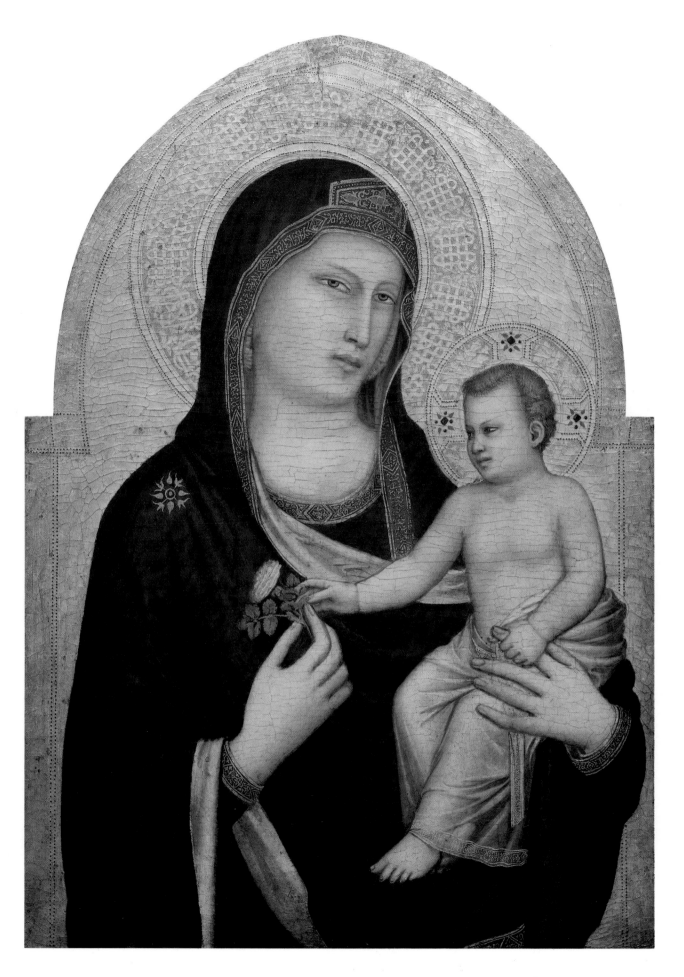

Giotto • Madonna and Child

Panel • *33⅝ x 24⅜ ″* • *National Gallery of Art, Washington, D.C.* • *Samuel H. Kress Collection*

Francisco de Goya • Don Manuel Osorio de Zuniga

Oil on canvas • 50 x 40" • The Metropolitan Museum of Art, New York City

The Jules S. Bache Collection

Jan van Eyck

Jan van Eyck • The Annunciation
National Gallery of Art, Washington, D.C. • Andrew W. Mellon Collection

Jan van Eyck

c. 1390—1441

The van Eyck brothers, often called the inventors of oil painting, were probably born near Maastricht, now West Germany, but then in the Netherlands province of Limburg governed by the dukes of Burgundy. They worked chiefly in Ghent and Bruges. They collaborated on their masterpiece, *The Adoration of the Lamb,* the famous altarpiece in the Church of St. Bavon at Ghent, and scholars are still laboring to distinguish between the work of the two brothers. Although little is known about the personal life of either, the records reveal that Philip the Good, Duke of Burgundy, regarded Jan highly and sent him on several special missions, including one to Portugal in 1428-29 where he painted a portrait of Princess Isabella, whom the duke wanted to marry.

There is, of course, no such thing as "progress" in the arts, just as there is no "progress" in human beings; there is only change. We of the twentieth century do not see, feel, smell, taste, hear, or even think any "better" than our forebears. There is progress only in the techniques with which we gratify and use these senses. But in the technique of oil painting, astonishingly, there has been no improvement on the five-hundred-year-old methods perfected by its inventors, the brothers van Eyck.

The use of oil as a substance to hold color pigment was known as early as the twelfth century, but like many other discoveries of man, it was not perfected until a definite need for it had arisen. Before A.D. 1400 most European pictures were painted in tempera, which is a quick-drying medium (usually egg white) well suited to the expression, in soft, map-like colors, of the weightless figures and symbols of the Middle Ages (see Fra Angelico and Giotto). With the coming of the Renaissance and the sudden, burning interest in the affairs of men, a medium was necessary for the representation of the real world—the world of physical things.

The van Eyck brothers discovered the new medium in the previously known but little used oil of flaxseed, known and used today as common linseed oil. (Oil of poppy and nuts is also sometimes used.) By mixing their pigments in clear linseed oil—exactly how has never been discovered—they were able to paint pictures which might be either flat or rich with liquid shadows, according to the demands of the subject. They were able to paint slowly, often using a magnifying glass, such minute details as those in the tiny picture of *St. Jerome in His Study* in the Detroit Institute of Arts. This painting was begun by Jan van Eyck and completed after his death by his pupil, Petrus Christus (active 1442?-72/73).

Because Jan van Eyck was a great artist as well as a master craftsman, these marvelously painted details are more than ends in themselves. They are the things we would see secondarily if we were to look reverently through a window at this fifth-century patron saint of scholars, magically transported from fifth-century Rome to fifteenth-century Bruges and continuing with his reading. We are inclined both to revere and to envy him in his warm, quiet study, with his books and instruments, his apple and his bottle of wine, all gleaming softly in the mellow light. After this feeling passes, we are free to admire for themselves the fine, jewel-like blues, greens, and reds and the textures of wool, paper, leather, and sparkling glass. We can also marvel at the fact that the colors are fresher than any painted since, defying not only time but the inquiring minds of artists who have tried in vain to match their enduring brilliance.

Jan van Eyck in America

District of Columbia
WASHINGTON, National Gallery of Art
The Annunciation, 36½ x 14⅜, 1432-35 (Mellon)

Michigan
DETROIT, The Detroit Institute of Arts
St. Jerome in His Study, 8⅛ x 5¼, 1442

New York
NEW YORK CITY
The Frick Collection
Virgin and Child, with Saints and Donor, 18⅝ x 24⅛,
early 1440s

The Metropolitan Museum of Art
The Crucifixion; The Last Judgment (diptych); ea. 22¼ x 7¾

Pennsylvania
PHILADELPHIA, Philadelphia Museum of Art
St. Francis Receiving the Stigmata, 5 x 5¾ (Johnson)

Jan van Eyck • St. Francis Receiving the Stigmata
5 x 5¾" • Philadelphia Museum of Art, Philadelphia, Pennsylvania
John G. Johnson Collection

Jean-Honoré Fragonard

Jean-Honoré Fragonard • Self-Portrait
Oil on canvas • 18 x 14¾" • California Palace of the Legion of Honor, San Francisco
Gift of Mr. and Mrs. Louis Benoist

Jean-Honoré Fragonard

1732–1806

Jean-Honoré Fragonard was born in Grasse, on France's Côte d'Azur. His father was a glove manufacturer, who, during a period of financial difficulty, apprenticed young Fragonard to a notary in Paris. The boy showed such talent in art, however, that at eighteen he was taken to the studio of François Boucher (Metropolitan Museum, Frick Collection). Boucher recognized his talents, but not wanting to teach a beginning student, sent him to Chardin for six months. Fragonard then returned to Boucher, and in 1752 won the Prix de Rome. Before proceeding to Italy, however, he spent three years studying with the portrait painter, Charles Van Loo. In Rome he studied at the French Academy under Natoire, while absorbing the silent lessons of the old masters. In 1761 he returned to Paris and four years later was admitted to the Academy with a painting of *Coresus and Callirhoë*, which was purchased by the king and reproduced in tapestry by the Gobelins factory. After his marriage in 1769 he painted children and family scenes. But his patronage by Mme de Pompadour and Mme du Barry seemed to assure his future as a court painter. The future of the court, however, was not assured, and in 1793 Fragonard fled to Grasse to escape the Revolution. He returned to Paris early in the nineteenth century and died there, neglected and forgotten.

If Chardin's paintings reflect Andre Siegfried's typical Frenchman with one hand clutching his pocketbook, those of Fragonard certainly suggest the other hand held over his heart. Fragonard was the painter *incomparable* of the brilliant, licentious French court that ended under the guillotine. Born eleven years after Watteau's premature death, Fragonard continued the tradition that Watteau began—with much the same vitality concealed beneath the silks and satins.

Thoroughly trained in the studios of Chardin, Boucher, Van Loo, and Natoire, Fragonard found the style most congenial to his genius (and to the taste of his patrons) during a summer sojourn at the Villa d'Este outside Rome. The gardens and fountains of that famous Renaissance villa, its grottoes and vistas, supplied Fragonard with the images which he transformed into the paintings that delighted the court of Louis XV. Among the most famous of these works is the series he painted for Mme du Barry, now in the Frick Collection in New York.

Entitled *The Romance of Young Love*, this series of eleven panels was originally commissioned by Mme du Barry for her pavilion at Louveciennes. Fragonard completed four of them (including *The Meeting*) in 1773, but for some reason they were refused. It may be that Du Barry's architect preferred another artist. At any rate, in 1793 Fragonard took the panels with him to his native town of Grasse when he left Paris during the Revolution. There they remained forgotten in the house of a cousin for more than a century. In 1898 a grandson of the cousin sold the entire set to a dealer who in turn sold them to J. P. Morgan. In 1915 Henry Clay Frick purchased them from Morgan, and in 1935 they were placed on public view for the first time anywhere.

The reasons for Fragonard's preeminence as a court artist are not hard to find. In addition to an almost perfect style of pink-and-blue boudoir decoration, these paintings reveal a mastery of drawing and color that goes straight back to Watteau. The young man's knee and hand, for example, are supporting the weight of a real body, not an actor in a love drama. The branch of the tree exists sharply in space, instead of on a canvas backdrop. The girl is clearly, enchantingly, alarmed. Perhaps Mme du Barry was right in refusing these pictures. They would have given her serious competition.

Jean-Honoré Fragonard in America

Arizona
TUCSON, The University of Arizona Museum of Art
Jeremiah Warning the King of Jerusalem (drawing), 5½ x 7⅝, c. 1755
Susanne Accused by the Elders (drawing), 5¼ x 8⅛, c. 1755
Burial of Jacob's Brother (drawing), 5⅝ x 8½, c. 1755
Jonathan and His Armor Bearer (drawing), 5⅝ x 8¼, c. 1755
Entombment of Christ (drawing), 5⅝ x 8⅛, c. 1755
David in Victory Pardons Saul (drawing), 5⅛ x 8⅛, c. 1755
Balaam on the Ass (drawing), 5½ x 8⅜, c. 1755
Samson with the Jawbone of an Ass (drawing), 5⅝ x 8¼, c. 1755
Daniel Interpreting Nebuchadnezzar's Dream (drawing), 5½ x 8½, c. 1755
Death of Joab's Brother (drawing), 5¾ x 8¼, c. 1755
Death of King Solomon (drawing), 5¼ x 8½, c. 1755
Pericles and Aspasia (drawing), 5⅝ x 8⅛, c. 1755
David and Bathsheba's Husband (drawing), 5½ x 8¼, c. 1755

California
LOS ANGELES, Los Angeles County Museum of Art
Winter, 31½ x 64½, c. 1765
Portrait of Mlle Colombe as Venus (oval), 22 x 18¼, c. 1775

PASADENA, Norton Simon Museum of Art
The Happy Lovers, 35½ x 47, 1760
Music and Venus Binding Cupid's Wings, 54½ x 31¼, 1760

SACRAMENTO, E. B. Crocker Art Gallery
Italian Park (Villa d'Este) (drawing), 9½ x 14½

SAN DIEGO, Timken Art Gallery, San Diego
Blindman's Bluff, 24¼ x 17⅝

SAN FRANCISCO, The Fine Arts Museums of San Francisco
Education of the Virgin, 33 x 45
Self-Portrait, 18 x 14¾

Connecticut
HARTFORD, Wadsworth Atheneum
Portrait of a Child, 15¼ x 12¼

NEW HAVEN, The Yale University Art Gallery
Ruined Buildings (drawing), 8¾ x 12½

District of Columbia
WASHINGTON
National Gallery of Art
A Game of Hot Cockles, 45½ x 36, 1767-73 (Kress)
A Game of Horse and Rider, 45⅜ x 34½, 1767-73 (Kress)
Love as Folly, 22 x 18¼, c. 1775
The Visit to the Nursery, 28¾ x 36¼, before 1784 (Kress)
Love as Conqueror, 22 x 18⅜, c. 1775
Blindman's Bluff, 85⅛ x 77⅞, c. 1765 (Kress)
The Swing, 85 x 73, c. 1765 (Kress)
A Young Girl Reading, 32 x 25½, c. 1776

The Phillips Collection
Rodomonte Leaps Across the Moat (drawing), 16 x 11⅛
Odorico Kills Corebo (drawing), 15¼ x 10¼

Indiana
BLOOMINGTON, Indiana University Art Museum
Temple of the Sibyl at Tivoli (drawing), 14⅜ x 18

INDIANAPOLIS, Indianapolis Museum of Art
The Little Pilgrim, 32⁵/₁₆ x 29¹⁵/₁₆

MUNCIE, Ball State University Art Gallery
Head of an Old Man, 7¾ x 7¾
Sultane Assise sur Une Ottomane, 12½ x 9½

Kentucky
LOUISVILLE, The J. B. Speed Art Museum
The Young Sculptor, 13 x 9⅞

Maryland
BALTIMORE, The Baltimore Museum of Art
Rest on the Flight, 26 x 22½ (Jacobs)

Massachusetts
BOSTON, Museum of Fine Arts
The Good Mother, 25¼ x 30¾
Mother and Children, 18¼ x 14¾

CAMBRIDGE, Fogg Art Museum, Harvard University
La Jeune Fille Brune, 18½ x 15⅝
Le Mari Confesseur (drawing), 8¼ x 10¾
The Donkey's Breakfast (drawing), 13½ x 19⅜
A Woman Standing with Hand on Hip (drawing), 15¾ x 9¾

NORTHAMPTON, Smith College Museum of Art
Sacrifice of Noah (drawing), 7⅞ x 11⅝

WILLIAMSTOWN, Sterling and Francine Clark Art Institute
Portrait of a Man (The Warrior), 32¹/₁₆ x 25⅜, c. 1769

Michigan
DETROIT, The Detroit Institute of Arts
Landscape with a Passing Shower, 15 x 18
Scenes of Country Life: The Shepherdess, 56½ x 35½
Scenes of Country Life: The Grape Gatherer, 56½ x 32½
Scenes of Country Life: The Reaper, 56½ x 32½
Scenes of Country Life: The Gardener, 56½ x 32½

Missouri
ST. LOUIS, The St. Louis Art Museum
The Washerwomen, 24¼ x 28¾, c. 1770

New York
GLENS FALLS, The Hyde Collection
Le Faucon (drawing), 8 x 5⁷/₁₆, 1790-95

NEW YORK CITY
The Brooklyn Museum
La Première Lecon d'Equitation (drawing), 13¾ x 17¾, c. 1782

The Frick Collection
The Pursuit, 125⅛ x 84⅞, 1771-73
The Meeting, 125 x 96, 1771-73
Love Letters, 124⅞ x 85⅜, 1773
The Lover Crowned, 125⅛ x 95¾, 1771-73
Reverie, 125⅛ x 77⅝, 1790-91
Love Triumphant, 125 x 56½, 1790-91
Love the Avenger, 59⅜ x 50⅜, 1790-91
Love Pursuing a Dove, 59⅝ x 47¾, 1790-91
Love the Jester, 59⅜ x 50⅜, 1790-91
Love the Sentinel, 57⅞ x 47½, 1790-91
Hollyhocks (55A), 125¼ x 25, 1790-91
Hollyhocks (55B), 125½ x 16⅜, 1790-91
Hollyhocks (55C), 125¼ x 25, 1790-91
Hollyhocks (55D), 125½ x 16⅜, 1790-91

The Metropolitan Museum of Art
Young Woman Reading (oval), 27⅛ x 21⅝
Portrait of a Lady with a Dog, 32 x 25¾
The Italian Family, 19¼ x 23⅜
A Shady Avenue, 11½ x 9½ (Bache)
The Love Letter, 32¾ x 26⅜ (Bache)
The Cascade, 11½ x 9½ (Bache)
The Two Sisters, 28¼ x 22
Gabriella de Caraman, Marquise de la Fare, 31¾ x 25
The Stolen Kiss, 19 x 25

Jean-Honoré Fragonard • Jupiter et Hebe
Oil on canvas • *21⅝ x 16⅜" • The Columbus Gallery of Fine Arts, Columbus, Ohio*
Bequest of Frederick W. Schumacher

North Carolina
RALEIGH, North Carolina Museum of Art
Jupiter, Io, and Juno, 21¼ x 18¼

Ohio
CINCINNATI, The Cincinnati Art Museum
La Lettre, 15 x 11⅝

CLEVELAND, The Cleveland Museum of Art
Young Boy Dressed in a Red-Lined Cloak, 8¼ x 6½

COLUMBUS, Columbus Museum of Art
Jupiter et Hébé, 21⅝ x 16⅜, c. 1762-63
Untitled (four figures), 7 x 8¾ (attrib. to)

TOLEDO, The Toledo Museum of Art
Blindman's Buff, 46 x 36, c. 1750-52

Oregon
PORTLAND, Portland Art Museum
Jeune Fille à la Marmotte, 15½ x 12½
Petit Garcon à la Curiosité, 15½ x 12½

Pennsylvania
PHILADELPHIA, The Pennsylvania Academy of The Fine Arts
Jeune Fille (miniature)

PITTSBURGH, The Frick Art Museum
Study for the Pursuit Panel of the Fragonard Room, The Frick Collection. New York, 11 x 14
Enfant à la Collerette, 15¼ x 12¼, 1789-1806
Portrait of a Woman Called Fragonard's Cook, 19 x 15¼, 1765

Texas
FORT WORTH, Kimbell Art Museum
The Pond, 25¾ x 28¾, c. 1761-65

Virginia
NORFOLK, Chrysler Museum at Norfolk
Rest on the Flight (oval), 87 x 75

Wisconsin
MILWAUKEE, Milwaukee Art Center
A Shepherdess, 46¾ x 63¾, c. 1750-52

Jean-Honoré Fragonard • Study for the Pursuit Panel of the Fragonard Room
The Frick Collection • Oil on canvas • 11 x 14"
The Frick Art Museum, Pittsburgh, Pennsylvania

Thomas Gainsborough

Thomas Gainsborough • Man with Book Seated in a Landscape
Oil on canvas • 23 x 19½ ''
Memorial Art Gallery of the University of Rochester, Rochester, New York
Gift of Dr. and Mrs. Fred W. Geib

Thomas Gainsborough

1727–1788

Thomas Gainsborough was born in Sudbury, Suffolk, the son of an English woolen manufacturer with a wife who excelled in flower painting. Both parents encouraged Gainsborough's early interest in drawing. (When he was twelve he sketched the face of a garden pilferer so quickly and accurately that the thief was later apprehended.) At the age of fourteen he was sent to London, where he studied briefly with the French engraver Gravelot, and also at St. Martin's Lane Academy. He returned to Sudbury in 1746 and married Margaret Burr, a young lady with an income of two hundred pounds a year. At their house in Ipswich (annual rent six pounds), Gainsborough painted landscapes and an increasing number of portraits which prompted him to seek more fertile fields. In 1760 he moved with his wife and two daughters to fashionable Bath, where his wit, social graces (he played five musical instruments), and obvious ability made him an instant success. In 1768 he was elected one of the original thirty-six members of the Royal Academy in London. Six years later the family moved there, taking a mansion on Pall Mall, where Gainsborough's fortune and his reputation steadily increased until his death from cancer at the age of sixty-one.

The names of Gainsborough, Reynolds, and Raeburn are familiar—more familiar than those of Hargreaves, Cartwright, and Watt. The latter were the inventors of, respectively, the spinning jenny, the power loom, and the steam engine. These and other inventions produced the new wealth and the new patrons that made it possible for Gainsborough to charge up to one hundred pounds for a portrait (he painted more than two hundred).

We, as well as the artists, are benefactors of that splendid century in England. Among other things, we have for our enjoyment many of the portraits that paid Gainsborough's rent. And although many of them reveal, by a kind of harshness in color and line, that he really preferred to paint landscapes, here and there in America is a portrait that he obviously enjoyed painting. The portrait of his two daughters in Worcester is one of these. *The Blue Boy* is another.

The Blue Boy is a portrait of Jonathan Buttall, son of a wealthy ironmonger who lived on Greek Street in Soho. Certainly its great and deserved popularity results from the fact that in addition to its being a superbly painted picture, Jonathan Buttall and Gainsborough were great friends. We know this from documents, but the painting tells us, too.

Not one square inch of its background is slighted, as is so often true of portraits. In exactly the right degree of detail so as not to compete with his subject, Gainsborough has freely brushed in one of the landscapes he loved to paint—but could not sell. Against this landscape, which slopes upward from left to right, he has posed the figure with its legs suggesting the opposite diagonal—ending at the waist, though again suggested in the position of the arms. The effect of this subtle opposing of basic lines is to give movement to the picture while at the same time establishing a firm base for the all-important head and shoulders. On these Gainsborough has lavished his skill as painter and draftsman.

The likeness, we can be sure from Gainsborough's reputation, is exact. The pure blue of the jacket, the crisp white of the collar, and the glowing flesh tones that bring the face to life create a perfect portrait.

Thomas Gainsborough in America

Alabama
BIRMINGHAM, Birmingham Museum of Art
Portrait of Lady Chad, 28½ x 23½
Portrait of Sir George Chad, 28½ x 24

Arizona
TUCSON, The University of Arizona Museum of Art
Portrait of General Whyte, 27½ x 22⅝

California

LOS ANGELES

Los Angeles County Museum of Art
Portrait of Maria Walpole, Lady Waldgrave, in Mourning, 50 x 40

University of Southern California, University Galleries
Mrs. Burroughs, 30 x 25, c. 1769

MALIBU, The J. Paul Getty Museum
Portrait of James Christie, 49⅝ x 40⅛, 1778
Portrait of Anne, Countess of Chesterfield, 86½ x 61½, 1778
Earl of Essex Presenting a Cup to Thomas Clutterbuck, 58½ x 68½, 1784

SAN FRANCISCO, The Fine Arts Museums of San Francisco
Landscape, 24⅜ x 29⅞, 1746-48
Samuel Kilderbee, 50½ x 40½, c. 1752-55
Portrait of Mrs. Fitzherbert, 29⅞ x 25

SAN MARINO, The Huntington Art Gallery
Edward, 2nd Viscount Ligonier, 92½ x 61½, 1770
Penelope, Viscountess Ligonier, 93 x 61, 1770
Mrs. Henry Beaufoy, 90 x 58¾, 1780
Karl Friedrich Abel, 88 x 58, 1777
The Blue Boy (Jonathan Buttall), 70 x 48, 1770
Anne, Duchess of Cumberland, 35¼ x 27¾, 1775-80
Mrs. Henry Fane, 35 x 27, 1782
Mrs. John Meares, 88 x 55½, 1777
The Cottage Door, 58 x 47, 1780
Juliana, Lady Petre, 88¾ x 57¼, 1788
Lady with a Spaniel, 30 x 25, c. 1750

STANFORD, Stanford University Museum of Art
James, Viscount Maitland, Earl of Lauderdale, 28 x 22¹³⁄₁₆, c. 1780
Trees Overhanging a Pond (drawing), 7⁹⁄₁₆ x 6

Connecticut

HARTFORD, Wadsworth Atheneum
Woody Landscape, 25³⁄₁₆ x 30¼

District of Columbia

WASHINGTON

Corcoran Gallery of Art
Lord Dunstanville, 50 x 40 (Clark)
Lady Dunstanville, 50 x 40 (Clark)
A Market Cart, 12 x 14 (Clark)

The National Collection of Fine Arts, Smithsonian Institution
Lord Mulgrave, 50 x 60 (Johnson)

National Gallery of Art
The Honorable Mrs. Graham, 36 x 28, c. 1775 (Widener)
Landscape with a Bridge, 44½ x 52½, 1780-88 (Mellon)
Georgiana, Duchess of Devonshire, 92¾ x 57⅝, c. 1783 (Mellon)
George IV as Prince of Wales, 30⅛ x 24⅞ (studio of) (Mellon)
Mrs. Richard Brinsley Sheridan, 86½ x 60½, 1785-86 (Mellon)
Miss Catherine Tatton, 30 x 25, c. 1785 (Mellon)
Mrs. John Taylor, 30 x 25, c. 1785 (Mellon)
The Earl of Darnley, 30 x 25, c. 1785 (Widener)
Mrs. Methuen, 33 x 28 (Widener)
Master John Heathcote, 50 x 39⅞, c. 1770-74
William Yelverton Davenport, 50⅛ x 40⅛, 1780-89
Seashore with Fishermen, 40¼ x 50⅜, c. 1781

Florida

SARASOTA, John and Mable Ringling Museum of Art
Portrait of General Philip Honywood, 124½ x 115½, 1765

Illinois

CHAMPAIGN, Krannert Art Museum
The Honorable Mrs. Henry Fane, 36 x 28, c. 1786
The Drover's Cart, 12¾ x 16

Indiana

INDIANAPOLIS, Indianapolis Museum of Art
The Old Stone Cottage, 39½ x 50⅜
Portrait of a Lady, 30 x 25

MUNCIE, Ball State University Art Gallery
Landscape and Cattle, 18 x 21½ (attrib. to)

Kentucky

LOUISVILLE, The J. B. Speed Art Museum
G. Hammond, Esquire, 6⅛ x 4⅝
John Russell, Fourth Duke of Bedford, 29 x 24¼
Portrait of Mrs. Hallam, 30 x 25

Maryland

BALTIMORE, The Baltimore Museum of Art
Portrait of Mrs. Charles Tudway, 89 x 60½, 1760-65 (Epstein)
Portrait of Dr. Benjamin Buckler, 29¾ x 24¾ (Seymer)
Portrait of Robert Adair, 25 x 29¾ (Epstein)

Massachusetts

AMHERST, The Mead Art Building, Amherst College
Portrait of Jeffery, Lord Amherst, 30 x 25, c. 1785

BOSTON, Museum of Fine Arts
Landscape with Milkmaids and Cattle, 47½ x 57¾
John Eld of Seighford Hall, 93 x 60
Portrait of a Young Girl, 24 x 19
Mrs. Edward Morton Pleydell, 49 x 41
John Taylor, 76 x 62
Mrs. Thomas Mathews, 29 x 24
Captain Thomas Mathews, 29 x 24
The Mushroom Girl, 89 x 58½

CAMBRIDGE, Fogg Art Museum, Harvard University
Portrait of Count Rumford, 29⅝ x 24⅝, 1783
Market Cart with Horses by a Stream (drawing), 10½ x 13¾
Landscape with a Cart (drawing), 7 x 8¼

NORTHAMPTON, Smith College Museum of Art
Study for the Market Cart (drawing), 10⅞ x 14¾, prob. 1786

WILLIAMSTOWN, Sterling and Francine Clark Art Institute
Miss Linley and Her Brother, 27½ x 24½, c. 1768
Viscount Hampden (oval), 28¼ x 22¾

WORCESTER, Worcester Art Museum
The Artist's Daughters, 50 x 40, 1763-64
Grand Landscape, 57¾ x 62½, 1763

Michigan

DETROIT, The Detroit Institute of Arts
Mrs. Mead, 29¾ x 24½, 1755-60
Portrait of Sir John Edward Swinburne, 26¼ x 23¼, 1785
Portrait of Edward Swinburne, 27⅛ x 23⅛, 1785
Portrait of Lady Anna Horatia Waldegrave (Lady Horatia Seymour, 1762-1801), 30 x 25
Family Group in Landscape, 36 x 26½
Thomas Brooke (1760-1825), 51¼ x 39¼
Honorable Richard Savage Nassau de Zuylenstein, 94 x 61
Lady Anne Hamilton (later Countess of Donegal), 92½ x 60⅝
The Market Cart, 48 x 40
Woman and Child, 26¼ x 20½

MUSKEGON, Hackley Art Museum
Portrait of Sir William Lynch, K.C.B., 30 x 24¾

Minnesota

MINNEAPOLIS, The Minneapolis Institute of Arts
The Fallen Tree, 40 x 36⅛
Portrait of John Langston, Esq. of Sarsden, 94⅛ x 61⅛

Missouri

KANSAS CITY, The Nelson Gallery and Atkins Museum
Repose, 48¼ x 59

Thomas Gainsborough • Suffolk Landscape
Oil on canvas • *25⅛ x 30¼″* • *Kimbell Art Museum, Fort Worth, Texas*

ST. LOUIS, The St. Louis Art Museum
Portrait of Lords John and Bernard Stuart (after van Dyck),
92½ x 57½
View in Suffolk, 37 x 49½

New Jersey
PRINCETON, The Art Museum, Princeton University
Mrs. Paul Jodrell, 30 x 25

New York
ALBANY, Albany Institute of History and Art
Lady Mostyn, 29¼ x 24¾

BUFFALO, The Albright-Knox Art Gallery
Miss Evans, 50 x 40, 1786-90

NEW YORK CITY
The Frick Collection
Sarah, Lady Innes, 40 x 28⅝, c. 1757
The Honorable Frances Duncombe, 92¼ x 61⅛, c. 1777-78
Mrs. Peter William Baker, 89⅝ x 59¾, 1781
The Mall in St. James's Park, 47½ x 57⅞, c. 1783
Mrs. Charles Hatchett, 29¾ x 24⅝, c. 1786
Richard Paul Jodrell, 30¼ x 25⅛, c. 1774
Grace Dalrymple Elliott, 30⅛ x 25, 1782

The Metropolitan Museum of Art
A Child with a Cat, 59¼ x 47½
Miss Sparrow, 30⅛ x 24⅞
Landscape, 47⅜ x 58⅛
Mrs. Grace Dalrymple Elliott (1754?-1823), 92¼ x 60½
Charles Rousseau Burney (1747-1819), 30¼ x 25⅛
Mrs. William Tennant (Mary Wylde, died 1798), 49½ x 40
The Wood Gatherers, 58⅛ x 47⅜
General Thomas Bligh (1693-1775?), 29½ x 24¾
Mrs. Ralph Izard (Alice DeLancey, 1746/7-1832), 30¼ x 25⅛

ROCHESTER, Memorial Art Gallery of The University of Rochester
Portrait of Mrs. Provis, 29 x 24 (Eastman)
Man with Book Seated in a Landscape, 23 x 19½, c. 1753

North Carolina
RALEIGH, North Carolina Museum of Art
Landscape with Three Donkeys, 25 x 30, 1780
John the Second, Earl of Buckinghamshire, 48 x 38 (attrib. to)
John Scrimgeour, Esquire, 92½ x 61
Clement Tudway, 30¼ x 25¼

Ohio
CINCINNATI
The Cincinnati Art Museum
Ann Ford, Mrs. Philip Thicknesse, 77⅝ x 53⅛
Returning from Market, 40 x 50
The Cottage Door, 48¼ x 58¾
A Gypsy Scene, 12⅜ x 14½
Dutch Fishing Village, 41 x 51
Mrs. William Hammond, 30 x 25
Portrait of Viscount Downe, 30 x 25
Portrait of Lord Mulgrave, 6 x 5
Miss Fitzpatrick, 30 x 25
Mrs. Provis, 30 x 25
Francis Greville, 50 x 40⅛
Sir John Durbin, 30 x 25

The Taft Museum
Edward and William Tomkinson, 83¾ x 59⅞, 1784
Landscape with Cattle and Figures, 48 x 58½
Sir Francis Basset, Lord Dunstanville, 6⅛ x 4¾
Maria Walpole, Countess Waldegrave and Duchess of Gloucester,
36¼ x 28¼, c. 1779

CLEVELAND, The Cleveland Museum of Art
George Pitt, First Lord Rivers, 92¼ x 60¾, late 1768 or
early 1769
The Reverend William Stevens, 49 x 39, 1780

TORONTO, Art Gallery of Ontario
The Harvest Waggon, 48 x 59, c. 1784

COLUMBUS, Columbus Museum of Art
Portrait of a Young Girl, 30 x 25, c. 1770-80

TOLEDO, The Toledo Museum of Art
The Shepherd Boy (oval), 32½ x 25½, c. 1757-59
The Road from Market, 47¾ x 67, 1767-68
Lady Frederick Campbell, 30½ x 25¼, c. 1770-75

ZANESVILLE, Zanesville Art Center
?Lt. Daniel Holroyd, 50 x 40, c. 1765?

Oklahoma
TULSA, The Philbrook Art Center
Horatio Nelson as a First Lieutenant, 30 x 24⅝ (attrib. to)

Pennsylvania
PHILADELPHIA, Philadelphia Museum of Art
Miss Linley (Mrs. Richard Brinsley Sheridan), 30⅛ x 25 (Elkins)
Lady Rodney, 50⅛ x 40, c. 1779-80 (McFadden)
View near King's Bromley-on-Trent, Staffordshire, 47¼ x 66¼
(Elkins)
John Palmer, 30⅛ x 23¼ (Elkins)
Rustic Lovers, 24 x 29, c. 1755-59
Lady in a Blue Dress, 30¼ x 25⅛, 1780s
Rest by the Way, 40⅛ x 58, 1747
Mrs. Tudway, 30¼ x 25⅛, c. 1770-74
Classical Landscape, 40½ x 50¼

Rhode Island
PROVIDENCE, Museum of Art, Rhode Island School of Design
Landscape (drawing), 9½ x 12¼
Wooded Landscape with Cottages, Figures, and Cows (drawing),
10¼ x 14⅜

Tennessee
MEMPHIS, The Brooks Memorial Art Gallery
Miss Elizabeth Lovett, 30 x 25
Portrait of Gainsborough Dupont, 30 x 25
River Landscape, 50 x 26

Texas
FORT WORTH, Kimbell Art Museum
Suffolk Landscape, 24¼ x 29, c. 1755
Miss Lloyd(?), 27⅜ x 20⅞, c. 1750
Miss Sarah Buxton, 43¼ x 34⅛, c. 1776-77
Mrs. Alexander Champion, 29½ x 24¾, c. 1775-80

Virginia
NORFOLK, Chrysler Museum at Norfolk
Miss Montagu, 30 x 24

RICHMOND, Virginia Museum
Miss Mary Clarges, 30 x 25, 1777-78
The Charlton Children, 58¼ x 48¾

Washington
SEATTLE, Seattle Art Museum
Landscape: Norwich(?) (drawing), 9¹/₁₆ x 12¹¹/₁₆, c. 1774-78

Canada

British Columbia
VANCOUVER, Vancouver Art Gallery
Portrait of George Montgomerie, 49½ x 39¾

Ontario
OTTAWA, The National Gallery of Canada
Portrait of Ignatius Sancho, 29 x 24½, 1768
Landscape with Fishermen (drawing), 10¾ x 14¼
A Hilltop Between Trees (drawing), 9 x 12¾
Landscape with Trees, Cottages, and Two Figures (drawing),
7⅜ x 9½

Quebec
MONTREAL, Montreal Museum of Fine Arts
Portrait of Mrs. George Drummond, 90 x 60
Woodland Scene (chalk), 9½ x 12

Giotto

Giotto di Bondone • Eternal Father with Angels
Tempera and gilt on panel • *(triangular) 32½ x31"*
San Diego Museum of Art, San Diego, California

Giotto

c. 1267–1337

Giotto di Bondone was born in Vespignano, a village near Florence, the son of a peasant landowner. An oft-repeated, and probably apocryphal, story is that he was taken to Florence as a boy by the painter Cimabue, who marveled at Giotto's drawings of some sheep he was tending. But however he got to Florence, Giotto soon established himself as its leading painter. Between 1295 and 1300 he painted his first important series of frescoes in the Upper Church at Assisi. The frescoes in the Arena Chapel at Padua, his best-preserved work, were painted about 1306, probably with the advice of his friend Dante. In demand all over Italy, he worked not only in Florence, but in many other towns, including Naples, where, from 1329 to 1333, he was a member of King Robert's household. He was recalled to Florence as a popular hero in 1334 and was named official architect of the city as well as master of works of the Cathedral of Santa Maria del Fiore, commonly called the Duomo. He designed and lived to see the beginning of the famous bell tower adjoining the cathedral, known ever since as "Giotto's Tower." Very few of his easel paintings have been preserved; America is fortunate indeed to have five of them on public view.

Perhaps the best way to appreciate the importance of Giotto's *Madonna and Child* in the National Gallery in Washington is to try to imagine how a man of the twelfth century might regard it.

Accustomed to the Byzantine style of painting, with its flat, formless figures that served as symbols of divinity rather than representations of it, he would find Giotto's Madonna altogether too lifelike and real—almost profane. Accustomed to thinking of his own body as an unfortunate vessel for sheltering the soul, he would be shocked to see the bodies of the Madonna and Child existing in space—like his own. Yet these are the qualities that made Giotto great in the eyes of his contemporaries and followers. He was the first painter in Europe to give believable form to the human figure.

Since Giotto, we have taken for granted the fact that a painting of the human (or divine) figure should suggest the bone structure concealed by its skin and clothing. This is a conception *in the mind* of the artist. To express this conception, the artist uses his knowledge of anatomy, drawing, and shading, with the result that his picture is basically a creation of his knowledge and feeling instead of a representation of anything he has seen. It is a work of art, with a reality of its own, quite apart from the reality it suggests. Giotto was the first European artist to have this conception.

His Madonna is posed well in front of the gold background—symbol of heaven. Although her head, as well as that of the Child, is surrounded by a nimbus painted on the background, both heads are projected forward into another plane. So, too, does the Madonna's right arm project forward under her rich blue mantle. Then her hand curves gently back—in space—to hold the double white rose which is her symbol. Her left arm encircles the Child, and her left hand supports him, with each finger pressing firmly and gracefully against his body. The Child's left hand is firmly grasped around her forefinger, and with his right he is reaching—through space—to touch the rose.

By means of these convincing gestures Giotto established the relationship between the two figures. They are the gestures of a real mother and a real child, in a picture that exists in its own right as form and color, as well as being a moving representation of the Madonna and Child. The man of the twelfth century would naturally be shocked to see two such divine persons so painted. The men of the Renaissance were electrified.

Giotto in America

California
SAN DIEGO, San Diego Museum of Art
The Eternal Father with Angels, 28 x 30, c. 1335

District of Columbia
WASHINGTON, National Gallery of Art
Madonna and Child, 33⅝ x 24⅜, c. 1320 (Kress)

Massachusetts
BOSTON, Isabella Stewart Gardner Museum
Presentation in the Temple, 17¼ x 16¾

New York
NEW YORK CITY, The Metropolitan Museum of Art
The Epiphany, 17¾ x 17¼

North Carolina
RALEIGH, North Carolina Museum of Art
Peruzzi Altarpiece (polyptych); middle panel, 23⅞ x 17½; side panels, 24⅜ x 16½ (with assistants) (Kress)

Giotto di Bondone • The Peruzzi Altarpiece
Panel • 98¼ x 41½″ • North Carolina Museum of Art, Raleigh
Gift of the Samuel H. Kress Foundation

Francisco de Goya

Francisco José de Goya y Lucientes • Self-Portrait
Oil on canvas • *23¼ x 16¾″* • *The St. Louis Art Museum, St. Louis, Missouri*

Francisco de Goya

1746–1828

Francisco José de Goya y Lucientes was born of poor parents in Fuendetodos, a small village in the northeastern Spanish province of Aragon. He first studied art in the city of Saragossa, but at the age of nineteen (partly as a result of his wild escapades) he left his native province for Madrid. Soon, however, he joined a troupe of bullfighters and worked his way to the Mediterranean to study in Rome, where he won a second prize in an art competition sponsored by the academy of Parma. He returned to Madrid, married Josefa, sister of Bayeu, a court painter, and got a job painting cartoons for a tapestry factory. (Josefa bore him thirteen children during their rather strained marriage, only one of whom, the boy Javier, outlived his father.) The talent displayed in these cartoons quickly attracted official attention, and Goya was soon caught up in the libertine life of the court, painting portraits of people whom he both disdained and envied, and one of whom he loved, the Duchess of Alba. Between 1790 and 1800 he produced his series of satirical etchings. *Los Caprichos.* His scathing indictment of humanity called *The Disasters of War*, a series of 65 etchings, were executed in 1810-14. When he was seventy, and completely deaf, he retired to a villa outside Madrid, and from there he exiled himself across the French border to Bordeaux, where he died. During his turbulent lifetime, Goya completed some five hundred oil paintings and murals, nearly three hundred etchings and lighographs, and many hundreds of drawings. He once wrote that he had three masters: "Nature, Velásquez, and Rembrandt."

Goya was a troubled genius. His self-portrait in St. Louis shows a frowning man with a pugnacious chin, sensual lips, piercing dark eyes, and wild hair. He flattered himself no more than he did that wretched queen, Maria Louisa, one of whose many portraits by him hangs in the Taft Museum in Cincinnati. His painting of a bullfight in Toledo is as brutally beautiful as that ancient sport is supposed to be. The series of six panels in Chicago telling the story of the capture of bandit Maragato are a delight to sadistic small boys. The satirical etchings, which may be viewed on request in many museum print rooms, are bitter; those inspired by Napoleon's attempt to conquer Spain are savage.

Yet the enormous vitality that bursts from all these pictures reveals a man very much in love with life. And some of the portraits, notably those of children, show a tenderness of which Goya was obviously not ashamed. America is fortunate in having probably the best of these in the portrait of *Don Manuel Osorio Manrique de Zúñiga* at the Metropolitan Museum. Painted for the Osorio family about 1784, it was one of the most popular pictures in the *Masterpieces of Art* exhibition at the 1939 World's Fair in New York.

The portrait of Don Manuel is popular because, first of all, it is highly decorative. The brilliant scarlet suit, set off by muted gray-greens and browns, invites the admiration even of people who do not like red. But more important is the fact that behind this decorative surface is a very real little boy whom Goya painted with the same brush that he used on himself and Maria Louisa. Goya did not sentimentalize adults, bullfights, or wars, and he saw no need to sentimentalize children—or cats. The cats in this picture are behaving like all cats confronted by a bird. They are not cute. Neither is Don Manuel. Goya was incapable of cuteness, and that is why his portraits of children are so fine.

Francisco de Goya in America

California
PASADENA, Norton Simon Museum of Art
St. Jerome, 76 x 45, 1798

SAN DIEGO, San Diego Museum of Art
Portrait of the Marquis de Sofraga, 42⅝ 32½, 1794-95

Connecticut
HARTFORD, Wadsworth Atheneum
Gossiping Women, 23³/₁₆ x 57¼

District of Columbia
WASHINGTON
National Gallery of Art
Carlos IV of Spain as Huntsman, 18¼ x 11¾, c. 1799 (Mellon)
Marquesa de Pontejos, 83 x 49¾, possibly 1786 (Mellon)
Maria Luisa, Queen of Spain, 18¼ x 11¾, c. 1799 (Mellon)
Don Bartolomé Sureda, 47⅛ x 31¼
Doña Teresa Sureda, 47⅛ x 31¼, c. 1801-4
Señora Sabasa Garcia, 28 x 23, c. 1810 (Mellon)
Victor Guye, 42 x 33½, 1810
Don Antonio Noriega, 40⅜ x 31⅞, 1801 (Kress)
The Duke of Wellington, 41½ x 33, c. 1812 (Frelinghuysen)
The Bookseller's Wife, 43¼ x 30¾, c. 1805 (Frelinghuysen)
Condesa de Chinchón, 53 x 46¼, 1783

The Phillips Collection
The Repentant Peter, 29 x 25½, 1824-25
Evil Counsel (drawing), 10 x 6¾, c. 1805

Illinois
CHICAGO, The Art Institute of Chicago
Isadoro Maiquez, 32⅜ x 24⅞, c. 1807
Capture of Maragato by Fray Pedro, six panels, ea. 11½ x 15⅛, c. 1807
The Hanged Monk, 12³/₁₆ x 15⁵/₁₆, c. 1810
Beware of that Step! (brush in gray and black wash), 10⅜ x 7³/₁₆, c. 1805
Portrait of General José Manuel Romero, 41½ x 37⅞, c. 1810

Indiana
INDIANAPOLIS, Indianapolis Museum of Art
Portrait of a Young Man, 23¼ x 19³/₁₆
Portrait of Don Felix Colon de Larria Tegui, 43⅝ x 33⅛, 1794

Iowa
DES MOINES, The Des Moines Art Center
Don Manuel Garcia de la Prada, 81½ x 49, c. 1810

Kentucky
LOUISVILLE, The J. B. Speed Art Museum
Fray Joaquin Company, Archbishop of Saragossa, 28¼ x 21½, 1797

Maryland
BALTIMORE, The Baltimore Museum of Art
Portrait of Don Antonio Raimondo Ibanez, 38 x 28½, c. 1808 (Epstein)

Massachusetts
BOSTON, Museum of Fine Arts
Manuel Garcia, 32 x 22¾
An Allegory: Spain, Time and History, 16½ x 12¾

CAMBRIDGE, Fogg Art Museum, Harvard University
Woman Knitting (drawing), 8½ x 5¾
You Make a Mistake If You Seek to Get Married (drawing), 10½ x 7⅛

WILLIAMSTOWN, Sterling and Francine Clark Art Institute
Ascensio Julia, 28¹³/₁₆ x 22¹¹/₁₆, 1814
Autumn, 13⅜ x 9½
La Madrileña, 30⁵/₁₆ x 21½, c. 1805
A Mass, 13½ x 17¹/₁₆

WORCESTER, Worcester Art Museum
Portrait of Bishop Miguel Fernandez, 39½ x 33, 1815

Michigan
DETROIT, The Detroit Institute of Arts
Doña Amalia Bonelle de Costa, 34⅜ x 25¾, c. 1805

MUSKEGON, Hackley Art Museum
Portrait of Don Juan Jose Perez Mora, 40¼ x 31½

Minnesota
MINNEAPOLIS, The Minneapolis Institute of Arts
Self-Portrait with Doctor Arrieta, 45½ x 31, 1820

Missouri
KANSAS CITY, The Nelson Gallery and Atkins Museum
Portrait of Don Ignacio Omulryan y Rourera, 33¼ x 25¼, 1815

ST. LOUIS, The St. Louis Art Museum
Self Portrait, 23¼ x 16¾, c. 1771

Nebraska
OMAHA, Joslyn Art Museum
Portrait of the Marquesa de Fontana, 28½ x 36¾, 1800

New Jersey
PRINCETON, The Art Museum, Princeton University
Sheet from Madrid Sketchbook: the Duchess of Alba (drawing), 8¾ x 5⅛

New York
NEW YORK CITY
The Brooklyn Museum
Tadeo Bravo de Rivera, 81½ x 45⅝, 1806

The Frick Collection
An Officer (Conde de Tepa?), 24⅞ x 19¼, c. 1802
Doña Maria Martinez de Puga, 31½ x 23, 1824
The Forge, 71½ x 49¼, 1815-20
Don Pedro, Duque de Osuña, 44½ x 32¾, 1790-99

Hispanic Society of America
Manuel Lapena, 88¼ x 55¼, 1799
Alberto Foraster, 55¼ x 43¾, 1804
Duchess of Alba, 82½ x 58¼, 1797
Pedro Mocarte, 31 x 22¾

The Metropolitan Museum of Art
Don Tiburcio Pérez y Cuervo, the Architect, 40¼ x 32, 1820
Majas on a Balcony, 76¾ x 49½ (Havemeyer)
The Bullfight, 38¾ x 49¾
Infanta Maria Luisa (1782-1824) and Her Son Carlos Luis (1799-1883), 39⅛ x 27, 1800
Ferdinand VII, King of Spain (1784-1833), as Prince of Asturias, 32¾ x 26¼, 1800
Doña Narcisa Barañana de Goicoechea, 44¼ x 30¾ (Havemeyer)
Don Manuel Osorio Manrique de Zúñiga, 50 x 40, 1784 (Bache)
Don Sebastián Martínez y Pérez (1747-1800), 36⅝ x 26⅝
Don Ignacio Garcini y Queralt, Brigadier of Engineers, 41 x 32¾
Doña Josefa Castilla Portugal de Garcini, 41 x 32⅝
Jose Costa y Bonells, called Pepito (died 1870), 41⅜ x 33¼

North Carolina
RALEIGH, North Carolina Museum of Art
The Topers, 40 x 30¼

Ohio
CINCINNATI, The Taft Museum
Joaquin Rodriguez Costillares, 20¾ x 16
Queen Maria Luisa, 32⅞ x 26⅜, c. 1799

CLEVELAND, The Cleveland Museum of Art
Portrait of Don Juan Antonio Cuervo, 47¼ x 34¼, 1819
St. Ambrose, 74¹³/₁₆ x 44¼
Portrait of the Infante Don Luis de Borbón, 60⅛ x 39⅜, 1783

TOLEDO, The Toledo Museum of Art
The Bull Fight, 24¾ x 36½, c. 1824 (attrib. to)
Children with a Cart, 57¼ x 37, 1778

Francisco José de Goya y Lucientes • Children with a Cart
*Oil on canvas • 57¼ x 37″ • The Toledo Museum of Art, Toledo, Ohio
Gift of Edward Drummond Libbey*

Pennsylvania
PHILADELPHIA, Philadelphia Museum of Art
The Seesaw, 32⁷⁄₁₆ x 65⅜, 1787

Rhode Island
PROVIDENCE, Museum of Art, Rhode Island School of Design
Two Heads (ivory), 2 x 2
Portrait of Gerónima Coicochea y Galarza (copper), 3½ diam., 1805
Portrait of Cesárea Coicochea y Galarza (copper), 3½ diam., 1806

Texas
FORT WORTH, Kimbell Art Museum
Rita Luna, 16¾ x 13½, c. 1814-15
Pedro Romero, 33⅛ x 25⅝, c. 1795-97

Virginia
RICHMOND, Virginia Museum
General Nicolas Guye, 41¾ x 33⅜, 1810

Washington
SEATTLE, Seattle Art Museum
Beggar and Dog (drawing), 7⅛ x 6

Canada

Ontario
OTTAWA, The National Gallery of Canada
Semana Santa en Tiempo Pasado en España (drawing), 7½ x 5¾, c. 1824-28
A Girl Skipping (drawing), 7½ x 6, c. 1824-28
Enredos de sus Vidas (drawing), 7½ x 6, c. 1824-28
Muerte d'Anton Requena (drawing), 7½ x 6, c. 1824-28

Quebec
MONTREAL, Montreal Museum of Fine Arts
Portrait of Altamirano, 31½ x 24

Francisco José de Goya y Lucientes • Fray Pedro Binds Margato
Oil on panel • 11¼ x 15⅛" • The Art Institute of Chicago
Mr. and Mrs. Martin A. Ryerson Collection

Jan van Goyen

Jan van Goyen • A View of Emmerich Across the Rhine
Oil on panel • 26 x 37½" • The Cleveland Museum of Art, Ohio
John L. Severance Fund

Jan van Goyen • A Windy Day
Oak panel • 18¼ x 26¼" • Detroit Institute of Arts

Jan van Goyen

1596–1656

Jan van Goyen was born in Leiden, a few miles from The Hague, where he settled with his wife in 1631 and led a productive life for twenty-five years. He had studied previously with several masters, including Esaias van de Velde, one of the founders of the Dutch school of realistic landscape painting. In 1640 he was elected president of The Hague painters' guild, another of whose members, Jan Steen, married his daughter Margaret. Unlike many Netherlandish artists, from Bruegel to Rubens, van Goyen never visited Italy to see the great art collections in Rome and Florence. Although he made one or two trips to France, he confined himself to painting the landscape of his native Holland. More than 250 of his signed and dated pictures exist today throughout the Western world; 41 of which are listed here in public collections of the United States and Canada. One of his largest paintings is a view of The Hague, executed in 1651 for the municipality and now in the collection of that city, where he died in 1656, possessed of land and houses valued at fifteen thousand florins.

The great inverted blue bowl of sky, with soft white clouds rolling in from the North Sea, dominates the Dutch landscape. The sky is what Jan van Goyen first saw and painted in this view of Arnhem on the Rhine River, near where it flows out of Germany into Holland. Yet if the sky is the principal actor in this quiet drama, it has a supporting cast, which is Holland itself with its fertile fields, smooth-flowing rivers, and busy towns.

Like a good theatrical director, van Goyen has used his principal actor to give action to the drama. He painted the biggest cloud just off center to give a feeling of movement from right to left. The clouds on either side are softer and more filmy. They recede, giving depth and distance to the picture. The blue sky frames all of them from above; the flat land surrounds Arnhem from below.

But in emphasizing the sky, van Goyen has by no means slighted the land below. Recognizable are Arnhem's Groote Kirk of St. Eusebius, dating from the fifteenth century, the earlier Roman Catholic church of St. Walpurgis, and the enormous palace of Maarten van Rossum—the town hall since 1830, called Duvelhuis ("devil's house") because of its grotesque exterior ornamentation. To give added life and warmth to his picture, van Goyen has peopled the nearby fields with farmers at work, producing part of the wealth that made Holland the envy of all the countries of seven-

teenth-century Europe. John Lothrop Motley described this unique commonwealth in his book, *The Rise of the Dutch Republic,* published in 1856. Two hundred years earlier, Jan van Goyen was one of a number of unique artists who painted it. E. P. Richardson characterized his work in the *Art Quarterly* (autumn, 1939) as follows:

"If van Goyen is a great painter, it should be possible to say what constitutes his greatness. On the surface, what may strike the casual museum visitor is his limitations. His pictures are generally rather small in size and modest in character, his subjects usually more simple than striking or picturesque; and he is totally without the brilliant color which modern painting has trained our eyes to expect. These limitations are all true, but they are only evidence that van Goyen's art is one of the most refined and concentrated in our history. Its greatness lies, I believe, in the combination of two qualities, each of great rarity and distinction. These are an almost unique concentration upon and perfection of aerial tone, and a sense of the universal harmony of nature in which all things, winds and clouds, trees and hills and rivers, cities and towns, the birds in the air and the men and beasts that walk on the earth, play their part. . . . The activity of a populous, busy, contented land exists as an undertone in his widest and grandest views. He was at peace with his world in spirit, whatever financial fevers or

disasters overtook him. No shadow touched the cheerful heart with which he surveyed the pleasant land about him, a land with grandeur of nature in its wide horizons and magnificent skies, but with also the pastoral beauty of fertile and well cared for earth. This unclouded serenity of spirit is the special charm of his work."

Jan van Goyen in America

California
LOS ANGELES, Los Angeles County Museum of Art
Fishing Ships at an Embankment, 14½ x 22, 1640
River Landscape with Boats, 13 x 20¾
Skating Scene, 6 diam.
View of the City of Veere, 16 x 22¼, 1645

MALIBU, The J. Paul Getty Museum
View of Castle of Wijk at Daurstede, 20¾ x 29, 1649

PASADENA, Norton Simon Museum of Art
River Landscape, 12¼ x 15¼, 1642
Winter Scene with Skaters, 15¼ x 21¾, 1640

SAN FRANCISCO, The Fine Arts Museums of San Francisco
Thunderstorm, 52½ x 62½

Connecticut
NEW HAVEN, The Yale University Art Gallery
A Sandy Road with Thatched Cottages, 12⅜ x 21, 1633

District of Columbia
WASHINGTON, Corcoran Gallery of Art
View of Dordrecht, 25½ x 34½ (Clark)
View of Rhenen, 40 x 53½ (Clark)

Illinois
CHICAGO, The Art Institute of Chicago
Fishing Boats off an Estuary, 13⁹⁄₁₆ x 21⁷⁄₁₆, 1653

Maryland
BALTIMORE, The Baltimore Museum of Art
View of Rhenen, 22½ x 32, 1646 (Jacobs)

Massachusetts
BOSTON, Museum of Fine Arts
River Scene, 18 x 26, 1656
Fort on a River, 16¾ x 29¾, 1644

CAMBRIDGE, Fogg Art Museum, Harvard University
Harbor Scene, 37½ x 52 (sight), 1636
River Scene, 34¾ x 51¾ (sight), 1634

NORTHAMPTON, Smith College Museum of Art
View of Rijnland, 16¼ x 24, 1647
View of Elterberg (drawing), 3⅞ x 6³⁄₁₆
A Castle by a River's Edge (drawing), 3⅞ x 6³⁄₁₆
Landscape with Two Figures (drawing), 4⅞ x 8½

SPRINGFIELD, The Springfield Museum of Fine Arts
River View with Leyden in the Background, 17½ x 24¼, 1651 (Gray)

WORCESTER, Worcester Art Museum
Landscape with Two Horsecarts, 9⁹⁄₁₆ x 14¾, 1652

Michigan
DETROIT, The Detroit Institute of Arts
A Windy Day, 18¼ x 26⅛
View of the Spaarne River, Haarlem, 14¾ x 19½

Missouri
ST. LOUIS, The St. Louis Art Museum
Skating on the Ice near Dordrecht, 14¾ x 13½, 1643

New York
NEW YORK CITY, The Metropolitan Museum of Art
Sandy Road with a Farmhouse, 12⅛ x 16¼
View of Rhenen, 39¾ x 53¾
View of Haarlem and the Haarlemmer Meer, 13⅝ x 19⅞
Country House near the Water, 14⅜ x 13
A Castle by a River, 26 x 38¼
The Pelkus Gate of Utrecht, 14½ x 22½
Boats near Moerdyck, 15 x 24¼

Ohio
CLEVELAND, The Cleveland Museum of Art
A View of Emmerich Across the Rhine, 26 x 37½, 1645

OBERLIN, The Allen Memorial Art Museum, Oberlin College
Landscape with Dunes, 18½ x 28, 1647

TOLEDO, The Toledo Museum of Art
View of Dordrecht, 26⅞ x 39¼, 1649
The River Shore, 16⅛ x 20½, 1651

Tennessee
MEMPHIS, The Brooks Memorial Art Gallery
River Scene, 25 x 29½

Texas
FORT WORTH, Kimbell Art Museum
View of Arnhem, 14⅛ x 24⅜, 1645-46

Virginia
RICHMOND, Virginia Museum
Thunderstorm near Haarlem, 13 x 18⅞

Canada

Ontario
TORONTO, Art Gallery of Ontario
View of Rhenen, 56½ x 87¾, 1641

El Greco

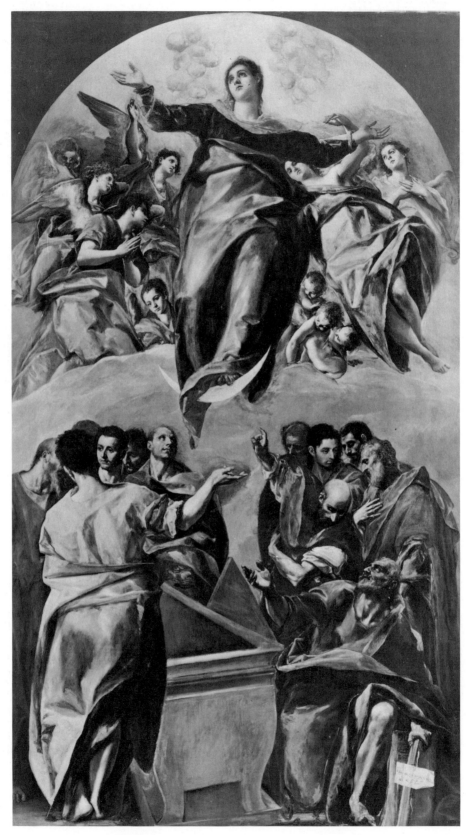

El Greco • The Assumption of the Virgin
Oil on canvas • 158 x 90" • The Art Institute of Chicago
Gift of Nancy Atwood Sprague in Memory of Albert Arnold Sprague

El Greco

1541–1614

El Greco was born on the island of Crete as Domenicos Theotocopoulos. (There are variant spellings.) Sometime during his youth he journeyed to Venice, where he became a disciple of Titian. By 1570 he had moved to Rome, and his Greek name had been shortened to "Il Greco," later becoming "El Greco" in Spain. Why he went to Toledo to live sometime before 1577, no one knows. The capital of Spain had been moved forty-five miles away to Madrid in 1560. But there was still vast wealth in Toledo, an attractive prospect for any painter. Also, Toledo had always been the center of Spanish Christianity, and its severely ascetic atmosphere, plus its granite, fortress-like appearance, must have been congenial to El Greco, who had spent some time in one of the Byzantine monasteries on the promontory of Mt. Athos, in the Aegean Sea. One of his first commissions in Toledo was an altarpiece for the Church of Santo Domingo el Antiguo, the center panel of which, *The Assumption,* is now in Chicago. El Greco remained in Toledo all his life, living grandly in a suite of twenty-four rooms in the palace of the Marquis de Vellena, where he ate his meals in splendor while listening to the music of his private orchestra and accepting painting commissions from Toldeo's many churches and the proud members of its declining aristocracy.

Many English-speaking people got their first introduction to the strange power of El Greco's paintings in Somerset Maugham's novel, *Of Human Bondage.* In the novel, Philip was more deeply moved by a photograph of a view of Toledo painted by El Greco than by any picture he had ever seen. "He felt strangely that he was on the threshold of some new discovery in life." That was a view which shows a boy holding a map in one corner. Another *View of Toledo,* without figures and possibly El Greco's only pure landscape, is in the Metropolitan Museum of Art, where millions of Americans have found as fascinating in fact as Philip did in fiction.

There are many explanations of this fascination which the paintings of El Greco hold for us in the twentieth century, but which they did not hold for people during nearly three centuries after his death. He was completely forgotten until his rediscovery by Cézanne and other leaders of the modern movement. None of these explanations can be exact; if words could express what El Greco had to say, he would have written poems. However, the events of his life are significant.

As a young man, El Greco saw the Byzantine frescoes on Mt. Athos, with their flat, elongated figures and stylized costumes so expressive of the early Christian spirit. Suddenly he was in Venice, confronted by the voluptuous paintings of Titian and Tintoretto. Whether or not he was conscious of it, his style results from a combination of these two totally different points of view—one mystical and idealistic, and the other practical and real.

Anyone who stands on the spot from which El Greco painted his *View of Toledo* will recognize it immediately. To improve the composition, he has moved the spire of the cathedral closer to the great building of the Alcazar and made a few other rearrangements. But the view is real enough —even four centuries later. The citizens of Toledo can point out their houses in it. The view is also unreal. The strange blue-greens and browns of the slopes, the silvery gray of the buildings, and the vast swirling clouds overhead give the picture an unearthly quality. It is exciting, even a little frightening. Yet it is also solid and reassuring.

El Greco in America

California
LOS ANGELES, Los Angeles County Museum of Art
The Apostle St. Andrew, 28 x 21½, 1595-1600

PASADENA, Norton Simon Museum of Art
Portrait of an Old Man with Fur Collar, 18½ x 15⅓, 1600

SAN DIEGO, San Diego Museum of Arts
The Penitent St. Peter, 48¼ x 40¼

SAN FRANCISCO, The Fine Arts Museums of San Francisco
St. Peter, 28⅛ x 21¾
St. John the Baptist, 43¼ x 26

Connecticut
HARTFORD, Wadsworth Atheneum
Virgin and Child with St. Anne, 35½ x 31½, 1590-1600

District of Columbia
WASHINGTON
Dumbarton Oaks, Harvard University
The Visitation, 38⅛ x 28⅛, c. 1610

National Gallery of Art
St. Martin and the Beggar, 41 x 23⅝, 1604-14 (Mellon)
The Laocoön, 54⅛ x 67⅞, c. 1610 (Kress)
Madonna and Child with St. Martina and St. Agnes,
 76⅛ x 40½, 1597-99 (Widener)
St. Martin and the Beggar, 76⅛ x 40½, 1597-99 (Widener)
St. Jerome, 66¼ x 43½, c. 1584-94 (Dale)
St. Ildefonso, 44¼ x 25¾, 1603-05 (Mellon)
Christ Cleansing the Temple, 25¾ x 32¾, c. 1570 (Kress)

The Phillips Collection
The Repentant Peter, 37 x 30, c. 1600

Florida
SARASOTA, John and Mable Ringling Museum of Art
Christ on the Cross, 41¾ x 27¼

Illinois
CHICAGO, The Art Institute of Chicago
The Assumption of the Virgin, 158 x 90, 1577
Feast in the House of Simon, 56½ x 39½, before 1607
St. Francis, 36½ x 29¼, 1590-1604
St. Martin and the Beggar, 43⅜ x 24⅞, 1599-1604

Maryland
BALTIMORE, The Walters Art Gallery
St. Francis Receiving the Stigmata, 40⅛ x 38³⁄₁₆

Massachusetts
BOSTON, Museum of Fine Arts
St. Dominic Kneeling, 41½ x 32½
Fray Felix Hortensio Paravicino, 44½ x 33¾
The Annunciation, 32½ x 24⅝ (attrib. to)

WORCESTER, Worcester Art Museum
The Repentant Magdalene, 42½ x 40, 1577-80

Michigan
DETROIT, The Detroit Institute of Arts
St. Francis in Ecstasy, 42¼ x 32, c. 1585-90

Minnesota
MINNEAPOLIS, The Minneapolis Institute of Arts
Christ Driving the Money Changers from the Temple, 46 x 59,
 1571-76

Missouri
KANSAS CITY, The Nelson Gallery and Atkins Museum
Crucifixion, 17⅛ x 11¼
Portrait of a Trinitarian Monk, 36¼ x 33½, 1604-10
The Penitent Magdalene, 41⅛ x 33½

ST. LOUIS, The St. Louis Art Museum
St. Paul, 27½ x 22

Nebraska
OMAHA, Joslyn Art Museum
St. Francis in Prayer, 39 x 44½, c. 1582

New York
GLENS FALLS, The Hyde Collection
St. James the Lesser, 24¾ x 19¾, 1587-95

NEW YORK CITY
The Frick Collection
St. Jerome, 43½ x 37½, 1590-1600
Vincenzo Anastagi, 74 x 49⅞, 1571-76
Purification of the Temple, 16½ x 20⅝, c. 1600

Hispanic Society of America
Holy Family, 41¾ x 34½
St. Luke, 28½ x 21¼
St. James the Great, 17 x 14½
St. Jerome, 31½ x 25½
St. Dominic, 28¼ x 23 (attrib. to)
Pietà, 26¼ x 19
Miniature of a Man, 3 x 2¼
St. James the Great, 24¾ x 12¾

The Metropolitan Museum of Art
The Adoration of the Shepherds, 43½ x 25⅝
Cardinal Don Fernando Niño de Guevara (1541-1609),
 67¼ x 42½ (Havemeyer)
Portrait of a Man, 20¾ x 18¾
View of Toledo, 47¾ x 42¾ (Havemeyer)
The Adoration of the Shepherds, 64½ x 42
St. Andrew, 43¾ x 25¼
St. James the Less, 14¼ x 10½
St. Simon, 14¼ x 10¼
The Vision of St. John, 88½ x 78½

ROCHESTER, Memorial Art Gallery of The University of Rochester
The Apparition of the Virgin to St. Hyacinth, 38½ x 23½

Ohio
CINCINNATI, The Cincinnati Art Museum
Crucifixion with View of Toledo, 41 x 24⅜, c. 1602-10

CLEVELAND, The Cleveland Museum of Art
Christ on the Cross with Landscape, 74 x 44, c. 1610-11
The Holy Family, 51⅛ x 39½, 1592-96

TOLEDO, The Toledo Museum of Art
The Agony in the Garden, 40¼ x 44¾, 1590s
The Annunciation, 49⅝ x 32, c. 1600

Pennsylvania
PHILADELPHIA, Philadelphia Museum of Art
Portrait of a Lady, 15⅝ x 12⅝ (attrib. to) (Johnson)
Crucifixion, 62¾ x 38¾ (attrib. to) (Johnson)
Pietà, 11¼ x 7⅞ (Johnson)

Rhode Island
PROVIDENCE, Museum of Art, Rhode Island School of Design
St. Andrew, 29¼ x 22¾ (attrib. to)

Texas
DALLAS, Dallas Museum of Fine Arts
St. John, 24¾ x 19⅞, 1590-95 (studio of) (Foundation for
 the Arts)

FORT WORTH, Kimbell Art Museum
St. John the Evangelist, 28⅜ x 21¾, c. 1612-14
Giacomo Bosio, 45²⁄₃ x 33⅞, c. 1600-10

SAN ANTONIO, Marion Koogler McNay Art Institute
Head of Christ, 19⅞ x 15⅜, 1586-90

Virginia
NORFOLK, Chrysler Museum at Norfolk
St. Thomas, 43 x 31 (workshop of)

Canada

Ontario
OTTAWA, The National Gallery of Canada
St. Francis in Meditation, with a Monk, 66 x 40⅝, c. 1606

Quebec
MONTREAL, Montreal Museum of Fine Arts
El Señor de la Casa de Leira, 34½ x 27¼

El Greco • Portrait of a Trinitarian Monk
Oil on canvas • 36¼ x 33¼ " • Atkins Museum of Fine Arts, Kansas City, Missouri
William Rockhill Nelson Fund

El Greco • Saint Francis in Prayer
Oil • 45½ x 40½" • Joslyn Art Museum, Omaha, Nebraska

Francesco Guardi

Francesco Guardi • Storm at Sea
Oil on canvas • 21 x 26 ¹/₁₆'' • The Montreal Museum of Fine Arts
Adaline Van Horne Bequest

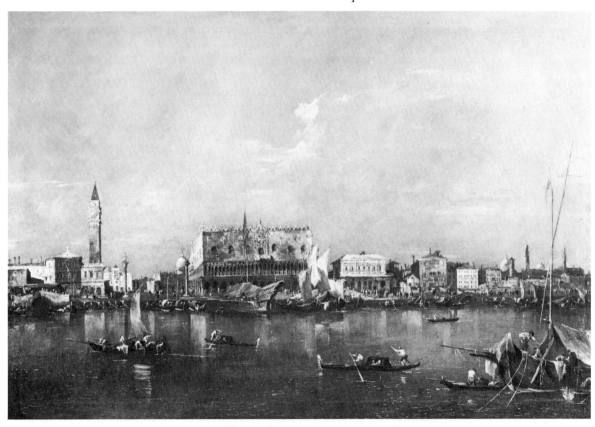

Francesco Guardi • Venice Viewed from the Bacino
Oil on canvas • 24⁷/₈ x 37³/₄'' • Kimbell Art Museum, Fort Worth, Texas

Francesco Guardi

1712–1793

Francesco Guardi was the son of a painter who had come to Venice from Austria. During his lifetime his work was less popular than that of his teacher, Canaletto, and only recent researchers have established that he was close to forty years old before he began to specialize in the landscapes for which he is famous today. During his early years (1730-60) Guardi worked under his elder brother, Gianantonio, a painter of altarpieces, and their individual contributions are not yet determined. The records show that his sister Cecelia married Giovanni Battista Tiepolo and that he himself married Maria Pagani sometime between 1750 and 1760. They had one daughter and three sons. Between 1761 and 1763 Guardi was a member of the Venetian painters' guild.

Guardi painted ahead of his time. His unique pictures provide an interesting example of changing taste in art. For years his work was completely overshadowed by that of Canaletto. Yet in 1950, when the Philadelphia Museum of Art celebrated its diamond jubilee with an exhibition of *Masterpieces of Painting*, it borrowed from San Diego the Guardi *Grand Canal* and showed no paintings by Canaletto.

The reasons for this reevaluation are not hard to find. Both Canaletto and Guardi painted scenes of Venice—its busy canals, its famous church and piazza of San Marco, its colorful festivals—all bathed in the wonderful light that has attracted artists and tourists for centuries. But gradually people began to realize that Guardi succeeded in capturing the special flavor of Venice more successfully than his master.

This realization came with our acceptance of Cézanne and the twentieth-century style in painting. Like poetry, it suggests more than it describes, evokes more than it defines. It is a style peculiarly appropriate to painting a Venetian scene with its gondoliers busily plying their oars between buildings whose colors and decorations sparkle with reflected, dancing sunlight.

There is not a line in Guardi's painting of *The Grand Canal with the Rialto Bridge* that could be drawn with a ruler. Even the buildings quiver. Guardi was content to suggest rather than to describe in detail, but to our eyes, his pictures are not less, but more, "real" than those of Canaletto. They *feel* like Venice.

Francesco Guardi in America

California
PASADENA, Norton Simon Museum of Art
View of Santa Maria della Salute, 16 x 20¼
View of the Rialto, 16½ x 24

SAN DIEGO, San Diego Museum of Art
The Grand Canal with the Rialto Bridge, 22½ x 33½

SAN FRANCISCO, The Fine Arts Museums of San Francisco
Old Customs House and Church of Santa Maria della Salute,
 19 x 26¼, c. 1750
Landscape Capriccio with Figures, 10¾ x 8⅛

STANFORD, Stanford University Museum of Art
Landscape with Ruins, 67 x 72
Venetian Scene (drawing), 8½ x 11½
*View of the Giudecca Canal from the Fondamenta della
 Zattere* (recto) and *Studies of a Female Head* (verso)
 (drawings), 10⁵/₁₆ x 18⁹/₁₆, c. 1745

Connecticut
HARTFORD, Wadsworth Atheneum
View of the Piazzetta, Venice, 18¼ x 29¹¹/₁₆
Drawing for the *"Piazzetta, Venice,"* 9¾ x 15

District of Columbia
WASHINGTON
Corcoran Gallery of Art
Santa Maria della Salute, 12¾ x 20¾ (Clark)
Group of Figures (drawing), 3 x 11¼ (Clark)

National Gallery of Art
Campo San Zanipolo, 14¾ x 12⅜, 1782 (Kress)
View of the Rialto, 27 x 36, c. 1775 (Widener)
View on the Cannaregio, Venice, 18¾ x 29¼, c. 1770 (Kress)
A Seaport and Classic Ruins in Italy, 48 x 70, c. 1760 (Kress)

The Phillips Collection
Piazza San Marco (drawing), 5 x 8⅞

Illinois

CHICAGO, The Art Institute of Chicago
Ruined Archway, 11½ x 19½, 1775-1800
Grand Canal, Venice, 28¾ x 47, c. 1745
Capriccio, 12 x 19½
Capriccio, The Laocoön, 8⅜ x 6¾
Interior (The Harem), 18 x 25, c. 1740

Indiana

INDIANAPOLIS, Indianapolis Museum of Art
A Palace Courtyard, 7½ x 5½

Maryland

BALTIMORE
The Baltimore Museum of Art
The Grand Canal, Venice, 37 x 53, c. 1750 (Jacobs)
Church of Santa Maria della Salute, Venice, 36¼ x 51¾ (Jacobs)

The Walters Art Gallery
A Venetian Courtyard, 21⅜ x 16

Massachusetts

BOSTON
Isabella Stewart Gardner Museum
Venice Across the Basin of S. Marco, 20¼ x 33
Venice: The Clock Tower in the Piazza S. Marco, 31 x 39

Museum of Fine Arts
Entrance to the Arsenal, Venice, 15½ x 19
The Dogana and Santa Maria della Salute, Venice, 18¼ x 24½
The Marriage of Venice and the Adriatic, 38¾ x 54½

CAMBRIDGE, Fogg Art Museum, Harvard University
Venice: Fondamenta delle Zattere, 18½ x 29¾, c. 1785-90
An Island on the Lagoon, 24 x 31¾
San Giorgio Maggiore (recto) (drawing), 5⅝ x 12¼
The Bucentaur Approaching the Lido (drawing), 4¾ x 9⁷⁄₁₆

NORTHAMPTON, Smith College Museum of Art
Spectators at a Ceremony (drawing), 3¹⁄₁₆ x 11⅜

SPRINGFIELD, The Springfield Museum of Fine Arts
Portrait of a Boy in Uniform, 38 x 32 (Gray)

WILLIAMSTOWN, Sterling and Francine Clark Art Institute
The Customs House, Venice, 11⅝ x 15¹⁵⁄₁₆
San Giorgio Maggiore, 7³⁄₁₆ x 11⅞

WORCESTER, Worcester Art Museum
Landscape with Figures, 18⅛ x 26, 1760

Michigan

DETROIT, The Detroit Institute of Arts
View of Dolo on the Brenta, 19 x 26

Minnesota

MINNEAPOLIS, The Minneapolis Institute of Arts
View up the Grand Canal Towards the Rialto, 25¾ x 35⁷⁄₁₆

Missouri

KANSAS CITY, The Nelson Gallery and Atkins Museum
The Entrance to the Grand Canal, Venice, 18½ x 25½

New Hampshire

HANOVER, Dartmouth College Museum and Galleries
Landscape, 28¾ x 40¾

New York

GLENS FALLS, The Hyde Collection
The Arsenal, Venice, 19 x 27

NEW YORK CITY
The Metropolitan Museum of Art
Venice: Piazza San Marco, 27⅛ x 33¾
Venice: Santa Maria della Salute, 21 x 33¾

Venice: The Grand Canal above the Rialto, 21 x 33¾
Fantastic Landscape, 61¼ x 74½
Fantastic Landscape, 61¼ x 107½
Landscape (oval), 6¼ x 4¾
Fantastic Landscape, 61¼ x 74½
Landscape (oval), 6¼ x 4¾
Architectural Fantasy, 12⅜ x 10⅝
Venice from the Sea, 48 x 60

North Carolina

RALEIGH, North Carolina Museum of Art
Roman Ruins near the Lagoon, 36½ x 26¾

Ohio

CLEVELAND, The Cleveland Museum of Art
Visit of the Pope in Venice: The Pope Greets the Representatives of La Serenissima, 20⅜ x 27¼, 1782
Visit of the Pope in Venice: Pontifical Ceremony in Church of SS. Giovanni and Paolo, 20¼ x 27⅛, 1782

TOLEDO, The Toledo Museum of Art
The Holy Family, 45½ x 37⅞, c. 1740-45
San Giorgio Maggiore, Venice, 18¼ x 30¹⁄₁₆, 1791

Pennsylvania

PHILADELPHIA, Philadelphia Museum of Art
Capriccio, 8⅛ x 6⅝, c. 1775-90
Festival on the Grand Canal, 47¼ x 66½ (Johnson)

Rhode Island

PROVIDENCE, Museum of Art, Rhode Island School of Design
Piazza di SS. Giovanni e Paolo, 15¼ x 12¾, after 1782
Scene in the Ridotto, Venice, Main Salon in the Ridotto, 12⅛ x 20
Villa Loredan at Paese (drawing), 11¾ x 21¼

South Carolina

COLUMBIA, Columbia Museums of Art and Science
View of the Grand Canal with the Dogana, 16½ x 26¼ (Kress)

Texas

FORT WORTH, Kimbell Art Museum
Venice Viewed from the Bacino, 24⅞ x 37⅜, c. 1780

HOUSTON, The Museum of Fine Arts
View of S. Maria della Salute, Venice, 19½ x 35½ (Straus)

Virginia

NORFOLK, Chrysler Museum at Norfolk
Naval Battle in a Storm (oval), 31 x 40

RICHMOND, Virginia Museum
Piazza San Marco, 18⅝ x 30⅝

Washington

SEATTLE, Seattle Art Museum
The Holy Family with St. John and a Family Martyr, 23⅞ x 27, c. 1750

Canada

Ontario

OTTAWA, The National Gallery of Canada
The Church of S. Maria della Salute, Venice, 28 x 37⅜, c. 1780
The Entrance to the Grand Canal (drawing), 5⅛ x 12⅛
The Dogana, Venice, 13¼ x 10½
The Piazzetta, Venice, 13¼ x 10½
Venetian Canal Scene, 14 x 23³⁄₁₆
Architectural Capriccio (drawing), 9¾ x 15¼

Quebec

MONTREAL, Montreal Museum of Fine Arts
Storm at Sea, 20⅞ x 25⅝

Frans Hals

Frans Hals • Joseph Coymans

Oil on canvas • 33 x 27½″ • Wadsworth Atheneum, Hartford, Conn.
Ella Gallup Sumner and Mary Catlin Sumner Collection

Frans Hals

1581/5—1666

Frans Hals, the eldest son of a clothmaker, was born in Antwerp when it was the capital of the Spanish Netherlands, but he spent most of his life in Haarlem, where his father and mother moved in 1591. There both he and his younger brother Dirk studied painting. In 1608 Frans married Anneke Hermanzoon, who died in 1615, leaving him with several children. (The exact number is not known.) Hals's first dated work is a group portrait of a Haarlem Civic Guard, painted in 1616 and preserved today in the Frans Hals Museum in Haarlem. The following year he visited Antwerp, where he possibly saw both Rubens and van Dyck. When he returned to Haarlem, he found awaiting him the first of a long series of lawsuits and claims for debts that were to plague him the rest of his life. In 1617 he married Lysbeth Reyniers (who bore him at least ten children) and began painting the many portraits with which he tried vainly to support his large family. Though he painted more than 250 pictures in his fifty active years, he died a city pensioner.

The word "painter" fits Frans Hals more accurately than it does most of the artists discussed in this book. His pictures have a particular fascination for anyone who has ever tried to cover a canvas with paint. Hals makes it look so easy, and like so much fun. The brushstrokes flash across the surface as surely and confidently as the blades of a champion skater cut the ice. (Hals painted directly on the canvas, without preliminary drawing.) And every square inch of his best pictures provides a feast of color and texture for the eye.

Anyone can see from the way Frans Hals painted that he was a lusty, vigorous citizen in a lusty, vigorous age. This is, of course, even more evident in his subject matter, for he painted only people, many of whom were as dashing as the way they are painted. But it would be a mistake to describe Hals as merely a fun-loving extrovert with a great facility for painting. He saw deeply, and he painted honestly as well as brilliantly. He was the first European artist to paint children as they are.

Once while visiting an exhibition of old masters with the American painter Max Weber, we stopped in front of a Frans Hals portrait, similar to the one reproduced here. Weber gazed at the white ruff and the brilliantly painted jacket beneath it and exclaimed, "Ah, that's eye-food!"

Pieter Tjarck, whose portrait Hals painted between 1635 and 1638, was a Haarlem dyer of silk. He seems to be caught here in a casual pose with his arm resting momentarily on the back of a chair, yet each element in the picture is carefully calculated. The painted frame unites the space between the viewer and the sitter, and the arm overlapping the body gives depth to the space within the oval frame. The geometrically conceived torso supports the head. The large hat counteracts the upward thrust of the collar to make the face the focus of the composition. This face, solidly modeled, is not that of a cavalier looking laughingly at the world, but of a serious, thoughtful man. The rose he is holding may symbolize the transience of life and material glories, or, as the flower of Venus, it may indicate that this is a wedding portrait. Or it may merely be, in Max Weber's words, colorful "eye-food."

Frans Hals in America

California

LOS ANGELES

Los Angeles County Museum of Art
Portrait of a Man, presumably Pieter Tjarck, 33⁹/₁₆ x 27½, c. 1635-38

University of Southern California, University Galleries
The Laughing Fisher Boy, 31 x 25 (attrib. to)

PASADENA, Norton Simon Museum of Art
Portrait of a Man, 26 x 19½, 1650

SAN DIEGO
San Diego Museum of Art
Portrait of Isaac Abrahamez Massa, 8¼ x 8, c. 1630

Timken Art Gallery, San Diego
Portrait of a Man, 31 x 29

Connecticut
HARTFORD, Wadsworth Atheneum
Joseph Coymans, 33 x 27½, 1644

NEW HAVEN, The Yale University Art Gallery
Portrait of an Old Lady, 29 x 23¼, 1628
De Heer Bodolphe, 48³/₁₆ x 38⅜, 1643
Merrouw Bodolphe, 48³/₁₆ x 38⅜, 1643

District of Columbia
WASHINGTON
Corcoran Gallery of Art
?Girl with a Flagon, 30½ x 25 (Clark)

National Gallery of Art
Willem Coymans, 30¼ x 25, 1645 (Mellon)
Portrait of an Elderly Woman, 40½ x 34, 1633 (Mellon)
A Young Man in a Large Hat, 11½ x 9⅛, c. 1626-27 (Mellon)
Portrait of a Gentleman, 45 x 33½, 1650-52 (Widener)
Portrait of a Man, 25 x 21, 1640-45 (Widener)
Portrait of a Young Man, 26⅞ x 21⅞, c. 1645-47 (Mellon)
Portrait of an Officer, 33¾ x 27, c. 1635 (Mellon)
Portrait of a Man, 37 x 29½, c. 1652-54 (Mellon)

Florida
SARASOTA, John and Mable Ringling Museum of Art
Portrait of Pieter Jacobz Olycan, 43¾ x 34, c. 1640

Illinois
CHAMPAIGN, Krannert Art Museum
Cornelius Guldewagen, Mayor of Haarlem, 16 x 12, c. 1660

CHICAGO, The Art Institute of Chicago
Portrait of an Artist, 32½ x 25½, 1644
Portrait of a Lady, 34¼ x 26⅜, 1627

Maryland
BALTIMORE, The Baltimore Museum of Art
Portrait of a Young Woman, 43¾ x 32¾, 1634 (Epstein)
Portrait of Dorothea Berck, 33 x 27½, 1644 (Jacobs)

Massachusetts
BOSTON, Museum of Fine Arts
Portrait of a Man, 33¾ x 26¼, c. 1666

Michigan
DETROIT, The Detroit Institute of Arts
Portrait of a Woman, 28½ x 21½, 1634
Laughing Boy, 13⅛ x 12¼, 1623-25
Portrait of Hendrik Swalmius, 10⅝ x 7⅞, 1639
Portrait of a Man, 34½ x 28, 1644

Missouri
KANSAS CITY, The Nelson Gallery and Atkins Museum
Portrait of a Gentleman, 41¼ x 35½

ST. LOUIS, The St. Louis Art Museum
Portrait of a Woman, 40⅜ x 27¾, 1650-55

New York
GLENS FALLS, The Hyde Collection
Portrait of One of the Artist's Sons (oval), 7¾ x 6½, c. 1630

NEW YORK CITY
The Brooklyn Museum
Portrait of a Man, 28¼ x 21¾, c. 1615

The Frick Collection
Portrait of an Elderly Man, 45½ x 36, 1627-30
Portrait of a Woman, 45⅞ x 36¾, 1635
Portrait of a Painter, 39½ x 32⅝, 1650-59
Portrait of a Man, 44½ x 32¼, early 1660s

The Metropolitan Museum of Art
Portrait of a Bearded Man with a Ruff, 30 x 25, 1625 (Bache)
Paulus Verschuur (1606-1667), 46¾ x 37, 1643
Portrait of a Woman, 39⅜ x 32¼
The Smoker (octagonal), 18⅜ x 19½
Boy with a Lute, 28⅜ x 23¼ (Altman)
Portrait of a Man, 43½ x 34
Portrait of a Man, possibly Claes Duyst van Voorhout, 31¾ x 26 (Bache)
Anna van der Aar (1576-after 1626), 8¾ x 6½, 1626 (Havemeyer)
Young Man and Woman in an Inn (Yonker Ramp and His Sweetheart), 41½ x 31¼, 1623 (Altman)
Merrymakers at Shrovetide (The Merry Company), 51¾ x 39¼ (Altman)
Petrus Scriverius (1575/76-1660), 8¾ x 6½, 1626 (Havemeyer)

ROCHESTER, Memorial Art Gallery of The University of Rochester
Portrait of a Man, 29½ x 24½ (Eastman)

Ohio
CINCINNATI
The Cincinnati Art Museum
A Dutch Family, 44½ x 36¾
Fisher Girl, 30¼ x 24¾ (attrib. to)

The Taft Museum
Head of Laughing Child with a Flute, 13¾ x 13
Michiel de Wael, 47⅝ x 37¾, 1639
Portrait of a Young Man, 43¼ x 32½, c. 1645
Portrait of a Young Woman, 43⅛ x 32½, c. 1645

CLEVELAND, The Cleveland Museum of Art
Portrait of a Lady in a Ruff, 27½ x 21⅜, 1638

Texas
FORT WORTH, Kimbell Art Museum
Portrait of a Man, 34⅝ x 25⅝, c. 1643-45

HOUSTON, The Museum of Fine Arts
Portrait of a Woman, 32⅜ x 25½ (Blaffer)

Virginia
RICHMOND, Virginia Museum .
The Laughing Boy, 13⅜ x 11⅝ (attrib. to)
The Violin Player, 29½ x 26 (attrib. to)

Canada

Ontario
OTTAWA, The National Gallery of Canada
Portrait of a Man (Adriaen van Ostade?), 16⅝ x 13, c. 1645

TORONTO, Art Gallery of Ontario
Vincent Laurensz van der Vinne, 25½ x 19¼, c. 1655
Isaak Abrahamsz Massa, 31½ x 25⅝, 1626

Meindert Hobbema

Meindert Hobbema • A Water Mill
Oil on canvas • 14³/₄ x 14¹/₈'' • Cincinnati Art Museum, Cincinnati, Ohio
Gift of Mary Hanna

Meindert Hobbema

1638—1709

Meindert Hobbema was born in Amsterdam, where he spent his entire life. Not much is documented about the details of that life except that he was married to Eeltije Vinck on November 2, 1668, in the Oudekerk of Amsterdam, and that Jacob van Ruisdael, his friend and teacher, was a witness. Also documented is the fact that Eeltije bore him four children and that she died in 1704 and was buried in the pauper section of the Leiden cemetery at Amsterdam. Meindert survived her five years, dying in December, 1709, with burial on the fourteenth of that month in the pauper section of the Wester-kerk cemetery. The couple lived in the Rozengracht, not far from where Rembrandt had spent his final days with Hendrijke Stoffels. What is not documented (or explained) about three of Holland's greatest artists, Hals, Rembrandt, and Hobbema, is why they died relatively poor after leading productive lives of, respectively, eighty-five, sixty-two, and seventy-one years. Hobbema's production declined after the year of his marriage, when he took a municipal job for the city of Amsterdam. However, he continued to make painting trips into the environs of the city, producing landscapes which apparently lost some of their appeal to the burghers of Amsterdam, but which today rank him second only to Ruisdael among Holland's landscape painters of the seventeenth century.

Love of content instead of form is what distinguishes the landscapes of Meindert Hobbema from those of Claude Lorrain. Where Claude saw trees, hills, clouds, and people measured by Euclid's golden section, Hobbema saw them as a Dutchman in love with his native land—Holland. He saw and painted them with the warmth of the sun. Here the sunlight blazes on the distant fields beyond the houses; it dapples the cows and the people tending them at the shaded pond and on the road; it beams on the seated woman working at her knitting.

This almost magical use of sunlight was Hobbema's special talent. Although he painted the same mills, houses, fields, ponds, and trees over and over again, none of his pictures is quite like another. The light is different in each because the time of day, the weather, or the season is different. Hobbema's eyes were sensitive to all the light changes, and his brush talented enough and patient enough to record them. In the landscape reproduced here, the light on each leaf of each tree has its own quality. This is what gives warmth and vitality to Hobbema's landscapes and makes them sparkle among the paintings on any museum wall.

Hobbema is the last of the great seventeenth-century Dutch painters discussed in this book: Hals (1581/5-1666), van Goyen (1596-1656), Rembrandt (1606-1669), Ruisdael (1628/9-1682), De Hooch (1629-1683), Vermeer (1632-1675), and so it is fitting here to attempt an assessment of this parade of genius unparalleled in the history of art. Most writers have related it to the historical fact that Holland had begun to free itself from the dominance of Spain by the Union of Utrecht in 1581, and in the next century was enjoying the fruits of that freedom from taxation, the Inquisition, and religious dogma. The American historian John Lothrop Motley described the Republic of Holland as, "A great naval and commercial commonwealth, occupying a small portion of Europe, but conquering a wide empire by the private enterprise of trading companies, girdling the world with its innumerable dependencies in Asia, America, Africa, Australia. . . " The results of this productivity are what we see in the portraits, landscapes, and objects of seventeenth-century Dutch painting. But what we see is more than a self-mirroring by its artists of a contented land. We see painting that had become a creative act in itself—line, color, texture, form, and tone—apart from subject matter. That is why these pictures receive the adulation that the world accords them.

Meindert Hobbema in America

California
SAN FRANCISCO, The Fine Arts Museums of San Francisco
Landscape with Washerwoman, 18½ x 25

Illinois
CHICAGO, The Art Institute of Chicago
The Watermill with the Great Red Roof, 32 x 43⅛, c. 1670
Wooded Landscape with Cottage, 39½ x 52½, 1663

Indiana
INDIANAPOLIS, Indianapolis Museum of Art
The Water Mill (The Trevor Landscape), 40¼ x 53, 1667

Massachusetts
WILLIAMSTOWN, Sterling and Francine Clark Art Institute
Woodland Landscape with a Farm, 23⅝ x 32¾

Michigan
DETROIT, The Detroit Institute of Arts
The Cottage, 24 x 33½
A River Scene, 18⅝ x 23¾
Landscape with a Dog Drinking at a Pool, 24⅞ x 33 ⅞

Minnesota
MINNEAPOLIS, The Minneapolis Institute of Arts
Wooded Landscape with Watermill, 40¼ x 53
A Country Road Past Houses and Rotting Tree Trunks,
23⅝ x 33⁵/₁₆

Missouri
KANSAS CITY, The Nelson Gallery and Atkins Museum
A Road in the Woods, 37 x 50¾

New York
ELMIRA, Arnot Art Museum
The Mill Pond, 24¹/₈ x 32¾

NEW YORK CITY
The Brooklyn Museum
Hamlet in the Woods, 38⅛ x 51⅝

The Frick Collection
Village Among Trees, 30 x 43½, 1665
Village with Watermill Among Trees, 37⅛ x 51⅛

The Metropolitan Museum of Art
Entrance to a Village, 29½ x 43⅜
Woodland Road, 37¼ x 51

Ohio
CINCINNATI
The Cincinnati Art Museum
A Water Mill, 14¾ x 14⅛

The Taft Museum
Landscape with Cattle and Figures, 38 x 50½

CLEVELAND, The Cleveland Museum of Art
A Wooded Landscape with Figures, 33³/₁₆ x 44

OBERLIN, The Allen Memorial Art Museum, Oberlin College
A Pond in a Forest, 23⅝ x 33¼, 1668

TOLEDO, The Toledo Museum of Art
The Water Mill, 37⅜ x 51¹³/₁₆, 1664

Tennessee
MEMPHIS, Brooks Memorial Art Gallery
Rural Landscape with Figures, 15¾ x 21¾

Virginia
RICHMOND, Virginia Museum
A River Landscape With a Boat, 23¾ x 33⅛

Meindert Hobbema • The Watermill with the Great Red Roof
Oil on canvas • 32 x 43⅛" • The Art Institute of Chicago
Gift of Mr. and Mrs. Frank G. Logan

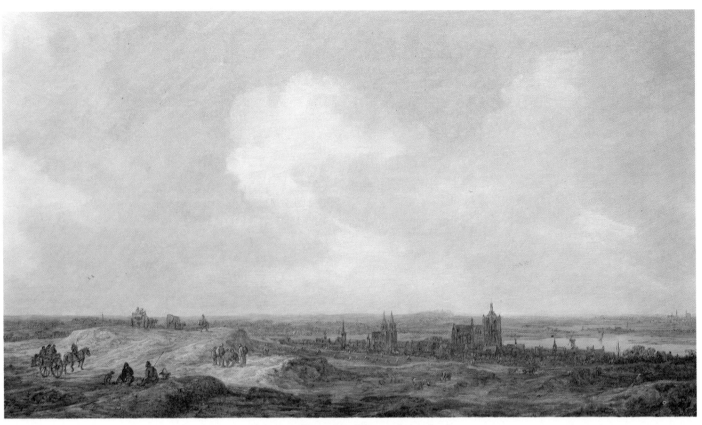

Jan van Goyen • View of Arnhem
Oil on panel • 14⅛ x 24⅜″ • Kimbell Art Museum, Fort Worth, Texas

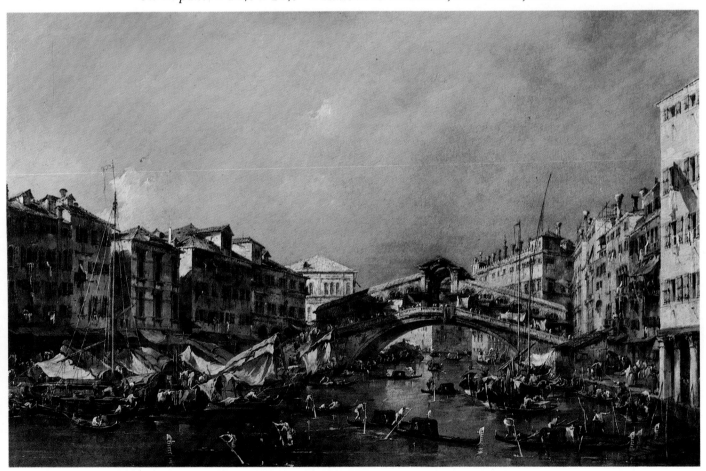

Francesco Guardi • The Grand Canal with the Rialto Bridge
Oil on canvas • 22½ x 33½″ • The San Diego Museum of Art

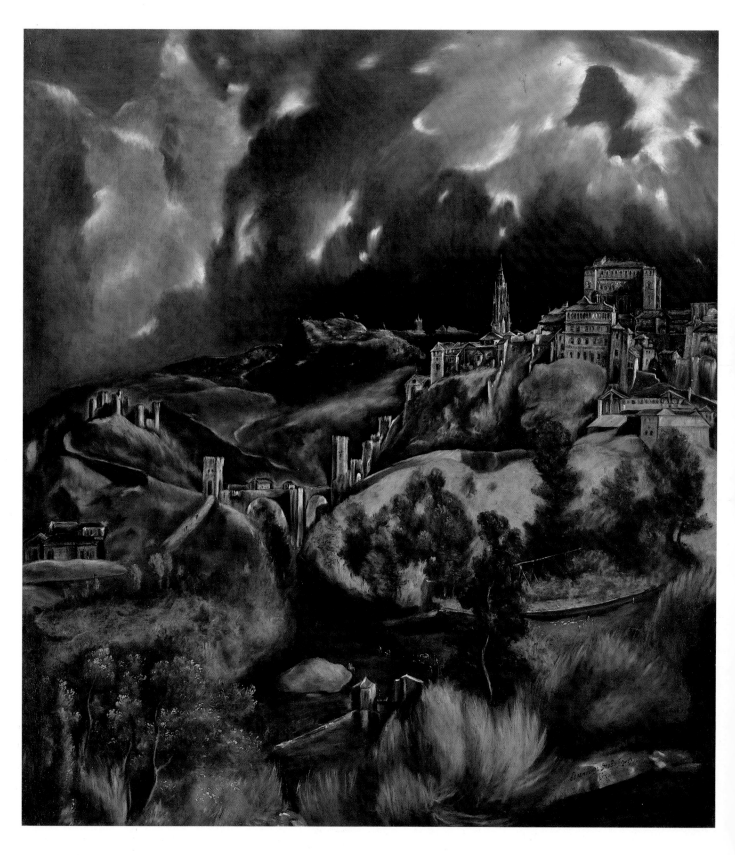

El Greco • View of Toledo
Oil on canvas • 47¾ x 42¾" • The Metropolitan Museum of Art, New York City
The H.O. Havemeyer Collection

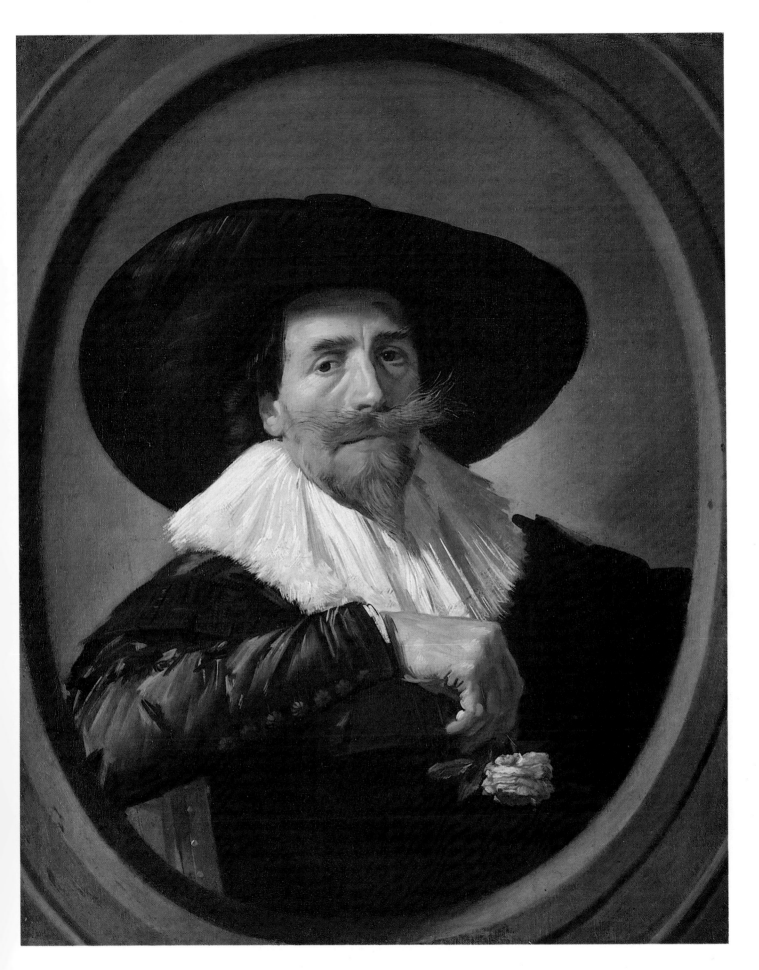

Frans Hals • Portrait of a Man, *presumably* Pieter Tjarck
Oil on canvas • *33⁹⁄₁₆ x 27½ ″* • *Los Angeles County Museum of Art* • *Gift of the Ahmanson Foundation*

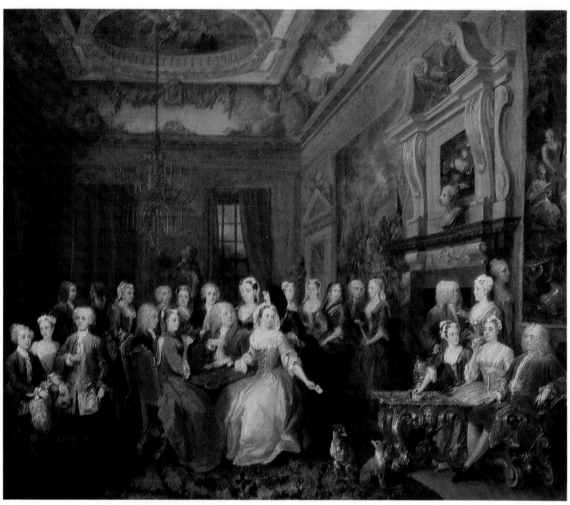

William Hogarth • The Assembly at Wanstead House
Oil on canvas • 25½ x 30" • Philadelphia Museum of Art • The John McFadden Collection

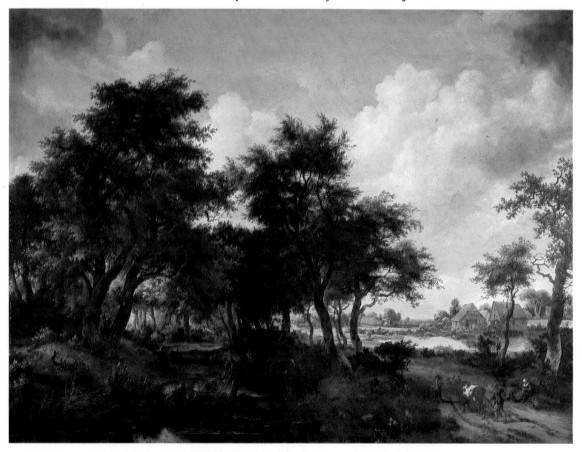

Meindert Hobbema • Landscape with Cattle and Figures
Oil on Canvas • 38 x 50½" • The Taft Museum, Cincinnati, Ohio

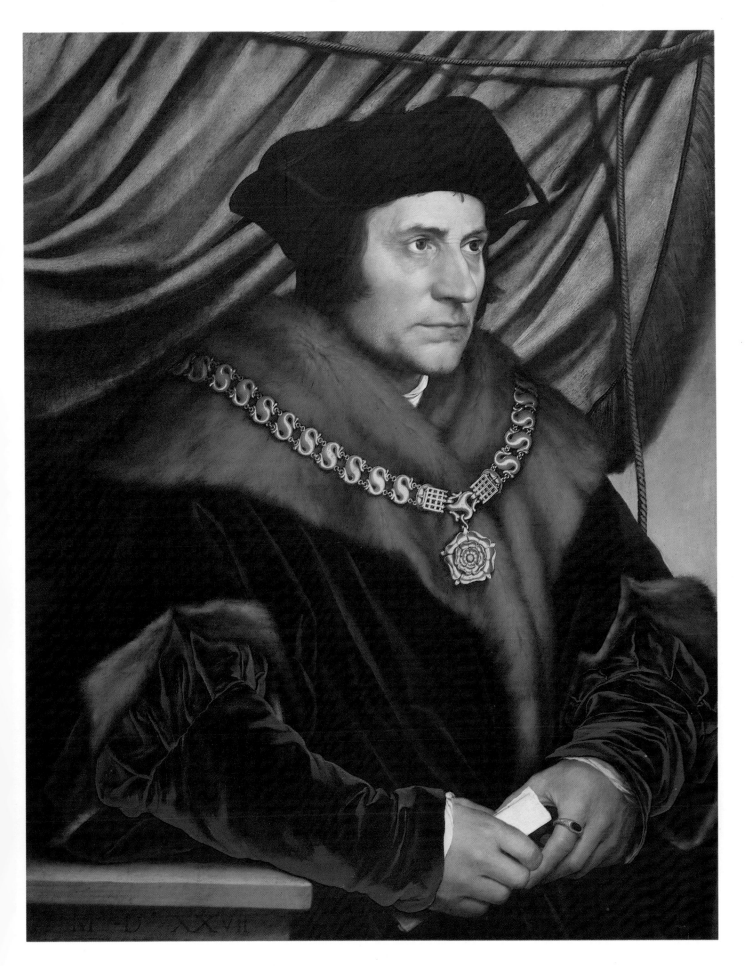

Hans Holbein • Sir Thomas More
Oil on canvas • 29½ x 23¾ʺ • The Frick Collection, New York

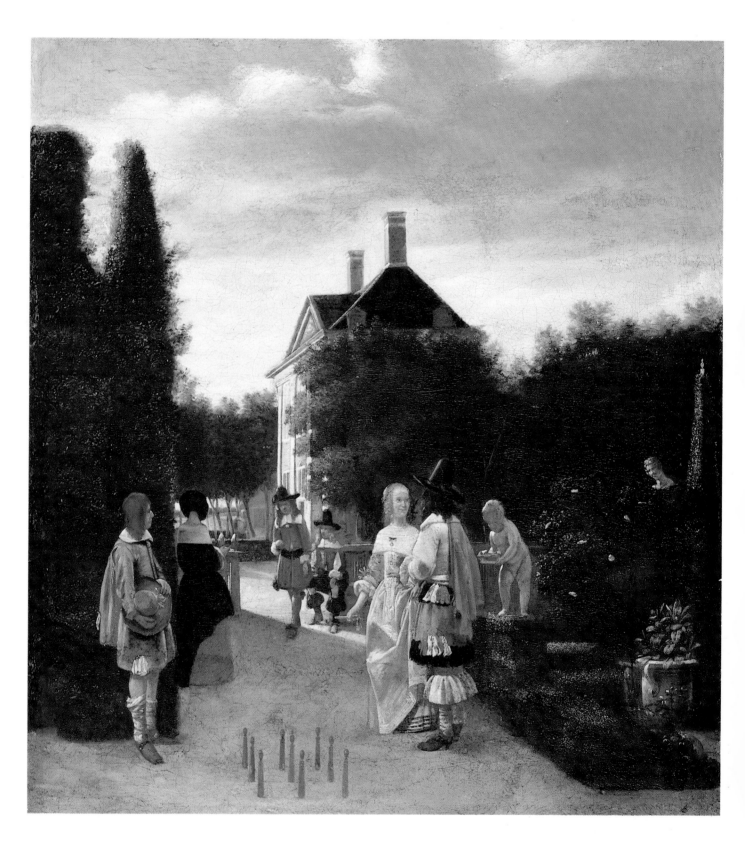

Pieter de Hooch • The Game of Skittles
Oil on canvas • 29⅛ x 26⅛″ • The Cincinnati Art Museum • Gift of Mary Hanna

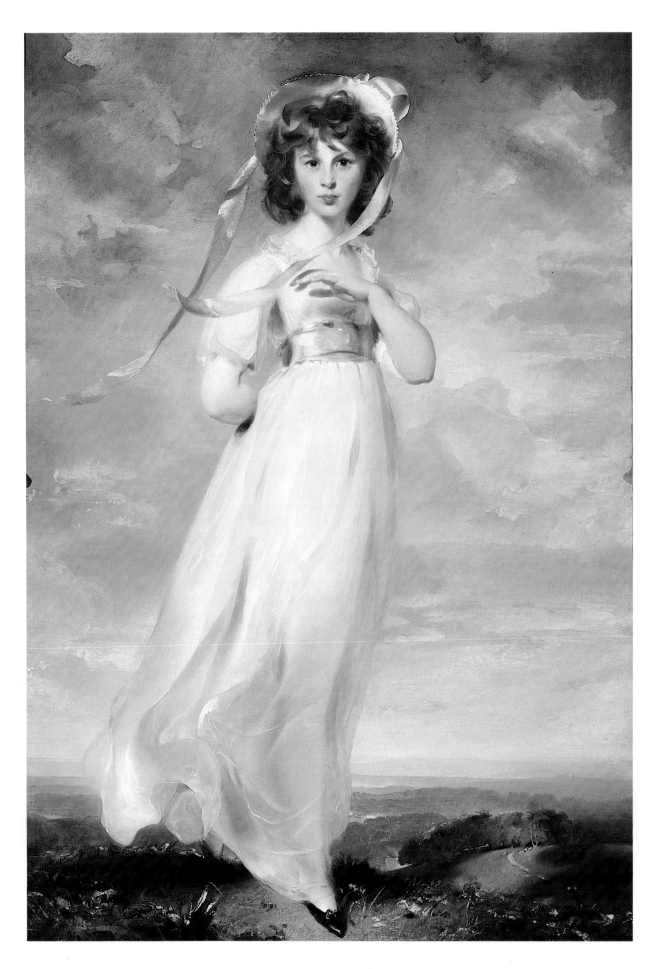

Sir Thomas Lawrence • Sarah Barrett Moulton ("Pinkie")
Oil on canvas • *57½ x 39¼″* • *The Huntington Art Gallery, San Marino, California*

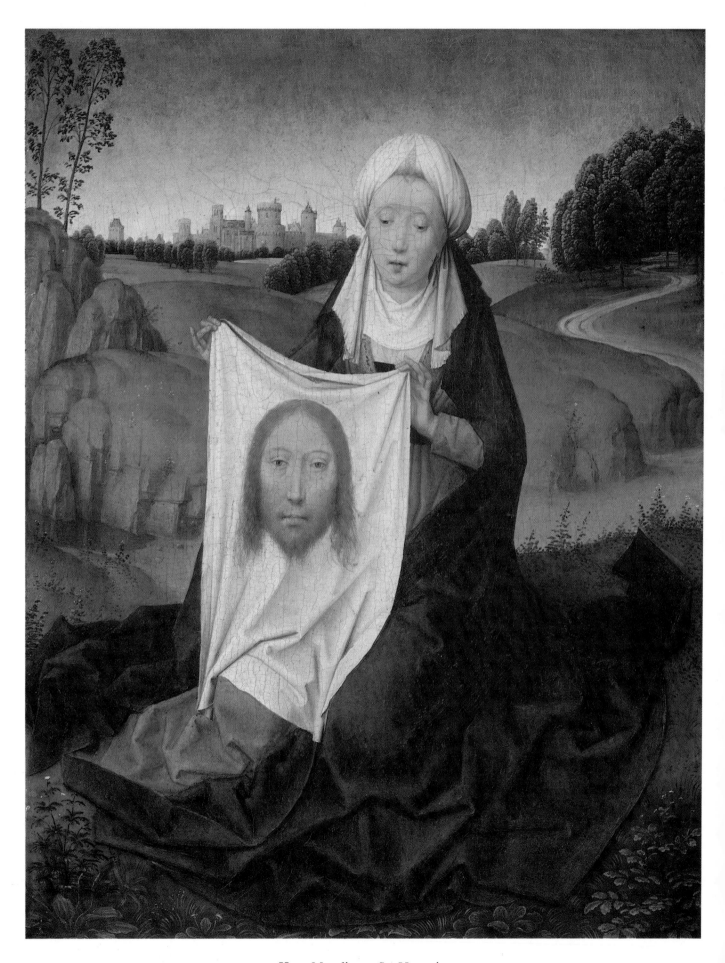

Hans Memling • St. Veronica

Oil on canvas • *12¼ x 9½ ''* • *National Gallery of Art, Washington, D.C.* • *Samuel H. Kress Collection*

William Hogarth

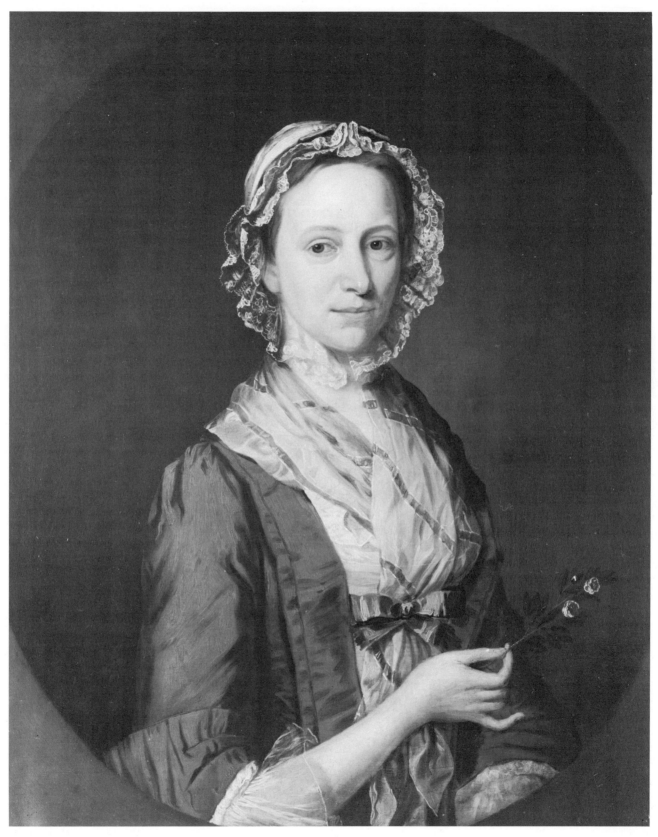

William Hogarth • Miss Ann Hogarth
Oil on canvas • 30 x 24″ • Brooks Memorial Museum, Memphis, Tennessee

William Hogarth

1697–1764

William Hogarth was born in London, the son of a schoolteacher who encouraged his early interest in drawing and apprenticed him at fifteen to an engraver of arms on silver plate. In 1720 he established his own engraving shop, but feeling that he needed to know anatomy better than it is represented in heraldic animals, he entered art school. Soon he was publishing topical prints, one of the first of which satirized the famous stock swindles known as the South Sea Bubble. Delighted with the first showing of the *Beggar's Opera* in 1728, he painted a scene from it. The same year he eloped with the daughter of his teacher, Sir James Thornhill, and soon afterwards "covered" a trial investigating conditions in debtors' prison. The publication of the resultant picture brought him the first of many portrait commissions, but he continued with his famous series of satirical paintings and prints (*A Harlot's Progress, A Rake's Progress, Marriage à la Mode,* etc.), and also with his serious study of art, which culminated in his book, *The Analysis of Beauty,* published in 1753.

William Hogarth was born into an age of reform. In 1697 Englishmen were beginning to emerge from the roaring, bawdy atmosphere of the generation that preceded them—the Restoration of Charles II—and to think of the salvation of their souls. Two young journalists named Addison and Steele were contemplating the weekly publication of a pamphlet to be called *The Spectator*, a pamphlet whose aim was to reform the morals and manners of Englishmen—while diverting them at the same time.

Addison and Steele hoped to bring about reform with their pens; Hogarth hoped to expose the folly of wickedness and vice with his pictures. Because he was not merely a moralist but a genuine artist as well, we have, in addition to the famous series of satirical paintings and prints, a number of the finest group and single portraits that England has produced. We are fortunate in having not only a number of these in America, but also, in *The Assembly at Wanstead House,* what is probably Hogarth's first commissioned group portrait.

It is the family and friends of Earl Tylney (seated at right), who in 1715 built one of the noblest houses in London. Seated beside him are his wife and eldest daughter; across the room are the younger children. The time is late afternoon, for tea is nearly finished and a servant is lighting candles. Cards have already begun, with the lady in the center holding out the ace of diamonds to show the slightly bored earl. One wonders what the earl is thinking of this charming assemblage, and indeed what he thought later of Hogarth's picture of it. For the charm is not unmixed with Hogarthian satire. Is it accidental that the immobile statue by the fireplace resembles the lady facing the other way, not listening politely to the gentleman with his left hand on his chest? And is it an accident that the two little dogs are also engaged in seeming conversation?

But if this is Hogarth the satirist, the painting is also Hogarth the artist, whose famous S-shaped "line of beauty" became almost aesthetic dogma for generations of artists and designers after its publication in 1753. The blues, reds, and greens of the elegant eighteenth-century costumes are subtly blended and balanced. The necessarily stiff grouping of twenty-five people in a row has been given movement by the strong diagonal action of the lady holding out the card. The counter diagonal is suggested by the slightly increasing height of the people to the right of the picture. The chandelier subtly compensates for the lower height of the people at the left. And in the legs of the table before the earl (contrasting with his?) is a suggestion of the famous serpentine, Hogarth's "line of beauty."

William Hogarth in America

California
MALIBU, The J. Paul Getty Museum
Before the Seduction, 15¼ x 13¼, 1731
After the Seduction, 15¼ x 13¼, 1731

SAN MARINO, The Huntington Art Gallery
Frederick Frankland, 50 x 40, c. 1740
Benjamin Hoadly, Bishop of Winchester, 24 x 19, c. 1740
Mrs. Hoadly, 24 x 19, c. 1740

District of Columbia
WASHINGTON, Dumbarton Oaks, Harvard University
Portrait of Peg Woffington, approx. 23⅝ x 18⅞ (attrib. to)

Kentucky
LOUISVILLE, The J. B. Speed Art Museum
Mr. Dudley Woodbridge Celebrates His Call to the Bar in His Chambers at No. 1, Brick Court, Middle Temple, 16⅜ x 21⅝, 1730

Massachusetts
BOSTON, Museum of Fine Arts
Portrait of a Lady, 30 x 25

NORTHAMPTON, Smith College Museum of Art
The Rev. John Hoadly, 29⅞ x 25, 1741
James Caulfield, Earl of Charlemont, 23½ x 19½, 1759-64

WORCESTER, Worcester Art Museum
William James, 29¾ x 25, 1744
Mrs. William James, 30 x 25, 1744

Michigan
DETROIT, The Detroit Institute of Arts
Portrait of a Lady, 29¾ x 25¼, 1740-45

MUSKEGON, Hackley Art Museum
Anne, Viscountess Irwin, 30 x 25

Minnesota
MINNEAPOLIS, The Minneapolis Institute of Arts
The Sleeping Congregation, 21¾ x 18, 1728

Missouri
KANSAS CITY, The Nelson Gallery and Atkins Museum
Tavern Scene: An Evening at the Rose, 25 x 30, c. 1735

New York
BUFFALO, The Albright-Knox Art Gallery
The Lady's Last Stake, 36 x 41½, 1759

NEW YORK CITY
The Frick Collection
Miss Mary Edwards, 49¾ x 39⅞, 1742

The Metropolitan Museum of Art
The Wedding of Stephen Beckingham and Mary Cox, 50½ x 40½, 1729

Ohio
COLUMBUS, The Columbus Museum of Art
Ann Hogarth, 18¼ x 16, c. 1740
Mary Hogarth, 18¼ x 16, c. 1740

OBERLIN, The Allen Memorial Art Museum, Oberlin College
Portrait of the Architect Theodore Jacobsen, 35⅝ x 27⅞, 1742

TOLEDO, The Toledo Museum of Art
Joseph Porter, 35¹¹/₁₆ x 27¹³/₁₆, c. 1740-45

Pennsylvania
PHILADELPHIA, Philadelphia Museum of Art
The Fountaine Family, 18¾ x 23½, c. 1730 (McFadden)
The Assembly at Wanstead House, 25½ x 30, 1729-31 (McFadden)

Tennessee
MEMPHIS, Brooks Memorial Art Gallery
Portrait of Miss Ann Hogarth, 30 x 24

Virginia
NORFOLK, Chrysler Museum at Norfolk
The Thornhill Family (so called), 24 x 26 (attrib. to) (loan)

RICHMOND, Virginia Museum
Portrait of Sir Edward Walpole, K. B., 30 x 25

Canada

British Columbia
VANCOUVER, Vancouver Art Gallery
Portrait of Mr. Bridgeman, 22½ x 18½

Ontario
OTTAWA, The National Gallery of Canada
Portrait of John Herring, 29 x 24, 1740
Hudibras Beats Sidrophel (drawing), 9³/₁₆ x 13⅛, c. 1725

Quebec
MONTREAL, Montreal Museum of Fine Arts
Portrait of a Little Girl, 17⅞ x 15⅝

William Hogarth • Tavern Scene:
An Evening at the Rose
Oil on canvas • 25 x 30"
Atkins Museum of Fine Arts
Kansas City, Missouri
William Rockhill Nelson Fund

Hans Holbein

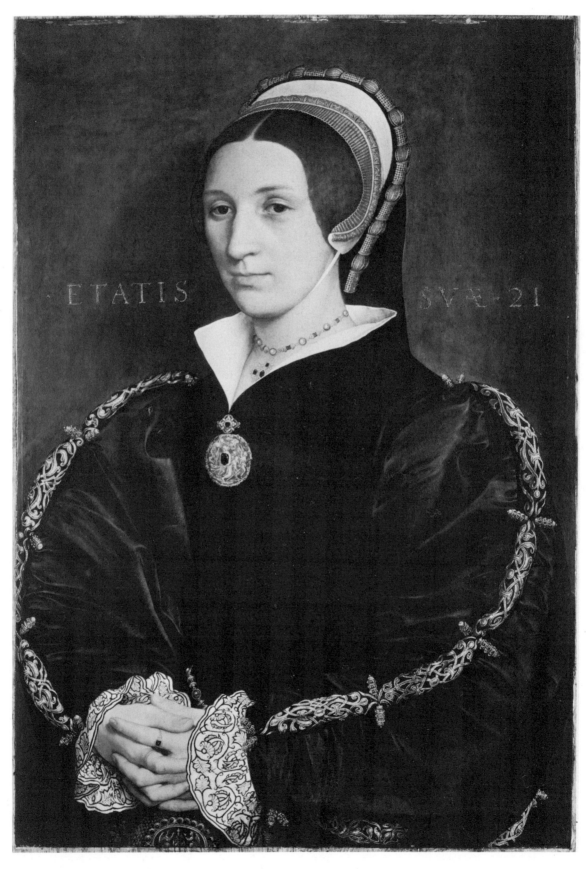

Hans Holbein the Younger • *A Lady of the Cromwell Family*
Oil on wood panel • 38⅜ x 19½″ • The Toledo Museum of Art, Toledo, Ohio
Gift of Edward Drummond Libbey

Hans Holbein
1497/8—1543

Hans Holbein was born in Augsburg, Germany, the son of Hans Holbein, the Elder, a painter and engraver, and the brother of Ambrosius Holbein, best known for his book illustrations. After a period of study with his father, Hans went to Basel, where he was soon employed as an illustrator by Johann Froben, a leading publisher of the time, whose editor was Erasmus. Holbein enjoyed the friendship of Erasmus, the Dutch humanist, for the rest of his life and painted several portraits of him (Muncie, Indiana). In 1519 Holbein visited Italy, returned to Basel the same year, became a Swiss citizen, and married Elsbeth Schmid. In 1524 he visited France, and two years later arrived in England with letters of introduction from Erasmus to Sir Thomas More. In 1528 Holbein went back to Basel, and after having bought a house for his wife and children, returned to England in 1532, where, in 1536, he became court painter to Henry VIII. He died of the plague in London seven years later.

In a room at the Frick Collection in New York a grim page of England's history is reflected in two portraits by Hans Holbein, the Younger. To the left is the portrait of Sir Thomas More, painted in 1527. Later Holbein painted the portrait of Sir Thomas Cromwell, who now stares across at the then-alive More, whose death he was to effect two years later. In 1540 Cromwell himself followed More to the Tower. In that year Holbein was probably at work on another portrait of the man responsible for this carnage—Henry VIII.

Eight years before he came to England in 1526, Holbein had drawn the title page and illustrations for an edition of Thomas More's *Utopia*, so he was prepared to meet a man of brilliance and courage. In London, thanks to their common friend Erasmus, Holbein was privileged to live near More in Chelsea and to see him often. He must have known him well before he painted this portrait the following year.

More, a privy councilor, was nearing the height of his career in 1527. The heavy gold chain he is wearing in the portrait, a symbol of the king's livery, was worn only by high officials. Against the rich sable collar, it provided Holbein not only with a pleasing contrast of textures to challenge his extraordinary painting skill, but also with an important element in the basic design of this monumental portrait—almost a statement of its theme. The basic design is a square, enclosing a series of concentric semicircles, in the center of which is the powerful face of the author of *Utopia*.

The lower left corner of the square is suggested by the tabletop on which More's right arm rests. Its opposite corner is defined by the curtain cord. The first of the semicircles is described by the curve of the two velvet-clad arms, a curve suggested again in the opposite corner, like the variation of a musical theme, by the folds of the curtain. The gold chain forms the second curve, which is repeated in the oval of the chin, to be rounded into a complete circle by the downward curve of the hat, thus centering attention on the strong, alert features of the face.

Knowing what we do of More, it is easy to read into these features the character of the man: the brilliant lawyer and inquiring philosopher who gave the word utopia to the English language; the pious scholar who refused to sanction Henry's marriage to Anne Boleyn, even though he knew it would mean his death; the friend of Erasmus, who wrote of him, "There is not any man living so affectionate to his children . . ." But if we did not know these things, we would know from Holbein's portrait that here was an exceptional man, painted by an equally exceptional artist.

Hans Holbein in America

California
LOS ANGELES, Los Angeles County Museum of Art
Portrait of a Young Woman with White Coif, 4⅜ diam., 1541

Connecticut
NEW HAVEN, Yale University Art Gallery
A Merchant of the Hanseatic League, 19½ x 15¼, 1538

District of Columbia
WASHINGTON, National Gallery of Art
Edward VI as a Child, 22⅜ x 17⅜, 1538 (Mellon)
Sir Brian Tuke, 19⅜ x 15¼ (Mellon)

Indiana
MUNCIE, Ball State University Art Gallery
Portrait of Erasmus of Rotterdam, 7 x 5½

Massachusetts
BOSTON, Isabella Stewart Gardner Museum
Portrait of Sir William Butts, 18 x 14¼
Portrait of Lady Butts, 18 x 14½

CAMBRIDGE, Fogg Art Museum, Harvard University
Head of a Young Man (drawing), 8⅛ x 6
A Design for a Coat of Arms (drawing), 11⅞ x 8½

Michigan
DETROIT, The Detroit Institute of Arts
Miniature Portrait of Sir Henry Guildford, 4½ diam.

Missouri
ST. LOUIS, The St. Louis Art Museum
Portrait of Lady Guildford, 34¼ x 27¾, 1527

New York
NEW YORK CITY
The Frick Collection
Sir Thomas More, 29½ x 23¾, 1527
Thomas Cromwell, 30⅞ x 25⅜

The Metropolitan Museum of Art
Benedikt von Hertenstein (c. 1495-1522), 20⅝ x 15, 1517
Lady Lee (Margaret Wyatt), 16¾ x 12⅞ (Altman)
Lady Rich (Elizabeth Jenks, died 1558), 17½ x 13⅜ (Altman)
Edward VI, King of England (1537-1553), *when Duke of
 Cornwall,* 12¾ diam. (Bache)
Portrait of a Man in a Black Cap, 8 x 6⅛, 1520
Portrait of A Lady of the Court of Henry VIII, 11¾ x 9¾ (Bache)
Portrait of a Man, 12 diam., 1535 (Bache)
Derick Berck, 21 x 16¾, 1536 (Bache)
Portrait of a Member of the Wedigh Family, 16⅝ x 12¾, 1532
Portrait of a Man in a Red Cap, 5 diam.

Ohio
TOLEDO, The Toledo Museum of Art
A Lady of the Cromwell Family, 28⅜ x 19½, c. 1535-40

Texas
HOUSTON, The Museum of Fine Arts
Portrait of Sir Henry Guildford, 5½ diam. (Straus)

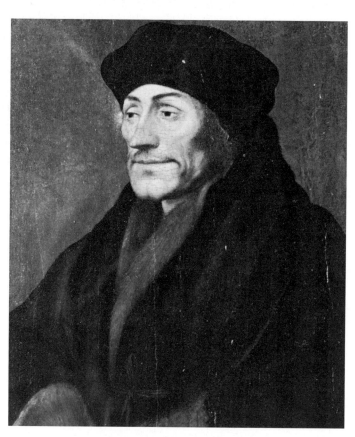

Hans Holbein • Erasmus
7 x 5½" • Ball State University, Muncie, Indiana

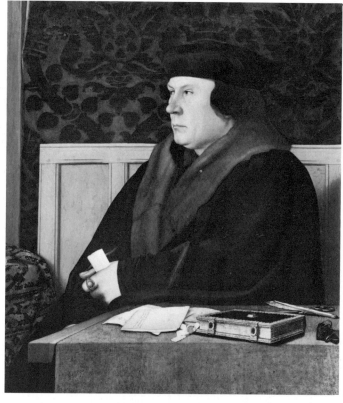

Hans Holbein • Thomas Cromwell
30⅞ x 25⅜" • The Frick Collection, New York City

Pieter de Hooch

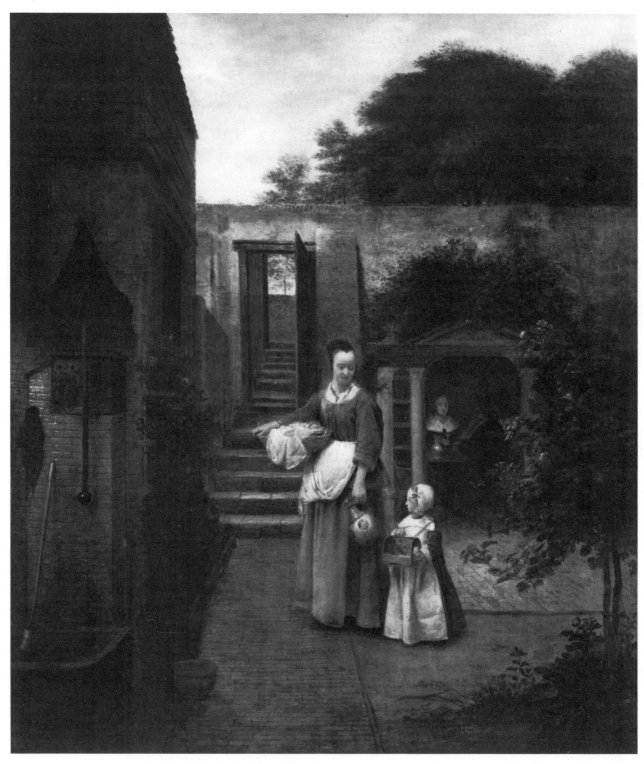

Pieter de Hooch • Woman and Child in a Courtyard
Canvas • 29 x 26″ • National Gallery of Art, Washington, D.C.
Widener Collection

Pieter de Hooch

1629–1683

Pieter de Hooch was born in Rotterdam a few years after the Dutch Republic was founded. Not much is known of his early life. He apparently wandered about Holland while studying painting, but he returned to Rotterdam to marry Jannetje van der Burch in 1654. He was a member of the painters' guild of Delft from 1655 to 1657. After 1668 he worked chiefly in Amsterdam, a follower of the Rembrandt school. Because of the extraordinary quality of light in many of his pictures, some of them have been confused with the work of Jan Vermeer.

Like Frans Hals, Pieter de Hooch was a Dutch portrait painter. But instead of individuals, he painted the portrait of Holland. It is largely due to the kind of painting in which he excelled that we know so much of the daily lives of these prosperous Dutch burghers of the seventeenth century. We know that they took unashamed delight in what a later century would derisively call "bourgeois pleasures." They had good reason.

As a people, they had added a new concept to Western civilization—the concept of a genuinely republican form of government, of a *laissez-faire* democracy. In the treaty of 1609, Holland threw off the yoke of Spanish tyranny with its heavy taxation and cruel religious persecution that had cost thousands of lives. At last the Dutch people owned themselves and their country, and they settled down to enjoy both. They found a fresh delight in everything about them—their rich black soil with its wide horizons emphasized by long vistas of canals and rivers; their solid brick houses with spotless, well-stocked kitchens and trim lawns; their position as the world's leading bankers; their Leiden and Utrecht universities; their leadership in map and book publishing. They had reason to be prouder than they appear in their pictures.

This is the Holland whose portrait Pieter de Hooch painted. He painted it with genuine sentiment instead of sentimentality; with a technique he inherited from the great Flemish masters of the centuries preceding; and with a fine eye for significant detail.

The Dutch version of the game called skittles could be reconstructed from de Hooch's painting in the Cincinnati Art Museum. A glance at *A Game of Skittles* would tell the historian of games that the Dutch of that period used nine pins placed in a square, with the crowned "king pin" in the center; that the players addressed the pins from an angle so they could possibly knock out the king pin without hitting the others; and that the Dutch used round balls instead of oval missiles as in other countries. (This is the game of ninepins, which the Dutch brought to America shortly before *A Game of Skittles* was painted and which is the ancestor of modern American bowling.)

Then, if the historian of games were not too engrossed in his research, he would see an interesting human relationship existing between the young man at the left and the couple at the right with the statue of Cupid placed suggestively behind them. He would also see the typical domestic architecture and landscape gardening of seventeenth-century Holland, as well as the fashion in clothes for a Sunday afternoon during the decade of 1660-70. In addition to these historical facts, he would see a group of ordinary people gathered together for a friendly exchange of ideas and gossip—a "bourgeois pleasure," perhaps, but still popular in most parts of the world.

Pieter de Hooch in America

California

LOS ANGELES

Los Angeles County Museum of Art
Woman Giving Money to Servant Girl, 28¾ x 26, c. 1670

University of Southern California, University Galleries
A Lady and Gentleman at Tea, 26½ x 33

District of Columbia

WASHINGTON
Corcoran Gallery of Art
The Greeting, 34 x 27½ (Clark)

National Gallery of Art
The Bedroom, 20 x 23½, c. 1660 (Widener)
A Dutch Courtyard, 26¾ x 23, c. 1656 (Mellon)
Woman and Child in a Courtyard, 29 x 36, c. 1660 (Weidener)

Hawaii
HONOLULU, Honolulu Academy of Arts
A Musical Conversation, 38⅝ x 45¼, 1674

Illinois
CHAMPAIGN, Krannert Art Museum
Dutch Interior, 14⅝ x 15⅛, c. 1670 (attrib. to)

Indiana
INDIANAPOLIS, Indianapolis Museum of Art
A Music Party, 36½ x 43¼

Massachusetts
BOSTON, Museum of Fine Arts
Interior of a Dutch House, 22¾ x 27½, 1656

PITTSFIELD, The Berkshire Museum
The Music Party, 26½ x 29½

Michigan
DETROIT, The Detroit Institute of Arts
Mother Nursing Her Child, 31½ x 23½, 1671-74

Missouri
ST. LOUIS, The St. Louis Art Museum
A Game of Skittles, 26¾ x 29, 1660-68

New York
NEW YORK CITY, The Metropolitan Museum of Art
Dutch Interior, 21¼ x 26¼
The Visit, 26¾ x 23 (Havemeyer)
Interior with a Young Couple, 21⅝ x 24¾ (Altman)
The Maidservant, 24¼ x 20½
Man and Woman in an Arbor, 17⅜ x 14¾
Paying the Hostess, 37¼ x 43¾

North Carolina
RALEIGH, North Carolina Museum of Art
The Fireside, 26⅜ x 30¼
Reveille, 18⅞ x 25⅝

Ohio
CINCINNATI
The Cincinnati Art Museum
Game of Skittles, 29⅛ x 26⅛, c. 1665

The Taft Museum
The Music Lesson, 27⅞ x 22⅞

CLEVELAND, The Cleveland Museum of Art
The Music Party, 39½ x 47⅞, c. 1665

TOLEDO, The Toledo Museum of Art
Courtyard, Delft, 26¾ x 22⅝, late 1650s
Interior, 20⅝ x 23⅞, c. 1660

Pennsylvania
PHILADELPHIA, Philadelphia Museum of Art
Interior with Figures, 32 x 39, 1675 (attrib. to) (Wilstach)

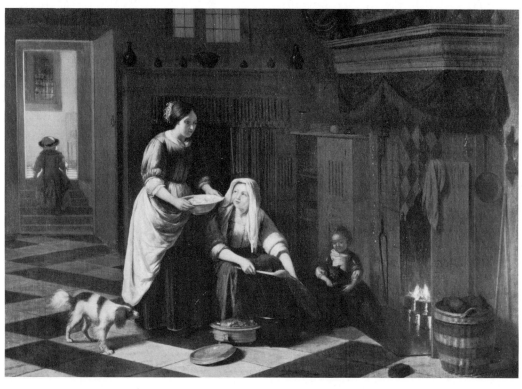

Pieter de Hooch • The Fireside
Canvas • 25¼ x 30¼″ • North Carolina Museum of Art, Raleigh

Sir Thomas Lawrence

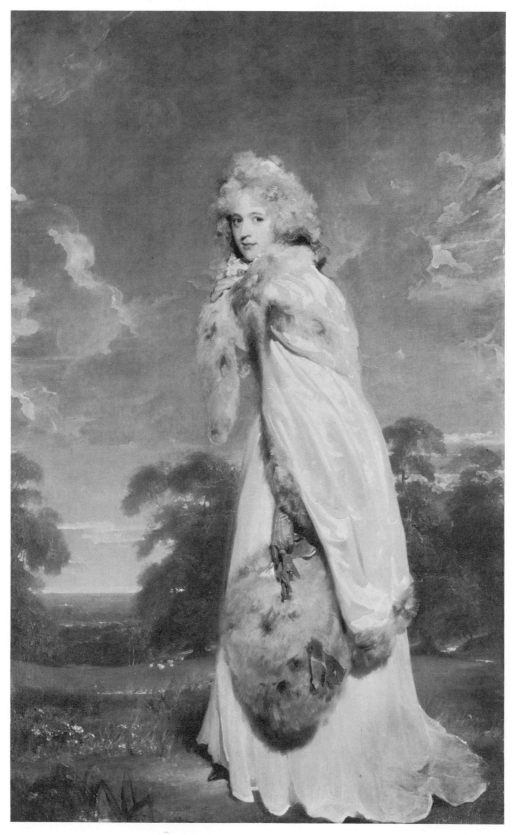

Thomas Lawrence • Elizabeth Farren, *later* Countess of Derby
Oil on canvas • 94 x 57½″ • The Metropolitan Museum of Art, New York City
Bequest of Edward S. Harkness

Sir Thomas Lawrence

1769–1830

Thomas Lawrence was born in Bristol, England, the son of an impecunious innkeeper, first in Bristol and then at the nearby village of Devizes on the Bath road. It was at Devizes's Black Boar Inn at the age of six that the precocious Thomas began making drawings of the guests, which his father sold to them for as much as one guinea each. But the Black Boar failed, and in 1780 the family moved to Bath, where it depended on the boy's increasing facility with portrait drawing for support. Almost entirely self-taught, Lawrence took a self-portrait sketch to London in 1787 and showed it to Sir Joshua Reynolds, who told him, "You have been looking too much at old masters. My advice to you is: study nature." So Lawrence entered the school of the Royal Academy, where his first oil was exhibited in 1788. He then received a commission to paint a portrait of the Queen (Charlotte Sophia, wife of George III), which he exhibited in 1789 at the Academy together with a portrait of the famous actress, Elizabeth Farren (now at the Metropolitan Museum). Immediately, his future was assured. For the remainder of his life he was never without a commission. He became "painter in ordinary" to the king in 1792, an academician in 1794, was knighted in 1815, sent to Europe in 1818 by the prince regent to paint portraits of heads of state and military leaders, and in 1820 became president of the Royal Academy. He never married but is reported to have had many love affairs, including some with the daughters of Mrs. Siddons, another famous actress whose portrait by Lawrence hangs in the Fogg Museum in Cambridge, Massachusetts.

Two of the world's most famous paintings of children hang in the Huntington Library at San Marino, California. They are Gainsborough's *Blue Boy* and Lawrence's *Pinkie*; both were commissioned by prosperous English families during the eighteenth century and brought across the Atlantic in the twentieth for the art and rare book collection of the financier, Henry E. Huntington.

The subject of the portrait known as *Pinkie* was Sarah Barrett Moulton, daughter of an English planter in Jamaica. She was born there in 1783, and ten years later was sent to England to be educated and have her portrait painted. On November 16, 1793, her grandmother wrote to a niece in Richmond Hill, near London:

"I become every day more desirous to see my dear little Pinkey; but as I cannot gratify myself with the Original, I must beg this favor of You to have her picture drawn at full length by one of the best Masters in an easy Careless attitude."

The selection of "one of the best Masters" was simplified at the time by the announcement of young Thomas Lawrence's election as full academician at the Royal Academy, where he had received acclaim in 1790 with his portrait of Queen Charlotte. Lawrence apparently began work on the portrait of *Pinkie* soon after the letter arrived from Jamaica, for he exhibited it at the Academy in the spring of 1795, after which it passed into family hands where it remained until 1910, when it was sold to a London art dealer. Pinkie herself did not live to see her finished portrait; she died of consumption on April 23, 1795, shortly before the exhibition opened.

There is certainly no hint of illness in Lawrence's portrait. The serious young face looks directly at the viewer with complete assurance. The position of the arms, the ribbons and dress billowing in the breeze, the rosy cheeks—all suggest healthy, vibrant youth. Instead of a drab studio backdrop, Lawrence has placed her on an imagined hilltop, against flying clouds and over a low horizon to give plenty of air and space.

The brushwork fits the mood of the picture. Instead of the satiny smooth paint of most of Lawrence's later pictures, it is crisp, fresh, and sparkling. It seems to express the artist's own joy at being twenty-five years old and at the be-

ginning of his career. Lawrence was to paint many famous people and their children during the next thirty-six years, but the lively quality of the paint in *Pinkie* makes it safe for us to assume that he enjoyed painting none of them more than he did Sarah Barrett Moulton.

Sir Thomas Lawrence in America

Alabama
BIRMINGHAM, Birmingham Museum of Art
Portrait of Mrs. Lamb, 29⅞ x 24¾

Arizona
TUCSON, The University of Arizona Museum of Art
Portrait of Mrs. Billington, 29¼ x 24¼

California
LOS ANGELES, Los Angeles County Museum of Art
Portrait of Arthur Atherley as an Etonian, 49½ x 39½, 1790-91

SAN FRANCISCO, The Fine Arts Museums of San Francisco
Lord Seaham as a Boy, 50¼ x 40⅛

SAN MARINO, The Huntington Art Gallery
Emily Anderson: "Little Red Riding Hood," 62¼ x 44, 1821
Mrs. Cunliffe-Offley, 49½ x 39½, 1809
Sarah Barrett Moulton ("Pinkie"), 57½ x 39¼, 1794

Connecticut
HARTFORD, Wadsworth Atheneum
Benjamin West, 107 x 69½, 1820-21
Lady St. John as "Hebe," 95¼ x 57, 1808

NEW HAVEN, Yale University Art Gallery
Portrait of the Duke of Wellington, 50⅜ x 40⅜ (attrib. to)

District of Columbia
WASHINGTON
National Collection of Fine Arts, Smithsonian Institution
Portrait of Mrs. Towry, 30¾ x 25⅜ (Johnson)

National Gallery of Art
Lady Templetown and Her Son, 84¾ x 58⅝, c. 1801 (Mellon)
Lady Robinson, 50 x 40, c. 1827 (Widener)
Marquis of Hertford, 50⅝ x 40¼, c. 1825

Illinois
CHICAGO, The Art Institute of Chicago
Mrs. Jens Wolff, 50⅜ x 40¼, 1803, 1815
The Marchioness of Ely, 30¾ x 25¾, c. 1810
The Hon. George Canning, M.P., 36 x 28
Lady Mary Bentinck, 24½ x 20⅛, c. 1805

Indiana
INDIANAPOLIS, Indianapolis Museum of Art
Portrait of a Lady, 25 x 30

Kentucky
LOUISVILLE, The J. B. Speed Art Museum
Susan, Countess of Guilford and Her Daughter Lady Georgina North, 81¼ x 57, 1812

Louisiana
NEW ORLEANS, New Orleans Museum of Art
Lady Anne Gore, 30 x 25½, early 19th cent.
Portrait of William Fleischer, 30 x 25, early 19th cent.

Maine
BRUNSWICK, Bowdoin College Museum of Art
Double Portrait of Two Ladies, 48¾ x 37½

Massachusetts
BOSTON, Museum of Fine Arts
William Lock of Norbury, 28¾ x 24

Sir Uvedale Price, 30 x 25
Man in a Blue Coat, 29¾ x 25

CAMBRIDGE, Fogg Art Museum, Harvard University
Napoleon II, King of Rome, Duke of Reichstadt, 22¾ x 19¼ (sight), 1819
Portrait of Sir Walter James and Charles Stewart Hardinge, 49 x 39
Portrait of Mirza Abdul Hassan Khan, 35⅛ x 27⅛ (sight), 1810
Portrait of Francis Moore, 30 x 25
Portrait of Mrs. Siddons, 29 x 23¼, 1797

NORTHAMPTON, Smith College Museum of Art
Portrait of the Honorable John Kennedy (framed) 37⁵/₁₆ x 32⁵/₁₆

PITTSFIELD, The Berkshire Museum
Lady Burdette, 80 x 49

WILLIAMSTOWN, Sterling and Francine Clark Art Institute
The Hon. Caroline Upton, 27½ x 22⁹/₁₆, c. 1800

WORCESTER, Worcester Art Museum
Mr. and Mrs. James Dunlop, 106½ x 70⅞, 1825

Michigan
DETROIT, The Detroit Institute of Arts
Portrait of Ewan Law, 30 x 25

Minnesota
MINNEAPOLIS, The Minneapolis Institute of Arts
Portrait of Frederick John Robinson, First Earl of Ripon, 36 x 28

Missouri
KANSAS CITY, The Nelson Gallery and Atkins Museum
Mrs. William Lock of Norbury, 30 x 24½, 1827-29
Portrait of a Woman, 33¼ x 26½

ST. LOUIS, The St. Louis Art Museum
General James Stuart, 50³/₁₆ x 39¹⁵/₁₆
Portrait of General Sir Galbraith Lowry Cole, 30 x 25, c. 1811

New Jersey
PRINCETON, The Art Museum, Princeton University
Louisa Catherine Caton, 27¾ x 35¾, c. 1817

New York
BUFFALO, The Albright-Knox Art Gallery
Miss Rosamond Croker, 30 x 25

NEW YORK CITY
The Brooklyn Museum
Portrait of Miss Caroline Fry, 29⅞ x 25

The Frick Collection
Julia, Lady Peel, 35¾ x 27⅞, 1827
Miss Louisa Murray, 36½ x 28⅞, after 1827

The Metropolitan Museum of Art
Elizabeth Farren, later Countess of Derby (c. 1759-1829), 94 x 57½
Rev. William Pennicott (1726-1811), 30 x 25
John Julius Angerstein (1735-1823), 50⅜ x 40⅝
Lady Anne Ellenborough (Anne Towry, died 1843), 30⅛ x 25¼
The Calmady Children (Emily, 1818-1906, and Laura Anne, 1820-1894), 30⅞ x 30⅛

Thomas Lawrence • Portrait of Mrs. Siddons
Oil on canvas • 29 x 23¼"
Fogg Art Museum, Harvard University, Cambridge, Massachusetts
Gift of Sydney J. Freeberg

Lady Harriet Maria Conyngham, later Lady Somerville
(died 1843), 36¼ x 28¼
John Julius Angerstein (1735-1823), 36 x 28

ROCHESTER, Memorial Art Gallery of the University of Rochester
Portrait of Admiral Frank Sotheran, 49½ x 39, c. 1809 (Eastman)

North Carolina
RALEIGH, North Carolina Museum of Art
Antonio Canova, 36 x 28
Mrs. John Halkett, 91 x 57
Lady Louisa Harvey and Her Children, 94 x 59
Sir Charles Lowther, 51 x 40

Ohio
CINCINNATI, The Cincinnati Art Museum
Portrait of Mrs. Francis Gregg and Master George Gregg, 50 x 40
Lady Beauchamp, 30 x 25
Portrait of Master Tucker, 36 x 28

CLEVELAND, The Cleveland Museum of Art
The Daughters of Colonel Thomas Carteret Hardy, 50¾ x 40⅝, 1801
Lady Louisa (Tollemache) Manners, later Countess of Dysart, as Juno, 100½ x 62⅜

COLUMBUS, The Columbus Museum of Art
Male Portrait, 30 x 25, c. 1810
Mr. Bolland, 49¾ x 40½, c. 1810

TOLEDO, The Toledo Museum of Art
Sophia, Lady Valletort, 30 x 25, c. 1790
Sir Thomas Frankland, 30⅛ x 25⅛, c. 1810-15
Lady Arundell, 50 x 40, c. 1812
Lord Amherst, 93 x 57½, 1821

Oklahoma
TULSA, The Philbrook Art Center
Master Bloxham, 21⅞ x 16¾
Portrait of a Lady, 17¼ x 15 (attrib. to)

Rhode Island
PROVIDENCE, Museum of Art, Rhode Island School of Design
Portrait of Lady Sarah Ingestere, 92 x 55½

John Philip Kemble as the "Stranger," 9½ x 7½
Mrs. Wolff (drawing), 8¾ x 9½, c. 1815

South Carolina
COLUMBIA, Columbia Museums of Art and Science
Unknown Gentlemen, 28 x 23⅝

Tennessee
MEMPHIS, Brooks Memorial Art Gallery
Portrait of a Gentleman, 16 x 14

Texas
DALLAS, Dallas Museum of Fine Arts
Lady Charles Burnaby, 29 x 24

FORT WORTH, Kimbell Art Museum
Frederick H. Hemming, 30 x 25⅜, c. 1824-25
Mrs. Frederick H. Hemming, 30 x 24½, c. 1824-25

Virginia
NORFOLK, Chrysler Museum at Norfolk
Portrait of Richard Cardwell, 51 x 42
Countess of Loudon, 93 x 61

RICHMOND, Virginia Museum
Edward Morris, Esq., 30 x 25
Portrait of Mrs. Sinclair, 36 x 28
Mrs. Raikes and Daughter, 94½ x 58½, c. 1804

Canada

British Columbia
VANCOUVER, Vancouver Art Gallery
Sir John McMahon, 36⅛ x 28⅛, 1814

Ontario
TORONTO, Art Gallery of Ontario
Lady Annesley and Child, 40 x 32¼

Quebec
MONTREAL, Montreal Museum of Fine Arts
Portrait of a Lady, 21 x 17
Portrait of Miss Harriet Maria Day, 30⁵/₁₆ x 25⅛
Portrait of Viscountess Castlereagh, 29¾ x 24½

Thomas Lawrence • Marquis of Hertford
Canvas • 50⅝ x 40¼ "
National Gallery of Art, Washington, D.C.
Gift of G. Grant Mason, Jr.

Hans Memling

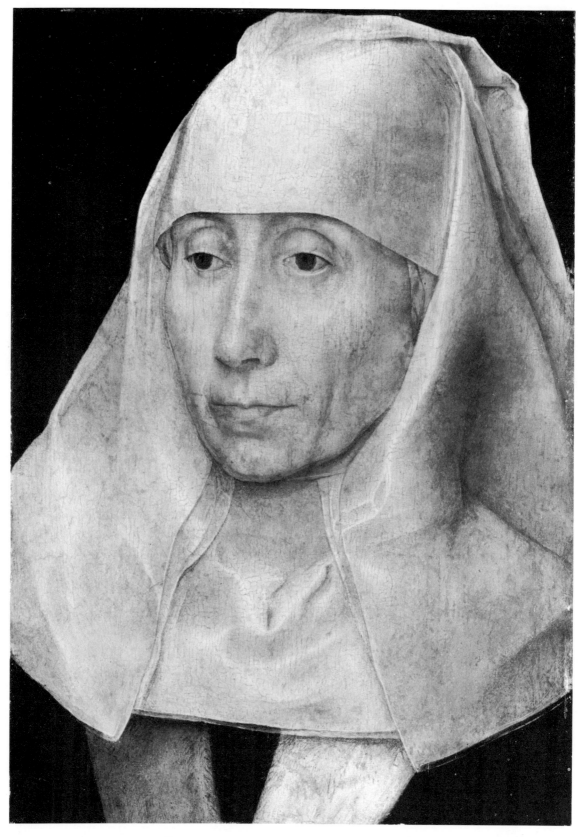

Hans Memling • Portrait of an Old Woman
Oil on wood • 10⅛ x 7″ • The Museum of Fine Arts, Houston, Texas
Edith A. and Percy S. Straus Collection

Hans Memling

1430/5–1494

Hans Memling was born in the German village of Seligenstadt, near Frankfurt, but about 1467 he moved to the Flemish city of Bruges, where he is thought to have studied with Rogier van der Weyden, and where in 1468 his name appeared as a free master in the painters' guild. He also married in Bruges and became one of its most popular and prosperous painters. In 1480 his name was mentioned as being among the richest taxpayers of the city. He painted altarpieces donated by the wealthy burghers of Bruges and also portraits of the burghers themselves and their Italian bankers, such as Tommaso Portinari, whose portrait now hangs in the Metropolitan Museum of Art. His altarpiece, *The Adoration of the Magi,* in the museum of Saint John's Hospital in Bruges is of particular interest to the readers of this book, for one of its outside wings bears a picture of St. Veronica, a version of which Memling had painted earlier, and which is now in the National Gallery in Washington. It is one of 26 Memling paintings in American public collections and according to the inventory of the Centre National de Recherches Primitifs Flamands, one of 250 belonging to the Memling group. Memling's popularity during his own lifetime surpassed even that of Jan van Eyck, and when the trustees of his will appeared before the court of wards at Bruges in 1495 it was recorded that he had left behind several children and considerable property.

The legend of St. Veronica dates back to Biblical times, but it did not become popular in Europe until the end of the Middle Ages, when Hans Memling painted this picture. The legend traditionally placed Veronica, a pious woman of Jerusalem, on the road to Calvary, when she saw Christ suffering under the weight of the cross. Moved to pity, she gave him her kerchief to wipe his brow, and when he returned it an impression of his face was miraculously left upon it. In the twelfth century this image began to be identified with one preserved in Rome, and in popular speech the image itself was also called Veronica, from the words *vera* and *icon*—"true image."

Memling has painted the saint in a Flemish landscape surrounded by the flowers that were named after her—(veronica or speedwell). In the background are various recognizable buildings of Bruges, one of the most important business centers of the world at the end of the fifteenth century. As in most Flemish cities, its buildings were of brick and sandstone; its streets were paved; distribution of drinking water was assured at numerous intersections; and luxury merchandise was abundant.

Among the luxury items were the Flemish textiles that were prized all over Europe in the fifteenth century: tapestries, embroidery, and woolens such as the rich blue fabric used by Memling to drape the figure of St. Veronica. He has painted it in the northern Gothic style of his day. The folds of cloth are crisp and angular, compared to the flowing robe of *The Alba Madonna* painted by Raphael about thirty years later in Renaissance Italy. The Renaissance was still to come to northern Europe, to be expressed in paint by a later Flemish artist, Peter Paul Rubens.

Hans Memling in America

California

PASADENA, Norton Simon Museum of Art
The Blessing Christ, 15⅛ x 11¼, 1478

SAN DIEGO, San Diego Museum of Art
Young Man with Folded Hands, 15⅜ x 11¾, c. 1470

District of Columbia

WASHINGTON, National Gallery of Art
The Presentation in the Temple, 23½ x 19, c. 1463 (Kress)
St. Veronica, 12¼ x 9½, c. 1480 (Kress)

Illinois

CHICAGO, The Art Institute of Chicago
Madonna and Child with Donor (diptych): 13½ x 10½ and
13¾ x 10⅝, c. 1485
King David and Boy, 10 x 7¾, c. 1485

Indiana

SOUTH BEND, Notre Dame University Art Gallery
Virgin and Child with Two Angels, 13½ x 9¾ (attrib. to)

Massachusetts

WILLIAMSTOWN, Sterling and Francine Clark Art Institute
The Canon Gilles Joye, 12⅜ x 8¾; (with engaged frame),
14¹³⁄₁₆ x 11⁷⁄₁₆, 1472

Missouri

KANSAS CITY, The Nelson Gallery and Atkins Museum
Madonna and Child Enthroned, 28½ x 19½

New York

NEW YORK CITY
The Frick Collection
Portrait of a Man, 13⅛ x 9⅛

The Metropolitan Museum of Art
Virgin Suckling the Child, 9¾ diam.
Portrait of an Old Man, 10⅜ x 7⅝
The Annunciation, 73¼ x 45¼
Woman with a Pink, 17 x 7¼
Tommaso Portinari (c. 1432-1501), 17⅜ x 13¼
Maria Maddalena Baroncelli, Wife of Tommaso Portinari
(born 1456), 17⅜ x 13⅜
Marriage of St. Catherine, 27 x 28⅞
Virgin and Child, 9½ x 7
Salvator Mundi, 10¾ diam.
Portrait of a Woman, 10¼ x 8¼

North Carolina

RALEIGH, North Carolina Museum of Art
Christ on the Cross, 17¼ x 10½

Ohio

CINCINNATI, The Cincinnati Art Museum
St. Christopher, 19 x 6⅝
St. Stephen, 18⅞ x 6⅝

South Carolina

GREENVILLE, Bob Jones University Art Gallery and Museum
Madonna and Child, 13⅞ x 9¼

Texas

HOUSTON, The Museum of Fine Arts
Portrait of an Old Woman, 10⅛ x 7 (Straus)

Canada

Ontario

OTTAWA, The National Gallery of Canada
The Virgin and Child with St. Anthony Abbot and a Donor,
36½ x 21⅛, 1472

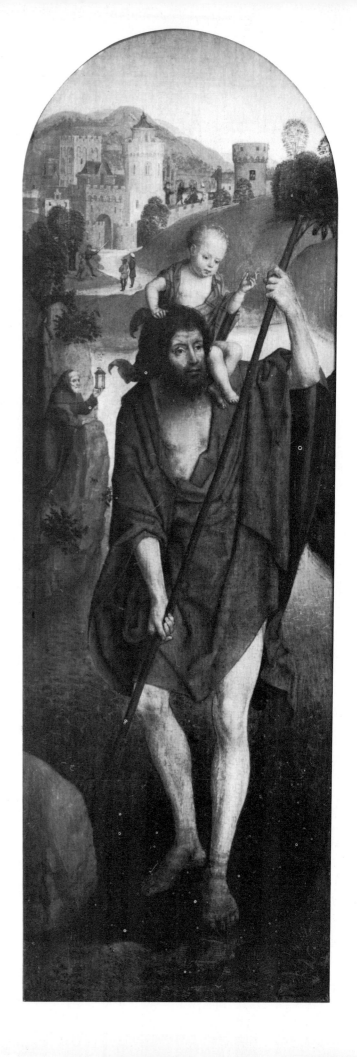

Hans Memling • St. Christopher
19 x 6⅝" • Cincinnati Art Museum
Cincinnati, Ohio
Gift of Mrs. E. W. Edwards

Bartolomé Esteban Murillo

Bartolomé Esteban Murillo • Jacob's Dream
Oil on canvas • 23 x 15⅜"
The J. B. Speed Art Museum, Louisville, Kentucky • Satterwhite Fund

Bartolomé Esteban Murillo

1617–1682

Bartolomé Esteban Murillo was born of poor parents in Seville. His father, an artisan, being impressed by the quality of his son's youthful drawings, placed him under the care of Juan del Castillo, a minor painter and distant relative. The death of his parents and Castillo's removal to Cadiz in 1639 forced Bartolomé to support himself by painting pictures, which he sold at the Seville fair. By this means he saved enough money to go to Madrid, where Velásquez befriended him and enabled him to study the fabulous royal collection of paintings now in the Prado Museum. Velásquez also urged him to visit Italy, but instead Murillo returned to his native Seville, where he spent the remainder of his highly productive life. Fame came to him suddenly with a series of eleven paintings which he executed in 1645-46 for the convent of San Francisco in Seville, one of which is reproduced here. From that date he was never lacking in commissions from the churches and the deeply religious citizens of Andalusia. He died in Seville from injuries received when he fell from a scaffold while painting a picture for the Capuchin church of Cadiz.

Murillo was a true native of Seville, a city famed not only for its gaiety and wit, but also for its cathedral (exceeded in size only by St. Peter's in Rome) and for its splendid church festivals. It is not surprising that of the many Murillo paintings on public view in America the majority are of religious subjects. The painting of *Blessed Giles Before Pope Gregory IX* in the North Carolina Museum of Art in Raleigh is one of the most interesting of these; with it and ten others of a series he painted for a convent in Seville, the twenty-eight-year-old Murillo established himself as the leading Spanish painter after Velásquez.

The painting shows the Blessed Giles (not to be confused with St. Giles, patron saint of cripples) standing in a transport of ecstasy before Pope Gregory, who had come to Perugia especially to consult with him. The inscription at the bottom reads: "There flourished in sanctity Giles, and Gregory the 9th went to Perugia to speak to him. Brother Giles visited him, being full of humility and loving obedience. He was afraid to enter, and finally entered the cloister for good. Sensing the Pope's tremendous faith and love, he stood transfixed in his presence in a divine ecstasy."

Giles, the most intimate associate of St. Francis of Assisi, had received his habit from the saint in 1209 and had become famed for his holy wisdom. The story of his ecstasy on seeing the pope, and the latter's deeply felt reaction, was a popular one with the order, and so its inclusion was natural in the series which the Franciscan monks of Seville commissioned Murillo to paint. The series was removed by the French soldiers when they entered Seville in 1810 and is now scattered.

The North Carolina picture reveals Murillo's extraordinary skill in unifying several figures in a large painting. The five men are by necessity divided into two groups: the pope and his cardinals, and the two monks. The problem was to keep them divided and yet express the strong emotion felt by both Gregory and Giles on meeting each other. The rich red carpet, of course, connects them. But more important is the simple fact that none of the three witnesses to this experience between two men is looking at either of them. The two cardinals and the other monk look at each other, thus uniting themselves while drawing attention to the principal actors in the scene. Gregory and Giles are left alone, together with their emotions.

Bartolomé Esteban Murillo in America

California
PASADENA, Norton Simon Museum of Art
Birth of St. John, 57¾ x 74, 1655
St. Thomas Giving Alms, 51¼ x 29½, 1678

SAN DIEGO
San Diego Museum of Art
Mary Magdalen, 63 x 41⅜

Timken Art Gallery, San Diego
Christ on the Cross, 81½ x 43½

Connecticut
HARTFORD, Wadsworth Atheneum
St. Francis Xavier, 86⁵/₁₆ x 63⅞

District of Columbia
WASHINGTON, National Gallery of Art
A Girl and Her Duenna, 49⅜ x 41, c. 1665-75
The Return of the Prodigal Son, 93 x 102¾, 1670-74

Florida
WEST PALM BEACH, Norton Gallery of Art
St. Thomas Dividing His Clothes Among Beggar Children, 10¼ x 14¼

Illinois
CHAMPAIGN, Krannert Art Museum
Christ After the Flagellation, 50⅛ x 57½
Madonna and Child, 13⅜ x 8½

CHICAGO, The Art Institute of Chicago
Christ and St. John the Baptist, 104 x 68¼, c. 1655

Indiana
INDIANAPOLIS, Indianapolis Museum of Art
Boy Blowing Bubbles, 26½ x 20

Kentucky
LOUISVILLE, The J. B. Speed Art Museum
Jacob's Dream, 23 x 15⅝

Maryland
BALTIMORE, The Walters Art Gallery
Immaculate Conception, 98½ x 70¼ (Murillo and assistants)

Massachusetts
BOSTON, Museum of Fine Arts
Christ After the Flagellation, 44¼ x 58
The Good Shepherd, 21½ x 15¾

CAMBRIDGE, Fogg Art Museum, Harvard University
The Holy Family, 47 x 43
The Dream of St. Joseph (drawing), 4¹¹/₁₆ x 4⅞

PITTSFIELD, The Berkshire Museum
St. Francis, 48 x 35

WILLIAMSTOWN, Sterling and Francine Clark Art Institute
Fray Julian's Vision of the Ascension of the Soul of King Philip II, 66¹⁵/₁₆ x 73⅝, 1645-48

Michigan
DETROIT, The Detroit Institute of Arts
The Flight into Egypt, 81¾ x 61½
Jacob and Rachel, 30¾ x 41½
St. Francis Xavier, 22½ x 18½
Portrait of a Gentleman, 19 x 15

Missouri
KANSAS CITY, The Nelson Gallery and Atkins Museum
The Little Conception, 53¾ x 46

ST. LOUIS, The St. Louis Art Museum
Portrait of a Man, 22¾ x 19½

New York
ELMIRA, Arnot Art Museum
?The Infant Christ Sleeping, 25 x 21

NEW YORK CITY, The Metropolitan Museum of Art
Don Andrés de Andrade y la Cal, 79 x 47
Virgin and Child, 65¼ x 43
Crucifixion, 20 x 13
Pedro Nuñez de Villavicencio (1644-1700)?, 77 x 43¾

North Carolina
RALEIGH, North Carolina Museum of Art
Esau Selling His Birthright, 33¾ x 40⅜
Blessed Giles Before Pope Gregory IX, 65⅝ x 73⅜
The Sposalizio, 97¾ x 62⅛

Ohio
CINCINNATI, The Cincinnati Art Museum
St. Thomas of Villanueva Dividing His Clothes Among Beggar Boys, 86½ x 58½

CLEVELAND, The Cleveland Museum of Art
The Immaculate Conception, 86⅞ x 50¼
Laban Searching for His Household Gods in Rachel's Tent, 95½ x 142½

TOLEDO, The Toledo Museum of Art
The Adoration of the Magi, 75⅛ x 57½, c. 1655-60

Oklahoma
TULSA, The Philbrook Art Center
A Madonna, 33 x 30 (attrib. to)

Oregon
PORTLAND, Portland Art Museum
The Virgin of Belen, 21½ x 16½

Rhode Island
PROVIDENCE, Museum of Art, Rhode Island School of Design
Monk's Head, 13 x 19¹¹/₁₆

South Carolina
COLUMBIA, Columbia Museums of Art and Science
Joseph and the Christ Child, 33¼ x 24¼

GREENVILLE, Bob Jones University Art Gallery and Museum
The Heavenly Shepherd, 41⅞ x 32⅝
Scene of Charity, 65¾ x 43

Texas
FORT WORTH, Kimbell Art Museum
The Immaculate Conception, 66¼ x 42⅞, early 1670s

HOUSTON, The Museum of Fine Arts
Virgin of the Annunciation, 28½ x 22½, 1670-80 (Kress)

Virginia
RICHMOND, Virginia Museum
The Magdalen, 65¼ x 42¾ (attrib. to)

Canada

Ontario
OTTAWA, The National Gallery of Canada
Abraham and the Three Angels, 93 x 103, c. 1673-74
Two Franciscan Monks, 65⅜ x 42¾, 1645-46
The Immaculate Conception, 12¼ x 10⅛

Nicolas Poussin

Nicolas Poussin • Moses Sweetening the Waters of Marah
Oil on canvas • 60 x 82½″ • The Baltimore Museum of Art

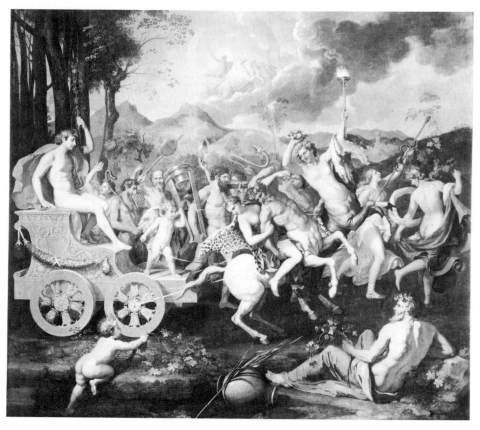

Nicolas Poussin • Triumph of Bacchus
Oil on canvas • 50½ x 59½″ • Atkins Museum of Fine Arts, Kansas City, Missouri
William Rockhill Nelson Fund

Nicolas Poussin

1593/4–1665

Nicolas Poussin was born in the town of Les Andelys in northwestern France. His early drawings attracted the attention of a local artist, with whom he studied until he went to Paris in 1612. There he saw his first engravings after the Italian masters and immediately decided to go to Italy. After several disappointments he finally reached Italy in 1624 and was presently established in the house of a fellow painter, Gaspard Dughet, whose sister he married in 1629. Later Poussin legally adopted Gaspard, who then assumed the name of Gaspard Poussin. Among Poussin's first patrons in Italy was Cardinal Barberini, for whom he painted the *Death of Germanicus.* In 1640 he returned to Paris and was appointed "first painter in ordinary" by Louis XIII. He also was commissioned by Cardinal Richelieu to paint *The Triumph of Truth,* now in the Louvre. After two years in Paris, however, Poussin became annoyed with court intrigue and returned to Rome, where he spent the remainder of his productive life.

Sir Joshua Reynolds once remarked that "Poussin was better acquainted with the ancients than with those who surrounded him." It is true that nearly one-third of Poussin's approximately 350 paintings deal with Greek and Roman mythology, such as the *Triumph of Bacchus,* in Kansas City, and the *Triumph of Neptune and Amphitrite,* in Philadelphia. Italy was the model of the French court during the seventeenth century, and Poussin's classical pictures in the grand style, most of which were painted in Italy, were exactly to the court's taste.

Poussin never painted a landscape from nature. He made sketches as he walked about the environs of Rome and indicated the colors and tones with red chalk. These he took back to his studio, where he carefully designed and planned his picture before he began painting.

"There must first be arrangement," he once wrote, "then ornament, grace, animation, truth, and judgment everywhere. The last two qualities belong to the painter and cannot be taught. They are like Virgil's golden bough which no man can find or gather unless guided by Fate."

In addition to being an exciting picture in itself, Poussin's *Selene and Endymion* in Detroit is an admirable illustration of his theories. It tells Ovid's story of Selene, the moon goddess, and her nocturnal love for the shepherd Endymion, who was condemned to sleep eternally on a mountainside, but where Selene could come and visit him each night and leave again with the dawn. Poussin tells this charming story in a style as classic as its source. In fact, one suspects him of choosing the incident because of its possibilities for magnificent effects: the golden splendor of Apollo's chariot; the clear, cool blue of early morning; the half-draped figures gleaming like Greek marbles.

These various elements are all "arranged" in the best Italian Renaissance tradition around a flat **X** that holds them all together. Endymion's knee and thigh start the diagonal from left to upper right, which is continued in the man's sleeping form. The shepherd's arms and hands suggest the opposite diagonal, repeated in the figure drawing back the curtain of night, and in the plunging horses. The colors, too, are balanced. Selene wears a white gown with a brilliant yellow-gold girdle, a color repeated diagonally across the canvas in the gold of the chariot. Endymion, in front of her, wears a robe of pale violet, and across the picture, part of Apollo's costume is also violet-red. Here is "ornament, grace, animation, truth, and judgment everywhere."

Nicolas Poussin in America

California
MALIBU, The J. Paul Getty Museum
St. John Baptizing the People, 37⁵/₆ x 47⁵/₆, late 1630s

PASADENA, Norton Simon Museum of Art
Camillus and the Schoolmaster of Palerii, 13⅞ x 52⅜, 1635

Connecticut
HARTFORD, Wadsworth Atheneum
The Crucifixion, 58½ x 86, 1646

District of Columbia
WASHINGTON, National Gallery of Art
Holy Family on the Steps, 27 x 38½, 1648 (Kress)
The Baptism of Christ, 37⅝ x 47⅝, 1641-42 (Kress)
The Feeding of the Child Jupiter, 46⅛ x 61⅛, c. 1640 (Kress)
The Assumption of the Virgin, 52⅞ x 38⅝, c. 1626

Florida
SARASOTA, John and Mable Ringling Museum of Art
Holy Family with the Infant St. John, 76 x 50½, c. 1650

Illinois
CHICAGO, The Art Institute of Chicago
St. John on Patmos, 40 x 53½, c. 1650

Maryland
BALTIMORE, The Baltimore Museum of Art
Moses Sweetening the Waters of Marah, 60 x 82½, c. 1627-28

Massachusetts
BOSTON, Museum of Fine Arts
Achilles on Skyros, 38 x 51
Mars and Venus, 61 x 84

CAMBRIDGE, Fogg Art Museum, Harvard University
The Holy Family, 38½ x 51, 1650-51
The Infant Bacchus Entrusted to the Nymphs, 46½ x 69½, 1657
The Presentation in the Temple (drawing), 6¼ x 4¾
The Infant Bacchus Entrusted to the Nymphs (drawing), 9 x 14¾

WORCESTER, Worcester Art Museum
Flight in Egypt, 40½ x 50¼, 1626-28

Michigan
DETROIT, The Detroit Institute of Arts
Selene and Endymion, 48 x 66½, 1635
The Holy Family, 27 x 17½, 1641

Minnesota
MINNEAPOLIS, The Minneapolis Institute of Arts
The Death of Germanicus, 58¼ x 78

Missouri
KANSAS CITY, The Nelson Gallery and Atkins Museum
Triumph of Bacchus, 50½ x 59½

New York
NEW YORK CITY, The Metropolitan Museum of Art
The Rape of the Sabine Women, 60⅞ x 82⅝

Midas Bathing in the River Pactolus, 38⅜ x 28⅝
St. Peter and St. John Healing the Lame Man, 49½ x 65
The Blind Orion Searching for the Rising Sun, 46⅞ x 72
The Companions of Rinaldo, 46½ x 40¼

Ohio
CLEVELAND, The Cleveland Museum of Art
The Return to Nazareth, 52 x 38¾

TOLEDO, The Toledo Museum of Art
The Holy Family with St. John, 66¾ x 47½, c. 1627
Mars and Venus, 62 x 74¾, c. 1633-34

Pennsylvania
PHILADELPHIA, Philadelphia Museum of Art
Triumph of Neptune and Amphitrite, 42½ x 58½, c. 1640 (Elkins)
Baptism of Christ, 37⅞ x 53⅜ (Johnson)

Rhode Island
PROVIDENCE, Museum of Art, Rhode Island School of Design
Venus and Adonis, 29¾ x 39½
Death of Socrates (drawing), 12¹/₁₆ x 10¹/₁₆
Combat of Three Men (drawing), 6½ x 6⅜

South Carolina
GREENVILLE, Bob Jones University Art Gallery and Museum
The Holy Family, 28 x 22¼
The Grateful Father, 21 x 17½

Virginia
RICHMOND, Virginia Museum
Achilles on Skyros, 39½ x 52½, 1656

Canada

Ontario
OTTAWA, The National Gallery of Canada
Landscape with a Bather, 45 x 69, 1650
The Martyrdom of St. Erasmus, 39 x 29¼, c. 1628
Cupid and Four Sea-horses (drawing), 5¹³/₁₆ x 6¼ (attrib. to)

TORONTO, Art Gallery of Ontario
Venus, Mother of Aeneas, Presenting Him with Arms Forged by Vulcan, 42 x 52½, c. 1635

Quebec
MONTREAL, Montreal Museum of Fine Arts
Man Pursued by a Snake, 25½ x 29⅞, 1643-44

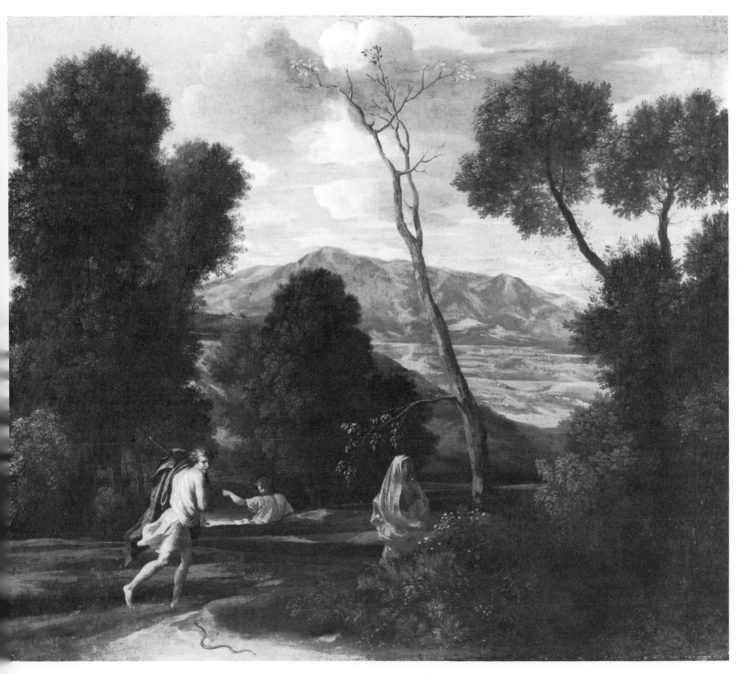

Nicolas Poussin • Man Pursued by a Snake
Oil on canvas • *The Montreal Museum of Fine Arts*

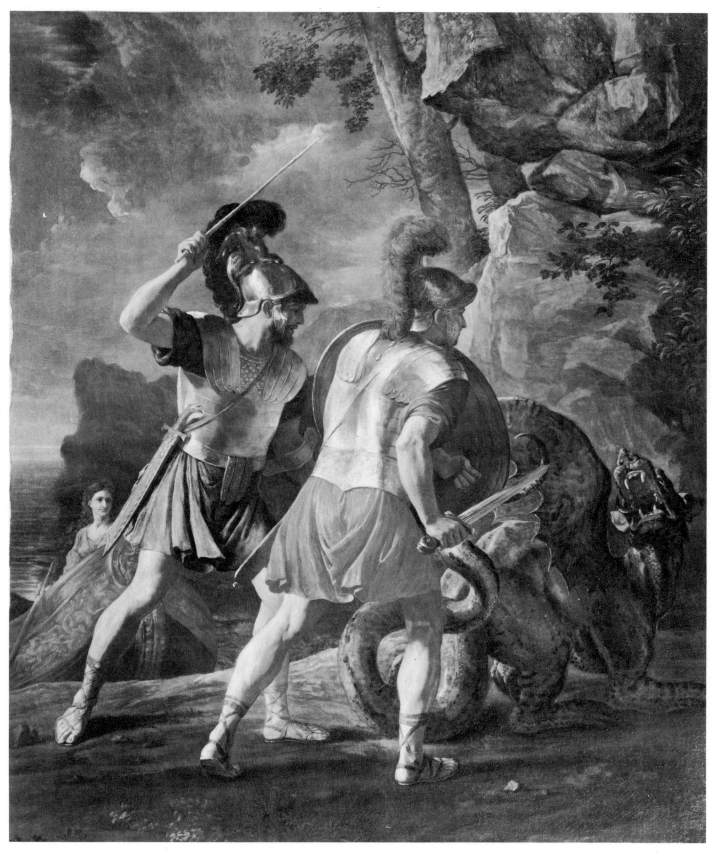

Nicolas Poussin • The Companions of Rinaldo
Oil on canvas • 46⅜ x 40⅛'' • The Metropolitan Museum of Art,
New York City • Gift of Mr. and Mrs. Charles Wrightsman, 1977

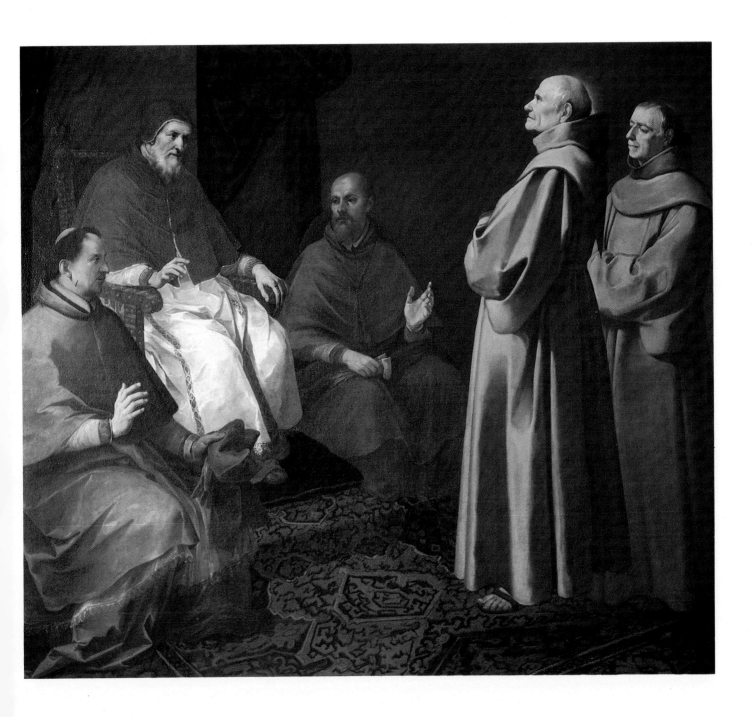

Bartolomé Esteban Murillo • The Blessed Giles Before Pope Gregory IX
Oil on canvas • 65⅝ x 73⅜'' • North Carolina Museum of Art, Raleigh

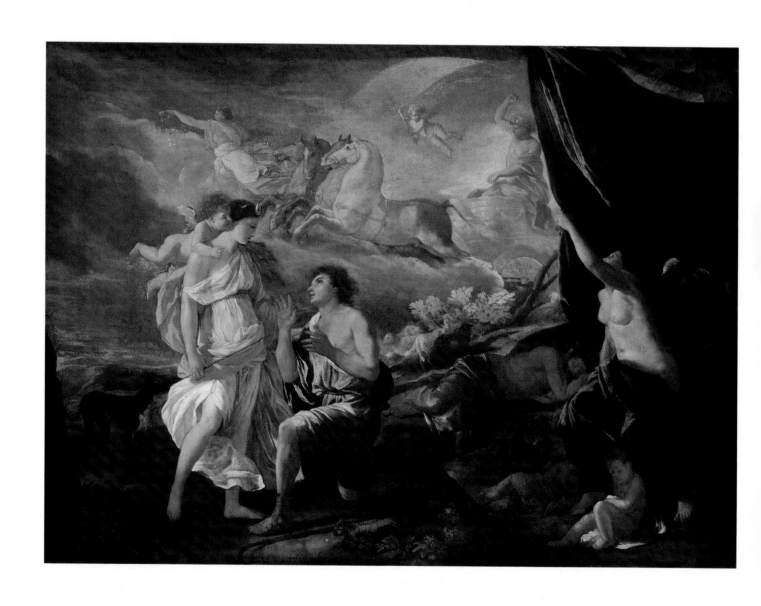

Nicolas Poussin • Selene and Endymion
Oil on canvas • 48 x 66½'' • Detroit Institute of Arts • General Membership and Donations Fund

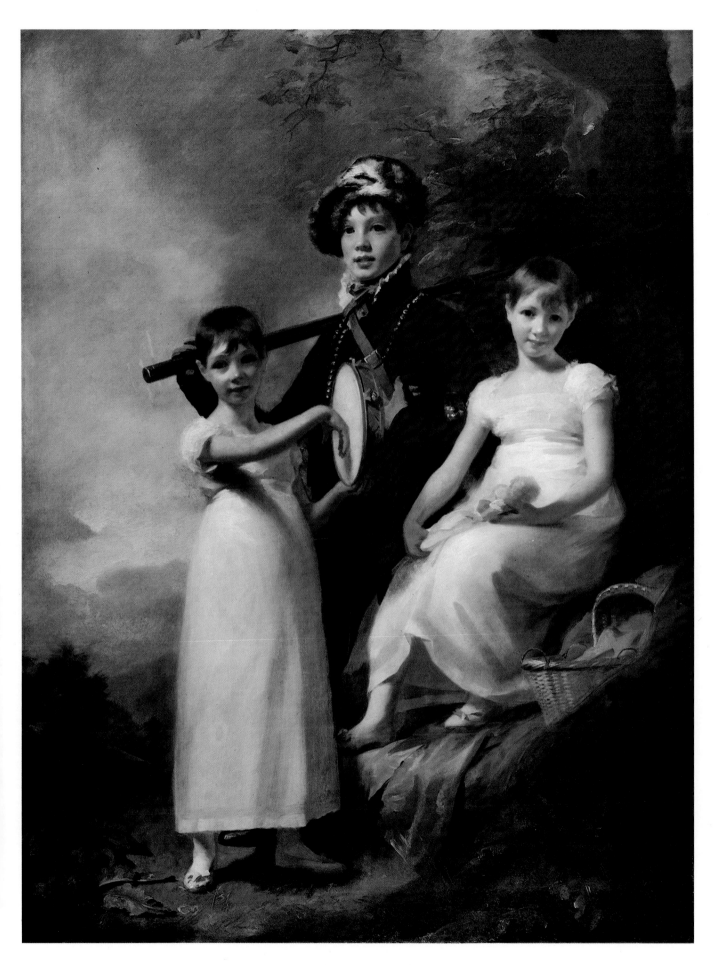

Sir Henry Raeburn • The Elphinstone Children
Oil on canvas • 78 x 60½'' • The Cincinnati Art Museum • Bequest of Mary M. Emery

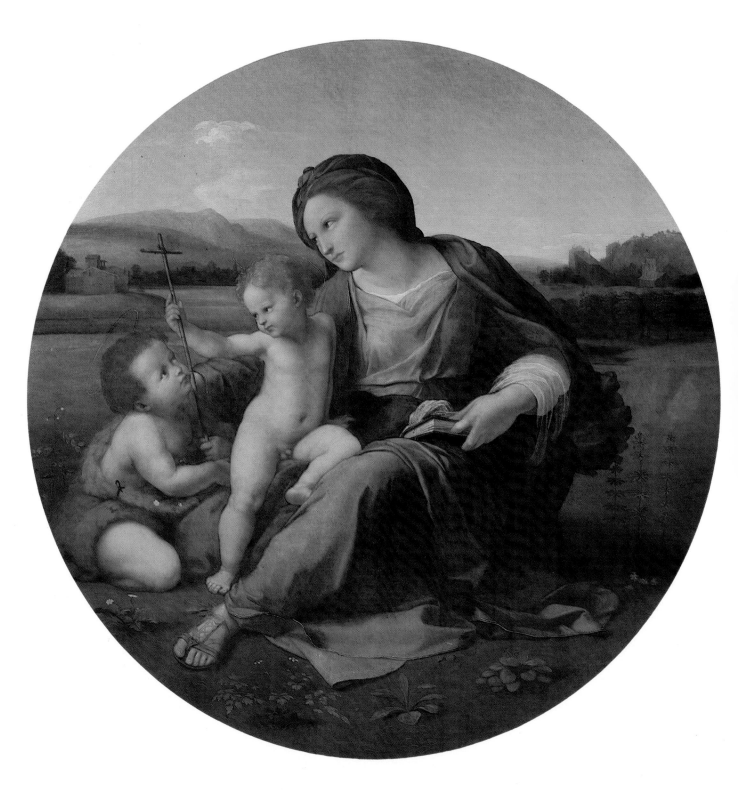

Raphael • The Alba Madonna

Canvas, transferred from panel • 37¼″ diameter • National Gallery of Art, Washington, D.C.

Samuel H. Kress Collection

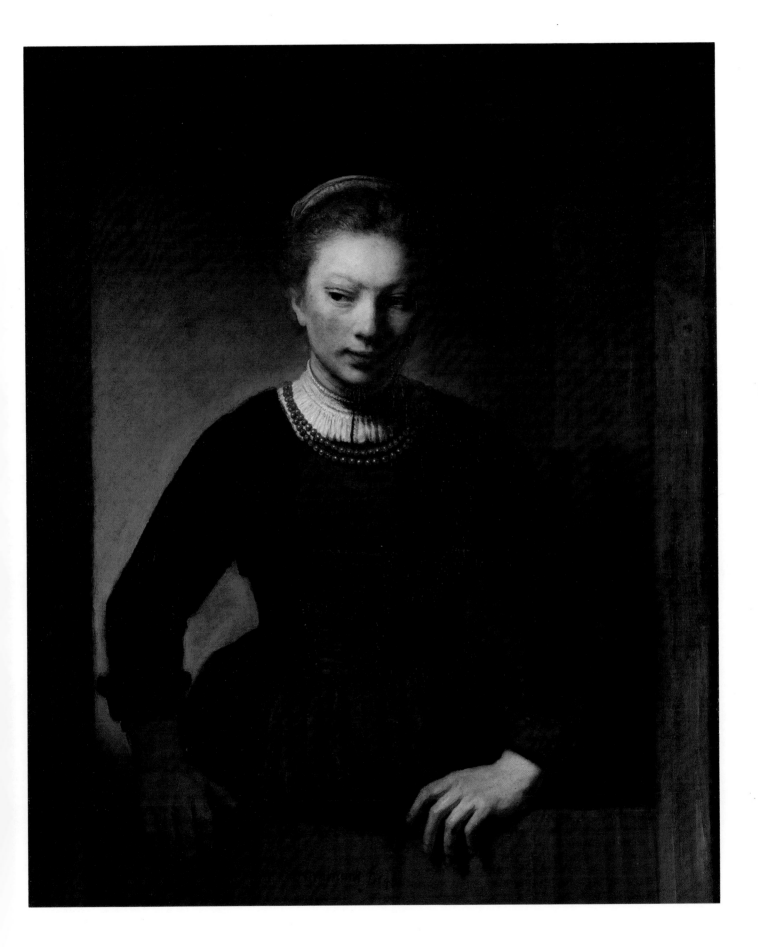

Rembrandt van Rijn • Young Girl at an Open Half-Door

Oil on canvas • 40⅛ x 33⅛″ • The Art Institute of Chicago • Mr. & Mrs. Martin A. Ryerson Collection

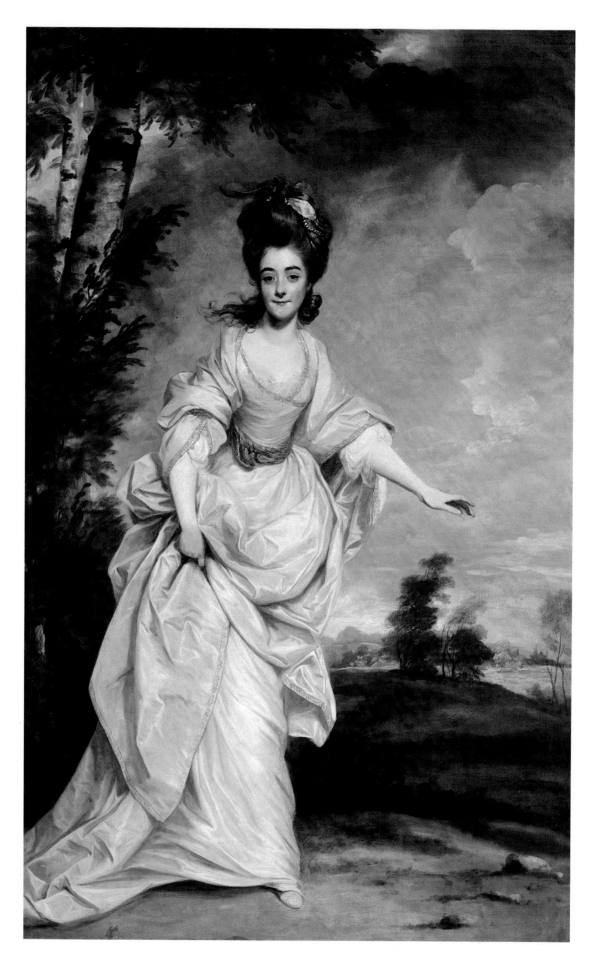

Sir Joshua Reynolds • Diana, Viscountess Crosbie
Oil on canvas • 93 x 57" • The Huntington Art Gallery, San Marino, California

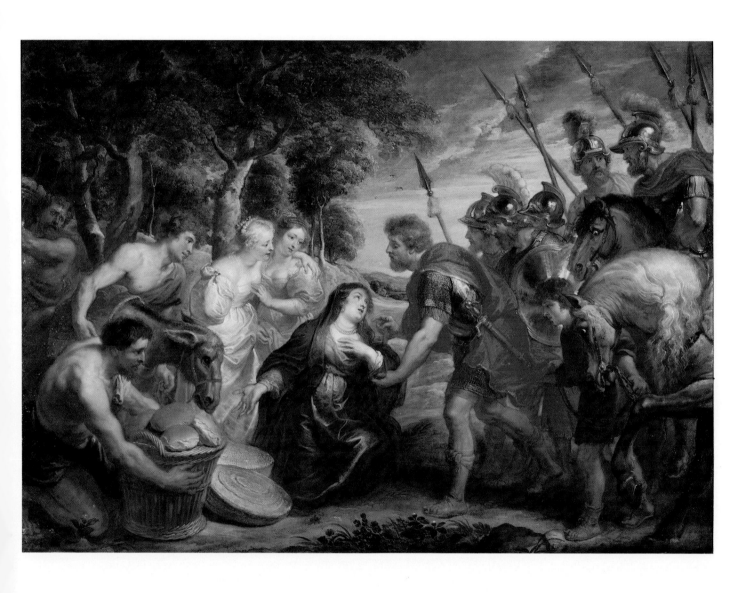

Peter Paul Rubens • The Meeting of David and Abigail
Oil on canvas • 70¾ x 98½ '' • Detroit Institute of Arts • Gift of James E. Scripps

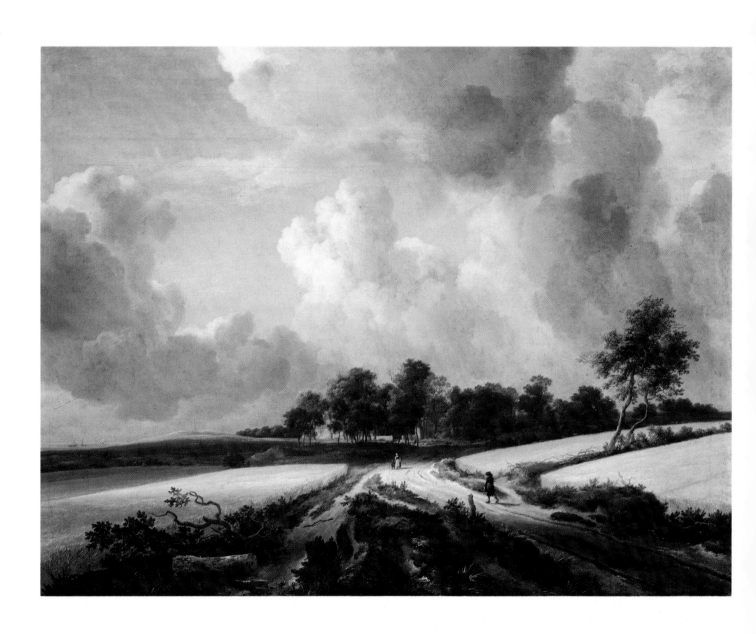

Jacob van Ruisdael • Wheatfields
Oil on canvas • 39⅜ x 51¼″ • The Metropolitan Museum of Art, New York City
Bequest of Benjamin Altman

Sir Henry Raeburn

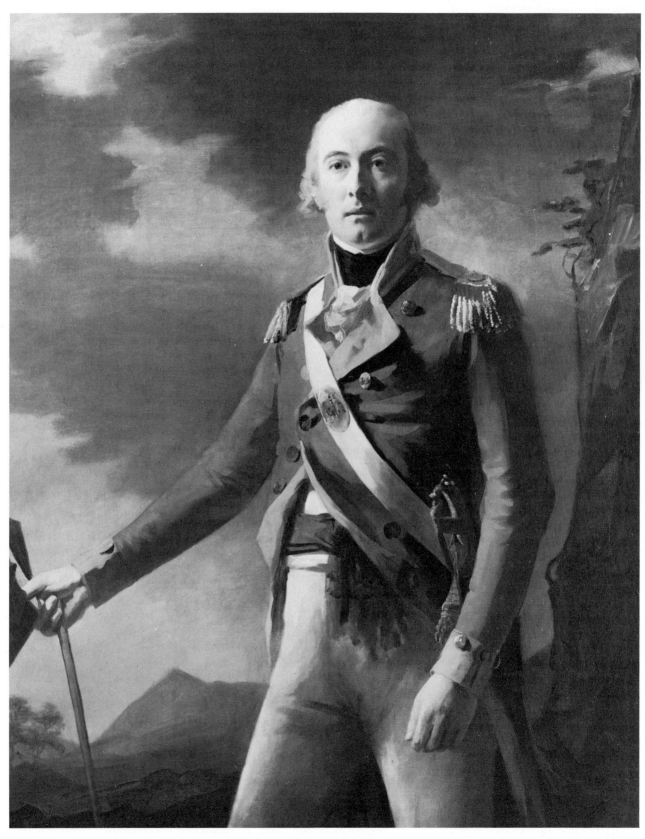

Henry Raeburn • Major General Andrew Hay
Canvas • 50 x 40" • North Carolina Museum of Art, Raleigh
Gift of John Hay Whitney

Sir Henry Raeburn

1756–1823

Sir Henry Raeburn was born at Stockbridge, a suburb of Edinburgh, the city in which he was to make his successful career. Orphaned at an early age, he received his education from Heriot's Hospital and was then apprenticed to a goldsmith. On observing his skill at miniature drawing and carving, the goldsmith introduced him to one of the assistants of Allan Ramsay, Jr., the city's leading portrait painter. This introduction led to the serious study of painting and presently to a portrait commission from a wealthy young widow, whom Raeburn married a month later. Her two daughters and their son soon formed a happy, congenial family. The couple visited Italy in 1785, stopping in London en route to get letters of introduction from Sir Joshua Reynolds, and returning in 1787 to establish the Edinburgh studio in which Scotland's leading citizens were to pose for Scotland's leading artist. Raeburn made several trips to London, becoming an associate of the Royal Academy there in 1812 and an academician in 1815. He was knighted in 1822 by King George IV.

Sir Henry Raeburn was born at exactly the right time. He both contributed to and shared in a period of great renaissance in Scotland. Within fifteen years after his birth came those of the famous Scotch poets Robert Burns and James Hogg and the novelist Sir Walter Scott, who sat several times for his portrait by Raeburn.

Magnificient is the word for Raeburn's portraits, though not in its usual sense. His people have a kind of magnificent health about them. They all look as though they had just come in from a brisk walk. Yet many of them look as though they might be hurrying on to a library. Whoever they are, one feels that they have been painted directly and honestly, with no beating about the bush, which indeed was Raeburn's method. He once said that the most important thing he learned on his trip to Italy was the advice of an English painter: "Never copy an object from memory, but, from the principal figure to the minutest accessory, have it placed before you."

Perhaps Raeburn's directness and honesty account for his extraordinary success with children's portraits. Children are notoriously quick at detecting humbug. Certainly those in *The Elphinstone Children,* in Cincinnati, must have understood and liked the man who was painting them. They look as though they enjoyed posing for him as much as Raeburn must have enjoyed painting their portrait.

Actually, they are not posing. The great charm of this portrait is that the children are perfectly natural. Though they may be the heirs of Admiral Elphinstone, Viscount Keith, to Raeburn they were three children like his own.

Sir Henry Raeburn in America

California
LOS ANGELES
Los Angeles County Museum of Art
Portrait of Judge Blair, 50 x 40
Portrait of Mrs. Alexander Allan and Daughter Matilda, 50 x 39½

University of Southern California, University Galleries
Francis, Lord Gray, 73 x 60
The Honorable Mrs. Bushell, 30 x 25
Mrs. John Campbell, Sr., of Possil, 30 x 25

SAN FRANCISCO, The Fine Arts Museums of San Francisco
Portrait of Mrs. Alex Henderson, 30 x 25, c. 1800
Sir William Napier, Bart., 95 x 58¾
Portrait of Mrs. William Urquhart, 35½ x 27¼

SAN MARINO, The Huntington Art Gallery
Master William Blair, 29½ x 24¾, 1814
Thomas Miller, Lord Glenlee, 83 x 57½, 1787
Mrs. John Pitcairn, 35 x 27½
James Watt, 30 x 25, 1815

Connecticut
HARTFORD, Wadsworth Atheneum
Portrait of Peter Van Brugh Livingston, 29¾ x 24, c. 1818
(Portrait of) Robert Allan of Edinburgh, 30 x 25

NEW HAVEN, Yale University Art Gallery
Mrs. John Campbell, 49½ x 39½
William Egerton of Gresford Lodge, Denbighshire, England, 30 x 24½
Mrs. James Wedderburn, 30 x 25, 1819-20

District of Columbia

WASHINGTON

Corcoran Gallery of Art
Mrs. Vere, of Stonebyres, 47½ x 37½ (Clark)

National Collection of Fine Arts, Smithsonian Institution
Portrait of Archibald Skirving, Esq., 30 x 25 (Johnson)

National Gallery of Art
John Tait and His Grandson, 49½ x 39¾, 1790-1800 (Mellon)
David Anderson, 60 x 46¼, c. 1790 (Widener)
Captain Patrick Miller, 66 x 52¼ ,
Miss Eleanor Urquhart, 29⅜ x 24¼, c. 1795 (Mellon)
John Johnstone of Alva, His Sister and His Niece,
 40 x 47¼, c. 1805
Binning Children, 50⅝ x 40⅜, c. 1811
Mrs. George Hill, 38⅛ x 30⅛, c. 1796
Colonel Francis James Scott, 50¼ x 40, c. 1800 (Mellon)

Florida

WEST PALM BEACH, Norton Gallery of Art
Jacobina Asleep, 21⅞ x 19¼
George Bruce Esq. of Langlee, 50 x 40

Georgia

ATLANTA, The High Museum of Art
Sir John Colville, 29½ x 24½

Illinois

CHICAGO, The Art Institute of Chicago
Lady Helen Boyle, 29⅞ x 25⅛, c. 1790
Dr. Welsh Tennent, 49¾ x 39, c. 1820
Portrait of Colonel Duff of Fetteresso, 30 x 25
Portrait of a Gentleman with Grey Hair, 29 x 24¾
Miss Eleanor Margaret Gibson-Carmichael, 47 x 37⅜
Sir Francis Horner, 30⅛ x 25⅜, c. 1812
Portrait of Adam Rolland of Gask, 78 x 60, c. 1800

Indiana

INDIANAPOLIS, Indianapolis Museum of Art
Major General Charles Reynolds, 35½ x 27½
General Wood, 29¼ x 24⅞
Portrait of Lord Robert Blair, 50½ x 40
Mrs. MacDowall, 28 x 36
Portrait of George Deuchar, 30 x 25⅛

SOUTH BEND, Notre Dame University Art Gallery
John Paterson, Esq. of Leith, 50 x 38⅜

Kentucky

LOUISVILLE, The J. B. Speed Art Museum
Mrs. Margaret Mair (née Thompson), 60 x 47

Maryland

BALTIMORE, The Baltimore Museum of Art
Portrait of Philip Yorke, 50 x 40 (Epstein)
Portrait of Janet Law, 36 x 28, 1788 (Jacobs)
Henry, Viscount Melville, 63 x 49½ (Jacobs)
James Byers of Tonley, 30 x 25, 1785-87 (Eisenberg)

Massachusetts

AMHERST, The Mead Art Building, Amherst College
Lieutenant-General the Honorable William Stuart, 30 x 25,
 1815-23

BOSTON, Museum of Fine Arts
Mr. Fairlie, 50 x 40
Robert Hay, 30 x 25
Charles Hope, 30 x 25

CAMBRIDGE, Fogg Art Museum, Harvard University
Portrait of a Lady, 35¼ x 27

NORTHAMPTON, Smith College Museum of Art
James Wedderburn, Esq., 30 x 25

PITTSFIELD, The Berkshire Museum
Lady Baird, 50 x 41½

WILLIAMSTOWN

Sterling and Francine Clark Art Institute
Colin Campbell of Park, 30 x 25, c. 1822-23

Williams College Museum of Art
Portrait of Dr. Thomas Reid, 29 x 25
Portrait of Sir William Johnstone Pulteney, 34½ x 28½
Portrait of Mr. Clark of Montrose, 29 x 25

Michigan

DETROIT, The Detroit Institute of Arts
Henry David Erskine, 12th Earl of Buchan, 50 x 40
Alexander Murray, 8th Baron Elibank, 35¼ x 27½
Thomas Charles Hope, 30 x 25
*Portrait of Mrs. Alexander Campbell of Possil (Daughter
 of Donald Maclachlan)*, 29⅞ x 25
Sir James Montgomery, Second Baronet of Stanhope, 49 x 39½
Mrs. Irvine J. Boswell (Margaret Christie), 30 x 25

MUSKEGON, Hackley Art Museum
Man with the Hat, Portrait of Sir William Napier, 35½ x 26½

Missouri

KANSAS CITY, The Nelson Gallery and Atkins Museum
Portrait of Sir George Abercromby, 30 x 25
Master Alexander MacKenzie, 30 x 25
Portrait of Lady Abercromby, 30 x 25

ST. LOUIS, The St. Louis Art Museum
Kirkman Finley, M.P., 35 x 27
Anne Pringle, 30¼ x 25, c. 1813
Portrait of a Lady, 35⅛ x 27¾

Nebraska

OMAHA, Joslyn Art Museum
Portrait of Mrs. Andrew Hay, 38½ x 48½

New Hampshire

MANCHESTER, The Currier Gallery of Art
Portrait of John Clerk of Eldin, 30 x 25, c. 1800

New Jersey

PRINCETON, The Art Museum, Princeton University
Portrait of Cornelius Elliot, 30¼ x 25³/₁₆

New York

NEW YORK CITY

The Brooklyn Museum
Ann Fraser, 30¼ x 25

The Frick Collection
James Cruikshank, 50 x 40, 1805-8
Mrs. Cruikshank, 50¾ x 40, 1805-8

The Metropolitan Museum of Art
Miss Janet Law, 35¼ x 27¼
Dr. Blake, 51 x 40⅛
William Scott-Elliot (1811-1901), 47⅜ x 36⅝
William, Lord Robertson (1754-1835), 49½ x 39¼
William Forsyth (1749-1814), 30 x 24⅞
The Drummond Children, 94¼ x 60¼
Harley Drummond (1783-1855), 94¼ x 58
Mrs. James O. Lee Harvey (died 1853) and Her Daughter,
 93½ x 60
Lady Catherine Maitland (Catherine Connor, died 1865),
 49¾ x 39¾

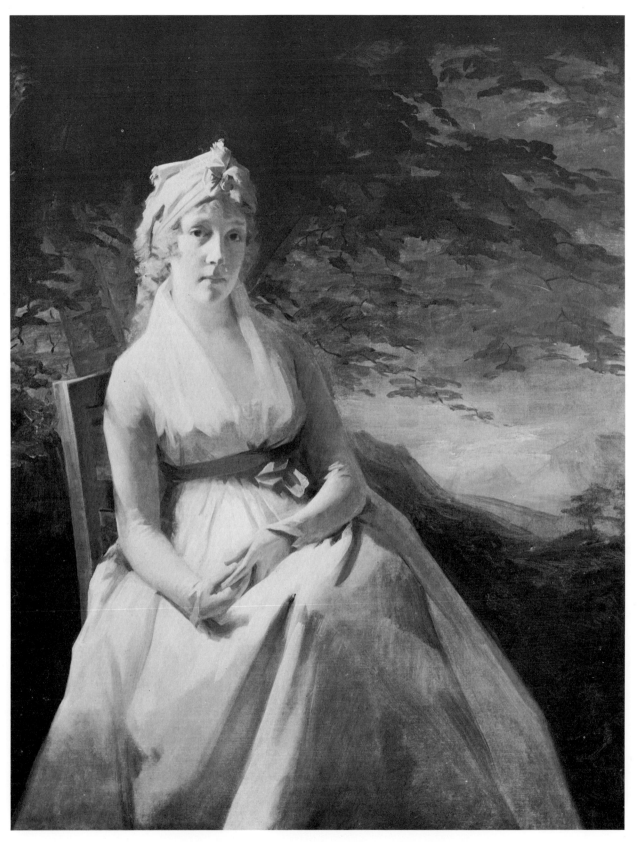

Henry Raeburn • Portrait of Mrs. Andrew Hay
Oil • 49¼ x 39" • Joslyn Art Museum, Omaha, Nebraska

James Johnston, 35¼ x 27¼
John Gray (1731-1811), 49⅜ x 40
The Honorable Alexander Maconochie-Welwood, Lord
 Meadowbank (1777-1861), 30½ x 25

ROCHESTER, Memorial Art Gallery of the University of Rochester
Mrs. Johnston of Straiton, 35 x 27½ (Eastman)
General Hay MacDowall, 93 x 58 (Eastman)

North Carolina
RALEIGH, North Carolina Museum of Art
Lieutenant General Alexander Campbell, 50 x 40
Charles James Fox, 50 x 40
Major General Andrew Hay, 50 x 40
Thomas Robert, Earl of Kinnoull, 93½ x 59

Ohio
CINCINNATI
 The Cincinnati Art Museum
 Miss Margaret Suttie, 21½ x 18⅝
 The Leslie Boy, 30¼ x 25
 The Elphinstone Children, 78 x 60½

 The Taft Museum
 Edward Satchwell Fraser, 29¾ x 24¾, 1803
 Jane Fraser-Tytler, 30⅛ x 25, c. 1813

CLEVELAND, The Cleveland Museum of Art
General Duncan Campbell, 30 x 25

COLUMBUS, The Columbus Museum of Art
Mrs. Robertson Williamson, 58 x 46, c. 1823 (Schumacher)

DAYTON, The Dayton Art Institute
Portrait of John James Ruskin, 30 x 25, c. 1810

TOLEDO, The Toledo Museum of Art
Lady Janet Traill, 50¼ x 40¼, c. 1800
Mrs. Bell, 30 x 25¼, early 1800s
Miss Cristina Thomson, 30⅛ x 25⅛, c. 1822

Oklahoma
TULSA, The Philbrook Art Center
Mrs. George Cameron, 36 x 30

Oregon
PORTLAND, Portland Art Museum
Sir James McCartney, 29½ x 24¼

Pennsylvania
PHILADELPHIA, Philadelphia Museum of Art
Portrait of Lady Elibank, 36 x 28¼ (McFadden)
Portrait of Master Thomas Bissland, 56½ x 44¼ (McFadden)
Portrait of Master John Campbell of Sadell, 49⅜ x 39¼
 (McFadden)

READING, The Reading Public Museum and Art Gallery
R. Brown and His Son, 50 x 40, c. 1818

Rhode Island
PROVIDENCE, Museum of Art, Rhode Island School of Design
Portrait of Robert Sym, 30 x 25

Tennessee
MEMPHIS, The Brooks Memorial Art Gallery
Charles Gordon, Fourth Earl of Aboyne, 50 x 40
Portrait of Alexander Home, 30 x 25
Portrait of Mrs. Mary Russell, 29½ x 24½

Texas
FORT WORTH, Kimbell Art Museum
Mrs. John Parrish, 50⅛ x 40⅛, 1780s
Mrs. John Anderson, 35 x 27, late 1780s

HOUSTON, The Museum of Fine Arts
Portrait of Lady Delves Broughton, 34½ x 26½

Utah
SALT LAKE CITY, Utah Museum of Fine Arts, University of Utah
Sir James Innes Ker, 32 x 25½

Virginia
NORFOLK, Chrysler Museum at Norfolk
William Hunt of Pittencrieff, 54 x 78 (loan)

RICHMOND, Virginia Museum
Sir Thomas Miller, 30¼ x 25

Canada

Ontario
OTTAWA, The National Gallery of Canada
Portrait of Jacobina Copland, 30 x 25¼, c. 1794

TORONTO, Art Gallery of Ontario
Portrait of William Darnell, 50½ x 40¼

Quebec
MONTREAL, Montreal Museum of Fine Arts
Portrait of Alexander Selkirk, 30 x 25
Portrait of Miss Somerset, 30 x 25
Portrait of Mr. D., 30 x 25
Portrait of Mrs. D., 30 x 25
Portrait of Mrs. O'Beirne, 35½ x 27½
Portrait of a Gentleman, 26 x 22

Raphael

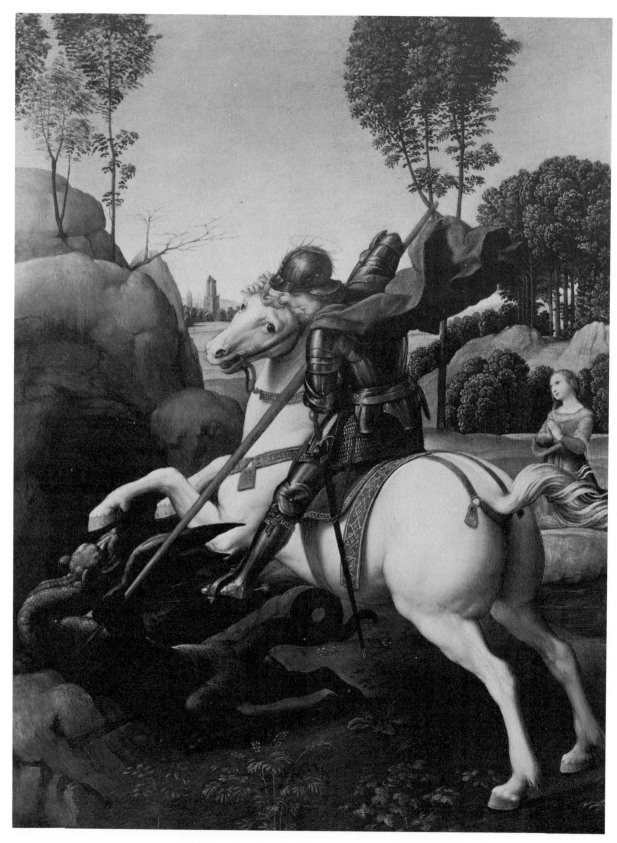

Raphael • Saint George and the Dragon
Wood • 11⅛ x 8⅜" • National Gallery of Art, Washington, D.C.
Andrew Mellon Collection

Raphael
1483–1520

Raphael Sanzio, or Santi, was born at Urbino, where he studied painting with his father. When he was about seventeen he moved to the Italian hill town of Perugia and entered the studio of Perugino. Here he produced his first independent works and moved on to Florence in 1504, where he began the series of small Madonna paintings for which he is so well known. Summoned to Rome in 1508 to help decorate the Vatican, he remained there for the rest of his short life, painting his masterworks in fresco for the famous Raphael Stanze, as well as some of his greatest easel paintings. He died of a fever in Rome and was buried in the Pantheon.

Americans may admire Raphael's marvelous draftsmanship, his superb color and composition in several museums without going to Europe. In the portrait of Count Tommaso Inghirami in Boston, Raphael was at his best in the delineation of character and the handsome portrayal of it. The two saints of the *Madonna and Child Enthroned with Saints* in New York anticipate the great heroic frescoes of the Raphael Stanze in the Vatican. And in Washington, hanging near *The Alba Madonna,* is the small but astonishingly active and colorful *St. George and the Dragon.*

The Alba Madonna, perhaps the most famous of Raphael Madonnas, is a round picture, or *tondo,* which presents a difficult problem in design. The artist must compose his picture to conform to the round shape, yet he must make it appear to hang steadily on the wall without threatening to roll off in either direction. Raphael has simply but effectively solved this problem by painting a bold (and charming) landscape just above the bisection of the circle to provide a solid horizontal axis. In this landscape are strongly vertical trees and buildings. These vertical lines are repeated in the flowers on either side of the figure, and, most importantly, in the body of the Christ Child, especially his stiff left arm. This arm is carefully placed to the left of center, as the horizon is placed just above center, to avoid any suggestion of spokes in a rolling wheel.

With the *tondo* thus solidly fixed, Raphael could proceed with the beautifully curved and composed figure of the Madonna, and here his marvelous draftsmanship was necessary. Any art student knows the difficulty of foreshortening legs and arms. Yet here the left leg and arm are projected forward so convincingly and effortlessly that the marvel becomes apparent only on analysis. Color also plays a part in this illusion. Red is the advancing color in a picture, as blue is the receding one; Raphael has let a corner of the Madonna's rich red robe show in the foreground, beneath her brilliant blue mantle.

Raphael in America

California
MALIBU, The J. Paul Getty Museum
Madonna del Velo, 47½ x 35⅞, 1509

PASADENA, Norton Simon Museum of Art
Madonna and Child with Book, 21¾ x 15¾, 1504

District of Columbia
WASHINGTON, National Gallery of Art
St. George and the Dragon, 11⅛ x 8⅜, 1504-5 (Mellon)
The Niccolini-Cowper Madonna, 31¾ x 22⅝, 1508 (Mellon)
The Alba Madonna, 37¼ diam., c. 1509 (Mellon)
Bindo Altoviti, 23½ x 17¼ (Kress)
The Small Cowper Madonna, 23⅜ x 17⅜, c. 1505 (Widener)

Maryland
BALTIMORE
The Baltimore Museum of Art
Emilia Pia de Montefeltro, 15¾ x 10¾, 1509 (Epstein)

The Walters Art Gallery
Madonna of the Candelabra, 25⅞ x 25¼ (Raphael and workshop)

Massachusetts
BOSTON, Isabella Stewart Gardner Museum
Pietà, 9 x 11⅛, c. 1504
Count Tommaso Inghirami, 35 x 24½

CAMBRIDGE, Fogg Art Museum, Harvard University
Head of a Girl Looking Inward (recto) (drawing), 9⅛ x 6

Michigan
DETROIT, The Detroit Institute of Arts
An Incident in the Life of St. Nicolas of Tolentino (two predella panels) ea. 10¼ x 20½

New York
GLENS FALLS, The Hyde Collection
Portrait of a Man, 16½ x 13, c. 1510

NEW YORK CITY, The Metropolitan Museum of Art
The Agony in the Garden, 9½ x 11⅜
Madonna and Child Enthroned with Sts. Catherine, Peter, Cecilia, Paul and the Infant St. John the Baptist, 67⅞ x 67⅞; lunette: *God the Father and Angels*, 29½ x 70⅞

North Carolina
RALEIGH, North Carolina Museum of Art
St. Jerome Punishing the Heretic Sabinian, 10⅛ x 16½

Canada

Ontario
OTTAWA, The National Gallery of Canada
Young Saint in an Attitude of Prayer (drawing), 4⅞ x 2, c. 1500

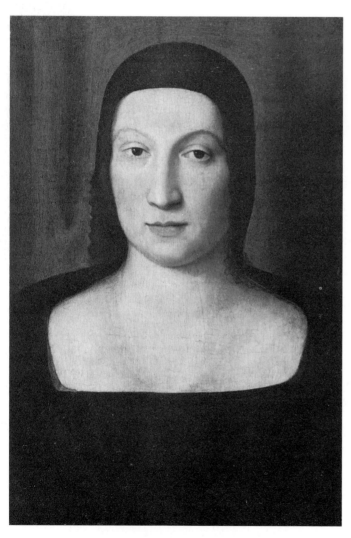

Raphael *(attributed to)*
Portrait of Emilia Pia da Montefeltro
Oil on panel • 15¾ x 10¾"
The Baltimore Museum of Art
Jacob Epstein Collection

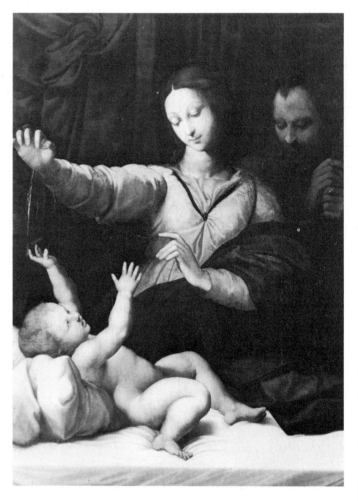

Raphael • Madonna del Velo
47½ x 35⅞"
The J. Paul Getty Museum
Malibu, California

226

Rembrandt

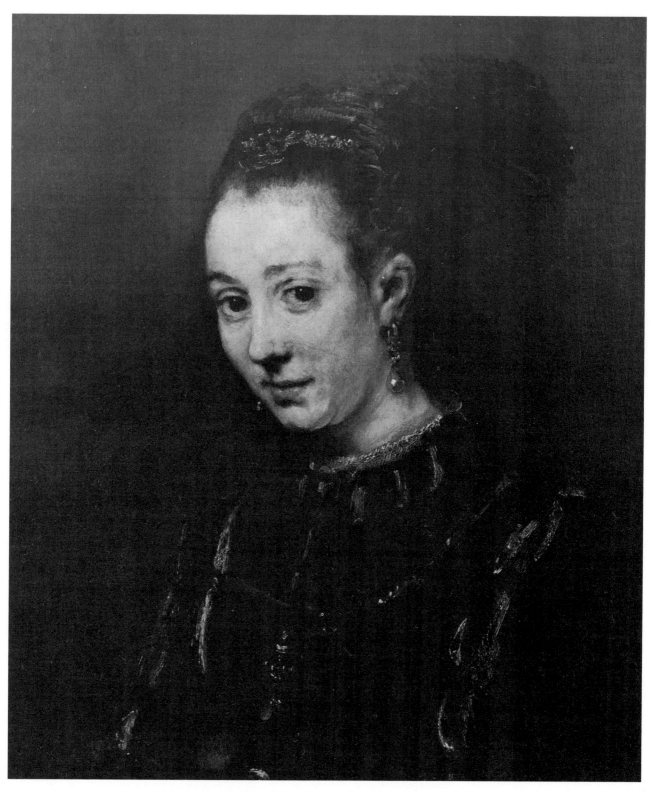

Rembrandt • Portrait of a Young Woman
Oil on canvas • 22³/₁₆ x 18¹¹/₁₆" • The Montreal Museum of Fine Arts
Bequest of Mrs. R.MacD. Paterson • The R.B. Angus Collection

Rembrandt

1606–1669

Rembrandt Harmensz van Rijn was born in Leiden, Holland, where he studied at a Latin school and was enrolled for a few months at Leiden University. He was the son of a prosperous miller, who apprenticed him to a local artist at the age of twelve and three years later sent him to Amsterdam to study. His natural ability to draw and paint eventually established him in a fine studio with a devoted wife, Saskia van Uilenburgh, one son, Titus, and many pupils and commissions. (Portraits of Saskia are in Washington, Indianapolis, and Virginia; of Titus in Baltimore, Detroit, and Pasadena.) Saskia's death in 1642 coincided with Rembrandt's painting of a group portrait entitled *The Company of Captain Frans Banning Cocq's Civic Guards,* known as *The Night Watch* since about 1800, when it was so overlaid with darkened varnish that it looked like a night scene. Modern research discounts the story that Rembrandt's decline in popularity and fortune began with the rejection of his famous painting because some members of the civic guard who commissioned it objected to being painted in shadow. Actually, the painting was well received. Rembrandt was paid about sixteen hundred guilders for it, and he continued to receive commissions (paintings for the town hall in Amsterdam, 1661; *The Syndics of the Drapers Guild,* 1662—known throughout the world today as the advertising image of Dutch Masters cigars). Rembrandt's decline in popularity and fortune (he declared himself bankrupt in 1656, and his house and effects were sold at auction) apparently resulted from the fact that after Saskia's death Rembrandt became more interested in portraying inner life and character than outward appearance and action. He began painting for himself instead of his patrons. Also, he continued to spend large sums of money on his art collection. Now in less-grand surroundings with Titus and his housekeeper, Hendricjke Stoffels (portrait in New York), Rembrandt continued to paint until his death, producing the astounding output of approximately six hundred paintings, three hundred etchings, and two thousand drawings.

Rembrandt and Rubens were painting at the same time less than one hundred miles from each other, one in Amsterdam and the other in Antwerp. Yet their work seems centuries and continents apart. There are many reasons for this, including the fact that Amsterdam was the capital of the Protestant Dutch Republic and Antwerp the capital of the Catholic, Spanish-dominated southern provinces of the Netherlands, which were to be united as Belgium in the nineteenth century. But the simpler reason is that whereas Rubens was the mirror of his age, Rembrandt was one of those giants—like Shakespeare and Michelangelo—who transcend theirs. His paintings are proof that to discover the particular character and flavor of any age we must go not to the giants, but simply to the men of genius. One feels that Rembrandt would have painted much as he did had he lived a hundred years earlier or later.

It is easy to say that the reason for the enduring appeal of Rembrandt's pictures is the deep humanity that pervades them—the same respect and love for all living things that made St. Francis a saint. It is harder to analyze Rembrandt's unique ability to express this deep humanity. But one key to the power of his pictures is a very simple one—his masterly use of light and dark *(chiaroscuro)* to give each object in his pictures its exact importance in relation both to form and content. Rembrandt saw that human experience embraces the commonplace as well as the sublime. His gift was to see everything, and then to emphasize with his art what is truly important. It is these truly important, significant things which most of us can recognize only when they are pointed out by men of greater sensitivity and understanding—in other words, by artists.

Perhaps the best way to appreciate Chicago's *Young Girl at an Open Half-Door* is to imagine how a lesser artist might have painted it. First of all, he probably would have painted a background

of miscellaneous objects in the room, instead of leaving it in shadow. He might have enjoyed painting the hardware on the door: its hinges and bolts. Certainly he would have painted both hands in equal light. But by the simple avoidance of these objects and areas, Rembrandt has made us concentrate on the girl's face, with its expression of mixed anxiety and eagerness on looking out at an adult world. This feeling we recognize, understand, and sympathize with—once the artist has revealed it to us.

Rembrandt in America

California
LOS ANGELES
Los Angeles County Museum of Art
Portrait of Marten Looten, 36½ x 30, 1632
Portrait of a Man of the Raman Family, 25½ x 19⅞, 1634
The Raising of Lazarus, 37¹⁵/₁₆ x 32, c. 1630
Bust of St. John the Baptist, 25 x 20, 1632

University of Southern California, University Galleries
Christ Disputing the Elders, 27 x 42, (with Dou)

MALIBU, The J. Paul Getty Museum
St. Bartholomew, 34⅛ x 29¾, 1661

PASADENA, Norton Simon Museum of Art
Portrait of the Artist's Son, Titus, 25½ x 22, 1653
Self-Portrait, 25 x 20, 1636
Portrait of a Gentleman (oval), 27½ x 21¾

SACRAMENTO, The E. B. Crocker Art Gallery
St. Peter Liberated by the Angel (drawing), 3⅞ x 3½

SAN DIEGO
San Diego Museum of Art
Young Man with a Cock's Feather in His Cap, 22 x 18, 1631

Timken Art Gallery
St. Bartholomew, 48¼ x 39½

SAN FRANCISCO, The Fine Arts Museums of San Francisco
Portrait of a Rabbi, 31 x 25½, 1657
Joris de Caullery, 40½ x 32¾

Connecticut
HARTFORD, Wadsworth Atheneum
Departure of Prodigal Son (drawing), 8 x 10⅜, c. 1655
Portrait of a Young Man, 38 x 32½, 1655

District of Columbia
WASHINGTON
Corcoran Gallery of Art
Man with Hat Holding Scroll, 26 x 18½ (Clark)
?Elderly Man in Armchair, 49¼ x 38 (Clark)

National Gallery of Art
Saskia van Uilenburgh, the Wife of the Artist, 23¾ x 19¼, c. 1633 (Widener)
Self-Portrait, 36¼ x 29¾, 1650 (Widener)
The Apostle Paul, 50¾ x 40⅛, c. 1657 (Widener)
The Philosopher, 24¼ x 19½, c. 1650 (Widener)
The Descent from the Cross, 56¼ x 43¾, 1651 (Widener)
Philemon and Baucis, 21½ x 27, 1658 (Widener)
Head of an Aged Woman, 8¼ x 6¾, 1657 (Widener)
Study of an Old Man, 11⅛ x 8½, c. 1645 (Widener)
The Mill, 34½ x 41½, c. 1650 (Widener)
Portrait of a Man in a Tall Hat, 47¾ x 37, c. 1662 (Widener)
A Polish Nobleman, 38⅛ x 26, 1637 (Mellon)
The Circumcision, 22¼ x 29½, 1661 (Widener)
Portrait of a Lady with an Ostrich Feather Fan, 39¼ x 32⅝, c. 1667 (Widener)
Portrait of a Gentleman with a Tall Hat and Gloves, 39⅛ x 32½, c. 1667 (Widener)

A Woman Holding a Pink, 40⅜ x 33¾, 1656 (Mellon)
Self-Portrait, 33¼ x 26, 1659 (Mellon)
A Young Man Seated at a Table, 43¼ x 35¼, 1662-63 (Mellon)
Head of St. Matthew, 9⅞ x 7¾, c. 1661 (Widener)
Joseph Accused by Potiphar's Wife, 41⅝ x 38½, 1654-55 (Mellon)
Lucretia, 47¼ x 39¾, 1664 (Mellon)
An Old Lady with a Book, 43 x 36, 1647 (Mellon)
A Turk, 38¾ x 29⅛, c. 1630-35 (Mellon)
A Girl with a Broom, 42¼ x 36, 1651 (Mellon)

Illinois
CHAMPAIGN, Krannert Art Museum
Portrait of Amsterdam Burgher, 27¼ x 22¼ (attrib. to)

CHICAGO, The Art Institute of Chicago
Presumed Portrait of the Artist's Father, 32⅞ x 29¾, c. 1631
Young Girl at an Open Half Door, 40⅛ x 33⅛, 1645

Indiana
INDIANAPOLIS, Indianapolis Museum of Art
Portrait of Saskia (oval bust), 24⅜ x 19¼ (attrib. to)

Kentucky
LOUISVILLE, The J. B. Speed Art Museum
Portrait of a Woman, 27 x 21½, 1634

Maryland
BALTIMORE, The Baltimore Museum of Art
Titus, the Artist's Son, 32 x 27, 1660 (Jacobs)

Massachusetts
BOSTON
Isabella Stewart Gardner Museum
Self-Portrait, 35 x 29
A Gentleman and His Wife in Black, 51¾ x 42
Landscape with Obelisk, 21¾ x 28
Storm on the Sea of Galilee, 63 x 50

Museum of Fine Arts
Portrait of a Man, 27 x 20, 1634
St. John the Evangelist, 40 x 33
Artist in His Studio, 10 x 12½
Old Man, 30 x 24
Portrait of a Lady, 27 x 20
Rev. Johannes Elison, 68⅛ x 48⅞, 1634
Maria Bockenolle Elison, 68¾ x 48⅞, 1634

CAMBRIDGE, Fogg Art Museum, Harvard University
Head of Christ, 10 x 7⅞, c. 1648
Self-Portrait, 8¼ x 6¾, 1629
Portrait of the Artist's Father, 8¾ x 6⅞ (sight), 1629
A Winter Landscape (drawing), 2⅝ x 6⁵/₁₆
Three Studies of a Child and one of an Old Woman (drawing), 8⅜ x 6¼

NORTHAMPTON, Smith College Museum of Art
Woman Kneeling in Prayer (drawing), 3¼ x 3⅜

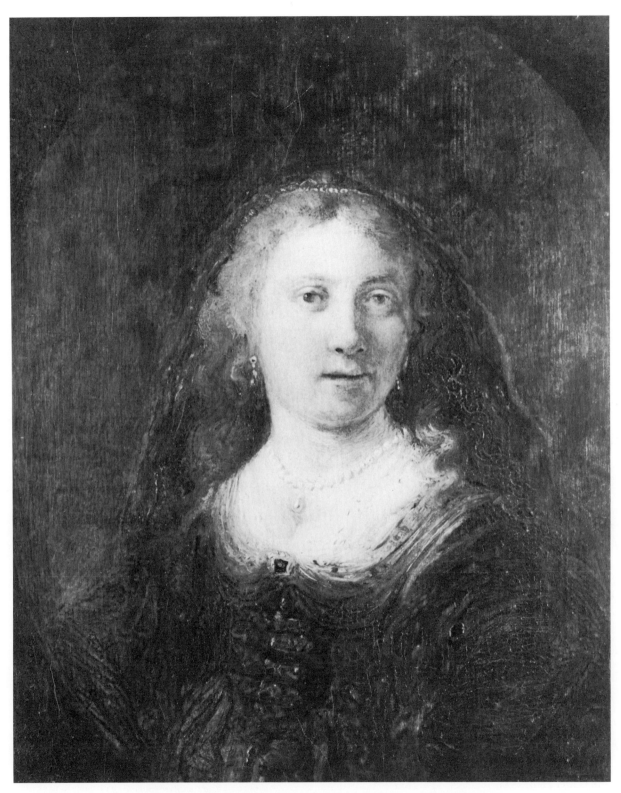

Rembrandt *(attributed to)* • Portrait of Saskia van Uylenburch
*Oil on panel • 8¾ x 6⅗'' • Virginia Museum, Richmond
Gift of Mrs. A. D. Williams*

WILLIAMSTOWN, Sterling and Francine Clark Art Institute
Crucifixion, 12¹⁵/₁₆ x 11¼, 1657
A Man Reading, 29³/₁₆ x 22⅛, 1645

WORCESTER, Worcester Art Museum
S. Bartholomew, 24⅞ x 18¾

Michigan
DETROIT, The Detroit Institute of Arts
Head of Christ, 10 x 9, c. 1648
The Visitation, 22½ x 18⅞, 1640
Head of a Bearded Old Man, 21⅞ x 15¾, c. 1630
Portrait of an Old Woman, 31 x 25½, 1634
Titus, 16 x 13⅝
Man Wearing a Plumed Beret and Gorget, 16 x 13⅝
A Woman Weeping, 8½ x 6¾

Minnesota
MINNEAPOLIS, The Minneapolis Institute of Arts
Lucretia, 41⅜ x 36¹/₃, 1666

Missouri
KANSAS CITY, The Nelson Gallery and Atkins Museum
Portrait of a Youth with a Black Cap, 32 x 25⅝, 1666

ST. LOUIS, The St. Louis Art Museum
Portrait of a Young Man, 35⅜ x 27⅛

Nebraska
OMAHA, Joslyn Art Museum
Portrait of Dirk van Os, 34 x 40¾, 1662

New York
GLENS FALLS, The Hyde Collection
Two Men Shaking Hands (drawing), 5¾ x 4¾, c. 1635
Christ, 43 x 35½, 1657

NEW YORK CITY
The Frick Collection
The Polish Rider, 46 x 53⅛, c. 1655
Self-Portrait, 52⅝ x 40⅞, 1658
Portrait of a Young Artist, 39⅛ x 35, 1647(?)
Nicolaes Ruts, 46 x 34⅜, 1631

The Metropolitan Museum of Art
St. John the Evangelist, 40 x 33
Head of Christ, 18⅝ x 14⅝
Portrait of a Young Man (The Auctioneer), 42¾ x 34, 1658
 (Altman)
The Standard-Bearer, 55¼ x 45¼, 1654 (Bache)
Self-Portrait, 31⅝ x 26½, 1660 (Altman)
Hendrickje Stoffels (1626-1663), 30⅝ x 27⅛, 1660
Portrait of a Man, 32⅞ x 25⅜
Christ with a Pilgrim's Staff, 37½ x 32½, 1661 (Bache)
Man with a Magnifying Glass, 36 x 29¼ (Altman)
Portrait of a Man, 44 x 35, 1632 (Havemeyer)
Portrait of a Woman, 44 x 35, 1632 (Havemeyer)
Portrait of a Woman (oval), 26¾ x 19¾, 1633 (Altman)
Bellona, 50 x 38⅜, 1633
Portrait of a Lady with a Fan, 49½ x 39¾, 1633
Herman Doomer (c. 1600-1654), 29⅝ x 21¾,
 1640 (Havemeyer)
The Toilet of Bathsheba, 22½ x 30, 1643 (Altman)
Flora, 39⅜ x 36¼
Portrait of a Man Holding Gloves, 31¾ x 26½, 164(?)
 (Altman)
Lady with a Pink, 36¼ x 29⅜ (Altman)
Aristotle with a Bust of Homer, 56½ x 53¾, 1653
Christ and the Woman of Samaria, 25 x 19¼
Man in Oriental Costume (The Noble Slav), 60⅛ x 43¾
Portrait of a Man, 29¾ x 20½

ROCHESTER, Memorial Art Gallery of the University of Rochester
Young Man in Arm Chair, 36½ x 32½ (Eastman)

North Carolina
RALEIGH, North Carolina Museum of Art
Esther's Feast, 52⅝ x 65½

Ohio
CINCINNATI
The Cincinnati Art Museum
Young Girl Holding a Medal, 25⅞ x 22⅞ (attrib. to)

The Taft Museum
Portrait of a Young Man, 49 x 39¼, 1633
Portrait of an Elderly Woman, 25½ x 20½, 1642
Man Leaning on Sill, 32⁷/₁₆ x 26⅞, 1650

CLEVELAND, The Cleveland Museum of Art
Portrait of a Young Student, 33¾ x 27¼, c. 1657
Portrait of a Lady, 30½ x 25½, 1635
Portrait of a Youth, 22¾ x 17¼, 1632
Old Man Praying, 34½ x 28½, 166(1)

COLUMBUS, The Columbus Museum of Art
St. Francis Praying, 24 x 19, 1637

TOLEDO, The Toledo Museum of Art
Young Man with Plumed Hat, 32 x 26, 1631
Man in a Fur-Lined Coat, 45¼ x 34¾, c. 1655-60

Pennsylvania
PHILADELPHIA, Philadelphia Museum of Art
Finding of Moses, 19 x 23¾ (attrib. to) (Johnson)
Head of Christ, 14¼ x 12⅜ (attrib. to) (Johnson)

Rhode Island
PROVIDENCE, Museum of Art, Rhode Island School of Design
Landscape with Farm Buildings and High Embankment
 (drawing), 5¾ x 10¼, 1646-47

South Carolina
GREENVILLE, Bob Jones University Art Gallery and Museum
Head of Christ, 9¼ x 7¾

Texas
FORT WORTH, Kimbell Art Museum
Portrait of a Young Jew, 25⅞ x 22⅝, 1663

HOUSTON, The Museum of Fine Arts
Head of an Old Man, 6 x 4¾

Virginia
NORFOLK, Chrysler Museum at Norfolk
Samson Threatening his Father-in-Law, 61⅜ x 51½ (workshop
 of) (loan)

RICHMOND, Virginia Museum
Liesbeth van Rijn, 23 x 18, 1633
Portrait of Saskia van Uilenburgh, 8¾ x 7¼, 1633
Portrait of a Bearded Old Man, 8¼ x 6¾, 1643

Canada

Ontario
OTTAWA, The National Gallery of Canada
The Toilet of Bathsheba, 43 x 37, 1632
The Tribute Money, 16⅜ x 12⅞, 1629
Old Man Seated (drawing), 5⁹/₁₆ x 4

TORONTO, Art Gallery of Ontario
Portrait of a Lady with a Lap Dog, 32 x 24½, c. 1665

Quebec
MONTREAL, Montreal Museum of Fine Arts
Death of a Patriarch (drawing), 9¼ x 14, c. 1640-42
Portrait of a Young Woman, 16¼ x 20

Sir Joshua Reynolds

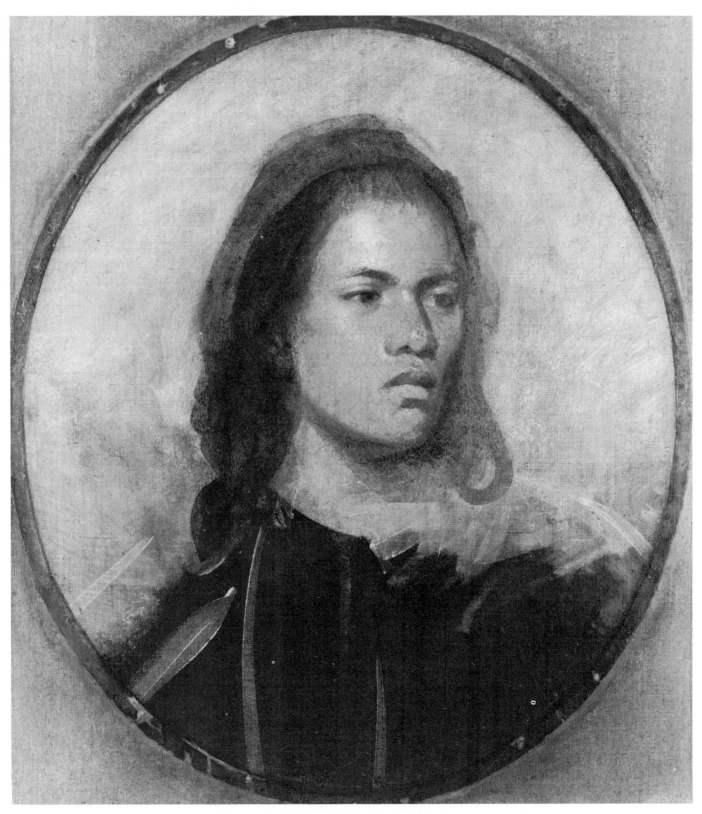

Joshua Reynolds • Omai
23¾ x 20¾" • Yale University Art Gallery, New Haven, Connecticut

Sir Joshua Reynolds

1723–1792

Sir Joshua Reynolds was born at Plympton, Devonshire, the son of a clergyman who was master of the town's free grammar school. Having shown an early talent for drawing, he was sent to London at the age of seventeen and apprenticed to the artist Thomas Hudson, with whom he remained for two years. He spent the next seven years successfully establishing himself as a portrait painter, both in London and Devonshire, and in 1749 was invited by Commodore Keppel of the Royal Navy to sail with him to the Mediterranean. Reynolds spent two years in Italy, studying the old masters. He then returned to London by way of Paris and opened his first studio in St. Martin's Lane. Steadily increasing portrait commissions enabled him to move to Great Newport Street, and finally, in 1760, to Leicester Square. In 1768 he was elected the first president of the newly formed Royal Academy and was knighted the following year. In 1781 he visited Holland and Flanders, where study of the paintings by the seventeenth-century masters seems to have given an added warmth to his own work from then on. In 1784 he received his culminating honor with his appointment as painter to the king. He was buried eight years later in St. Paul's Cathedral.

Sir Joshua Reynolds was the most popular and prominent painter of his time. In 1755 his portrait clients numbered 120, and two years later the number of sittings recorded in his books was 677. In his studio in Leicester Square he played genial host to the great personages of the day: Dr. Johnson, Lady Montagu, Edmund Burke, Oliver Goldsmith, David Garrick, Laurence Sterne, and many others. His only real rival was Thomas Gainsborough, of whom he once said, "I cannot imagine how he manages to produce his effects." Gainsborough, on the other hand, once exclaimed of Reynolds, "Damn him! How various he is."

The chief difference between these two great English artists seems to be that whereas Gainsborough achieved his masterful effects intuitively, Reynolds achieved his through hard work and study. And yet, as the above quotation reveals, Gainsborough recognized in his rival the quality of imagination without which any painter cannot hope to achieve greatness. This quality is strikingly illustrated in the portrait of *Diana, Viscountess Crosbie* in The Huntington Art collection.

The story of the painting is that when Lord Crosbie invited Reynolds to come and paint a portrait of his future daughter-in-law, Diana Sackville, the artist caught his first glimpse of her running across the lawn. He was so enchanted with the sight that he promptly decided to paint her in that pose, daring as it would be. The result was one of his finest works.

To achieve the effect of running across the lawn, Reynolds had to leave space at one side of his picture into which Diana could conceivably be running. But such a space would make the picture lopsided, suggesting anything but the grace and charm expected of the future viscountess. Here Reynolds used his imagination.

The toe of Diana's slipper is in the exact center of the picture, although it seems farther to the left. By centering this foot, by suggesting a forward motion in the curve of the body, and—most important—by painting one hand outstretched with its palm in dark shadows, Reynolds has created the illusion of space while at the same time filling it. To see how important the outstretched hand is, cover it with your thumb. Diana is falling from one side of the picture into the other. Remove your thumb and she is once more the young girl who enchanted Reynolds as she came running across the lawn, and who enchants us today in San Marino, California.

Sir Joshua Reynolds in America

Alabama

BIRMINGHAM, Birmingham Museum of Art
Portrait of Captain Arthur Blake, 49½ x 39½, 1769

California

LOS ANGELES
Los Angeles County Museum of Art
Mrs. Sheridan(?) as St. Cecilia

University of Southern California, University Galleries
Sir Patrick Blake, Bart., 95 x 58

SAN FRANCISCO, The Fine Arts Museums of San Francisco
Portrait of the Rev. William Turner, 48½ x 38
Miss Boothby, 30⅛ x 25⅛, 1758
Lady in Ermine Cloak: Portrait of Mrs. Montgomery, 30 x 25

SAN MARINO, The Huntington Art Gallery
Lavinia, Countess Spencer, and Viscount Althorp, 57½ x 43, 1783-84
Mrs. Edwin Lascelles (Lady Harewood), 92½ x 57, 1777
Frances, Marchioness Camden, 54½ x 44½, 1777
The Young Fortune Teller, 55 x 43, 1775
Sarah Siddons as the Tragic Muse, 93 x 57½, 1784
Theresa Parker, 30 x 25, 1787
Diana, Viscountess Crosbie, 93 x 57, 1777
Georgiana, Duchess of Devonshire, 93¾ x 57, 1775-76
Jane, Countess of Harrington, 93 x 37, 1777-79
Francis, Earl of Huntington, 49½ x 39½, 1754
Van der Gucht Children, 30½ x 25, c. 1785

STANFORD, Stanford University Museum of Art
General von Keppel (Timothy Hopkins Collection)
Elizabeth, Lady Turner of Clints, Yorkshire, 60 x 48, 1757

Connecticut

HARTFORD, Wadsworth Atheneum
"Marchesa Castiglione," 29¼ x 24½
"Miss Paine," 46⅛ x 34¾

NEW HAVEN, The Yale University Art Gallery
Omai, 23¾ x 20¾
Jane, Countess of Harrington, Viscount Petersham, The Honorable Lincoln Stanhope, 56½ x 44⅞, 1786-87
Mr. and Mrs. Godfrey Wentworth, 56¼ x 61, 1763
Harriet, Wife of Major Davey, 30½ x 25

District of Columbia

WASHINGTON
Corcoran Gallery of Art
Annette Coke Gage, 29¾ x 24¾ (Clark)

The National Collection of Fine Arts, Smithsonian Institution
The Duchess of Ancaster, 25 x 21 (attrib. to) (Johnson)

National Gallery of Art
Lady Elizabeth Delmé and Her Children, 94 x 58⅛, c. 1780 (Mellon)
Lady Caroline Howard, 56¼ x 44½, c. 1778 (Mellon)
Lady Elizabeth Compton, 94½ x 58½, 1781 (Mellon)
Lady Cornewall, 50 x 40, c. 1785 (Widener)
Lady Betty Hamilton, 46 x 33, 1758 (Widener)

Florida

SARASOTA, John and Mable Ringling Museum of Art
Portrait of the Marquis of Granby, 96⅝ x 82, 1766

WEST PALM BEACH, Norton Gallery of Art
Jane, Duchess of Gordon, 93¾ x 58, 1778

Illinois

CHICAGO, The Art Institute of Chicago
Lady Sarah Bunbury Sacrificing to the Graces, 94 x 60, 1765
Mrs. George Huddesford, 29⅝ x 25¾, c. 1776
Master Worsley, the Boy in Red, 30½ x 24⅞, c. 1780
Miss Anne Mead, 29¼ x 24¼, 1768
Sir Thomas Rumbold, 50 x 40, 1788

Indiana

INDIANAPOLIS, Indianapolis Museum of Art
Charles Brandling, 48½ x 38½
Portrait of Thomas Bowlby, 29⅞ x 25½
Pick-a-Back, 30 x 25
Portrait of Lady Warde, 27⅛ x 22⅛
The Golden Age, 25 x 21½
Portrait of Joseph Baretti, 30¼ x 24⅞

MUNCIE, Ball State University Art Gallery
Portrait of a Lady, 30 x 25
Lady Spencer, 59 x 39

Kansas

LAWRENCE, Helen Foreman Spencer Museum of Art
Elizabeth, Countess of Ancrum, 30 x 25, 1770
Mrs. James Fortescue, 30 x 25, 1760

Kentucky

LOUISVILLE, The J. B. Speed Art Museum
Master Lamb, (oval), 20¼ x 16, c. 1784
William Cavendish, Fourth Duke of Devonshire, 50¼ x 40

Louisiana

NEW ORLEANS, New Orleans Museum of Art
Mrs. Eliza Hartley, 21 x 17, 1771-73 (attrib. to)

Maryland

BALTIMORE, The Baltimore Museum of Art
Portrait of Lady St. Asaph and Son, 55¾ x 43½, 1786 (Epstein)
Portrait of Miss Pelham, 33 x 27 (Jacobs)
Lady Stanhope as "Contemplation," 93 x 57½, 1765 (Jacobs)
George Spencer and His Wife, 54 x 45 (Jacobs)

Massachusetts

AMHERST, The Mead Art Building, Amherst College
Mrs. Barnard, 30 x 25, 1767

BOSTON, Museum of Fine Arts
Miss Henrietta Edgcumbe, 30 x 25
Lady Scott, 29⅞ x 25⅛
General Barrington, 30 x 25
Mrs. Mary Robinson as "Contemplation", 29½ x 24½
A Lady, 30 x 25
Mrs. Palk, 30 x 25
Lady Gertrude Fitzpatrick, as "Sylvia," 56½ x 40¼

CAMBRIDGE, Fogg Art Museum, Harvard University
Portrait of Mrs. Brudnell, 29¾ x 25, 1760
Portrait of Miss Elizabeth Beauclerk as "Una with the Lion," 29½ x 24½ (sight), 1777
A Sketchbook (p. 30, verso) (drawing), 8¹/₁₆ x 6⅜
A Sketchbook (p. 31, verso and p. 32 recto) (drawings), ea. 8¹/₁₆ x 6⅜

NORTHAMPTON, Smith College Museum of Art
Mrs. Nesbitt as Circe, 49¼ x 39½, 1781

PITTSFIELD, The Berkshire Museum
?Portrait of Miss Barnard, 30 x 25 (Miles)

WILLIAMSTOWN, Williams College Museum of Art
Portrait of Master Henry Vansittart (oval), 27 x 22, 1776
Portrait of Rev. Zachariah Mudge, 29 x 25

WORCESTER, Worcester Art Museum
An Unknown Army Officer, 50 x 40, c. 1785

Michigan
DETROIT, The Detroit Institute of Arts
Portrait of Mrs. Chalmers, 30 x 25, 1755-60
Sir Brooke Boothby, 29 x 24, c. 1787
Crying Forfeits, 50½ x 40
George William, 6th Earl of Coventry, 30¼ x 25
Lady Caroline Prite, 3⅜ x 2½
Felina with a Kitten, 30 x 24
Mrs. Richard Paul Jodrell, 30 x 25

Minnesota
MINNEAPOLIS, The Minneapolis Institute of Arts
The Child Baptist in the Wilderness, 49½ x 39⅞

Missouri
ST. LOUIS, The St. Louis Art Museum
*Portrait of Robert Hay Drummond, Archbishop of York, and
 Chancellor of the Order of the Garter*, 50 x 40, 1764
Portrait of Admiral Samuel Barrington, 29 x 24, 1779
Portrait of John Julius Angerstein, 36 x 28, 1765

Nebraska
OMAHA, Joslyn Art Museum
Portrait of Miss Franks, 24⅞ x 29⅝, 1766

New York
BUFFALO, The Albright-Knox Art Gallery
Cupid as a Link Boy, 30 x 25, 1774

ELMIRA, Arnot Art Museum
Portrait of Miss Hannah Vincent, 49⅞ x 40¾
Portrait of Sir Anthony Malone

NEW YORK CITY
The Brooklyn Museum
Lady Mary Crosbie, 50¾ x 40½
Portrait of Lord George Sackville, 49¾ x 39¾

The Frick Collection
General John Burgoyne, 50 x 39⅞, c. 1766
Elizabeth, Lady Taylor, 50⅛ x 40¼, c. 1780
Selina, Lady Skipwith, 50½ x 40¼, 1787

The Metropolitan Museum of Art
Mrs. Barnard, 50 x 40¼
Annabella, Viscountess Maynard (Nancy Parsons, (c. 1734)
 died c. 1814), 36¼ x 28
*George, Viscount Malden (1757-1839) and His Sister, Lady
 Elizabeth Capel (1755-1834)*, 71½ x 57¼, 1768
William Augustus, Duke of Cumberland (1721-1765), 49⅞ x 39¾
Lady Charlotte Johnstone (died 1762), 29⅝ x 24½
Mrs. Domenick Angelo (Elizabeth Johnson, (c. 1738-
 1805), 30⅛ x 25
John Barker (1707-1787), 68¼ x 47½
Lady Smith (Charlotte Delaval) and Her Children, 55⅜ x 44⅛
Georgiana Augusta Frederica Seymour (1782-1813), 35 x 30
Mrs. Richard Brinsley Sheridan.(?) (Elizabeth Ann Linley,
 1754-1792), 29⅞ x 25
*The Hon. Henry Fane (1739-1802) with His Guardians,
 Inigo Jones and Charles Blair*, 100¼ x 142
*Colonel George K.H. Coussmaker, Grenadier Guards,
 (1759-1801)*, 93¾ x 57¼, 1782
Lady Carew, 30⅛ x 25
Anne Dashwood, later Countess of Galloway (1743-1830),
 52½ x 46¾
Mrs. Baldwin, 36⅛ x 29⅛

ROCHESTER, Memorial Art Gallery of The University of Rochester
Portrait of Miss Hoare, 36 x 27 (Eastman)

North Carolina
RALEIGH, North Carolina Museum of Art
Captain John Brice, 50 x 40, c. 1764
Sir Walter Blackett, 50 x 40

Joshua Reynolds
Lady Sarah Bunbury Sacrificing to the Graces
Oil on canvas • 94 x 60"
The Art Institute of Chicago
W. W. Kimball Collection

Ohio

CINCINNATI

The Cincinnati Art Museum
Boy with Grapes, 30½ x 25⅜
Miss Ridge, 29¼ x 25
Mrs. Carnac, 22¼ x 17⅛
Portrait of Francis Meynell, 29⅜ x 24⅞
William, Viscount Pulteney, 36½ x 28¼
Mr. Sedgwick

The Taft Museum
Mrs. Mary Robinson, 29⅞ x 24⅝
Mrs. John Weyland and Her Son John, 56 x 44⅞, 1776

CLEVELAND, The Cleveland Museum of Art
The Ladies Amabel and Mary Jemima Yorke, 77 x 67½, 1761

COLUMBUS, Columbus Museum of Art
Collina (Lady Gertrude Fitzpatrick), 55½ x 49, 1779

DAYTON, The Dayton Art Institute
Portrait of Henry, 8th Lord Arundel of Wardour, 94 x 58, 1764
Portrait of Miss Mary Powys, afterwards Lady Stopford and Countess of Courtown, 30 x 25, 1762
Portrait of Mr. H. Mervyn, 30 x 25, 1747-48
Portrait of Mrs. Mervyn, 30 x 25, 1747-48

OBERLIN, The Allen Memorial Art Museum, Oberlin College
The Strawberry Girl, 30¼ x 25⅛, after 1773

TOLEDO, The Toledo Museum of Art
Miss Esther Jacobs, 36 x 28¾, 1761
Captain William Hamilton, 30¼ x 25⅛, 1757-72
Master Henry Hoare, 50¼ x 39⅞, 1788
Miss Frances Harris, 55½ x 44, 1789

Oklahoma

TULSA, The Philbrook Art Center
Infant Samuel, 36 x 33 (attrib. to)
Mary Horneck, 48 x 36 (attrib. to)

Oregon

PORTLAND, Portland Art Museum
Arabella Penelope Reynolds, 30 x 25, c. 1765

Pennsylvania

PHILADELPHIA, Philadelphia Museum of Art
Master Bunbury, 30¼ x 25¼ (McFadden)

Rhode Island

PROVIDENCE, Museum of Art, Rhode Island School of Design
A Caricature Group of Musicians, 24¾ x 19

South Carolina

COLUMBIA, Columbia Museums of Art and Science
Bacchante (Mrs. Elizabeth Palmer as), 30 x 24½

Tennessee

MEMPHIS, Brooks Memorial Art Gallery
Mary Palmer, 30 x 25
Portrait of Mrs. Way, 50 x 60
Admiral Barrington, 30 x 25
Portrait of Mrs. Margaret Baker, 30 x 25

Texas

FORT WORTH, Kimbell Art Museum
Miss Anna Ward with Her Dog, 55¾ x 44¾, 1787
Miss Charlotte Fish, 50 x 39¾, 1761
Miss Warren (?), 93¾ x 58¼, 1758-59

Canada

Ontario

OTTAWA, The National Gallery of Canada
Jeffrey, Lord Amherst, 29½ x 24½, c. 1765-68
Colonel Charles Churchill, 47½ x 38, 1755

TORONTO, Art Gallery of Ontario
Field Marshall George, First Marquess Townshend, 93½ x 57½, c. 1759
Portrait of Horace Walpole, 50 x 40½

Quebec

MONTREAL, Montreal Museum of Fine Arts
A Lady of the Meade Family, 49 x 38¾
The Lady Talbot, 35¾ x 28
Portrait of a Gentleman, 29½ x 25

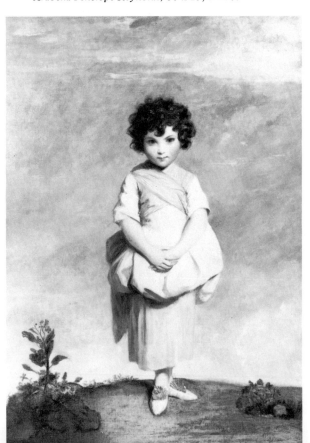

Joshua Reynolds
Collina (Lady Gertrude Fitzpatrick)
Oil on canvas • 55½ x 49"
The Columbus Gallery of Fine Arts
Columbus, Ohio
Derby Fund

Peter Paul Rubens

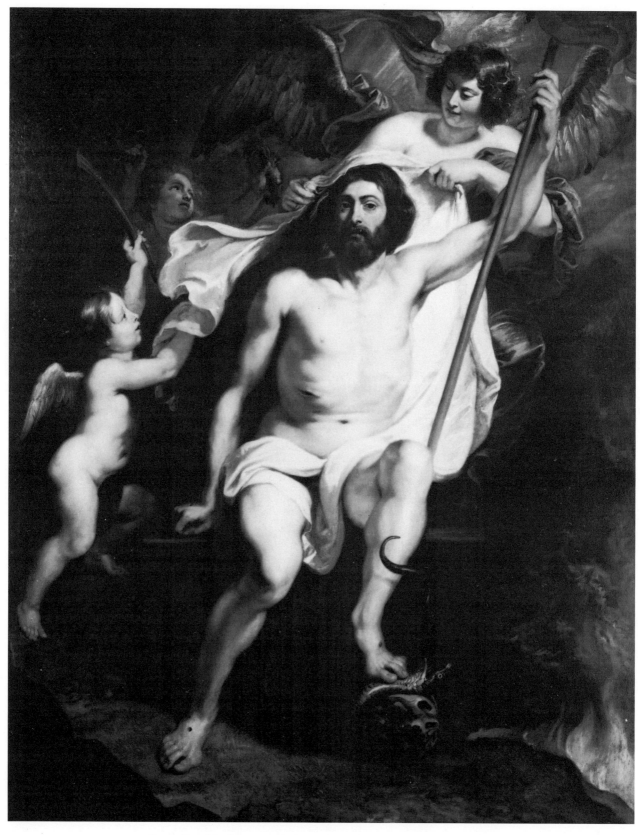

Peter Paul Rubens • Christ Triumphant over Sin and Death
Oil on canvas • *83¼ x 67¼″* • *The Columbus Gallery of Fine Arts, Columbus, Ohio*
Derby Fund

Peter Paul Rubens

1577–1640

Peter Paul Rubens was born near Cologne, Germany, where his father, an Antwerp lawyer, had fled from religious persecution. The family returned to Antwerp in 1586, where Rubens received a classical education at a Jesuit school and began to study painting. From 1600 until 1608 he painted in both Italy and Spain as the protégé of the Duke of Mantua. Back in Antwerp in 1609, he was appointed painter to the Spanish governors of the Netherlands and immediately married Isabella Brandt, who died in 1626. (His portrait of her is in Cleveland.) In 1622, Maria de' Medici commissioned him to decorate the Luxembourg Palace, and in 1628 he went to Madrid on the first of many diplomatic missions which culminated in his conclusion of a treaty between Spain and England, for which he was knighted. In 1630 he married Helene Fourment, who bore him children and posed for many of his last pictures, including her portrait in Richmond, Virginia.

Rubens had the extraordinary good fortune of belonging completely to his time and place—seventeenth-century Europe, when political intrigue was as thick as London fog, and the unprecedented wealth of the colonial world was being lavished on decorations for the enormous new palaces and chateaux of rival rulers. It was the great Baroque period, a vigorous time of high living, loving, and learning; the time of the fictional *Three Musketeers* and the very real George Villiers, Duke of Buckingham, whom Rubens painted. (His sketch for the painting is in Zanesville, Ohio.)

A visitor to Rubens's studio has left the following account of his remarkable vitality. "We paid a visit to the very celebrated and eminent painter, Rubens, whom we found at work, and, while he went on with his painting, listening to a reading from Tacitus and dictating a letter . . . he spoke to us, without stopping his work, or the reading, or the dictation, and answered our questions as if to give us proof of his powerful faculties . . . We also saw a vast room in which a number of young painters were gathered, each engaged on a different work for which M. Rubens had given him a pencil drawing, touched with color here and there. These young people must carry out these pictures in paint, when M. Rubens finishes them off."

It was this production-line system that enabled the Rubens studio to turn out the incredible number of more than fifteen hundred paintings.

It was this system, too, that has plagued art scholars ever since, forcing them to distinguish between the genuine Rubens and the student work. But interested amateurs can play the same game with profit and pleasure. Even to an inexperienced eye, there can be almost no mistaking the luminous, glowing flesh tones of the master, as contrasted with the flat, comparatively dull, paint of lesser artists. And if, under a magnifying glass, the brushstrokes show a fine vigor and vitality that give them a life of their own, quite apart from the subject they depict, the glass is probably hovering over the work of Rubens himself. The biggest pictures may be substantially student work, yet many (as in the Ringling Museum in Sarasota) show the sure hand of the master who composed them. The smaller ones, especially the portraits of his two wives, are mostly Rubens. And the sketches, such as the one in Zanesville, are *all* Rubens.

Among the large paintings in America that reveal a great amount of Rubens is the one reproduced, formerly owned by Cardinal Richelieu and now in Detroit. It tells the Biblical story (Samuel 1: 28) of Abigail, wife of Nabal, placating David, who had been offended by her husband. And it is told as only Rubens would tell it. The picture is bursting with action and color. Horses stomp. Soldiers finger their weapons impatiently. Great areas of bright vermilion are boldly placed next to brilliant blues. Yet all is held together by the great swirling design of a letter S laid on its side, with Abigail's two arms suggesting its center curve.

Peter Paul Rubens in America

Alabama
BIRMINGHAM, Birmingham Museum of Art
Ceres and Pomona, 81 x 60 (studio of)

California
LOS ANGELES
Los Angeles County Museum of Art
?Bust of a Bearded Man, 26 x 20, c. 1612-15
Holy Family with the Dove, 54½ x 47½, 1609-10
The Israelites Gathering Manna in the Desert, 25½ x 21

University of Southern California, University Galleries
Venus Wounded by a Thorn, 32¼ x 24½
The Nativity, 32 x 24½

MALIBU, The J. Paul Getty Museum
Diana and Her Nymphs on the Hunt, 111⅞ x 71
Four Studies of a Negro's Head, 10 x 25½, c. 1617-20
Death of Queen Dido, 72 x 48½, c. 1635-38
Andromeda, 77½ x 51½, c. 1638

PASADENA, Norton Simon Museum of Art
Sketch of Calydonian Boar Hunt, 18¾ x 29¾, 1620
St. Ignatius of Loyola, 88 x 54½, 1620
David and Goliath, 48 x 39, 1630
The Holy Women at the Sepulchre, 44 x 57½, 1614

SACRAMENTO, The E. B. Crocker Art Gallery
Head of a Man (Apostle?) (drawing), 13 x 10⅞

SAN DIEGO
San Diego Museum of Art
Allegory of Eternity (sketch), 26 x 13½, c. 1635

Timken Art Gallery
Portrait of a Young Captain, 25 x 19½

SAN FRANCISCO, The Fine Arts Museums of San Francisco
Portrait of Archduke Ferdinand, Cardinal Infante of Spain,
 28½ x 21 (attrib. to)
Christ Appears to St. Mary Magdalen After His Resurrection,
 22⅝ x 36½ (with Jan Brueghel, the Elder)
The Tribute Money, 56½ x 74¾, 1611-12

Colorado
DENVER, The Denver Art Museum
Head of a Bearded Man, 17 x 12½

Connecticut
HARTFORD, Wadsworth Atheneum
The Tiger Hunt, 38 x 48¾
The Return of the Holy Family from Egypt, 89½ x 59, c. 1614

NEW HAVEN, Yale University Art Gallery
Hero and Leander, 37¾ x 50⅜, 1605-6
The Assumption of the Virgin, 22 x 16, 1636-38

District of Columbia
WASHINGTON
National Collection of Fine Arts, Smithsonian Institution
Madonna and Child, 41⅝ x 29⅛ (Gellatly)

National Gallery of Art
Head of One of the Three Kings, 26¼ x 20¼, c. 1615 (Dale)
Marchesa Brigida Spinola Doria, 60 x 38⅞, c. 1606
Tiberius and Agrippina, 26¼ x 22½, c. 1614
Daniel in the Lion's Den, 88¼ x 130⅛, c. 1615
Deborah Kip, Wife of Sir Balthasar Gerbier, and Her
 Children, 65¼ x 70, c. 1630
The Assumption of the Virgin, 49⅜ x 37⅛, c. 1626
Decius Mus Addressing the Legions, 31¾ x 33¼, c. 1617
The Meeting of Abraham and Melchizedek, 26 x 32½, c. 1625

Florida
SARASOTA, John and Mable Ringling Museum of Art
Departure of Lot and His Family from Sodom, 85½ x 96
Pausias and Glycera, 80 x 76½, c. 1613 (with Osias Beert,
 the Elder)
Portrait of the Archduke Ferdinand, Cardinal-Infante of Spain,
 46½ x 37½, 1635
Portrait Head of a Young Monk, 18¾ x 15¼
Israelites Gathering Manna in the Desert, 192 x 163 (studio of)
Abraham Receiving Bread and Wine from Melchizedek,
 168 x 228 (studio)
The Four Evangelists, 168 x 174 (studio of)
The Fathers of the Church, 168 x 174 (studio of)
Thetis and Achilles, 43 x 35¼ (studio of)

Illinois
CHAMPAIGN, Krannert Art Museum
The Banquet of Tereus, 11³⁄₁₆ x 15¹⁵⁄₁₆

CHICAGO, The Art Institute of Chicago
Samson and Delilah (sketch), 19¾ x 25¾, 1610-11
The Wedding of Peleus and Thetis (sketch), 10⅝ x 16¾,
 1636-37
The Triumph of the Eucharist, 12½ x 12½, 1626-27
Portrait of Isabella of Bourbon, 24⅝ x 18¾, 1628-29
Portrait of Nicholas Rubens, 29⅜ x 27½, late 1630s
St. Albert of Louvain, 13¾ x 18⅛, 1620
Holy Family with St. Elizabeth and St. John the Baptist,
 46 x 35½, c. 1615

Kentucky
LOUISVILLE, The J. B. Speed Art Museum
The Hierarchy of the Church, 26¼ x 18⅜

Maryland
BALTIMORE, The Baltimore Museum of Art
Portrait of a Man, 22½ x 18½ (workshop of) (Epstein)
Portrait of a Lady, 29 x 18¼ (workshop of) (Jacobs)

Massachusetts
BOSTON
Isabella Stewart Gardner Museum
Portrait of Thomas Howard, Earl of Arundel, 54 x 15

Museum of Fine Arts
Portrait of Mulay Ahmad, 39 x 28½
Mercury and Argus, 25 x 20¾
Head of Cyrus Brought to Queen Tomyris, 80½ x 141
Hercules Slaying Envy, 25 x 19

CAMBRIDGE, Fogg Art Museum, Harvard University
Quos Ego (sketch), 19¼ x 25⅛, c. 1635
Studies for Apostles (drawing), 13⅞ x 10⅛
Study for the Figure of Christ (drawing), 15¾ x 11¾

PITTSFIELD, The Berkshire Museum
Vision of St. Ignatius, 50 x 36

WELLESLEY, The Wellesley College Museum, Jewett Arts Center
Portrait of Spinola, 28 x 33 (studio of)

WILLIAMSTOWN, Sterling and Francine Clark Art Institute
The Holy Family Under an Apple Tree, 42¹⁄₁₆ x 38, c. 1632

Michigan
DETROIT, The Detroit Institute of Arts
The Meeting of David and Abigail, 70¾ x 98½, c. 1618
Portrait of the Artist's Brother, Philippe, 27 x 21¼, 1608-11
Hygeia, the Goddess of Health, 41¼ x 29¼, c. 1615
The Archduke Ferdinand, Cardinal-Infante of Spain, at the
 Battle of Nordlingen, 48½ x 36⅝, 1635
St. Ives of Treguier (Patron of Lawyers, Defender of Widows
 and Orphans), 112½ x 87½

242

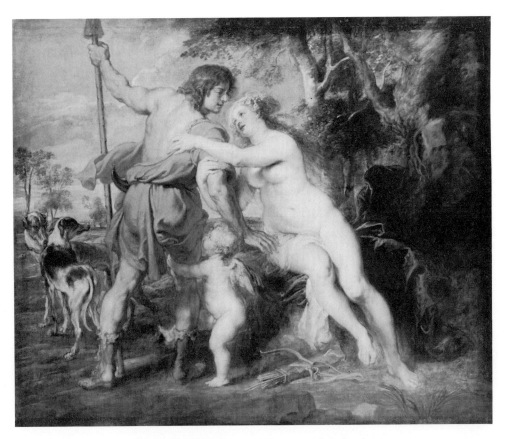

Peter Paul Rubens • Venus and Adonis
Oil on canvas • 77½ x 94⅝″ • The Metropolitan Museum of Art, New York City
Gift of Harry Payne Bingham

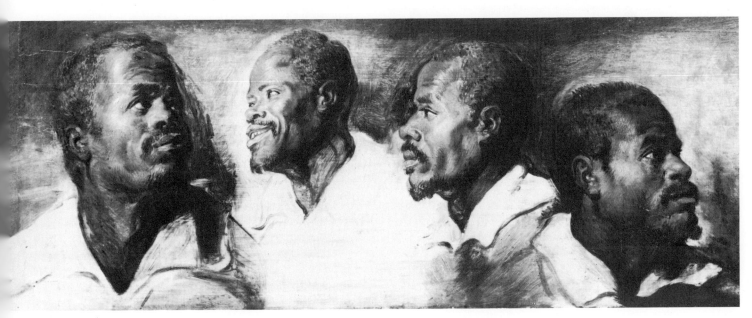

Rubens or van Dyck • Four Studies of a Negro's Head
10 x 25½″ • The J. Paul Getty Museum, Malibu, California

Minnesota
MINNEAPOLIS, The Minneapolis Institute of Arts
Crowning of the Prince of Wales by England, Scotland, and Wales (sketch), 33¼ x 27⅞, 1630

Missouri
KANSAS CITY, The Nelson Gallery and Atkins Museum
Portrait of "Old Parr," 25½ x 19¾, c. 1620
Battle of Constantine and Licinius, 14 x 22½, 1622
The Holy Family with St. John, 42 x 34, c. 1630-31
The Sacrifice of Abraham, 55½ x 43½, 1613

ST. LOUIS, The St. Louis Art Museum
Portrait of Marquis Ambrosio Spinola, 46½ x 33⅝, c. 1628 (with associates)

Nebraska
OMAHA, Joslyn Art Museum
Decius Mus Consulting the Soothsayers, 41 x 28¼, 1617-18

New Jersey
PRINCETON, The Art Museum, Princeton University
Death of Adonis, 13⅝ x 20⅝

New York
BUFFALO, The Albright-Knox Art Gallery
St. Gregory of Nazianzus, 19¾ x 25¾, 1620
Silenus (drawing), 18⅛ x 16⅝ (studio)

GLENS FALLS, The Hyde Collection
Man in Armor, 20¹/₁₆ x 16½, c. 1615
Head of a Negro, 18 x 14½, 1620-24

NEW YORK CITY
The Metropolitan Museum of Art
Wolf and Fox Hunt, 96 x 148½ (workshop of)
Vladislay Sigismund IV, King of Poland (1595-1648), 49¼ x 39¾, 1624 (workshop of) (Havemeyer)
The Triumph of Henry IV, 19½ x 32⅞, 1628-31
Saint Theresa Interceding for the Soul of Bernardino de Mendoza, 25½ x 19¼ (workshop of)
Virgin and Child, 39¾ x 30⅝ (workshop of)
The Holy Family with Saint Francis, 68½ x 82⅛ (workshop of)
The Feast of Acheloüs, 42½ x 64½ (with Jan Brueghel, the Elder)
Atalanta and Meleager, 52½ x 42
Anne of Austria (1601-1666), 60 x 47¾, c. 1622 (workshop of)
Venus and Adonis, 77¾ x 95⅝
Christ Triumphant over Sin and Death, 28 x 19
Study Head of Old Man with a White Beard, 26 x 20¼
Portrait of a Member of the Fourment Family, 30¼ x 23⅝

New York Historical Society
St. Catherine, 38½ x 28½

ROCHESTER, Memorial Art Gallery of the University of Rochester
Sketch for a Story from the Life of King Henry IV of France, 9 x 7½

North Carolina
RALEIGH, North Carolina Museum of Art
The Bear Hunt, 51⅝ x 77¹⁵/₁₆
The Holy Family with St. Anne, 68⅜ x 55⅞
Joan of Arc, 71¾ x 45⅝
Portrait of Philip III, 96½ x 50¾
Portrait of Dr. Théodore Turquet Mayerne, 54 x 43
Portrait of Philip IV, 96½ x 52⅛

Ohio
CINCINNATI, The Cincinnati Art Museum
Samson and Delilah, 20½ x 19⅞

CLEVELAND, The Cleveland Museum of Art
The Triumph of the Holy Sacrament over Ignorance and Blindness, 28¼ x 41⅜ (workshop of)

Portrait of Isabella Brandt, 22½ x 18⅞, c. 1620-22
Diana and Her Nymphs Departing for the Chase, 85 x 70⅜

COLUMBUS, The Columbus Museum of Art
Christ Triumphant over Sin and Death, 83¼ x 67¼, c. 1615-20

DAYTON, The Dayton Art Institute
Portrait of Daniel Nijs, 26 x 19, c. 1612-15
Study Head of an Old Man, 26½ x 19¾, c. 1612

OBERLIN, The Allen Memorial Art Museum, Oberlin College
The Daughters of Cecrops Discovering Erichthonius, 43¼ x 40½, c. 1633

TOLEDO, The Toledo Museum of Art
The Crowning of St. Catherine, 104⅝ x 84⅜, 1633

ZANESVILLE, Zanesville Art Center
Study for the Portrait of George Villiers, 18 x 17½

Pennsylvania
PHILADELPHIA, Philadelphia Museum of Art
Prometheus Bound, 95⅝ x 82½, 1612-18 (Wilstach)
The Discovery of Achilles, 14⅛ x 19¾ (attrib. to)
The Recognition of Philopoemen, 94 x 112
Burgomaster Rockox, 15⅜ x 12¼, c. 1614
Allegory in Honor of the Franciscan Order and the Spanish Royal House, 21⅛ x 30⅜, 1631-32 (Johnson)
Reconciliation of the Romans and the Sabines, 11¼ x 25¼ (Johnson)
The Vision of Emperor Constantine, 18¼ x 22⅛, 1621-22 (Johnson)
Ascanius Killing the Stag of Silvia, 13¼ x 20⅝, 1603-4 (Johnson)
Christ on the Cross, 48¼ x 36¾ (studio of) (Johnson)

PITTSBURGH, The Frick Art Museum
Princesse de Condé, Éléonore de Bourbon, 43 x 34, c. 1610

READING, The Reading Public Museum and Art Gallery
Orpheus and Eurydice, 24¾ x 31¼

South Carolina
COLUMBIA, Columbia Museums of Art and Science
?Christ at the Home of the Pharisees, 64 x 88

GREENVILLE, Bob Jones University Art Gallery and Museum
The Dead Abel, 55 x 70
Christ on the Cross, 45 x 30¾
The Holy Family, 47⅝ x 35⅝ (studio)

Tennessee
MEMPHIS, Brooks Memorial Art Gallery
Portrait of a Lady, 45 x 38

Texas
FORT WORTH, Kimbell Art Museum
The Triumph of David, 23 x 31½, c. 1638
The Duke of Buckingham, 18⅜ x 20⅜, 1625

Utah
SALT LAKE CITY, Utah Museum of Fine Arts
?Madonna and Child, 36 x 31

Virginia
NORFOLK, Chrysler Museum at Norfolk
Portrait of the Archduchess Isabella Clara Eugenia, 46½ x 36
Portrait of a Young Man With a Sword, 39 x 28½

RICHMOND, Virginia Museum
Helene Fourment, 25⅛ x 19⅛, after 1630
Pallas and Arachne, 10½ x 15, c. 1636

Washington
SEATTLE, Seattle Art Museum
The Last Supper, 17⅛ x 17¼, 1620-21 (Kress)

Canada

Ontario

OTTAWA, The National Gallery of Canada
Head of an Old Woman, 20½ x 17, c. 1615-17
Christ with the Cross, 44⅝ x 32, c. 1603
Study of Head, Arm, and Hand (drawing), 12⅜ x 10⅞, before(?) 1620

The Flight of Meriones (drawing) (after Romano), 10 x 14¾

TORONTO, Art Gallery of Ontario
The Elevation of the Cross, 28 x 52, c. 1638

Quebec

MONTREAL, Montreal Museum of Fine Arts
The Leopards, 80¼ x 124½, c. 1615

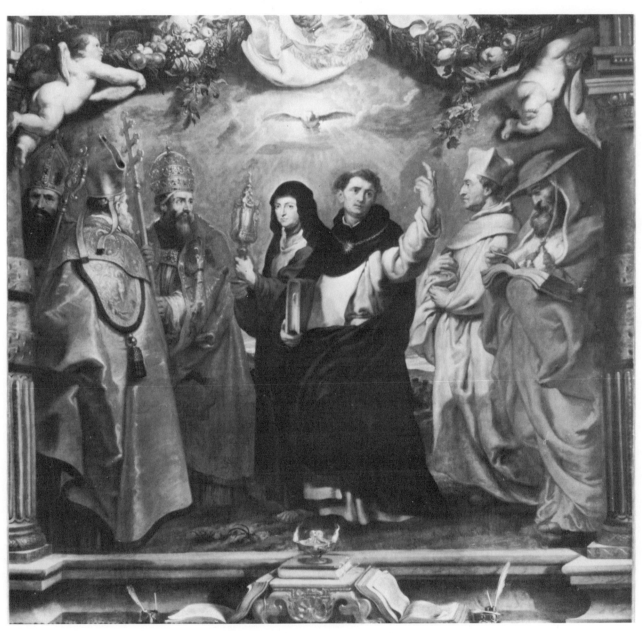

Peter Paul Rubens • The Fathers of the Church
Oil on canvas • 168 x 174" • Ringling Museum of Art, Sarasota, Florida

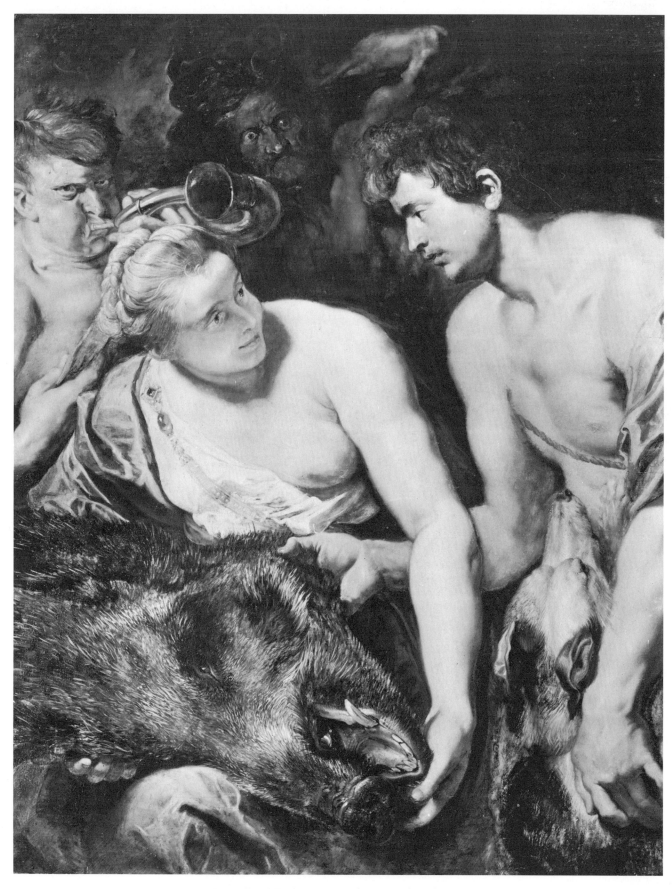

Peter Paul Rubens • Atalanta and Meleager

Oil on panel • *52½ x 41"* • *The Metropolitan Museum of Art*

New York City • *Fletcher Fund, 1944*

Jacob van Ruisdael

Jacob van Ruisdael • Quay at Amsterdam
Oil on canvas • *20³⁄₈ x 25⁷⁄₈"* • *The Frick Collection, New York City*

Jacob van Ruisdael
1628/9—1682

Jacob van Ruisdael, son of a framemaker, was born in Haarlem, where he studied with his uncle, Salomon Ruysdael, and where he was admitted to the painters' guild in 1648. (The uncle's use of "y" instead of "i" in the spelling of his name distinguishes him from his nephew.) Little is known of Ruisdael's life except that after 1657 he lived in Amsterdam as a bachelor, making a comfortable living with his painting. (The story that he died penniless in the Haarlem almshouse is now considered to be based on mistaken identity.) In 1676 he qualified as a medical doctor at Caen and presumably practised medicine in Amsterdam for the remaining six years of his life, while continuing with his painting. His picture *Park with a Country House*, in the National Gallery, is dated c. 1680. Ruisdael had many followers and a number of pupils, the most famous of whom was Meindert Hobbema.

Ruisdael, the greatest and most versatile of the Dutch landscape painters of the seventeenth century, seems to have been an isolated and melancholy personality, wholly immersed in his work, Like his contemporary, Rembrandt, he was more concerned with the timeless than the timely, with the universal rather than the particular. There is a quality of wonder in both. Rembrandt found it in people; Ruisdael in nature.

Ruisdael painted nothing but landscapes. When people appear in them, as in the Metropolitan's *Wheatfields*, we know that Ruisdael has asked one of his painter friends to supply the figures. In some of these landscapes it is easy to read the reflection of what seems to have been a dreary life. Certainly a chord of melancholy sounds in many of them—as in the great *Cemetery* in Detroit, the favorite painting of the poet Goethe, who called Ruisdael a "thinking painter." But it is a majestic melancholy, a kind of sorrowful loftiness. Ruisdael seems somehow to have achieved wisdom and understanding without losing his ability to wonder and marvel.

As you stand before any one of the Ruisdaels scattered throughout America, you are immediately aware of the point of view of the man who painted it. You can imagine Ruisdael himself standing behind you, marveling at the view as though seeing it for the first time. He is not dogmatic. He looks at trees, for example, with neither the sentimentality of Joyce Kilmer nor the bitterness of Thomas Hardy. If he sees no tree with "a nest of robins in her hair," neither does he see trees as "combatants all," with sycamore shouldering oak. What he sees and expresses in paint for all the rest of us to see is the wonder which most of us lose in childhood, to replace with pedantry.

How wonderfully the light falls on the Metropolitan's *Wheatfields*! How pleasant it would be to sit for a while on that weathered log and admire the great clouds that come rolling in from the North Sea, obscuring for a few moments the soft blue Holland sky above them! And how interesting it will be when we reach the distant grove and see what kind of Dutch houses and buildings are hidden behind the trees! Do the people walking on the road live there? Childish thoughts, perhaps, but how wonderful to have them once again!

Jacob van Ruisdael in America

Alabama
BIRMINGHAM, Birmingham Museum of Art
Winter Landscape, 14⅜ x 12¾

California
LOS ANGELES
Los Angeles County Museum of Art
Landscape with Dunes, 20⅝ x 26⅝, 1649

University of Southern California, University Galleries
Countryside, 22½ x 29
Wooded Landscape with Herdsmen and Cattle, 41½ x 54
Château in the Park, 18½ x 21½

PASADENA, Norton Simon Museum of Art
Three Old Beech Trees, 54⅜ x 68⅛
Woody Landscape, 27½ x 36¼

SACRAMENTO, The E. B. Crocker Art Gallery
Tree and Houses in Town (drawing), 8¾ x 5¼

SAN DIEGO
San Diego Museum of Art
Landscape with Waterfall, 35½ x 39½

Timken Art Gallery
View of Haarlem, 30½ x 23½, c. 1670

SANTA BARBARA, UCSB Art Museum, University of California
The Gnarled Oak, 20 x 25½ (Sedgwick)

Connecticut
HARTFORD, Wadsworth Atheneum
Bleaching Grounds near Haarlem, 14$^1/_{16}$ x 17⅛

District of Columbia
WASHINGTON
Corcoran Gallery of Art
Landscape, 27¼ x 39 (Clark)
The Fallen Tree, 28 x 25¾ (Clark)

National Gallery of Art
Forest Scene, 41½ x 51½, c. 1660-65 (Widener)
Park with a Country House, 30 x 38⅜, c. 1680
Landscape, 21 x 23⅝, 1655-60

Illinois
CHAMPAIGN, Krannert Art Museum
Ford in the Woods, 29¾ x 32½

CHICAGO, The Art Institute of Chicago
Ruins of Egmond, 38⅝ x 51⅛, 1650-60

Indiana
INDIANAPOLIS, Indianapolis Museum of Art
Landscape with Cascade, 30 x 37
The Great Pool, 17 x 21$^{13}/_{16}$
A Hilly Landscape with a Little Stream, 20 x 26
A River Scene with Angler, 10³/₁₆ x 15⅝

SOUTH BEND, Notre Dame University Art Gallery
The Watermill, 20½ x 26¾

Kentucky
LOUISVILLE, The J. B. Speed Art Museum
Landscape, 38¾ x 33¼

Maryland
BALTIMORE, The Baltimore Museum of Art
A Wooded Landscape with a Pool, 27 x 31 (Dickey)
Landscape with Waterfall, 43 x 36 (Jacobs)

Massachusetts
BOSTON, Museum of Fine Arts
Haarlem from the Dunes, 16½ x 16
A Rough Sea, 42½ x 49⅛

CAMBRIDGE, Fogg Art Museum, Harvard University
A Waterfall, 38½ x 33¾, c. 1665
The Old Oak, 25¼ x 28½, 1650-55
A Road Lined with Trees, 25⅜ x 20⅞, c. 1675

NORTHAMPTON, Smith College Museum of Art
A Panoramic View with the Church of Beverwijk, 12½ x 16, 1660-65

SPRINGFIELD, The Springfield Museum of Fine Arts
Landscape near Dordrecht, 12½ x 22¼, 1648 (Gray)

WILLIAMSTOWN, Sterling and Francine Clark Art Institute
Landscape with Bridge, Cattle and Figures, 37⅝ x 51$^1/_{16}$, c. 1650

WORCESTER, Worcester Art Museum
The Y on a Stormy Day, 25¾ x 32½, c. 1660

Michigan
DETROIT, The Detroit Institute of Arts
Landscape with Water Mill, 42 x 52½
Canal Scene, 15⅜ x 20¼
The Dunes, 9¼ x 12¾
Landscape with Windmill, 12¾ x 14
The Cemetery, 56 x 74½
Landscape with Windmill, 20⅞ x 24½

Missouri
KANSAS CITY, The Nelson Gallery and Atkins Museum
Landscape, 40½ x 64 (Kress)

ST. LOUIS, The St. Louis Art Museum
The Water Fall, 27⁵/₁₆ x 22$^1/_{16}$

Nebraska
OMAHA, Joslyn Art Museum
Landscape with Waterfall, 51½ x 37½

New Hampshire
MANCHESTER, The Currier Gallery of Art
View of Egmond-on-the-Sea, 24¼ x 19½, 1648

New York
GLENS FALLS, The Hyde Collection
Landscape, 11⅝ x 11⅛

NEW YORK CITY
The Frick Collection
Quay at Amsterdam, 20⅜ x 25⅞, c. 1670
Landscape with a Footbridge, 38¾ x 62⅝, 1652

The Metropolitan Museum of Art
Grainfields, 18½ x 22½
Landscape, 39¼ x 50⅞
Wheatfields, 39⅜ x 51¼ (Altman)
Landscape with a Village in the Distance, 30 x 43
Mountain Torrent, 21¼ x 16½ .

North Carolina
RALEIGH, North Carolina Museum of Art
Wooded Landscape with Waterfall, 40¹⁵/₁₆ x 56½

Ohio
CINCINNATI
The Cincinnati Art Museum
Scene in Westphalia, 40¼ x 49⅝
Edge of Forest, 24 x 28½

The Taft Museum
A View on the High Road, 22⅝ x 26¾

CLEVELAND, The Cleveland Museum of Art
Landscape with a Church by a Torrent, 28 x 21¾
A Wooded and Hilly Landscape, Evening, 20⁵/₁₆ x 23⅜
Landscape with a Windmill, 19⁹/₁₆ x 27, 1646
Landscape with a Dead Tree, 39$^1/_{16}$ x 51⅝

COLUMBUS, The Columbus Museum of Art
River Scene, 35 x 53¼, c. 1654

DAYTON, The Dayton Art Institute
Waterfall Before a Castle, 27 x 20, c. 1670

TOLEDO, The Toledo Museum of Art
Landscape with Waterfall, 45¼ x 58⅛, c. 1665

Jacob van Ruisdael • Wheatfields
Oil on canvas • 39⅜ x 51¼" • The Metropolitan Museum of Art, New York City

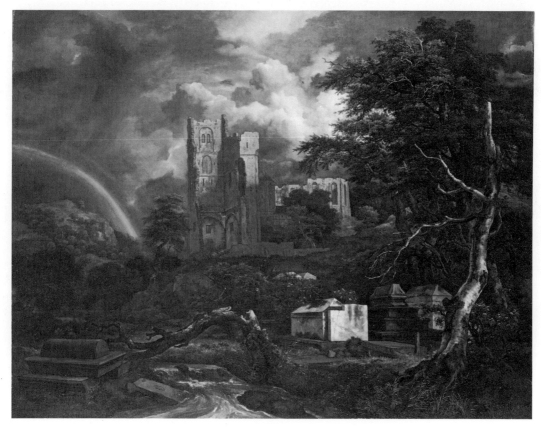

Jacob van Ruisdael • The Cemetery
Canvas • 56 x 74½" • The Detroit Institute of Arts
Gift of Juilus H. Haass in memory of his brother, Dr. E. W. Haass

Pennsylvania
PHILADELPHIA, Philadelphia Museum of Art
Landscape, 41 x 50 (Elkins)
Marine, 30 x 41¼ (Elkins)
Castle of Brederode, 11¾ x 14¾ (Johnson)
Storm on the Dunes, 27½ x 32⅜ (Johnson)

READING, The Reading Public Museum and Art Gallery
Twilight, 14⅝ x 18¼

Rhode Island
PROVIDENCE, Museum of Art, Rhode Island School of Design
The Ferry Boat, 38¼ x 56¾
Waterfalls, 30¾ x 37¼

South Carolina
COLUMBIA, Columbia Museums of Art and Science
Landscape, 31¼ x 38½

Texas
FORT WORTH, Kimbell Art Museum
Landscape with Ruins of Egmond Abbey, 26½ x 38½, 1664

Canada

Ontario
OTTAWA, The National Gallery of Canada
The Waterfall, 42 x 38¾

Quebec
MONTREAL, Montreal Museum of Fine Arts
Bleaching Grounds near Haarlem, 21¾ x 26½

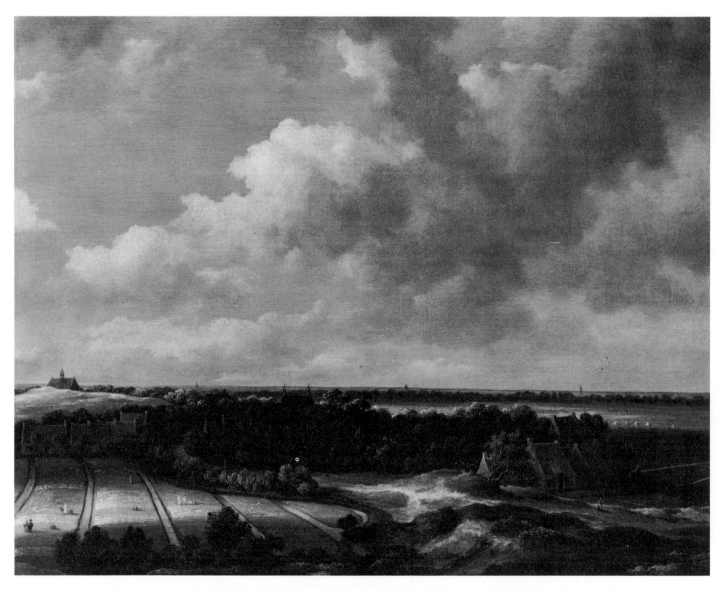

Jacob van Ruisdael • Bleaching Grounds near Haarlem
Oil on canvas • 14¹/₁₆ x 17⅛'' • Wadsworth Atheneum, Hartford, Conn.
Ella Gallup Sumner and Mary Catlin Sumner Collection

Giovanni Battista Tiepolo

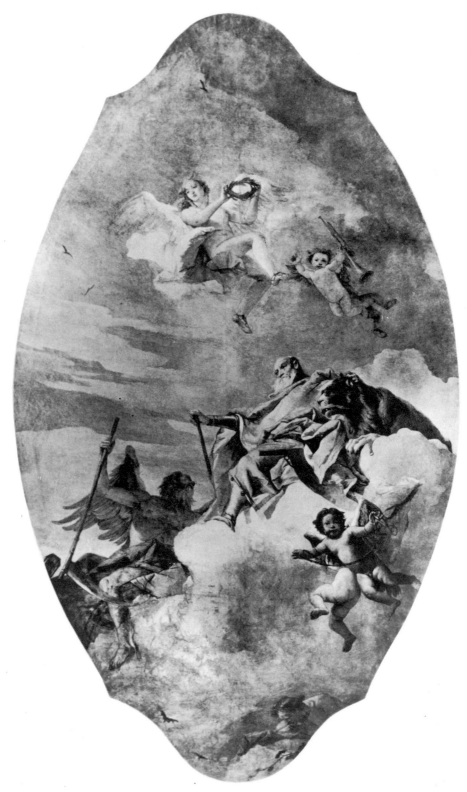

Giovanni Battista Tiepolo • Glorification of the Porto Family
Fresco transferred to canvas • *16'8" x 9'10"* • *Seattle Art Museum*
S.F. Kress Collection

Giovanni Battista Tiepolo

1696–1770

Giovanni Battista Tiepolo was born in Venice, where, after studying with Gregorio Lazzarini, a minor Venetian artist, he won instantaneous acclaim at the age of only twenty with a painting of *Pharaoh Drowned.* From that date (1716) he never lacked for commissions, with the result that today his ceiling and wall decorations may be seen in many of the great houses all over Venice as well as in a number of American museums. They may be seen also in Wurzburg, Germany, where he decorated the archbishop's palace, and in Spain, where he journeyed in 1763 to paint a series of frescoes for the royal palace and where he spent the remainder of his life. His wife, the sister of Francesco Guardi, had died before he left for Spain. Their son, Giovanni Domenico, worked closely with his father, engraving many of his easel paintings. After the elder Tiepolo's death he continued so successfully in the same tradition that the works of father and son are often confused.

Tiepolo was the last of the great Venetians to paint in the grand style. His immediate artistic ancestor was Veronese, who preserved the robust sixteenth-century Renaissance tradition of Titian and Tintoretto while leaning toward the more dramatic style of the seventeenth century which art historians call Baroque. Tiepolo belonged to the Rococo period of art, the elegant eighteenth century, when artists seem to have made an all-out effort to supersede everything that had been done before. Colors were brighter, gayer. Curves swelled to bursting points. It was hard to tell where the decoration of a building left off and the architecture began.

Tiepolo's painting of *Rinaldo and Armida in the Garden* at the Art Institute of Chicago is one of four wall decorations inspired by Tasso's poem *Jerusalem Delivered.* In it the sixteenth-century Italian poet tells the medieval story of the enchantress, Armida, who used her charms to seduce the crusaders from their vows and prevent them from reaching Jerusalem. Rinaldo succumbed, but was finally saved by a talisman and went on to the wars. Armida followed and was defeated in battle by Rinaldo, who then converted her to Christianity and became her knight.

Giovanni Battista Tiepolo in America

Arizona
TUCSON, The University of Arizona Museum of Art
The Circumcision of the Children of Israel, 20 x 28⅜, 1730-40 (Kress)
Sacrifice of Iphigenia, 19⅝ x 27³⁄₁₆ , 1730s

California
PASADENA, Norton Simon Museum of Art
Triumph of Virtue, 126 x 154½, 1740

SAN DIEGO, San Diego Museum of Art
Head of an Oriental, 13¾ x 11¼
Flight into Egypt, 24¾ x 19¾, c. 1718

SAN FRANCISCO, The Fine Arts Museums of San Francisco
Triumph of Flora, 28¼ x 35

STANFORD, Stanford University Museum of Art
Study of Bearded Man (drawing), 8 x 4¼
Caricature of a Cloaked Man Wearing a Long Wig (recto) and *Profile Sketch of a Man* (verso) (drawings), 7⅞ x 4

Connecticut
HARTFORD, Wadsworth Atheneum
The Building of the Trojan Horse, 75 x 140

Susanna and the Elders, 22 x 17
Holy Family (drawing), 10 x 7½
The Last Supper, 26 x 16, c. 1750

NEW HAVEN, Yale University Art Gallery
Apotheosis of a Saint (St. Roch Between Angels), 16⅛ x 13⅜
Allegory of Drama, 28 diam. (also seventeen ink-and-wash drawings)
Allegory of Poetry, 28 diam.
Flora and Zephyr, 103¾ x 81 (with assistants)

District of Columbia
WASHINGTON, National Gallery of Art
Apotheosis of a Poet, 10¾ x 19¼, c. 1750 (Kress)
Madonna of the Goldfinch, 24⅛ x 19¾, c. 1760 (Kress)
The World Pays Homage to Spain, 71½ x 41⅛, c. 1764 (Kress)
Apollo Pursuing Daphne, 27 x 34¼, c. 1765-66 (Kress)
Timocleia and the Thracian Commander, 55¼ x 43⅛, c. 1755
A Young Venetian Lady in Domino and Tricorne (Bautia), 24⅝ x 19⅝, c. 1760 (Kress)

Florida
SARASOTA, John and Mable Ringling Museum of Art
Two Allegorical Figures, 148 x 75

Georgia
ATLANTA, The High Museum of Art
Offerings by the Vestals to Juno, 58 x 46

Illinois
CHAMPAIGN, Krannert Art Museum
St. Maximus and St. Oswald, 23 x 14½, 1740-45

CHICAGO, The Art Institute of Chicago
St. Jerome, 13½ x 9⅜, c. 1720
The Institution of the Rosary, 38 x 19, before 1739
*Ubaldo and Guelpho Surprising Rinaldo and Armida in the
 Garden*, (four panels): two panels, 73½ x 84½; two panels,
 73 x 102⅛, c. 1740
Madonna and Child with St. Dominic and St. Hyacinth,
 108 x 54, 1740-50
The Baptism of Christ, 13⅛ x 17⅞
The Death of Seneca (drawing), 13½ x 9½

Kentucky
LOUISVILLE, The J. B. Speed Art Museum
Sacrifice of Iphigenia, 15¼ x 24¾, c. 1735-40

Louisiana
NEW ORLEANS, New Orleans Museum of Art
Portrait of a Boy Holding a Book, 19 x 15⅜, c. 1725-30 (Kress)
St. Joseph and the Christ Child, 36 x 28¾, 1730-35

Maryland
BALTIMORE, The Walters Art Gallery
Jugurtha Brought Before the Roman Consul, 110 x 192

Massachusetts
BOSTON
Isabella Stewart Gardner Museum
The Wedding of Barbarossa and Beatrice of Burgundy, 27¾ x 21¼

Museum of Fine Arts
Aeneas in the Temple of Immortality, 27 x 19½
Ceiling from the Mocenigo Palace, Venice, 72 x 54
Apotheosis of a Poet, 13 x 16
Time Unveiling Truth, 90¾ x 65¾
The Virgin Hearing the Prayers of St. Dominic, 15 x 20½

CAMBRIDGE, Fogg Art Museum, Harvard University
The Apotheosis of Aeneas (sketch), 27½ x 19¼
Rest on the Flight into Egypt (drawing), 16⅞ x 11⅜
Head of a Bearded Man (drawing), 11¼ x 8¼, c. 1753

NORTHAMPTON, Smith College Museum of Art
Rinaldo and Armida (drawing), 16¹³/₁₆ x 11⁹/₁₆

SPRINGFIELD, The Springfield Museum of Fine Arts
Madonna and Child, 51½ x 32¼ (Gray)

WILLIAMSTOWN, Sterling and Francine Clark Art Institute
The Chariot of Aurora, 19⅜ x 19⅛, c. 1730-35

Michigan
DETROIT, The Detroit Institute of Arts
St. Joseph and the Christ Child, 60½ x 43¾, 1767-69
Alexander the Great with the Women of Darius, 46½ x 38½
Madonna and Child, 19 x 16½, c. 1720
Girl with a Lute (Pandorina), 36¾ x 29½

Minnesota
MINNEAPOLIS, The Minneapolis Institute of Arts
Saint Roch, 17¼ x 12⅞

Missouri
KANSAS CITY, The Nelson Gallery and Atkins Museum
Apparition of the Angel to Hagar and Ishmael, 33 x 41½

ST. LOUIS, The St. Louis Art Museum
The Crucifixion, 31¼ x 34¾, 1755-60

New Hampshire
MANCHESTER, The Currier Gallery of Art
The Triumph of Hercules (oval), 36½ x 27½

New York
GLENS FALLS, The Hyde Collection
Madonna and Child with St. Catherine and St. John the Baptist,
 18¾ x 10⅞, c. 1755-60
Virgin and Child Adorned by Saints and Bishops (drawing),
 10⅞ x 8¹/₁₆, c. 1733
Christ Child (drawing), 8 x 11⅜, after 1750

NEW YORK CITY
The Frick Collection
Perseus and Andromeda, 20⅜ x 16, 1730

The Metropolitan Museum of Art
The Glorification of Francesco Barbaro, 96 x 183¾
The Investiture of Bishop Harold as Duke of Franconia, 28¼ x 20¼
The Adoration of the Magi, 23¾ x 18¾
Saint Thecla Praying for the Plague-Stricken, 32 x 17⅝
Juno and Luna, 83⅞ x 91
Neptune and the Winds, 24½ x 24½
The Apotheosis of the Spanish Monarchy, 32⅛ x 26⅛
Allegorical Composition (fresco), 114 diam. (workshop of)
*Allegorical Figures: Metaphysics, Arithmetic, Geometry,
 Grammar* (four frescoes), ea. 146 x 57⅞ (workshop of)
Allegorical Figures: Asia, Africa, Europe, America (four
 frescoes), ea. 32¼ x 41¾-42¾ (workshop of)
Four Allegorical Figures (fresco), 49⅛ x 36¼, 49⅜ x 36¼,
 55⅞ x 48, 45⅝ x 33½ (workshop of)
Allegory of the Planets and Continents, 73 x 54⅞
The Battle of Vercellae, 170 x 148
The Capture of Carthage, 169½ x 148½
The Triumph of Marius, 214¾ x 127¾
The Glorification of the Giustiniani Family, 46 x 32½
The Sacrifice of Isaac, 15⅜ x 21

POUGHKEEPSIE, Vassar College Art Gallery
Chronos Devouring His Child (drawing), 8½ x 11½
Two Standing Male Figures (Beggars?) (drawings), 9¹/₁₆ x 6⅜
 and 9¾ x 7

Ohio
CINCINNATI, The Cincinnati Art Museum
St. Charles Borromeo, 48⅛ x 44⅛, c. 1769

CLEVELAND, The Cleveland Museum of Art
Sketch for a Ceiling, 16¼ x 13½, c. 1753
Horatius Cocles Swimming the Tiber, 53¾ x 82, 1730
Horatius Cocles Defending Rome Against the Etruscans,
 53¾ x 82, c. 1730
Model for "The Martyrdom of St. Sebastian," Diessen, Bavaria,
 20¾ x 12¾, c. 1739

COLUMBUS, The Columbus Museum of Art
Madonna and Child with the Goldfinch, 20½ x 17¼, c. 1770-80

ZANESVILLE, Zanesville Art Center
Tarquin and Lucrece (oval), height 52

Pennsylvania
PHILADELPHIA, Philadelphia Museum of Art
Venus and Vulcan, 27⅛ x 34¼ (Johnson)

Rhode Island
PROVIDENCE, Museum of Art, Rhode Island School of Design
The Genius of Fame (fresco), 1757
Sketch of Three Heads, probably from a cameo
Bearded Man with Cloak (drawing), 9⅛ x 5⅝

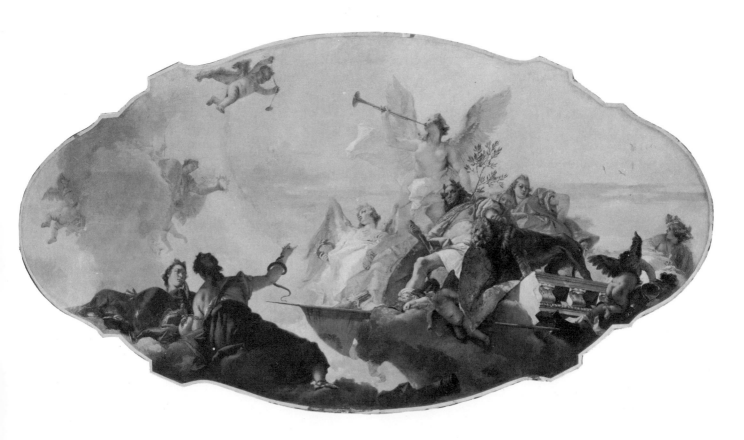

Giovanni Battista Tiepolo • The Glorification of Francesco Barbaro
Oil on canvas • 96 x 183¾'' • The Metropolitan Museum of Art
New York City • Anonymous Gift in Memory of Oliver H. Payne

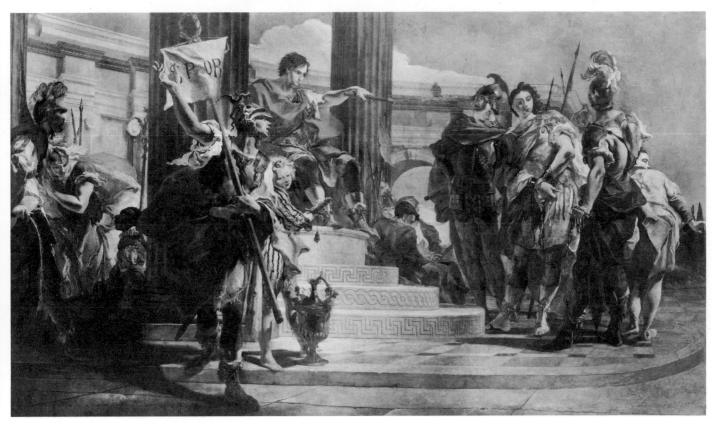

Giovanni Battista Tiepolo • King Jugurtha Brought Before Sulla
110 x 192'' • Walters Art Gallery, Baltimore, Maryland

Head of Youth (drawing), 9¾ x 7⁹/₁₆
Heads from a Cameo (drawing) 8½ x 6½
Holy Family (drawing), 12⅜ x 8¹³/₁₆
Head of Old Man (drawing), 9¼ x 7½
Study of Old Man's Head (drawing), 10 x 7⁹/₁₆

South Carolina
GREENVILLE, Bob Jones University Art Gallery and Museum
Jewish Priest or Prophet, 23 x 18⅞
Resurrection of Christ, 37 x 21

Virginia
NORFOLK, Chrysler Museum at Norfolk
Glorification of Francesco Barbaro (sketch) (oval), 19 x 25

RICHMOND, Virginia Museum
The Ascension of Christ, 30 x 35¼, c. 1740-45

Washington
SEATTLE, Seattle Art Museum
Glorification of the Porto Family (ceiling) (oval), 200 x 118, 1755-60 (Kress)
Sketch for "Glorification of the Porto Family" (oval), 23½ x 17 (Kress)

Canada

Ontario
OTTAWA, The National Gallery of Canada
Head of a Clown in Profile to Left (drawing), 9¾ x 8
Design for Ceiling (drawing), 6¼ x 5¼
Head of an Old Man (drawing), 14¾ x 9
Visiting Time at a Nunnery (drawing), 11¼ x 16¼
Man in a Large Hat Holding a Fan (drawing), 8½ x 6
Man Wearing a Three-Cornered Hat (drawing), 8⅝ x 5½
An Oriental Warrior (drawing), 10⅞ x 7¹/₅
Angels with Putti Among Clouds (drawing), 7¾ x 11⅛
Design for an Altarpiece (drawing), 10⅜ x 6⅞

Quebec
MONTREAL, Montreal Museum of Fine Arts
Apelles Painting a Portrait of Campaspe, 22½ x 28¾

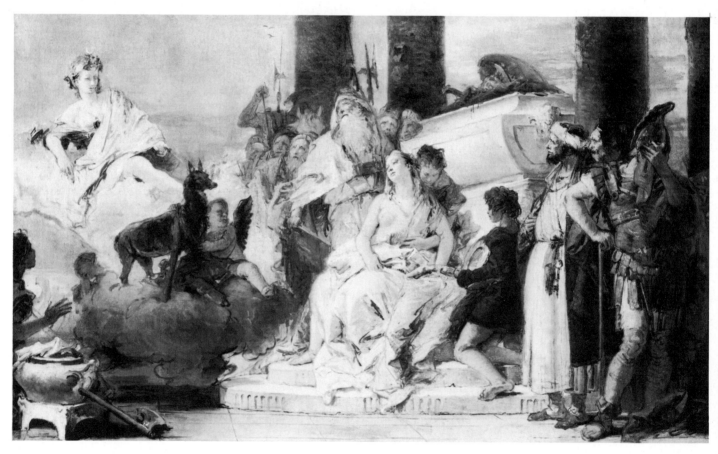

Giovanni Battista Tiepolo • Sacrifice of Iphigenia
Oil on canvas • *15¼ x 24¾"* • *The J. B. Speed Art Museum, Louisville, Kentucky*

Tintoretto

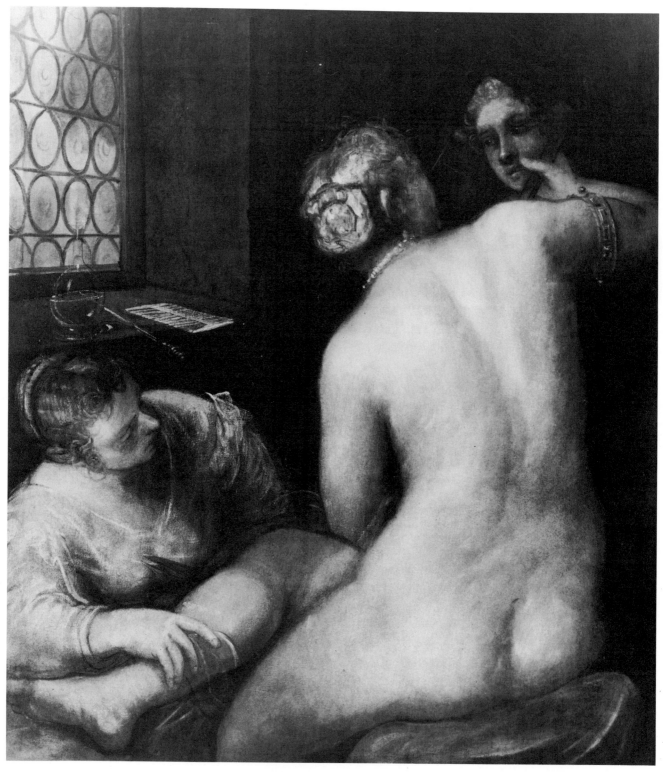

Tintoretto • Toilette of Venus
Oil on canvas • 45½ x 40⅝″ • The J. Paul Getty Museum, Malibu, California

Tintoretto

1518–1594

Tintoretto, born in Venice as Jacopo Robusti, took his painting name from the trade of his father—*tintore,* or "dyer." He studied briefly under Titian, but apparently both his own impetuous temperament and his master's dislike of teaching led him soon to strike out on his own. When he was only thirty he painted the enormous *Miracle of St. Mark,* now in the Academy in Venice, and from then on he seems never to have been without a brush in hand. He worked upon his great paintings for the school of San Rocco during the period of 1565-87. Four years before his death, he completed, with assistants, what is probably the largest canvas in the world—*The Paradise* (30 x 74 feet)—for the great hall of the Doge's Palace. He was happily married and had six children, three of whom became painters: Domenico, Marco, and Marietta.

Tintoretto's real name, Robusti, describes him and his work more accurately than his painting name. One of his rivals for the many painting commissions he won in Venice complained sadly that Tintoretto could paint more in two days than he could in a year. This enormous energy was dramatically demonstrated in the competition for an oval ceiling painting for the Albergo of the School of San Rocco. Five painters, including Tintoretto, were asked to submit sketches. After his four competitors had shown theirs, Tintoretto uncovered his entry—the completed work, already in place on the ceiling, where it can be seen today. (Another of Tintoretto's ceiling paintings can be seen in Detroit, and their style is represented in his paintings in Hartford, Washington, Chicago, Boston, New York, Providence, and other American cities.)

It was typical of Tintoretto that on the wall of his studio he should write the bold boast: "The draftsmanship of Michelangelo and the color of Titian." It was a boast that many people feel he achieved. Certainly both of these Italian giants are suggested in his *Christ at the Sea of Galilee* in the National Gallery. So is another artist who also studied briefly with Titian—El Greco.

The figure of Christ stands bold and strong as he calls to two of his future disciples in the boat (Matthew 4:21). And yet his features are gentle, as is the gesture of his hand. Here is strength without brutality, drama without melodrama. The colors, too, are dramatic without being violent. Rich purples, yellows, blues, and greens are blended in an astonishing way that makes it easy to believe El Greco was influenced by this painting when he was in Venice. (Its date, c. 1562, corresponds with El Greco's Venetian stay; compare his own later painting of *The Laocoön* and others in the National Gallery.)

But this painting is pure Tintoretto. It is the work of a man gifted to see everything with an intensity denied most people, and also gifted with the ability to express that intensity in line and color so that the rest of us may feel it in the degree to which our individual experience with painting has prepared us. Looking at Tintoretto's paintings is like listening to great music, or watching a great play. It is not merely thrilling; it is what Aristotle called catharsis.

Tintoretto in America

Alabama
BIRMINGHAM, Birmingham Museum of Art
Allegory of Vigilance, 42¼ x 40, 1580 (Kress)

Arizona
TUCSON, The University of Arizona Museum of Art
Venus Lamenting the Death of Adonis, 42¾ x 56½, c. 1580
Head of a Bearded Man, 18⅞ x 15¼, c. 1580-90

California
LOS ANGELES, University of Southern California, University Galleries
Portrait of a Venetian General, 22½ x 19½

MALIBU, The J. Paul Getty Museum
Allegory of Prudence, 56⅜ x 41⅜
Toilette of Venus, 45½ x 40⅝, c. 1572-80

SAN DIEGO, San Diego Museum of Art
Portrait of a Venetian Senator, 18½ x 14⅜, c. 1550

SAN FRANCISCO, The Fine Arts Museums of San Francisco
Madonna and Child, 39½ x 51½

Colorado
DENVER, The Denver Art Museum
Portrait of an Old Man, 26⅜ x 23⅜

Connecticut
HARTFORD, Wadsworth Atheneum
The Contest Between Apollo and Marsyas, 55 x 94½, 1545
Hercules and Antaeus, 60 x 40, c. 1570

NEW HAVEN, Yale University Art Gallery
Portrait of a Man, 48¾ x 37⅛

District of Columbia
WASHINGTON, National Gallery of Art
The Madonna of the Stars, 36½ x 28⅝, c. 1565
The Worship of the Golden Calf, 62⅝ x 107, c. 1545 (Kress)
Christ at the Sea of Galilee, 46 x 66¼, c. 1562 (Kress)
Portrait of a Procurator of St. Mark's, 54½ x 39⅞, c. 1580
 (Kress)
Susanna, 59⅛ x 40⅜, c. 1575 (Kress)
Portrait of a Venetian Senator, 43½ x 34¾, c. 1570 (Dale)
The Conversion of St. Paul, 60 x 92⅞, c. 1545 (Kress)

Illinois
CHICAGO, The Art Institute of Chicago
Venus and Mars in a Landscape with Three Graces, 41¼ x 55¾,
 c. 1575
Tarquin and Lucretia, 69 x 59¾, c. 1560
Antonio Zantani, 12⅛ x 9½, 1550-70

Kentucky
LOUISVILLE, The J. B. Speed Art Museum
A Procurator of San Marco, 47½ x 39, c. 1565 (with assistant)

Louisiana
NEW ORLEANS, New Orleans Museum of Art
Portrait of a Young Man with Ermine Collar, 22 x 17½, 1550
 (Kress)

Massachusetts
BOSTON
Isabella Stewart Gardner Museum
A Lady in Black, 45¼ x 38

Museum of Fine Arts
The Nativity, 64¼ x 143¼
Portrait of a Man, 40 x 36

CAMBRIDGE, Fogg Art Museum, Harvard University
Samson and the Philistine (drawing), 17¾ x 10¾
Madonna and Child (drawing), 11¾ x 6½

Michigan
DETROIT, The Detroit Institute of Arts
The Doge Girolamo Priult, 39¼ x 32, 1559-67
The Magdalene in the Wilderness, 79½ x 53⅜, 1565-70
The Dreams of Men (ceiling), 147¼ x 85⅜
Portrait of a Young Man with a Beard, 18 x 14½

Missouri
KANSAS CITY, The Nelson Gallery and Atkins Museum
Portrait of Tommaso Contarini, 42⅛ x 68¾, 1555

ST. LOUIS, The St. Louis Art Museum
The Finding of Moses, 30 x 68

New Hampshire
MANCHESTER, The Currier Gallery of Art
Portrait of a Venetian Nobleman, 42 x 37, c. 1585

New Jersey
PRINCETON, The Art Museum, Princeton University
Poet or Hermit in Forest, 23⅜ x 18⅜
Study of a Nude Male Figure (for an angel in *The
 Resurrection*, Scuola di San Rocco) (drawing),
 11½ x 7³⁄₁₆

New York
GLENS FALLS, The Hyde Collection
Finding of the True Cross, 8⅜ x 19⅛
Portrait of a Venetian Senator, 21½ x 15½, c. 1570

NEW YORK CITY
The Frick Collection
Portrait of a Venetian Procurator, 44⅝ x 35, before 1560

The Metropolitan Museum of Art
Doge Alvise Mocenigo Presented to the Redeemer, 38¼ x 78
The Miracle of the Loaves and the Fishes, 61 x 160½
The Finding of Moses, 30½ x 52¾
Portrait of a Man, 44⅜ x 35
Portrait of a Young Man, 54½ x 42

POUGHKEEPSIE, Vassar College Art Gallery
Portrait of a Procurator, 37 x 38 (studio of)

ROCHESTER, Memorial Art Gallery of the University of Rochester
Portrait of a Venetian Patrician, 44 x 34½ (Eastman)

North Carolina
RALEIGH, North Carolina Museum of Art
The Forge of Vulcan, 30⅜ x 51½
Portrait of a Lady, 28⅞ x 25½ (attrib. to) (Kress)

Ohio
CINCINNATI, The Cincinnati Art Museum
Portrait of Venetian Doge Cicogna, 47 x 42¾

CLEVELAND, The Cleveland Museum of Art
Baptism of Christ, 66½ x 99, c. 1570

COLUMBUS, The Columbus Museum of Art
?Portrait of a Venetian Senator, 33 x 26½

TOLEDO, The Toledo Museum of Art
Noli Me Tangere, 82¼ x 72¼, 1570-80

Pennsylvania
PITTSBURGH, The Frick Art Museum
Susannah and the Elders, 30 x 36⅝

Rhode Island
PROVIDENCE, Museum of Art, Rhode Island School of Design
Sketch for a Battle Scene, 28 x 16½
Portrait of a Man, 45 x 38

South Carolina
COLUMBIA, Columbia Museums of Art and Science
The Trinity Adored by the Heavenly Choir, 46 x 42⅝ (Kress)
Gentleman of the Emo Family, 49½ x 39½

GREENVILLE, Bob Jones University Art Gallery and Museum
The Visit of the Queen of Sheba to Solomon, 59 x 93½

Texas
FORT WORTH, Kimbell Art Museum
The Raising of Lazarus, 26½ x 30½, 1573

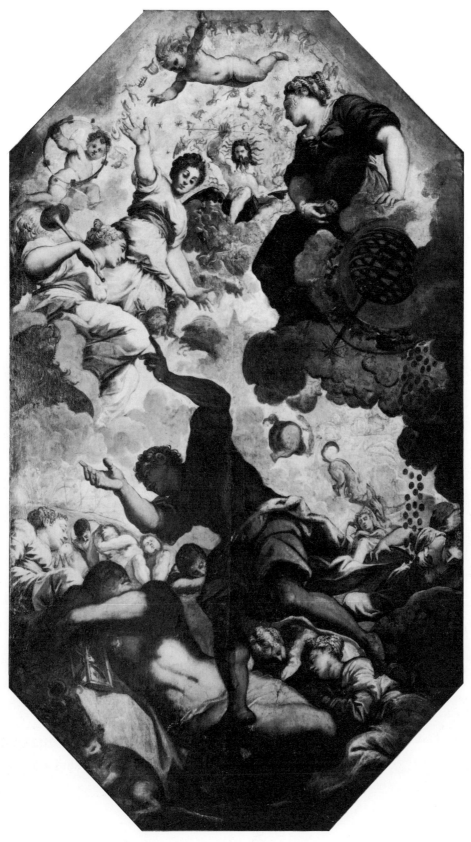

Tintoretto • The Dreams of Men
Canvas • 12'3¼'' x 7'1⅜'' • Detroit Institute of Arts

Virginia
NORFOLK, Chrysler Museum at Norfolk
Allegorical Figure of Spring, 76 x 41½, c. 1560 (loan)
Portrait of Giovanni Sopranzo, 42 x 35 (loan)

Washington
SEATTLE, Seattle Art Museum
Portrait of Gabriele de Pietro Emo, Procurator of San Marco,
45⅞ x 35¾, 1572 (with assistant) (Kress)

Canada

Ontario
OTTAWA, The National Gallery of Canada
Portrait of an Old Man, 29 x 23, c. 1570-80
Adam and Eve, 44¼ x 38½, c. 1555
Portrait of a Servant, 42¼ x 35, c. 1555

TORONTO, Art Gallery of Ontario
Christ Washing His Disciples' Feet, 61 x 160½, c. 1580-90
(workshop of)

Quebec
MONTREAL, Montreal Museum of Fine Arts
Portrait of a Man, 43½ x 35½

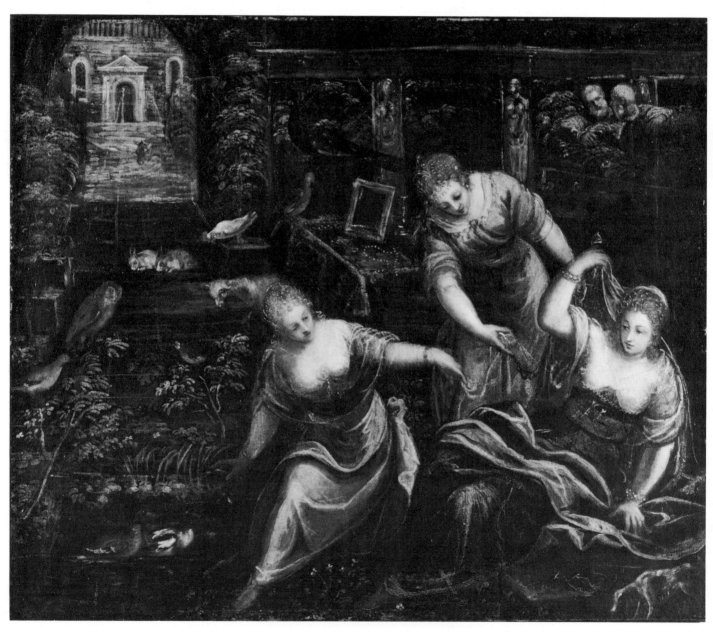

Tintoretto • Susannah and the Elders
Oil on canvas • 30 x 36½" • The Frick Art Museum, Pittsburgh, Pennsylvania

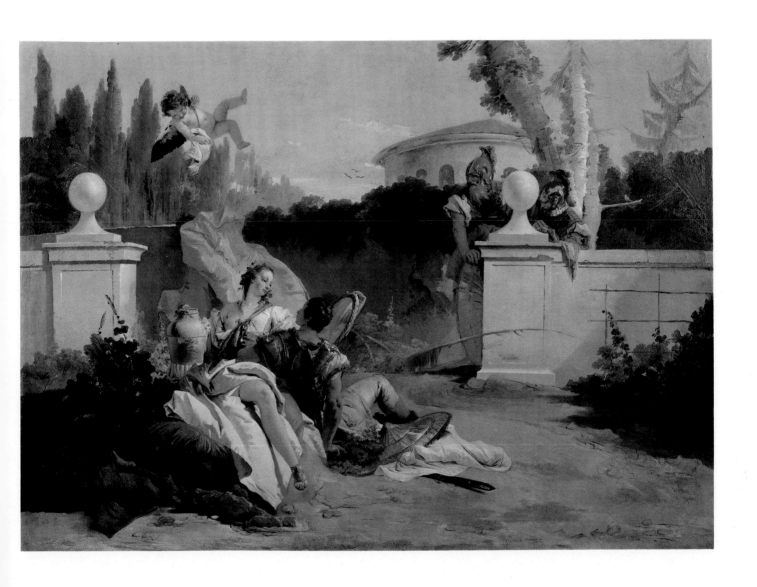

Workshop of Tiepolo • Rinaldo and Armida in Garden Surprised by Ubaldo and Guelfo
Oil on canvas • 73 x 102⅛" • The Art Institute of Chicago • Gift of James Deering

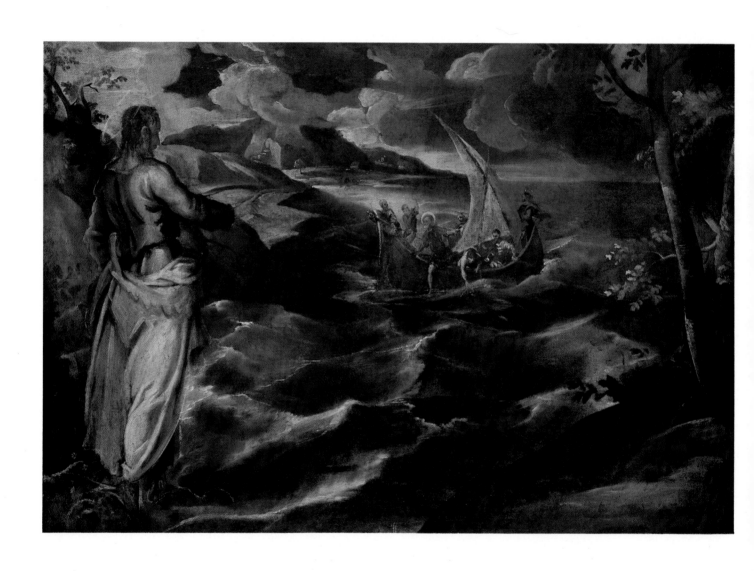

Jacopo Tintoretto • Christ at the Sea of Galilee
Oil on canvas • 46 x 66¼'' • National Gallery of Art, Washington, D.C. • Samuel H. Kress Collection

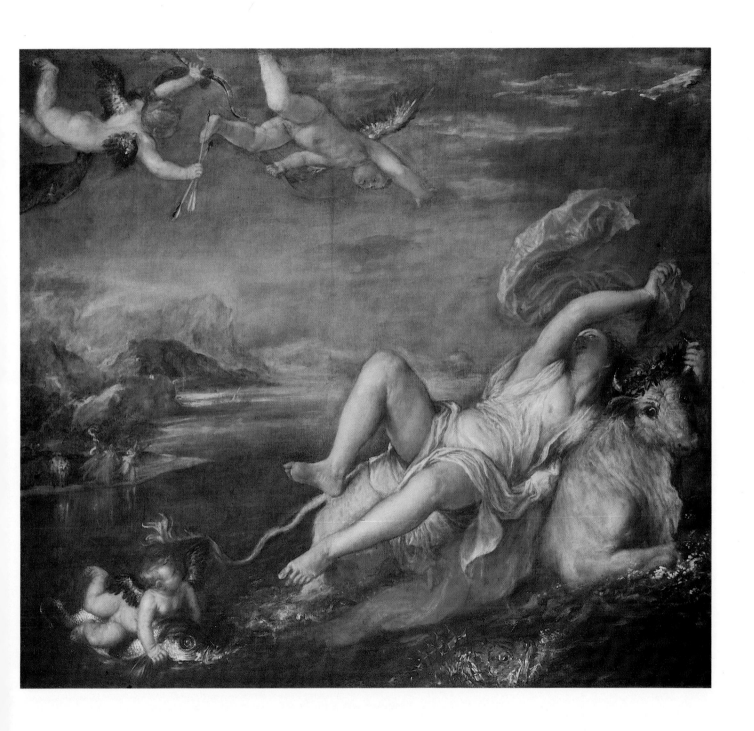

Titian • The Rape of Europa
Oil on canvas • *70 x 80½″* • *Isabella Stewart Gardner Museum, Boston*

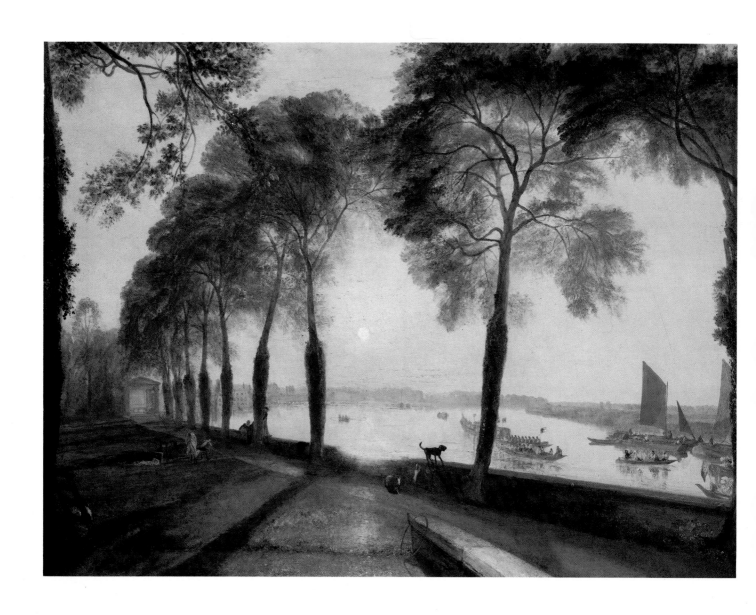

J.M.W. Turner • Mortlake Terrace

Oil on canvas • *36¼ x 48⅛″* • *National Gallery of Art, Washington, D.C.* • *Andrew W. Mellon Collection*

Diego Rodriguez de Silva y Velásquez • Don Baltasar Carlos and His Dwarf
Oil on canvas • *53½ x 41″* • *Museum of Fine Arts, Boston* • *Henry Lillie Pierce Fund*

Jan Vermeer • Officer and Laughing Girl
Oil on canvas • 19⅞ x 18⅛ ″ • The Frick Collection, New York

Veronese • Rest on the Flight into Egypt
Oil on canvas • 92¼ x 63¼" • John and Mable Ringling Museum of Art, Sarasota, Florida

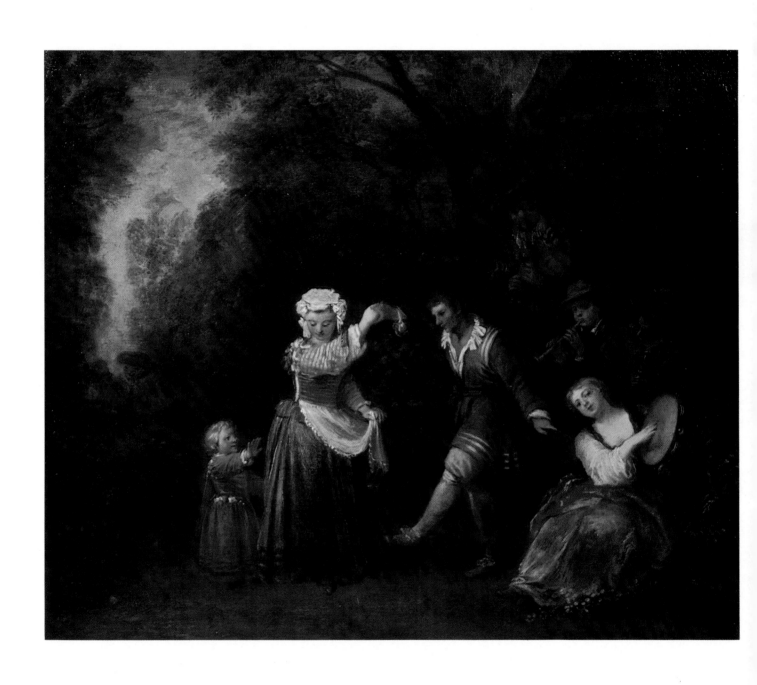

Antoine Watteau • La Danse Champêtre
Oil on canvas • 19½ x 25⅝ ″ • Indianapolis Museum of Art • Gift of Mrs. Herman C. Krannert

Titian

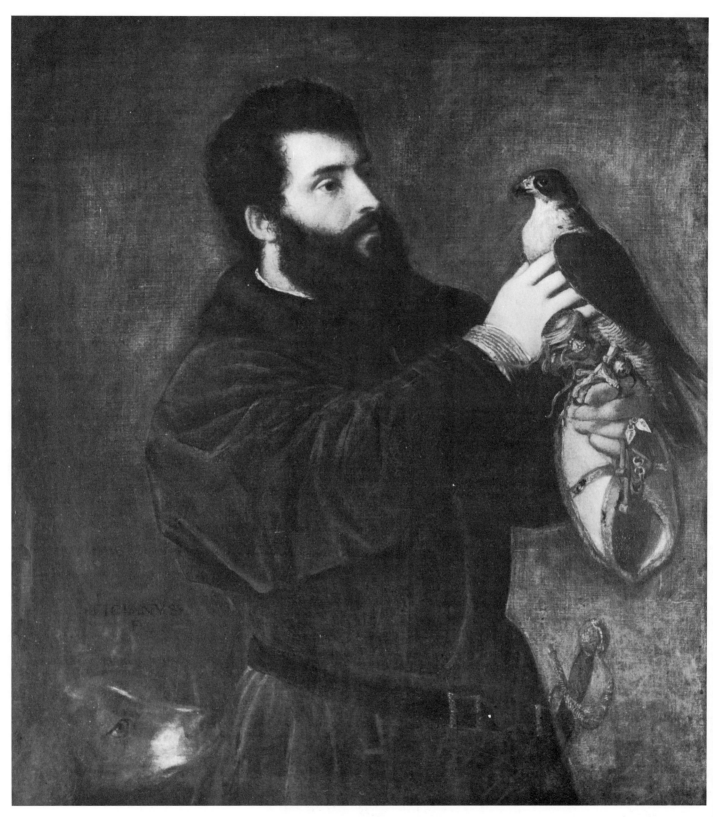

Titian • Man with a Falcon
Oil on canvas • 37 x 42¼″ • Joslyn Art Museum, Omaha, Nebraska

Titian

c. 1487–1576

Titian, whose full name was Tiziano Vecellio, was born in the little Dolomite town of Pieve di Cadore, where he began to paint. When he was quite young he was taken to Venice to study (together with Giorgione) in the studio of Giovanni Bellini, the first of the great Venetian masters. Presently his own work began to attract attention. Upon the completion of his celebrated *Assumption,* still in the Church of the Frari in Venice (where he was later buried), he became not only the chief painter of Venice, but one greatly in demand throughout Europe. Among other commissions, he journeyed to Augsburg to paint Emperor Charles V and his son Philip II and to Rome to paint Pope Paul III and his nephews. But after about 1550 Titian remained in Venice, a widower with two sons and three daughters, the youngest of whom, Lavinia, is supposed to have posed for many of his pictures. He died of the plague at the age of eighty-nine.

During the eighty-nine years of Titian's life, his home city of Venice reached the peak of her greatness and began the first steps of her gradual decline. But Titian was spared the sight of any tarnish on this "gilded warehouse of the Mediterranean." His portraits reflect the confident serenity of a people whose families for five hundred years had known nothing but triumph, success, and wealth. His mythological pictures, such as *The Rape of Europa,* tell us that these families used their wealth in intellectual pursuits as well as commercial ones.

In Ovid's *Metamorphoses* appears the story that the beauty of a Phoenician princess named Europa enticed Zeus to assume the form of a bull and swim with her on his back to Crete, where she bore him three sons and was worshipped under the name of Hellotis. Titian painted this picture for Philip II of Spain to decorate the royal palace in Madrid, from where it passed into various private collections and finally into the Gardner Museum in Boston.

The subject was a natural one for Titian: a semi-nude female figure on the back of an amorous bull, painted against a background of mountains and bays and surrounded by cupids. The canvas measures 70 x 80½ inches, large enough to tax the energy of a young man. Titian was seventy-three when he painted it, and he filled every square inch with the glowing color that made his pictures in demand throughout Europe. He has boldly placed the main action far to the right of center, but the picture does not appear lopsided. The movement of Europa's red scarf and the tilt of her right thigh turn the eye back to the left side of the picture, where it moves easily over the surface of the water, lingers on the solidly painted mountains, and continues up into a blue sky filled with cupids who seem to be taking delight in what they are observing below. Titian was not without humor.

While *The Rape of Europa* was still in Madrid in 1628-29, Peter Paul Rubens made a full-size copy of it and, according to legend, called it "the first painting in the world." Visitors to the Gardner Museum in Boston may well be inclined to agree with him.

Titian in America

California
MALIBU, The J. Paul Getty Museum
The Penitent Magdalen, 42 x 36⅝, 1567

SAN DIEGO, San Diego Museum of Art
Madonna with Christ Child and St. John, 27½ x 22, c. 1515

Connecticut
NEW HAVEN, Yale University Art Gallery
Circumcision, 14⁷/₁₆ x 31¼, c. 1510 (attrib. to)
Portrait of a Man, 43¼ x 36⅞, c. 1540

District of Columbia

WASHINGTON

Corcoran Gallery of Art
Martin Pasqualigo, 31¼ x 25 (Clark)

National Gallery of Art
Cupid with the Wheel of Fortune, 26 x 21¾, c. 1520 (Kress)
Portrait of a Lady, 38½ x 29⅛, 1550-55 (Kress)
Madonna and Child and the Infant St. John in a Landscape,
 11 x 22¾, c. 1530 (Mellon)
Cardinal Pietro Bembo, 37⅛ x 30⅛, c. 1510 (Kress)
Venus with a Mirror, 49 x 41½, c. 1555 (Mellon)
Andrea dei Franceschi, 25½ x 20, c. 1530 (Mellon)
Venus and Adonis, 42 x 53⅜, after 1560 (Widener)
Ranuccio Farnese, 35¼ x 29, 1542 (Kress)
Doge Andrea Gritti, 52½ x 41½, c. 1535-40 (Kress)

Indiana

INDIANAPOLIS, Indianapolis Museum of Art
Portrait of a Man, Lodovico Ariosto, 23½ x 18½

Maryland

BALTIMORE, The Baltimore Museum of Art
Portrait of a Nobleman, 34 x 28, 1561 (Epstein)

Massachusetts

BOSTON

Isabella Stewart Gardner Museum
The Rape of Europa, 70 x 80½

Museum of Fine Arts
St. Catherine of Alexandria, 46¾ x 39¼
Man with a Book, 38½ x 30¼

Michigan

DETROIT, The Detroit Institute of Arts
Portrait of Andrea de Franceschi, 32 x 25, c. 1540-45
Judith with the Head of Holofernes, 44½ x 37½, c. 1570
Portrait of a Man Holding a Flute, 38½ x 30, c. 1560

Minnesota

MINNEAPOLIS, The Minneapolis Institute of Arts
Temptation of Christ, 36⅛ x 28½

Missouri

KANSAS CITY, The Nelson Gallery and Atkins Museum
Portrait of Antoine Perrenot de Granvelle, 44½ x 34¾, 1548-49
Rape of Lucretia by Tarquinius, 71¼ x 61¼

ST. LOUIS, The St. Louis Art Museum
Christ Shown to the People, 43 x 36½

Nebraska

OMAHA, Joslyn Art Museum
Man with a Falcon, 37 x 42¼, 1530-40

New York

GLENS FALLS, The Hyde Collection
Doge Petrus Lando, 46 x 39, 1545

NEW YORK CITY

The Frick Collection
Pietro Aretino, 40⅛ x 33¾, 1548-50
Portrait of a Man in a Red Cap, 32⅜ x 28, c. 1515

The Metropolitan Museum of Art
Venus and the Lute Player, 65 x 82½
Filippo Archinto, Archbishop of Milan (born c. 1500, died
 1558), 46½ x 37 (Altman)
Portrait of a Venetian Nobleman, 47½ x 36½ (Bache)
Madonna and Child, 18 x 22 (Bache)
Doge Andrea Gritti (1455-1538), 40¼ x 31¾
Venus and Adonis, 42 x 52½ (Bache)
Portrait of a Man, 19¾ x 17¾ (Altman)

North Carolina

RALEIGH, North Carolina Museum of Art
The Adoration of the Child, 7½ x 6⅜ (attrib. to) (Kress)

Ohio

CINCINNATI, The Cincinnati Art Museum
Philip II of Spain, 42 x 36

CLEVELAND, The Cleveland Museum of Art
Adoration of the Magi, 56 x 89⅞

Pennsylvania

PHILADELPHIA, Philadelphia Museum of Art
Filippo Archinto, 45¼ x 35 (Johnson)

South Carolina

GREENVILLE, Bob Jones University Art Gallery and Museum
Christ with a Book, 8 x 5½
The Last Supper, 87¼ x 14½ (studio of)

Virginia

NORFOLK, Chrysler Museum at Norfolk
Admiral Vincenzo Capello, 53½ x 45¼, c. 1540 (attrib. to)

Canada

Ontario

OTTAWA, The National Gallery of Canada
Portrait of Daniele Barbaro, 33¾ x 28

Joseph Mallord William Turner

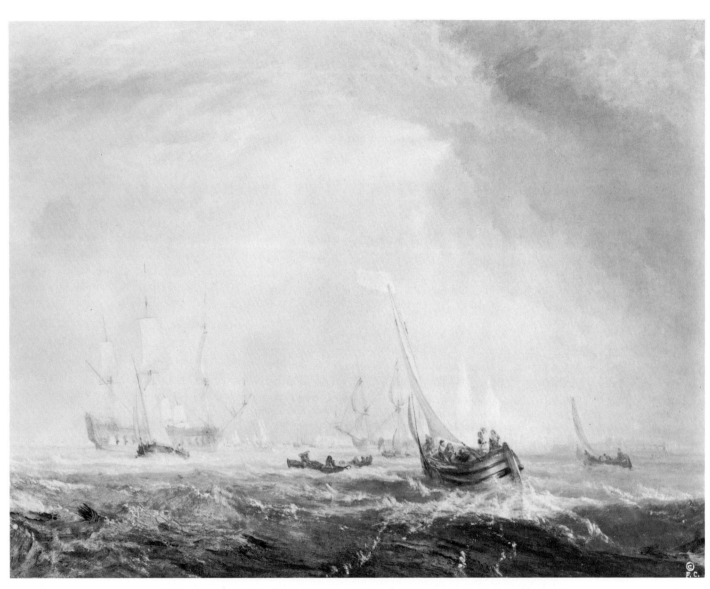

J.M.W. Turner • Antwerp: Van Goyen Looking Out for a Subject
Canvas • 46⅛ x 48⅜" • The Frick Collection, New York City

Joseph Mallord William Turner

1775–1851

Joseph Mallord William Turner was born in London, the son of a barber who encouraged his son's early interest in art by showing some of the boy's drawings in his shop window, where a number of them attracted buyers. Turner had little formal education and began his professional career in a printing shop, coloring engravings. He was then apprenticed to the architect, Thomas Hardwick, while taking lessons in perspective from the watercolorist, Thomas Malton. In 1789, when only fourteen, he was admitted to the school of the Royal Academy, where one of his drawings was exhibited the following year and where he continued to exhibit during the remainder of his long, industrious life. Commissioned by *Copper Plate Magazine* in 1792, he traveled on foot through Wales, Kent, Cheshire, Shropshire, Cumberland, and the Midlands, making drawings of castles, abbeys, rivers, and bridges. In 1802 he was elected an academician of the Royal Academy, where he later became professor of perspective. After a journey to France and Switzerland, Turner built a gallery behind his house on Harley Street, which he shared with his widowed father, and began to show his pictures. The inspiration of his Italian trip in 1819 made his work immensely popular, and he was soon overwhelmed with commissions. He never married and had no pupils. A great admirer of Claude's landscapes, Turner stipulated in his will that two of his paintings be hung in the National Gallery between two Claudes, so that people could judge for themselves who was the superior painter. Also in his will he left to the nation about 300 oil paintings and some 19,000 drawings and watercolors, many of which are on exhibit in the British Museum. Seventy-six of his pictures are in the United States and Canada and are listed in this book.

Mortlake is a parish in Surrey, thirty miles up the Thames from London. It has traditionally marked the end of university boat races rowed up the river from Putney. In 1826, when Turner painted this picture, Mortlake Terrace was the home of William Moffat, who presumably commissioned this and another view of the terrace by Turner now in the Frick Collection.

It is not surprising that when the Impressionist painters Monet and Pissarro visited London in 1870 they were struck by the Impressionist qualities in Turner's paintings on view in the National Gallery. What they saw was brilliant color in unexpected places, just as they themselves were then using it in France, in contrast to the Barbizon browns of their contemporaries. Turner was always intrigued by the play of both natural and artificial light on natural and man-made objects. (See his *Burning of the Houses of Parliament* in Cleveland and Philadelphia.) In this respect, he and his English contemporary Constable anticipated French Impressionism by fifty years. In *Mortlake Terrace* the golden light of the afternoon sun almost dissolves the stone parapet as it streams across the water, making the leaves shimmer overhead, although the surface of the Thames is calm.

But Turner never forgot his early lessons in perspective nor his experience in teaching the subject at the Royal Academy. The light of the sun also casts long tree shadows on the grass, leading your eye away from the picture's foreground and out across the river to the distant shore.

The dog on the parapet, also looking out across the river, has a story of its own. When the animal painter Sir Edwin Landseer entered Turner's studio one day during the artist's absence he studied this picture, then on the easel, and felt the need of an accent in the center. So from a piece of dark paper he cut out the dog and mounted it on a parapet, where Turner found it on his return —and left it there in apparent agreement.

To test the validity of Landseer's observation, cover the dog with one finger. Your view of the river is now clear. Your eye stretches unimpeded across the water. But when you remove your finger to reveal the dog, you realize that he is neither large enough nor important enough to obscure the view. He is indeed only a welcome and interesting accent in one of Turner's splendid landscapes.

Joseph Mallord William Turner in America

California

LOS ANGELES, Los Angeles County Museum of Art
Lake Geneva from Montreux, 40½ x 64, c. 1810

SAN MARINO, The Huntington Art Gallery
The Grand Canal, Venice; Shylock, 58¼ x 43½, 1837

STANFORD, Stanford University Museum of Art
Drachenfels on the Rhine, Seen from Rhondorf (drawing),
9½ x 11⅝, c. 1817
Chester, A Near View of the Castle (drawing), 3⅜ x 6¹/₁₆
Windsor and the Thames (drawing), 3⅜ x 6¹/₁₆
Rainbow: Osterpey and Feltzen on the Rhine (watercolor
drawing), 8½ x 12⅞, 1817

Connecticut

HARTFORD, Wadsworth Atheneum
Van Tromp's Shallop at the Entrance of the Scheldt, 35 x 47,
c. 1832

District of Columbia

WASHINGTON, National Gallery of Art
Mortlake Terrace, 36¼ x 48⅛, c. 1826 (Mellon)
Approach to Venice, 24½ x 37, c. 1843 (Mellon)
Venice: Dogana and San Giorgio Maggiore, 36 x 48, c. 1834
(Widener)
Keelmen Heaving in Coals by Moonlight, 36¼ x 48¼, c. 1835
(Widener)
The Junction of the Thames and the Medway, 42¾ x 56½,
c. 1805-8 (Widener)
The Rape of Proserpine, 36⅜ x 48⅝, 1839
The Evening of the Deluge, 29⅞ x 29⅞, c. 1843
The Dogana and Santa Maria della Salute, Venice, 24⅜ x 36⅝,
c. 1843
Van Tromp's Shallop, 36⅜ x 48¼, c. 1832

Illinois

CHICAGO, The Art Institute of Chicago
Valley of Aosta—Snowstorm, Avalanche, and Thunderstorm,
36 x 48¼, 1836-37
Dutch Fishing Boats, 68¹¹/₁₆ x 88¼, 1837-38
Valley of Aosta—Snowstorm, Avalanche, and Thunderstorm,
1836

Indiana

INDIANAPOLIS, Indianapolis Museum of Art
*East Cowes Castle, The Seat of J. Nash, Esq., The Regatta
Beating to Windward,* 36¼ x 48, 1828
Fifth Plague of Egypt, 49 x 72, 1800

Maryland

BALTIMORE, The Walters Art Gallery
Raby Castle, 46⅞ x 71⅛

Massachusetts

BOSTON
Isabella Stewart Gardner Museum
The Roman Tower, Aldernach (watercolor), 7⅞ x 11

Museum of Fine Arts
The Slave Ship, 35¾ x 48, 1840
Falls of the Rhine at Schaffhausen, 58½ x 94, 1806

NORTHAMPTON, Smith College Museum of Art
Landscape (watercolor), 6⅞ x 9½
Watermill at Valinbillston (drawing), 8⁷/₁₆ x 11
St. Augustine's Abbey, Canterbury (watercolor), 9⅝ x 7¹⁵/₁₆,
1793
Sea Coast with Dover Castle (drawing), 10¹/₁₆ x 8½
Windy Day, Lullingstone Park (watercolor), 7¼ x 10¼
Dover Harbor (watercolor), 8⅛ x 10¼

WILLIAMSTOWN, Sterling and Francine Clark Art Institute
*Rockets and Blue Lights (Close at Hand) to Warn Steamboats of
Shoal Water,* 36¹/₁₆ x 48⅛, 1840

WORCESTER, Worcester Art Museum
A View Looking Over a Lake, 28 x 20⅞, 1827

Missouri

KANSAS CITY, The Nelson Gallery and Atkins Museum
The Fish Market at Hastings Beach, 35¾ x 47½, 1810

ST. LOUIS, The St. Louis Art Museum
Burning of the Houses of Parliament (Oct. 16, 1834),
c. 17½ x 23¾, c. 1835 (attrib. to)

New Hampshire

HANOVER, Dartmouth College Museum and Galleries
London Tower and Bridge, 16 x 22
Harbor Scene (watercolor), 1 x 2

New York

GLENS FALLS, The Hyde Collection
Grand Canal, Venice, 21⅛ x 29¾, c. 1840

NEW YORK CITY
The Frick Collection
Fishing Boats Entering Calais Harbor, 29 x 38¾, c. 1803
The Harbor of Dieppe, 68⅜ x 88¾, 1826(?)
Cologne: The Arrival of a Packet Boat: Evening, 66⅜ x 88¼,
1826
Mortlake Terrace: Early Summer Morning, 36⅝ x 48½, 1826
Antwerp: Van Goyen Looking out for a Subject, 36⅛ x 48⅜,
1833

The Metropolitan Museum of Art
The Ferry Beach and Inn at Saltash, Cornwall, 35⅜ x 47½
The Grand Canal, Venice, 36 x 48⅛
The Whale Ship, 36⅛ x 48¼

POUGHKEEPSIE, Vassar College Art Gallery
Landscape, 42 x 56½

Ohio

CINCINNATI, The Taft Museum
The Rape of Europa, 35⅞ x 47⅞, c. 1836
The Trout Stream, 36 x 48, c. 1808
Old London Bridge, 40⅛ x 49½

CLEVELAND, The Cleveland Museum of Art
Burning of the Houses of Parliament, 1834, 36½ x 48½, 1835

COLUMBUS, The Columbus Museum of Art
Laugharne Castle, Carmarthenshire, Coast of South Wales
(watercolor), 12 x 18, c. 1831

OBERLIN, The Allen Memorial Art Museum, Oberlin College
*View of Venice: Ducal Palace, Dogana, with Part of
San Giorgio,* 25 x 36⅝

TOLEDO, The Toledo Museum of Art
The Campo Santo, Venice, 24½ x 36½, 1842

Oregon

PORTLAND, Portland Art Museum
Landscape (watercolor), 3¼ x 4⅝

Pennsylvania

PHILADELPHIA, Philadelphia Museum of Art
Burning of the Houses of Parliament, 36¼ x 48½, 1835

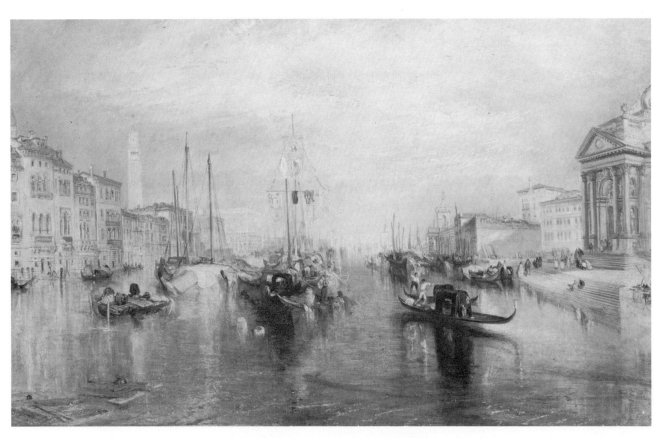

J. M. W. Turner • Grand Canal, Venice
Oil on canvas • 36 x 48⅛" • The Metropolitan Museum of Art, New York City
Bequest of Cornelius Vanderbilt

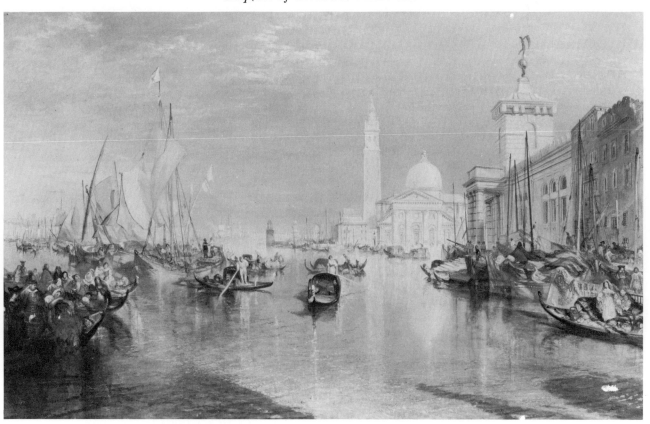

J.M.W. Turner • Venice: Dogana and San Giorgio Maggiore
Canvas • 36 x 48" • National Gallery of Art, Washington, D.C.
Widener Collection

Rhode Island
PROVIDENCE, Museum of Art, Rhode Island School of Design
Rainbow: Osterspey and Feltzen on the Rhine
watercolor), $7^5/_{16}$ x $11^7/_{16}$
Wharfedale from the Chevin (watercolor), $10^3/_{16}$ x $14\frac{1}{2}$
Sleaford, Lincolnshire (watercolor), $9^5/_{16}$ x $13^{11}/_{16}$
The Head of Lake Windermere (drawing), $10^7/_{16}$ x $15^3/_{16}$
The Arch of the Old Abbey, Evesham (watercolor),
$8\frac{1}{2}$ x $10^{15}/_{16}$
Norbury Park (drawing), $7^5/_{16}$ x $9\frac{1}{4}$
Southampton (drawing), $5\frac{1}{8}$ x 8
A Mountain Gorge (watercolor), 9 x $11\frac{1}{2}$
The Lake in Petworth Park (watercolor), $5^7/_{16}$ x $7\frac{1}{2}$
Pont du Burzet (?) in the Ardeche (watercolor), $5\frac{1}{2}$ x $7^9/_{16}$

Pass of St. Bernard (watercolor), $8\frac{7}{8}$ x $11\frac{1}{4}$
Sunset on the River (drawing), $7\frac{5}{8}$ x $10\frac{5}{8}$
Glencoe (drawing), $3^{11}/_{16}$ x $5\frac{5}{8}$, c. 1831

Texas
FORT WORTH, Kimbell Art Museum
Glaucus and Scylla, 31 x $30\frac{1}{2}$, 1841

Canada

Ontario
OTTAWA, The National Gallery of Canada
Mercury and Argus, $59\frac{3}{4}$ x 44
Shoeburyness Fishermen Hailing a Whitstable Hoy, $35\frac{1}{2}$ x $47\frac{1}{2}$,
c. 1809

TORONTO, Art Gallery of Ontario
London from Greenwich (watercolor), $4\frac{1}{8}$ x $6\frac{3}{4}$, 1833-35
Southwest View of a Gothic Abbey (Fonthill)—Morning
(watercolor), $29\frac{1}{4}$ x $42\frac{1}{4}$, 1799
Richmond Bridge, Yorkshire (watercolor), $7\frac{7}{8}$ x $11\frac{7}{8}$ (sight)

Quebec
MONTREAL, Montreal Museum of Fine Arts
South View of the Gothic Abbey (watercolor), $28\frac{1}{2}$ x $41\frac{1}{2}$
Wensleydale, Yorkshire (watercolor), $20\frac{3}{4}$ x $29\frac{1}{2}$

J.M.W. Turner • The Slave Ship
Canvas • $35\frac{3}{4}$ x 48" • Museum of Fine Arts, Boston • Henry Lillie Pierce Fund

Velásquez

Diego Rodriguez de Silva y Velásquez • Philip IV, King of Spain
Oil on canvas • 22³/₁₆ x 19⁷/₈″ • Cincinnati Art Museum, Cincinnati, Ohio • Bequest of Mary M. Emery

Velásquez

1599–1660

Diego Rodriguez de Silva y Velásquez was born in Seville, the son of Rodriguez de Silva, a lawyer of Portuguese descent, and Jeronima Velásquez, whose name he added to his father's according to Spanish custom. At an early age he was apprenticed to the artist Francisco Pacheco and showed such promise that his teacher chose him for his son-in-law. Velásquez moved with his wife to Madrid in 1623 and joined the king's service as court painter. The rest of his brilliant career was centered in the Spanish capital, and included excursions to the Escorial with the visiting Rubens, trips to Italy for King Philip IV, and many portrait commissions.

Velásquez may be truly described as the painter of Spain; his portraits are austerely elegant. Because black was and is the dominant note in Spanish dress, he could not rely on areas of brilliant color to make his portraits decorative and expressive. He was literally forced into subleties of both color and composition. This restraint is superbly illustrated in Boston's portrait of *Don Baltasar Carlos and His Dwarf.*

Velásquez has boldly suggested the contrasting status of master and slave by placing the infant prince in the commanding central position, with the dwarf before and beneath him. But this position by no means alters the relationship of the two human beings, which is one of mutual affection. The prince looks off imperiously over the dwarf's head, yet the position of his hands suggests a gesture of embrace. The dwarf is half-turned toward his friend and master, not in fear, nor yet in confidence, but as if he were considering offering the prince the apple in his hand.

The two figures are also bound together, yet separated, by other means. The warm dark purple curtain in the background embraces both. The rich gold brocade of the prince's dress contrasts pointedly with the dwarf's plain white apron. Yet the apron, with the prince's white collar and his plumed hat on the pillow to the right, form a triangle that gives the picture a basic unity.

Velásquez in America

California
SAN DIEGO, San Diego Museum of Art
Portrait of The Infanta Margarita, 21 x 18 (studio of)

District of Columbia
WASHINGTON, National Gallery of Art
Needlewoman, 29⅛ x 23⅝ (Mellon)
Pope Innocent X, 19½ x 16¼ (Mellon)

Illinois
CHICAGO, The Art Institute of Chicago
The Servant, 21⅞ x 41⅛, 1618-22
St. John in the Wilderness, 69 x 60, c. 1620-22

Massachusetts
BOSTON
Isabella Stewart Gardner Museum
King Philip IV of Spain, 78¼ x 42½

Museum of Fine Arts
Don Baltasar Carlos and His Dwarf, 53½ x 41
Luis de Gongora y Argote, 19¾ x 15¾
Philip IV, 82¼ x 43¼
Infanta Maria Theresa, 50¼ x 39½ (studio of)

Michigan
DETROIT, The Detroit Institute of Arts
Portrait of a Man, 20¼ x 15¾, c. 1623-24

Missouri
KANSAS CITY, The Nelson Gallery and Atkins Museum
Portrait of Maria Anna, Queen of Spain, 57 x 47½, 1651-52

New York
NEW YORK CITY
The Frick Collection
Philip IV of Spain, 51⅛ x 39⅛, 1644

Hispanic Society of America
Camillo Astalli, Cardinal Pamphili, 24¼ x 19¼
Gaspar de Guzmán, Count-Duke of Olivares, 87½ x 54, 1625
Portrait of a Little Girl, 20½ x 16¼

The Metropolitan Museum of Art
Don Gaspar de Guzmán, Count-Duke of Olivares (1587-1645), 27⅛ x 21 (workshop of)
The Supper at Emmaus, 48½ x 52¼ (Altman)
Portrait of a Gentleman, 27¼ x 22¼ (workshop of)

Mariana of Austria, Queen of Spain (1634-1696), 32¼ x 39½
 (workshop of)
Philip IV, King of Spain (1605-1665), 78¾ x 40½ (Altman)
Prince Baltasar Carlos (1629-1646), 20¾ x 16¼ (workshop of)
The Infanta Maria Theresa of Spain (1636-1683), 17½ x 15¾
 (Bache)
Portrait of a Gentleman, 27 x 21¾ (workshop of) (Bache)
Don Gaspar de Guzmán, Count Duke of Olivares (1587-1645),
 50¼ x 41
Juan de Pareja (c. 1610-c. 1670), 32 x 27½

Ohio
CINCINNATI, The Cincinnati Art Museum
 Philip IV, King of Spain, 22³/₁₆ x 19⅞

CLEVELAND, The Cleveland Museum of Art
 Portrait of the Jester Calabazas, 69 x 42

TOLEDO, The Toledo Museum of Art
 Man with a Wine Glass, 30 x 25, c. 1627-28 (attrib. to)

Virginia
NORFOLK, Chrysler Museum at Norfolk
 Portrait of a Bearded Man, 17½ x 25¼ (loan)

Diego Rodriguez de Silva y Velasquez *(attributed to)* • Man with a Wine Glass
Oil on Canvas • 30 x 25" • The Toledo Museum of Art, Toledo, Ohio
Gift of Edward Drummond Libbey

Jan Vermeer

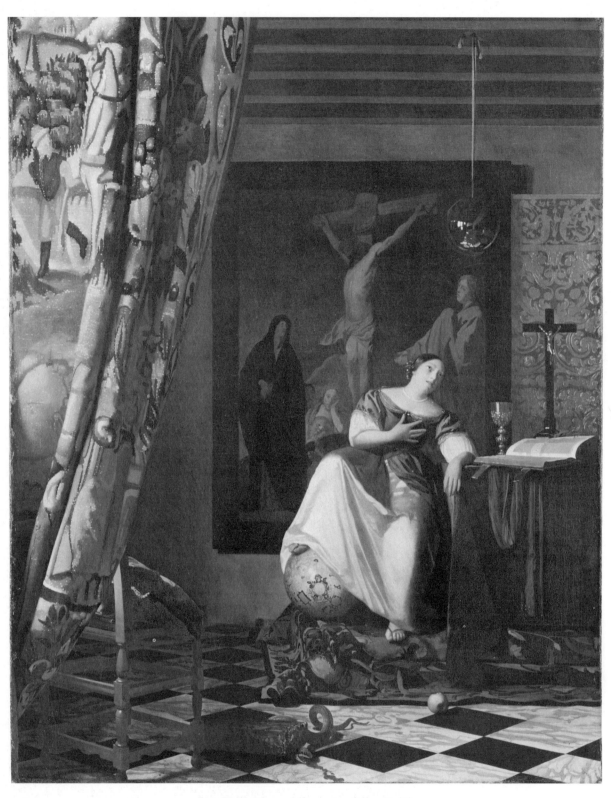

Jan Vermeer • Allegory of the Faith
Oil on canvas • 45 x 35″ • The Metropolitan Museum of Art, New York City
The Michael Friedsam Collection

Jan Vermeer

1632–1675

Jan Vermeer was born in Delft, Holland. Very little is known about his life except that on April 5, 1653, according to the archives, "Johannes, son of Reynier Vermeer, celibate, living at the market place, married Catherine Bolenes, maiden, from the same locality"; that he was admitted to the painters' guild on December 29, 1653; and that on December 13, 1675, "Jan Vermeer, artist painter, living on the old long dike, was buried at the Old Church. He leaves eight children, under age." We know also that his pictures were not much in demand during his lifetime, that his wife sold a number of them to pay her debts, and that less than forty authentic ones are known to exist today, twelve of which are in America and are listed in this book.

Although very little is known about Vermeer's life, it is not unreasonable to assume that the wonderful quality of light which distinguishes his paintings resulted partly from the scientific discoveries of his time. Christian Huygens, the Dutch scientist who established the principle of light waves ("the vibratory hypothesis"), was born three years before Vermeer at The Hague, a few miles from Delft. Throughout the artist's brief lifetime, experiments in the new science of optics were constantly being carried on. Vermeer must have known of them. Certainly he captured the evanescent, fluid quality of light as have few other artists.

He broke up sunlight into particles of paint, as Huygens might be said to have done in theory. Furthermore, he painted shadows not brown or black, like most of his contemporaries, but as the light determines them. Shadows are blue on snow during the day, for example, because they take their color from the sky and turn to purple and gold toward sunset. Leonardo da Vinci recognized this luminosity in shadows; Constable and the Impressionists were to rediscover it in the nineteenth century. Where Vermeer learned about it no one knows, but that he understood it thoroughly is evident in every one of his paintings, as, for example, the *Officer and Laughing Girl* in the Frick Collection.

The side of the girl's white scarf in shadow is painted light blue, with touches of yellow in it. The shadow on the wall at the bottom of the map is light blue, turning to darker blue as it recedes from the direct sunlight streaming through the window. (The map, of Holland and West Friesland, is recognizable to cartographers as one drawn by B. F. van Berkerode, surveyor of Holland, published by Willem Blaeu on June 21, 1621.)

A still more effective technique for creating the illusion of streaming sunlight is apparent. On whatever object sunlight falls—on the girl's scarf and chemisette, her golden bodice and striped sleeves, on the leather-covered Spanish chair, on the half-open window—Vermeer has made the light dance and sparkle with little touches of pigment which actually seem to vibrate, as Huygens had maintained. These touches of pigment vary according to the color of the object on which the light falls and the intensity with which it falls.

On the back of the soldier's chair, in near-shadow, the single spot is white; on the girl's chair, yellow. The spots are yellow in the crook of the soldier's arm, where the blue-green tablecloth shows faintly through, but on the bright blue wineglass in the girl's hand they are pure white. Those on her sleeve are yellow; one on her nose is light pink.

Jan Vermeer in America

District of Columbia

WASHINGTON, National Gallery of Art
Woman Holding a Balance, 16¾ x 15, c. 1664 (Widener)
The Girl with a Red Hat, 9⅛ x 7⅛, c. 1660 (Kress)
Young Girl with a Flute, 7⅞ x 7, c. 1658-60 (Widener)
A Lady Writing, 17¾ x 15¾, c. 1665

Massachusetts

BOSTON, Isabella Stewart Gardner Museum
The Concert, 27¼ x 24¾

New York

NEW YORK CITY
The Frick Collection
Officer and Laughing Girl, 19⅞ x 18⅛, 1655-60
Girl Interrupted at Her Music, 15½ x 17½, 1660-70
Mistress and Maid, 35½ x 31, 1665-70

The Metropolitan Museum of Art
Allegory of the Faith, 45 x 35
Young Woman with a Water Jug, 18 x 16
Woman with a Lute, 20¼ x 18
A Girl Asleep, 34½ x 30⅛ (Altman)

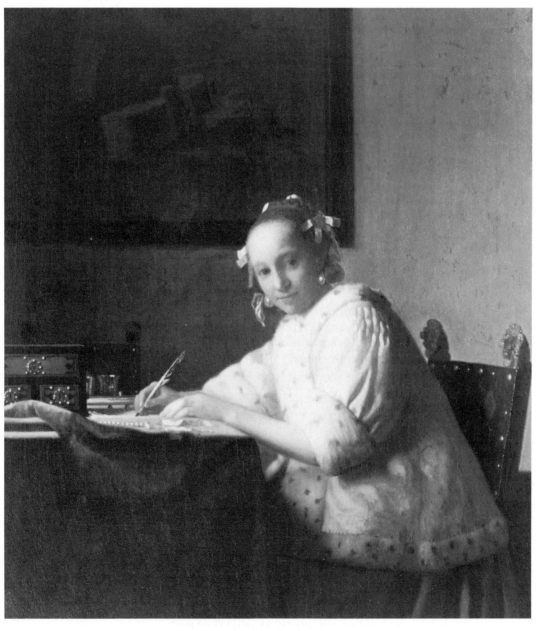

Jan Vermeer • A Lady Writing
Canvas • 17¾ x 15¾″ • National Gallery of Art, Washington, D.C.
Gift of Harry Waldron Havemeyer and Horace Havemeyer, Jr.

Veronese

Paolo Caliari, *called* **Veronese** • Allegory of Navigation (Holding Astrolobe)
Oil on canvas • 80½ x 46″ • Los Angeles County Museum of Art
Gift of the Ahmanson Foundation

Veronese

c. 1528–1588

Veronese was born Paolo Caliari in the north Italian town of Verona, from which he took his painting name. His father was a sculptor. Young Paolo showed more interest in painting, however, and so was apprenticed to his uncle Antonio Badile, a minor painter of Verona, whose daughter he eventually married. Paolo's first important work was collaborating on a painting for the cathedral in Mantua, for which he was highly praised. Soon he was in Venice, where in 1555 his paintings for the Church of San Sebastiano met with such acclaim that he was established, almost overnight, as the leading rival of Tintoretto and Titian, his seniors by many years. Except for occasional painting trips to nearby towns, and a visit to Rome to admire the work of Michelangelo and Raphael, he remained in Venice the rest of his life. He never lacked for commissions from churches and palaces, including the Ducal Palace, where some of his finest works may be seen today. But he is well and widely represented in America.

The Bible does not describe any rest taken by the Holy Family on their flight into Egypt, yet this natural legend grew and became a popular subject with artists during the Renaissance. Each one treated it according to his time, place, and temperament; Giotto devoutly; Gerard David calmly; Rembrandt humanely. Veronese regarded the rest on the flight as a wonderful opportunity to display his extraordinary skill at composing groups of people into big, colorful, decorative pictures. The painting illustrated is in the Ringling Museum in Sarasota, Florida.

The pictorial legend that grew up about the rest called for representations of Mary, Joseph, and the infant Jesus seated under a date palm, with their donkey waiting and angels in attendance. These conventions Veronese observed as no artist has before or since.

This is no rest at all. Except for the bull which Veronese introduced to balance his picture at the right, everyone is extremely busy. No one is resting, nor seems to feel the need of it. What they are doing, really, is posing actively for a fine, exciting composition.

In order to paint a lot of people in one picture and not have it fall apart, a strong basic framework is essential. In this painting Veronese has used a favorite design device of the Italians. It is the two arms of the letter X. The upper left arm is clearly defined by the trunk of the tree, continuing down through Mary's head and body. The other arm of the X begins with the wing of the

angel at lower left, is paralleled in Joseph's arms, accentuated in the body of the Child, continued through the head of the donkey and in the body of the angel catching the falling dates, and terminated in the broken tree trunk.

Within this framework Veronese has built a huge circle to give movement to his picture. The flying angels define most of this circle. It starts anywhere, of course, but it can begin with the angel reaching for the Child's freshly laundered dress at the left, continuing, clockwise, through the light tone behind the tree to the horizontal angel picking dates at the top, down through the angel's extended arm and the body of the other angel, and back to the Child.

To give the picture even more action, Veronese has placed this circular movement in a second plane, which leads the eye *into* the painting as well as around it. The angels and the donkey are definitely *behind* Joseph, Mary, and the Child, with the donkey poking his nose into the front plane and thus connecting them. Not content with this, Veronese introduced still a third plane behind these two. It is the plane of the sky and the clouds and the distant mountain. This is the reason for the broken tree trunk: it allows the blue sky to continue uninterrupted in the third plane. Chiefly by means of tone, with fresh, silvery blues, greens, and whites, Veronese has suggested the whole world beyond, into which the travelers must go after their "rest."

293

Veronese in America

California
LOS ANGELES, Los Angeles County Museum of Art
Allegory of Navigation (holding astrolabe), 80½ x 46, 1570s
Allegory of Navigation (holding cross staff), 80⁷⁄₁₆ x 46,
1570s

MALIBU, The J. Paul Getty Museum
Bust Portrait of a Young Man, 20¼ x 15¾
Self-Portrait, 76 x 53, c. 1570

SAN DIEGO
San Diego Museum of Art
Daphne and Apollo, 42½ x 43½, c. 1565

Timken Art Gallery
*Madonna and Child with St. Elizabeth, the Infant St. John,
and St. Justina*, 40½ x 61¾

SAN FRANCISCO, The Fine Arts Museums of San Francisco
?Family Group Portrait, 84 x 66

Colorado
DENVER, The Denver Art Museum
Portrait of the Architect Vignola, 36¾ x 32³⁄₁₆, c. 1560

District of Columbia
WASHINGTON, National Gallery of Art
The Finding of Moses, 22¾ x 17½, c. 1570 (Mellon)
St. Jerome in the Wilderness, 42½ x 33½, 1570s (Kress)

Florida
SARASOTA, John and Mable Ringling Museum of Art
Portrait Group, 86 x 71½
Rest on the Flight into Egypt, 92¼ x 63¼

Illinois
CHICAGO, The Art Institute of Chicago
St. Jerome, 53¼ x 69½, c. 1561
Madonna, Saints John the Baptist and Anthony Abbot.
63 x 77, c. 1575-88
Creation of Eve, 31⅞ x 40¼, c. 1570

Kentucky
LOUISVILLE, The J. B. Speed Art Museum
Portrait of a Young Woman, 39 x 31½

Louisiana
NEW ORLEANS, New Orleans Museum of Art
Sacra Conversazione, 40⅝ x 50¼, c. 1560-70 (with assistants)
(Kress)

Maryland
BALTIMORE
The Baltimore Museum of Art
The Holy Family with St. Barbara, 38 x 46½, 1590-1600
(workshop of) (Epstein)

The Walters Art Gallery
Portrait of Lucia da Thiene and Her Daughter Porzia, 81 x 47½

Massachusetts
BOSTON, Museum of Fine Arts
Diana and Actaeon, 10 x 43½
Venus and Jupiter, 10½ x 43½
Olympus, 10 x 43¾
Atalanta and Meleager, 10 x 43¼

CAMBRIDGE, Fogg Art Museum, Harvard University
Rest on the Flight into Egypt (drawing), 9¾ x 7¾
Study for the Louvre Crucifixion (recto) (drawing), 11⅝ x 7⅞

Michigan
DETROIT, The Detroit Institute of Arts
The Mystic Marriage of St. Catherine, 66½ x 46, c. 1555-60

The Muse of Painting, 11 x 7¼

Missouri
KANSAS CITY, The Nelson Gallery and Atkins Museum
Christ and the Centurion, 56 x 82

ST. LOUIS, The St. Louis Art Museum
Christ and the Woman of Samaria, 40 x 51¼, c. 1560

Nebraska
OMAHA, Joslyn Art Museum
Venus at Her Toilette, 27¼ x 63, 1570-75

New York
GLENS FALLS, The Hyde Collection
Rebecca at the Well, 18 x 22, c. 1550

NEW YORK CITY
The Frick Collection
Allegory of Wisdom and Strength, 84½ x 65¾
Allegory of Virtue and Vice (The Choice of Hercules),
86¼ x 66¾

The Metropolitan Museum of Art
Alessandro Vittoria (1524/25-1608), 43½ x 32¼
Boy with a Greyhound, 68⅜ x 40⅛ (Havemeyer)
Mars and Venus United by Love, 81 x 63⅜
Portrait of a Woman, 46¾ x 39 (Havemeyer)

North Carolina
RALEIGH, North Carolina Museum of Art
The Baptism of Christ, 33¾ x 46 (studio of) (Kress)

Ohio
CLEVELAND, The Cleveland Museum of Art
Portrait of Agostino Barbarigo, 44½ x 45¾, 1565-70
Annunciation, 59 x 52½, c. 1575-80

TOLEDO, The Toledo Museum of Art
Christ and the Centurion, 39⅛ x 52½, c. 1580

Pennsylvania
PHILADELPHIA, Philadelphia Museum of Art
Diana and Actaeon, 47½ x 64½ (Johnson)
Venetian Admiral, 49⅝ x 44⅝ (Johnson)

South Carolina
GREENVILLE, Bob Jones University Art Gallery and Museum
The Good Samaritan, 61½ x 50⅛ (studio)
The Marriage at Cana, 45 x 81¼ (studio)

Virginia
NORFOLK, Chrysler Museum at Norfolk
*The Virgin and Child with Angels Appearing to Sts. Anthony
Abbot and Paul the Hermit*, 112 x 66½, 1562

Washington
SEATTLE, Seattle Art Museum
Venus and Adonis, 88½ x 66¼, c. 1580 (attrib. to) (Kress)

Canada

Ontario
OTTAWA, The National Gallery of Canada
Figure Studies for a Decoration (drawing), 5⅝ x 5⅜
Study for a Circumcision (drawing), 3⅜ x 2¾
Rest on the Flight into Egypt, 65 x 104
Christ with Angels (fragment of an altarpiece), 85 x 95⅝,
before 1584
The Repentant Magdalen, 66¾ x 53, c. 1560-70
A Group of Four Figures (drawing), 3⁵⁄₁₆ x 3⅝

Jean-Antoine Watteau

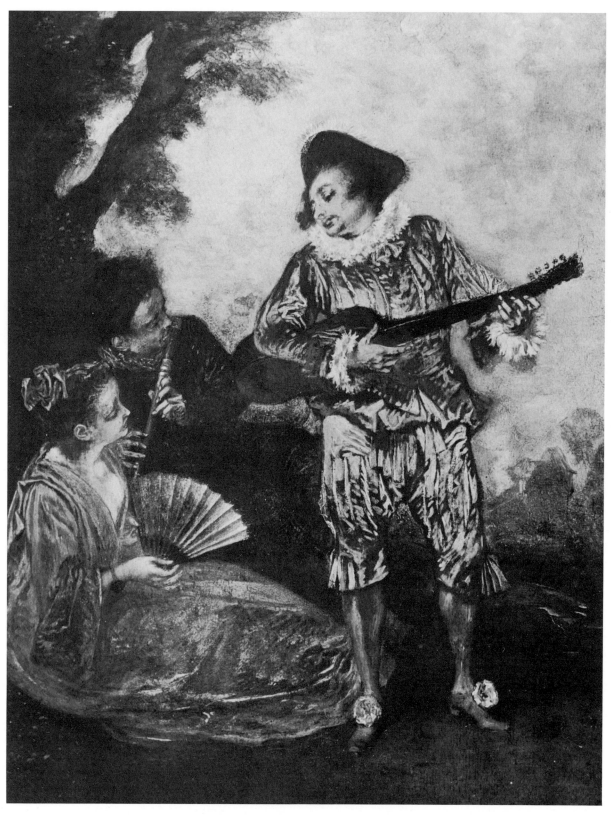

Jean-Antoine Watteau • Le Lorgneur
*Oil on panel • 12³/₄ x9⁷/₁₆″ • The Virginia Museum of Fine Arts, Richmond
Williams Fund*

Jean-Antoine Watteau

1684–1721

Jean-Antoine Watteau was born of Flemish ancestry in the town of Valenciennes in northern France. After studying briefly with a local artist, he moved to Paris in 1702, where his talent soon excited the envy of his teacher, Claude Gillot. A quarrel ensued, and Watteau and Lancret, a fellow pupil, entered the studio of Claude Audran, a decorative painter who was keeper of the collections of the Luxembourg Palace. Here Watteau painted the first picture in the manner that was to make him famous. From then on he enjoyed the patronage of various Paris critics and collectors, and in 1717 was made a member of the Academy for his *Embarkation for Cythera,* now in the Louvre. By then, however, he had contracted tuberculosis, and despite a trip to London to consult a specialist, he died at the age of thirty-seven.

Many Americans, including this one, formed their first (and erroneous) impression of the paintings of Watteau from a line in Gilbert and Sullivan's operetta, *Trial by Jury.* Describing the idyllic life promised to the plaintiff by the defendant, her counsel sums up with the phrase, "an existence à la Watteau." He implied a kind of sweet idleness in a woodland bower, with pink cherubs flying about among the branches. The description possibly fits the paintings of Francois Boucher and other followers of Watteau, but certainly not those of Antoine. Although he was fond of painting the elegant ladies and gentlemen of the French court, he painted them with a vigor and vitality which many of them probably wished they possessed.

The quality of vitality in a drawn line is as hard to describe as that same quality is in music. Critics say that Mozart's music is "clear," "sure," "incisive." They point out that it could not possibly be other than it is; that nothing could be added, nothing taken away. This still means little to listeners who do not already *feel* that clarity, sureness, and incisiveness—after much listening to music. (And yet the words can be helpful in realizing the feeling.) It is the same with the drawn line.

Vitality of line is a phrase that has meaning only after much looking—or drawing. This quality in Watteau is most apparent in his drawings, such as those reproduced here. But it is evident too in his paintings, such as *La Danse Champêtre* in Indianapolis.

The people here are not mere embellishments in a rustic scene. The two dancers are really dancing, and the girl with the tambourine is really striking it. The hands of the man and woman are joined in delicate tension. Beneath their silks, these people have muscles and bones thoroughly understood by Watteau and put to work by him.

Most artists understand anatomy and know how to draw the human figure—to "articulate" it, as they say. Few are gifted with the ability to enhance that articulation with a line that is vigorous and lively in itself. Watteau was one of these artists, which explains the extraordinary activity of the two dancing figures.

Jean-Antoine Watteau in America

California
PASADENA, Norton Simon Museum of Art
Reclining Nude, 5½ x 6¾, 1713

SAN FRANCISCO, The Fine Arts Museums of San Francisco
La Partie Quarrée, 19½ x 23¾

Connecticut
HARTFORD, Wadsworth Atheneum
La Danse Paysanne, 9⅛ x 6½

District of Columbia
WASHINGTON
National Gallery of Art
Italian Comedians, 25⅛ x 30, 1720 (Kress)
"Sylvia" (Jeanne-Rose-Guyonne Benozzi), 27¼ x 23⅛,
c. 1720 (Kress)
Ceres (Summer), 56¾ x 45¾, c. 1712

The Phillips Collection
Musicians (drawing), 4⅝ x 7½

Illinois

CHICAGO, The Art Institute of Chicago
The Dreamer, 9⅛ x 6½
The Old Savoyard (drawing), 14¼ x 8⅞
Studies of Figures from the Italian Comedy (drawing), 10¼ x 15⅝
Pantaloon Catching a Fly, 22⅞ x 29 (attrib. to)

Indiana

BLOOMINGTON, Indiana University Art Museum
Mezzatin Dancing (drawing), 8¾ x 6

INDIANAPOLIS, Indianapolis Museum of Art
La Danse Champêtre, 19½ x 25⅝

MUNCIE, Ball State University Art Gallery
Portrait of Frère Blaise, 19¾ x 13½

Massachusetts

BOSTON, Museum of Fine Arts
La Perspective, 18½ x 22

CAMBRIDGE, Fogg Art Museum, Harvard University
Six Studies of Heads (drawing), 8¾ x 8½
A Group of Trees in a Park (drawing), 4¾ x 10¼

New York

NEW YORK CITY, The Metropolitan Museum of Art
The French Comedians, 22½ x 28¾ (Bache)
Mezzetin, 21¾ x 17
A Musical Conversation, 8½ diam.
The Minuet, 8½ diam.

Ohio

TOLEDO, The Toledo Museum of Art
La Conversation, 19¾ x 24, 1712-15

Virginia

RICHMOND, Virginia Museum
Le Lorgneur, 12¾ x 9⁷⁄₁₆

Canada

Ontario

OTTAWA, The National Gallery of Canada
Two Figures (drawing), 7 x 7⅝
Head of Bacchus and Study of Hand (drawing), 8 x 8¾

TORONTO, Art Gallery of Ontario
Frieze of Cupids (after part of Rubens' Whitehall Ceiling),
8½ x 31½ (attrib. to)

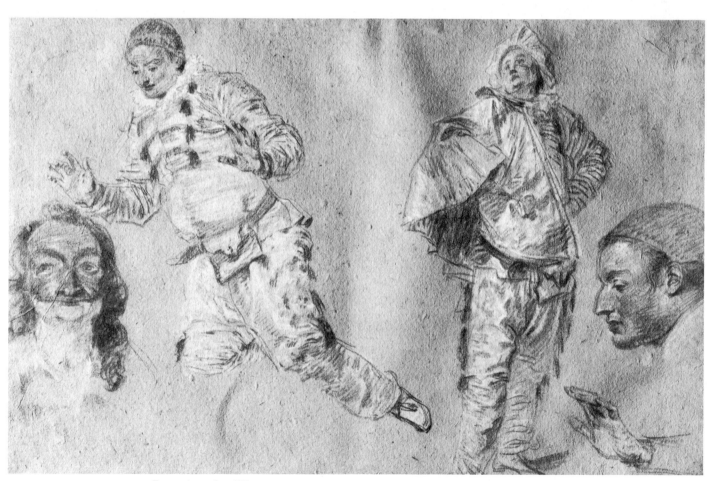

Jean-Antoine Watteau • Four Studies of Men (Italian comedians)
Red, black & white crayon • *10¼ x 15⅜"* • *The Art Institute of Chicago, Chicago, Illinois*
Gift of Tiffany and Margaret Blake

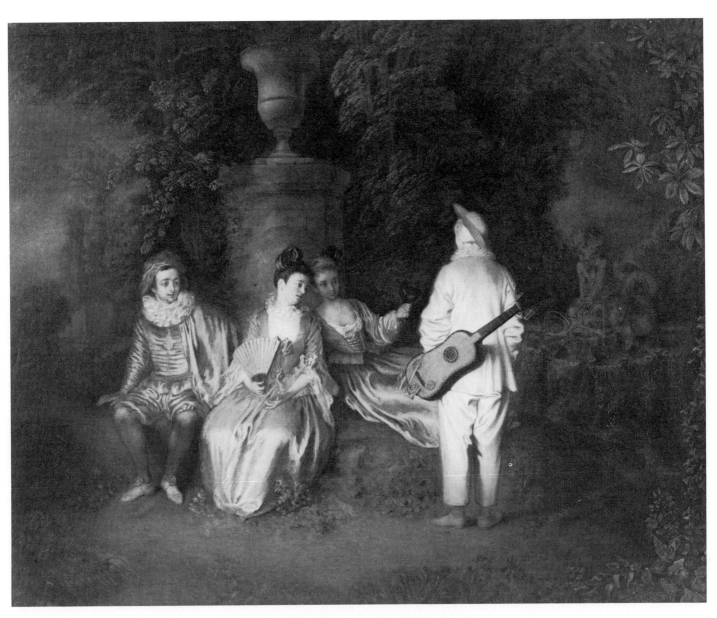

Jean-Antoine Watteau • La Partie Quarrée
Oil on canvas • *19½ x 24¼″* • *The Fine Arts Museum of San Francisco*
Mildred Anna Williams Purchase Fund

GEOGRAPHICAL INDEX TO MUSEUMS

Alabama

BIRMINGHAM

Birmingham Museum of Art, 2000 Eighth Avenue North. Founded 1950. Open free 10 to 5; Thurs., 10 to 9; Sun., 2 to 6.

CANALETTO, CONSTABLE, GAINSBOROUGH (2), LAWRENCE, REYNOLDS, RUBENS, RUISDAEL, TINTORETTO. Also: Jan Bruegel (the Elder), Magnasco, school of Titian, others.

Arizona

TUCSON

The University of Arizona Museum of Art. Founded 1955. Open free 9 to 5 Mon. thru Sat.; 1 to 5 Sun. Closed July 4, Thanksgiving, Christmas, and New Year's Day.

COROT, FRAGONARD (13 drawings), GAINSBOROUGH, LAWRENCE, TIEPOLO (2), TINTORETTO (2). Also: Dürer engraving, Goya and Rembrandt etchings.

California

LOS ANGELES

Los Angeles County Museum of Art, 5905 Wilshire Blvd. Founded 1910. Open free 10 to 5 Tues. thru Fri.; 10 to 6 Sat. & Sun. Closed Mondays, Thanksgiving, Christmas, and New Year's Day. Special exhibitions: adults $1.00; students and senior citizens 50¢; members no charge.

COROT (2), DELACROIX (2), VAN DYCK, FRAGONARD (2), GAINSBOROUGH, VAN GOYEN (4), EL GRECO, HALS, HOLBEIN, DE HOOCH, LAWRENCE, RAEBURN (2), REMBRANDT (4), REYNOLDS, RUBENS (3), RUISDAEL, TURNER, VERONESE (2). Also: Fra Bartolommeo, Petrus Christus, Baron Gros, A. Le Nain, de La Tour.

University of Southern California, University Galleries, 823 Exposition Blvd. Founded 1939. Open free 12 to 5 Mon. thru Fri. Closed month of August. Armand Hammer Collection (acquired 1965).

CLAUDE, COROT, COURBET, VAN DYCK, GAINSBOROUGH, HALS, DE HOOCH, RAEBURN (3), REMBRANDT, REYNOLDS, RUBENS (2), RUISDAEL (3), TINTORETTO. Also: J. Bruegel (the Elder), P. Bruegel (the Younger), others.

MALIBU

The J. Paul Getty Museum, 17985 Pacific Coast Highway. Founded 1953. Open free 10 to 5 five days per week depending on season: Oct. thru May, Tues. thru Sat.; June thru Sept., Mon. thru Fri.

CANALETTO, GAINSBOROUGH (3), VAN GOYEN, HOGARTH (2), POUSSIN, RAPHAEL, REMBRANDT, RUBENS (4), TINTORETTO (2), TITIAN, VERONESE (2). Also: Boucher, Kalf, Magnasco, de La Tour, van der Weyden.

PASADENA

Norton Simon Museum of Art, Colorado and Orange Grove Blvds. (formerly Pasadena Art Museum). Founded 1924. Open noon to 6 Thurs. thru Sun. Admission: adults $2.00; students and senior citizens 75¢.

BELLINI, CANALETTO, CHARDIN (2), CLAUDE (also 60 drawings), COROT (4), COURBET (6), CRANACH, DAUMIER, GERARD DAVID, DELACROIX, FRAGONARD (2), GOYA, VAN GOYEN (2), EL GRECO, GUARDI (2), HALS, MEMLING, MURILLO (2), POUSSIN, RAPHAEL, REMBRANDT (3), RUBENS (4), RUISDAEL (2), TIEPOLO, WATTEAU. Also: Jan Bruegel (the Elder), Ingres, Magnasco, others.

SACRAMENTO

The E. B. Crocker Art Gallery, 216 O St. Founded 1885. Open free 10 to 5 Wed. thru Sun.; 2 to 10 on Tues. Closed Mondays, July 4, Thanksgiving, and Christmas.

J.-L. DAVID, DÜRER, VAN DYCK, FRAGONARD, REMBRANDT, RUBENS, RUISDAEL. Also: Ingres.

SAN DIEGO

San Diego Museum of Art, Balboa Park. Founded 1925. Open free 10 to 5 Tues. thru Sun. Closed Mondays.

BELLINI, BOSCH, CANALETTO, CHARDIN, CONSTABLE, COROT (2), COURBET, DAUMIER, VAN DYCK, GIOTTO, GOYA, EL GRECO, GUARDI, HALS, MEMLING, MURILLO, REMBRANDT, RUBENS, RUISDAEL, TIEPOLO (2), TINTORETTO, TITIAN, VELASQUEZ, VERONESE. Also: Bellotto, Bronzino, Cotan, Crivelli, Giorgione, Ingres, Zurbarán.

Timken Art Gallery, San Diego; Balboa Park. Founded 1950. Open free 10 to 4:30 Tues. thru Sat.; 1:30 to 4:30 on Sun. Closed Mondays, legal holidays, and the month of September.

BRUEGEL, Claude COROT, J.-L. DAVID, FRAGONARD, HALS, LORRAIN, MURILLO, REMBRANDT, RUBENS, RUISDAEL, VERONESE. Also: Boucher, Petrus Christus, Claesz, Clouet, Metsu, de Witte, others.

SAN FRANCISCO

The Fine Arts Museums of San Francisco: M.H. de Young Memorial Museum, Golden Gate Park; **California Palace of the Legion of Honor,** Lincoln Park. Founded 1895 and 1924. Open daily 10 to 5. Admission: free on the first day of each month; adults $1.00; youths (12-17) 50¢; seniors (65 and over), children (under 12), members, and recognized educational groups free.

CHARDIN, CLAUDE, CONSTABLE, COROT (2), COUR-BET (2), CRANACH, J.-L. DAVID, DELACROIX, VAN DYCK, FRAGONARD (2), GAINSBOROUGH (3), VAN GOYEN, EL GRECO (2), GUARDI (2), HOBBEMA, LAW-RENCE, RAEBURN (3), REMBRANDT (3), REYNOLDS (3), RUBENS (3), TIEPOLO, TINTORETTO, VERONESE, WATTEAU. Also: Boucher, Bouts, Jan Breugel (the Elder), Magnasco, Morland, L. Le Nain, de La Tour, others.

SAN MARINO
The Huntington Art Gallery, 1151 Oxford Road. Founded 1919. Open free 1 to 4:30 Tues. thru Sun. Closed Mondays, Easter, Memorial Day, July 4, Labor Day, October, Thanks-giving, Christmas, New Year's Day.

CONSTABLE (4), GAINSBOROUGH (11), HOGARTH (3), LAWRENCE (3), RAEBURN (4), REYNOLDS (11), TURNER. Also: Hoppner, Morland, van der Weyden.

SANTA BARBARA
UCSB Art Museum, University of California. Founded 1960. Open free 10 to 4 Tues. thru Sat.; 1 to 5 Sun. and holidays. Major collection: Sedgwick.

BELLINI, GERARD DAVID, RUISDAEL. Also: Cuyp, van der Goes, others.

STANFORD
Stanford University Museum of Art. Founded 1891. Open free 10 to 4:45 Tues. thru Fri.; 1 to 4:45 Sat. and Sun.

BONINGTON, CONSTABLE, DAUMIER (2), DELA-CROIX, GAINSBOROUGH (2), GUARDI (3), REYNOLDS (2), TIEPOLO (2), TURNER (4). Also: Géricault, Hoppner, Magnasco, Morland.

Colorado
DENVER
The Denver Art Museum, 100 W. 14 Avenue Parkway. Founded 1894. Open free 9 to 5 Tues. thru Sat.; also Wed. evening 6 to 9; 1 to 5 Sun. Closed Mondays.

BOTTICELLI, COROT, COURBET, RUBENS, TINTO-RETTO, VERONESE.

Connecticut
HARTFORD
Wadsworth Atheneum, 600 Main Street. Founded 1842. Open 11 to 3 Tues. thru Thurs.; 11 to 8 Fridays; 11 to 5 Sat. and Sun. Voluntary admission: 12 to 18 yrs. 50¢; adults, $1.00. Closed Mondays, July 4, Thanksgiving, Christmas, and New Year's Day.

FRA ANGELICO, CANALETTO (2), CHARDIN, CLAUDE, CONSTABLE, COROT (4), COURBET (2), CRANACH (4), DAUMIER (2), J.-L. DAVID, DELACROIX (3), VAN DYCK (2), FRAGONARD, GAINSBOROUGH, GOYA, EL GRECO, GUARDI (2), HALS, LAWRENCE (2), MURILLO, POUS-SIN, RAEBURN (2), REMBRANDT (2), REYNOLDS (2), RUBENS (2), RUISDAEL, TIEPOLO (4), TINTORETTO (2) TURNER, WATTEAU. Also: Jan Breugel (the Elder), Gerard Dou, Géricault, Ingres, Magnasco, Metsu, L. Le Nain, Snijders, de Witte, others.

NEW HAVEN
Yale University Art Gallery, Chapel St. at York. Open free 10 to 5 Tues. thru Sat., mid-Sept. thru mid-May 6 to 9 Thurs. evenings; 2 to 5 on Sun. Closed Mondays, July 4, Thanksgiving, Christmas, and New Year's Day.

BOSCH, BOTTICELLI, CLAUDE, CONSTABLE, COROT (2), COURBET (3), CRANACH, DELACROIX, VAN DYCK (2), FRAGONARD, VAN GOYEN, HALS (3), HOLBEIN, LAWRENCE, RAEBURN (3), REYNOLDS (4), RUBENS (2), TIEPOLO (4), TINTORETTO, TITIAN (2). Also: Géricault, Magnasco, Morland.

Delaware
WILMINGTON
The Delaware Art Museum, 2301 Kentmere Parkway. Founded 1912. Open free 10 to 5 Mon. thru Sat.; 1 to 5 on Sun. Closed Thanksgiving, Christmas, and New Year's Day.

CONSTABLE. Also: Bancroft Collection of Pre-Raphaelite paintings, Dürer woodcut (1498), Hogarth engravings (1745).

District of Columbia
WASHINGTON
Corcoran Gallery of Art, 17th St. & New York Ave. N.W. Founded 1869. Open 11 to 5. Free Tues. and Wed.; admis-sion: $1.50 Thurs. thru Sun. Closed Mondays and holidays.

BONINGTON, CHARDIN, CONSTABLE, COROT (8), COURBET (2), DAUMIER (2), DELACROIX, VAN DYCK (2), GAINSBOROUGH (3), VAN GOYEN (2), GUARDI (2), HALS, DE HOOCH, RAEBURN, REMBRANDT (2), REYN-OLDS, RUISDAEL (2), TITIAN. Also: Morland.

Dumbarton Oaks, Harvard University, 1703 Thirty-second St. Founded 1940. Open free 2 to 5 Tues. thru Sun. Closed Mon-days, national holidays, July 1 thru Labor Day.

DAUMIER, EL GRECO, HOGARTH.

National Collection of Fine Arts, Smithsonian Institution, 8th and G Sts., N.W. Open free 10 to 5:30. Closed Christ-mas.

VAN DYCK, GAINSBOROUGH, LAWRENCE, RAE-BURN, REYNOLDS, RUBENS, others.

National Gallery of Art, 6th St. and Constitution Ave., N.W. Founded 1937. Open free 10 to 5 Mon. thru Fri.; 12 to 9 on Sun. Summers: regular hours extended to 9 p.m. (dates of hours announced). Closed Christmas and New Year's Day.

FRA ANGELICO (4), BELLINI (13), BOSCH, BOTTI-CELLI (5), CANALETTO, CHARDIN (7), CLAUDE (3), CONSTABLE (3), COROT (12), COURBET (5), CRANACH (4), DAUMIER (3), Gerard DAVID (2), J.-L. DAVID (2), DELACROIX (2), CURER (2), VAN DYCK (16), VAN EYCK, FRAGONARD (8), GAINSBOROUGH (12), GIOTTO, GOYA (2), DE HOOCH (3), LWARENCE (3), MEMLING (2), MU-RILLO (2), POUSSIN (4), RAEBURN (8), RAPHAEL (5), REMBRANDT (23), REYNOLDS (5), RUBENS (8), RUIS-DAEL (3), TIEPOLO (6), TINTORETTO (7), TITIAN (9), TURNER (9), VELÁSQUEZ (2), VERMEER (4), VERO-NESE (2), WATTEAU (3). Also: Bronzino, Géricault, Hoppner, Ingres, van der Weyden, others.
Ingres, Van der Weyden.

The Phillips Collection, 1600-1612 21st St., N.W. Founded 1918. Open free 10 to 5 Tues. thru Sat.; 2 to 7 on Sun. Closed Mondays, July 4, Labor Day, Thanksgiving, Christmas, and New Year's Day.

CHARDIN, CONSTABLE (2), COROT (4), COURBET (2), DAUMIER (9), DELACROIX (3), FRAGONARD (2), GOYA (2), EL GRECO, GUARDI, WATTEAU. Also: Géricault, In-gres, Magnasco.

Florida
SARASOTA
John and Mable Ringling Museum of Art, 5401 Bayshore Road. Founded 1930. Open 9 a.m. to 10 p.m. Mon. thru Fri.; 9 to 5 on Sat.; 11 to 6 on Sun. Admission: adults $3.50; children under 12 free if accompanied by adult. Fee includes admission to Ringling Circus Museum, Ringling residence.

VAN DYCK, GAINSBOROUGH, EL GRECO, HALS, POUSSIN, REYNOLDS, RUBENS (9), TIEPOLO, VERO-NESE (2). Also: Jan Bruegel (the Elder), others.

WEST PALM BEACH
Norton Gallery of Art, 1451 So. Olive Ave. Founded 1940.

Open 10 to 5 Tues. thru Fri.; 1 to 5 Sat. and Sun. Closed Mondays. Admission by donation.

COURBET (2), VAN DYCK, MURILLO, RAEBURN (2), REYNOLDS, others.

Georgia

ATLANTA
The High Museum of Art, 1280 Peachtree St., N.E. Founded 1905. Open free 10 to 5 Mon. thru Sat.; 12 to 5 on Sun.

BELLINI, CONSTABLE, COROT (2), CRANACH, RAEBURN, TIEPOLO. Also: Hoppner.

Hawaii

HONOLULU
Honolulu Academy of Arts, 900 South Beretania St. Founded 1922. Open free 10 to 4:30 Mon. thru Sat.; 2 to 5 on Sun. Major collection: Samuel H. Kress.

DELACROIX, DE HOOCH. Also: A. Bouts, di Cione, di Cosimo, Crivelli, Magnasco, Moroni, Vivarini, others in S. H. Kress Collection.

Illinois

CHAMPAIGN
Krannert Art Museum, University of Illinois, 500 Peabody Drive. Founded 1961. Open free 9 to 4 Mon. thru Sat.; 2 to 5 Sunday.

CONSTABLE, J.-L. DAVID, DELACROIX, GAINS—BOROUGH (2), HALS, DE HOOCH, MURILLO (2), REMBRANDT, RUBENS, RUISDAEL, TIEPOLO. Also: Ingres, others.

CHICAGO
The Art Institute of Chicago, Michigan Ave. at Adams St. Founded 1879. Open 10:30 to 4:30 Mon., Tues., Wed., Fri.; 10:30 to 8 on Thurs.; 10 to 5 on Sat.; 12 to 5 on Sun. and holidays. Admission: discretionary fee, except Thurs. free.

BOTTICELLI, CANALETTO (3), CHARDIN, CLAUDE, CONSTABLE (3), COROT (8), COURBET (5), CRANACH (2), DAUMIER (5), G. J.-L. DAVID (2), Gerard DAVID, DELACROIX (5), VAN DYCK, GOYA (5), VAN GOYEN, EL GRECO (4), GUARDI (5), HALS (2), HOBBEMA (2), LAWRENCE (4), MEMLING (2), MURILLO, POUSSIN, RAEBURN (7), REMBRANDT (2), REYNOLDS (5), RUBENS (7), RUISDAEL, TIEPOLO (6), TINTORETTO (3), TURNER (2), VELÁSQUEZ (2), VERONESE (3), WATTEAU (4). Also: Bronzino, Géricault, Hoppner, Ingres, Magnasco, Morland, Van der Weyden.

Indiana

BLOOMINGTON
Indiana University Art Museum, Fine Arts Building, Indiana University. Founded 1962. Open free 9 a.m. to 10 p.m. Tues., Thurs.; 9 to 5 Wed., Fri., Sat.; 12 to 5 on Sun. Closed Mondays.

CLAUDE (drawing), FRAGONARD (drawing), WATTEAU (drawing). Also: de Ribera drawing, Domenico Tiepolo drawings.

INDIANAPOLIS
Indianapolis Museum of Art, 1200 W. 38th St. Founded 1883. Open 11 to 5 Tues. thru Sun. Admission: no entrance fee, voluntary contributions welcome. Closed Mondays.

CANALETTO, CHARDIN, CONSTABLE (2), COROT (3), COURBET, CRANACH, J.-L. DAVID, VAN DYCK (2), FRAGONARD, GAINSBOROUGH (2), GOYA (2), GUARDI,, HOBBEMA, DE HOOCH, LAWRENCE, MURILLO, RAEBURN (5), REMBRANDT, REYNOLDS (6), RUISDAEL (4), TITIAN, TURNER (2), WATTEAU, others.

MUNCIE
Ball State University Art Gallery, Ball State University. Founded 1936. Open free 9 to 4:30 Mon. thru Fri. (also 7 to 9 p.m. Sept. thru May); 1:30 to 4:30 Sat. and Sun. Closed major holidays.

BONINGTON, CHARDIN, CLAUDE, CONSTABLE (3), COROT, FRAGONARD (2), GAINSBOROUGH, HOLBEIN, REYNOLDS (2), WATTEAU.

SOUTH BEND
Notre Dame University Art Gallery, Notre Dame University. Open free 10 to 4:45 Mon. thru Fri.; 1 to 5 Sat. & Sun.

BONINGTON, COURBET, MEMLING, RAEBURN, RUISDAEL. Also: Jan Bruegel (the Elder), Morland.

Iowa

DES MOINES
The Des Moines Art Center, Greenwood Park. Founded 1933. Open free 11 to 5 Tues. thru Sat.; 12 to 5 on Sun. Closed Mondays.

COROT, COURBET, DAUMIER, GOYA.

Kansas

LAWRENCE
Helen. Foresman Spencer Museum of Art, The University of Kansas. Founded 1928. Open free 10 to 4 Tues. thru Sat.; 1:30 to 4 on Sun. Closed Mondays.

REYNOLDS (2), others.

Kentucky

LOUISVILLE
The J. B. Speed Art Museum, 2035 South Third St. Founded 1925. Open free 10 to 4 Tues. thru Sat.; 10 a.m. to 10 p.m. on Thurs. during summer; 2 to 6 on Sun. Closed Mondays and holidays.

BONINGTON, CHARDIN, COROT, COURBET, CRANACH, DAUMIER, VAN DYCK (2), FRAGONARD, GAINSBOROUGH (3), GOYA, HOGARTH, LAWRENCE, MURILLO, RAEBURN, REMBRANDT, REYNOLDS (2), RUBENS, RUISDAEL, TIEPOLO, TINTORETTO, VERONESE. Also: Fra Bartolommeo, Jan Breugel (the Elder), Dirk Hals, Magnasco, others.

Louisiana

NEW ORLEANS
New Orleans Museum of Art, City Park. Founded 1910. Open 9 to 5 Tues. thru Sun. Admission: adults $1.00; children 50¢. Closed Mondays.

BELLINI, CONSTABLE, COROT, COURBET, LAWRENCE (2), REYNOLDS, TIEPOLO (2), TINTORETTO, VERONESE.

Maine

BRUNSWICK
Bowdoin College Museum of Art, Walker Art Building. Open free. Seasonal hours are posted. Closed Mondays and holidays.

BRUEGEL COROT, LAWRENCE. Also: School of Bonington, Morland, approx. ninety prints and drawings by old masters in this study.

Maryland

BALTIMORE
The Baltimore Museum of Art, Art Museum Drive. Founded 1914. The Maryland Institute, College of Art. Major collection: George A. Lucas (these paintings are on indefinite loan to The Baltimore Museum of Art and are indicated in the listing below as "Lucas loan"). Open free 11 to 5 Tues. thru Sat.; 1 to 5 on Sun. Closed Mondays.

CANALETTO, CHARDIN, CONSTABLE, COROT (8), COURBET, DAUMIER, DELACROIX (2), VAN DYCK (2), FRAGONARD, GAINSBOROUGH (3), GOYA, VAN GOYEN, GUARDI (2), HALS (2), POUSSIN, RAEBURN (4), RAPHAEL, REMBRANDT, REYNOLDS (4), RUBENS (2), RUISDAEL (2), TITIAN, VERONESE. Also: Hoppner, Magnasco, Lorenzo Tiepolo.

The Walters Art Gallery, 600 N. Charles St. Founded 1931. Open free 1 to 5 on Mon.; 11 to 5 Tues. thru Sat.; 2 to 5 on Sun. Closed July 4, Thanksgiving, Christmas Eve, Christmas, and New Year's Day.
BELLINI, COROT (2), DAUMIER (7), DELACROIX (3), VAN DYCK, EL GRECO, GUARDI, MURILLO, RAPHAEL, TIEPOLO, TURNER, VERONESE. Also: Jan Breughel (the Elder), Bronzino, Géricault, Ingres, others.

HAGERSTOWN

The Washington County Museum of Fine Arts, City Park. Founded 1929. Open free 10 to 5 Tues. thru Sat.; 1 to 6 on Sun. Closed Mondays.
COURBET. Also: Strozzi, Domenico Tintoretto, others.

Massachusetts

AMHERST

The Mead Art Building, Amherst College. Open free 10 to 5 Oct. thru May; 1 to 5 Sat. and Sun.; 12 to 4 June and July, daily. Closed August.
GAINSBOROUGH, RAEBURN, REYNOLDS.

BOSTON

Isabella Stewart Gardner Museum, 280 The Fenway. Founded 1900. Open 1 to 9:30 Tues.; 1 to 5:30 Wed. thru Sun. Voluntary admission: $1.00 is suggested but any amount is acceptable.
FRA ANGELICO, BELLINI, BOTTICELLI (2), COROT, COURBET, DELACROIX, DÜRER, VAN DYCK, GIOTTO, GUARDI (2), HOLBEIN (2), RAPHAEL (2), REMBRANDT (4), RUBENS, TIEPOLO, TINTORETTO, TITIAN, TURNER, VELÁSQUEZ, VERMEER.

Museum of Fine Arts, Huntington Ave. Founded 1870. Open daily except Mon. 10 to 5, Tues. evening until 9. Admission: $1.75. Collections from all civilizations from 5500 B.C. to the present.
FRA ANGELICO, BONINGTON (3), BOSCH, BRUE-GEL, CANALETTO, CHARDIN (2), CLAUDE (3), CONSTABLE (4), COROT (20), COURBET (4), CRANACH, DAUMIER (3), DELACROIX (3), VAN DYCK (6), FRA-GONARD (2), GAINSBOROUGH (8), GOYA (2), VAN GOYEN (2), EL GRECO (3), GUARDI (3), HALS, HO-GARTH, DE HOOCH, LAWRENCE (3), MURILLO (2), POUSSIN (2), RAEBURN (3), REMBRANDT (7), REYN-OLDS (7), RUBENS (4), RUISDAEL (2), TIEPOLO (5), TINTORETTO (2), TITIAN (2), TURNER (2), VELÁS-QUEZ (4), VERONESE (4), WATTEAU. Also: Magnasco, Morland, others.

CAMBRIDGE

Fogg Art Museum, Harvard University, 32 Quincy Street. Founded 1895. Open free 9 to 5 Mon. thru Sat.; 2 to 5 Sun. September (after Labor Day) to July 1. Closed weekends July 1 thru Labor Day. Closed holidays.
FRA ANGELICO, BONINGTON (4), BOTTICELLI, BRUEGEL, CANALETTO, CHARDIN, CLAUDE (2), CONSTABLE (2), COROT (2), COURBET (2), DAUMIER (5), J.-L. DAVID, DELACROIX (4), DÜRER (2), FRAGONARD (4), GAINSBOROUGH (3), GOYA (2), VAN GOYEN (2), GUARDI (4), HOLBEIN (2), LAWRENCE (5), MURILLO

(2), POUSSIN (4), RAEBURN, RAPHAEL, REMBRANDT (5), REYNOLDS (4), RUBENS (3), RUISDAEL (3), TIEPOLO (3), TINTORETTO (2), VERONESE (2), WATTEAU (2). Also: Géricault, Ingres, others.

NORTHAMPTON

Smith College Museum of Art, Elm St. at Bedford Terrace. Founded 1920. Open free. Sept. thru May: 11 to 4:30 Tues. thru Sat.; 2 to 4:30 on Sun. Closed Mondays. June: weekdays by appointment. July thru Aug.: 1 to 4 Tues. thru Sat. Closed Sundays and Mondays.
BONINGTON (2), BRUEGEL, CONSTABLE, COROT (4), COURBET (3), DAUMIER, J.-L. DAVID (3), DELA-CROIX (2), FRAGONARD, GAINSBOROUGH, VAN GOYEN (4), GUARDI, HOGARTH (2), LAWRENCE, RAEBURN, REMBRANDT, REYNOLDS, RUISDAEL, TIEPOLO, TUR-NER (6). Also: Jan Bruegel (the Elder), Géricault, Hoppner, Ingres, Magnasco.

PITTSFIELD

The Berkshire Museum, 39 South St. Founded 1903. Open free 10 to 5 Tues. thru Sat.; 2 to 5 on Sun. Closed Mondays except in July and Aug.
VAN DYCK, DE HOOCH, LAWRENCE, MURILLO, RAEBURN, REYNOLDS, RUBENS. Also: Hoppner, Magnasco, Morland.

SPRINGFIELD

The Springfield Museum of Fine Arts, 49 Chestnut St. Founded 1933. Open free 12 to 5 Tues. thru Sun. Closed Mondays, national holidays.
CANALETTO (2), CHARDIN, COROT, COURBET (2), VAN GOYEN, GUARDI, RUISDAEL, TIEPOLO. Also: Géricault, Hoppner, Kalf, Magnasco, M. Le Nain.

WELLESLEY

The Wellesley College Museum, Jewett Arts Center, Wellesley College. Open free 8:30 to 5 Mon. thru Fri.; 8:30 to 12 and 1 to 5 Sat.; 2 to 5 Sun.
CLAUDE, COROT, RUBENS. Also: Amigoni, Luca Giordano, Magnasco, Terborch, others.

WILLIAMSTOWN

Sterling and Francine Clark Art Institute, South Street. Founded 1950. Open free 10 to 5 Tues. thru Sun. Closed Mondays, Thanksgiving, Christmas, and New Year's Day.
BOTTICELLI, CHARDIN (2), CLAUDE (2), CONSTABLE, COROT (9), COURBET (2), DAUMIER (2), VAN DYCK, FRAGONARD, GAINSBOROUGH (2), GOYA (4), GUARDI (2), HOBBEMA, LAWRENCE, MEMLING, MURILLO, RAE-BURN, REMBRANDT (2), RUBENS, RUISDAEL, TIEPOLO, TURNER. Also: Bouts, Géricault, Morland, A. Le Nain, others. Drawing collection includes Daumier, Rembrandt, Rubens, Watteau, others.

Williams College Museum of Art, Main St. Founded 1926. Open free 10 to 12, 2 to 4 Mon. thru Sat.; 2 to 5 on Sun. Closed legal and college holidays.
DELACROIX (2), RAEBURN (3), REYNOLDS (2). Also: G. Guardi, Domenico Tiepolo, others.

WORCESTER

Worcester Art Museum, 55 Salisbury St. Founded 1896. Open 10 to 5 Tues. thru Sat.; 2 to 5 on Sun. Closed Mondays, July 4, Thanksgiving, Christmas, and New Year's Day. Admission is free to members; non-member adults $1.00; children under 14 and adults over 65, 50¢; accompanied children under 5, free.
CANALETTO, CONSTABLE, GAINSBOROUGH (2),

GOYA, VAN GOYEN, EL GRECO, GUARDI, HOGARTH
(2), LAWRENCE, POUSSIN, REMBRANDT, REYNOLDS,
RUISDAEL, TURNER. Also: Magnasco, Morland, Le Nain.

Michigan
DETROIT
The Detroit Institute of Arts, 5200 Woodward Ave. Founded
1885. Open free 9:30-5:30 Tues. thru Sun. Closed Mondays,
holidays. Voluntary admission: pay-what-you-wish.

FRA ANCELICO (3), BELLINI, BONINGTON, BOTTI-
CELLI, BRUEGEL, CANALETTO, CHARDIN (2), CLAUDE
(2), CONSTABLE (3), COROT (3), COURBET (2), CRA-
NACH (3), DAUMIER, Gerard DAVID, VAN DYCK (7), VAN
EYCK, FRAGONARD (5), GAINSBOROUGH (10), GOYA.
VAN GOYEN (2), EL GRECO, GUARDI, HALS (4), HOB-
BEMA (3), HOGARTH, HOLBEIN, DE HOOCH, LAWRENCE,
MURILLO (4), POUSSIN (2), RAEBURN (6), RAPHAEL,
REMBRANDT (7), REYNOLDS (7), RUBENS (5), RUIS-
DAEL (6), TIEPOLO (4), TINTORETTO (4), TITIAN (3),
VELASQUEZ, VERONESE (2). Also: Jan Bruegel (the Young-
er), Hoppner, Ingres, Kalf, Magnasco, Morland, A. Le Nain,
M. Le Nain, van der Weyden, others.

MUSKEGON
Hackley Art Museum, 296 W. Webster. Founded 1911. Open
free 9 to 5 Mon. thru Sat.; 2 to 5 Sun.

CONSTABLE, COROT, CRANACH (2), GAINSBOR-
OUGH, GOYA, HOGARTH, RAEBURN.

Minnesota
MINNEAPOLIS
The Minneapolis Institute of Arts, 2400 Third Ave. South.
Founded 1912. Open 10 to 5 Tues., Wed., Fri., Sat.; 10 to 9
on Thurs.; 12 to 5 on Sun. Closed Mondays. Admission: mem-
bers, children under 12, senior citizens, scheduled school
groups, and AFDC cardholders free. Students and prearranged
groups 50¢; Thurs. evenings 5 to 9 p.m. voluntary donation;
General admission: $1.00.

FRA ANGELICO, CANALETTO, CHARDIN, COROT
(2), COURBET (3), CRANACH (3), DAUMIER, DELA-
CROIX (2), VAN DYCK, GAINSBOROUGH (2), GOYA,
EL GRECO, GUARDI, HOBBEMA (2), HOGARTH, LAW-
RENCE, POUSSIN, REMBRANDT, REYNOLDS, RUBENS,
TIEPOLO, TITIAN. Also: Géricault, Van Ruysdael, others.

Mississippi
LAUREL
Lauren Rogers Library and Museum of Art, 5th Ave. at 7th
St. Founded 1922. Open free 10 to 12 and 2 to 5 Tues. thru
Sat.; 2 to 5 on Sun. Closed Mondays.

CONSTABLE, COROT, DAUMIER.

Missouri
KANSAS CITY
**The William Rockhill Nelson Gallery of Art and Atkins Muse-
um of Fine Arts,** 4525 Oak St. Founded 1926. Open 10 to 5
Tues. thru Sat.; 2 to 6 Sun. Closed Mondays, Memorial Day,
July 4, Thanksgiving, Christmas, and New Year's Day. Ad-
mission free Sun.; other days adults 50¢; children 25¢. Major
collections: Samuel H. Kress, Mr. and Mrs. Frank P. Burnap,
Starr Foundation.

BELLINI, BONINGTON, CANALETTO, CLAUDE (2),
CONSTABLE, COROT (2), COURBET (2), CRANACH
(3), DAUMIER, VAN DYCK, GAINSBOROUGH, GOYA,
EL GRECO (3), GUARDI, HALS, HOBBEMA, HOGARTH,
LAWRENCE (2), MEMLING, MURILLO, POUSSIN, RAE-
BURN (3), REMBRANDT, RUBENS (4), RUISDAEL, TIE-
POLO, TINTORETTO, TITIAN (2), TURNER, VELÁS-
QUEZ, VERONESE, others.

ST. LOUIS
The St. Louis Art Museum, Forest Park. Founded 1907. Open
free 2:30 to 9:30 on Tues.; 10 to 5 Wed. thru Sun. Closed
Mondays, Christmas, New Year's Day.

CANALETTO, CHARDIN, CLAUDE, CONSTABLE (2),
COROT (3), COURBET (3), CRANACH, Gerard DAVID,
DELACROIX, VAN DYCK, FRAGONARD, GAINSBOR-
OUGH (2), GOYA, VAN GOYEN, EL GRECO, HALS, HOL-
BEIN, DE HOOCH, LAWRENCE (2), MURILLO, RAEBURN
(3), REMBRANDT, REYNOLDS (3), RUBENS, RUISDAEL,
TIEPOLO, TINTORETTO, TITIAN, TURNER, VERONESE.
Also: di Cosimo, Hoppner, Kalf, Maes, Magnasco, others.

Nebraska
OMAHA
Joslyn Art Museum, 2200 Dodge St. Founded 1929. Open 10
to 5 Tues. thru Fri.; 1 to 5 on Sun. Closed Mondays. General
admission: 50¢.

CLAUDE, CONSTABLE, COROT, COURBET, J.-L.
DAVID, DELACROIX, VAN DYCK, GOYA, EL GRECO,
RAEBURN, REMBRANDT, REYNOLDS, RUBENS, RUIS-
DAEL, TITIAN, VERONESE. Also: Magnasco.

New Hampshire
HANOVER
Dartmouth College Museum and Galleries, College St. Open
free. Hopkins Center: 11 to 4, 7 to 10 p.m. daily; 2 to 5 on
Sun. Carpenter Hall: 10 to 4 daily; 2 to 5 on Sun.

GUARDI, TURNER (2). Also: da Cortona, Lely, van
Ostade, van de Velde, Zurbarán.

MANCHESTER
The Currier Gallery of Art, 192 Orange St. Founded 1929.
Open free 10 to 4 Tues. thru Sat.; 2 to 5 on Sun. Closed
Mondays and national holidays.

CONSTABLE, COROT, RAEBURN, RUISDAEL, TIE-
POLO, TINTORETTO. Also: Costa, Mabuse, Perugino, Preti,
others.

New Jersey
PRINCETON
The Art Museum, Princeton University. Open free 10 to 4
Tues. thru Sat.; 1 to 5 on Sun. during academic year; 2 to 4
during summer. Closed Mondays and major holidays. Draw-
ings shown by appointment only.

BOSCH, CHARDIN (2), CRANACH, DELACROIX, DÜ-
RER, GAINSBOROUGH, BOYA, LAWRENCE, RAEBURN,
RUBENS, TINTORETTO (2). Also: Claude drawings, Tiepolo
drawings, Hoppner, Morland.

New York
ALBANY
Albany Institute of History and Art, 125 Washington Avenue.
Founded 1791. Open free 10 to 4:45 Tues. thru Sat.; 2 to 5
Sun. Closed Mondays, national holidays.

GAINSBOROUGH. Also: Regional collection.

BUFFALO
The Albright-Knox Art Gallery, 1285 Elmwood Ave. Founded
1862. Open 10 to 5 Tues. thru Sat.; 12 to 5 on Sun. Closed
Mondays. An admission fee is requested on a voluntary basis.

CANALETTO, COROT, COURBET, DAUMIER (2),
J.-L. DAVID, DELACROIX, GAINSBOROUGH, HOGARTH,
LAWRENCE, REYNOLDS, RUBENS (2). Also: Géricault,
Ingres.

ELMIRA
Arnot Art Museum, 235 Lake St. Founded 1911. Open free
10 to 5 Tues. thru Fri.; 2 to 5 Sat. and Sun. Closed Mondays.

CLAUDE, COURBET, VAN DYCK, HOBBEMA, MU-
RILLO, REYNOLDS (2). Also Jan Bruegel (the elder).

GLENS FALLS
The Hyde Collection, 161 Warren St. Founded 1952. Open
free 2 to 5 Tues., Wed., Fri., Sat., Sun. Closed Mondays and
Thursdays.

BOTTICELLI, CLAUSE, COURBET, VAN DYCK, FRA-
GONARD, EL GRECO, GUARDI, HALS, RAPHAEL, REM-
BRANDT (2), RUBENS (2), RUISDAEL, TIEPOLO (3),
TINTORETTO (2), TITIAN, TURNER, VERONESE. Also:
Ingres.

NEW YORK CITY
The Brooklyn Museum, 188 Eastern Parkway. Founded 1823.
Open free 10 to 5 Wed. thru Sat.; 12 to 5 on Sun.

COROT (4), COURBET (3), CRANACH, DAUMIER (2),
DELACROIX (3), FRAGONARD, GOYA, HALS, HOB-
BEMA, LAWRENCE, RAEBURN, REYNOLDS (2). Also:
Géricault, Hoppner, Morland, others.

The Frick Collection, 1 E. 70th St. Founded 1920. Open 10 to
6 Tues. thru Sat.; 1 to 6 Sun., February 12, and Election Day.
Closed Mondays, July 4, Thanksgiving, December 24, 25, and
New Year's Day. Also closed Tuesdays during June, July, Aug.
Admission: adults $1.00; students and senior citizens 50¢; chil-
dren under 10 not admitted to the Collection, those under 16
must be accompanied by adults.

BELLINI, BRUEGEL, CHARDIN (2), CLAUDE, CON-
STABLE (2), COROT (4), Gerard DAVID, J.-L. DAVID, VAN
DYCK (8), VAN EYCK, FRAGONARD (14), GAINSBOR-
OUGH (7), GOYA (4), EL GRECO (3), HALS (4), HOB-
BEMA (2), HOGARTH, HOLBEIN (2), LAWRENCE (2),
MEMLING, RAEBURN (2), REMBRANDT (4), REYNOLDS
(3), RUISDAEL (2), TIEPOLO, TINTORETTO, TITIAN
(2), TURNER (5), VELÁSQUEZ, VERMEER (3), VERO-
NESE (2). Also: Hoppner, Ingres, others.

Hispanic Society of America, 155 St. and Broadway. Founded
1904. Open free 10 to 4:30 Tues. thru Sat.; 1 to 4 on Sun.
Closed Mondays, February 12 and 22, Good Friday, Easter,
May 30, July 4, October 12, Thanksgiving, December 24, 25,
31, and New Year's Day.

GOYA (4), EL GRECO (8), VELÁSQUEZ (3). Also: Goya
(eleven drawings).

The Metropolitan Museum of Art, Fifth Avenue at 82nd
Street. Founded 1870. Open 10 to 8:45 Tues.; 10 to 4:45
Wed. thru Sat.; 11 to 4:45 Sun. Closed Mondays. Admission:
amount voluntary, but visitors must pay something. Sug-
gested admission: adults $2.00; students 50¢.

FRA ANGELICO (2), BELLINI (4), BONINGTON (3),
BOSCH, BOTTICELLI (2), BRUEGEL, CANALETTO (2),
CHARDIN (2), CLAUDE (5), CONSTABLE (4), COROT
(28) COURBET (27), CRANACH (6), DAUMIER (4), GE-
RARD DAVID (6), J.-L. DAVID (4), DELACROIS (5),
DURER (3), VAN DYCK (13), VAN EYCK, FRAGONARD
(9), GAINSBOROUGH (9), GIOTTO, GOYA (11), VAN
GOYEN (7), EL GRECO (9), GUARDI (10), HALS (11),
HOBBEMA (2), HOGARTH, HOLBEIN (10), DE HOOCH
(6), LAWRENCE (7), MEMLING (10), MURILLO (4), POUS-
SIN (5), RAEBURN (12), RAPHAEL (2), REMBRANDT
(23), REYNOLDS (15), RUBENS (13), RUISDAEL (5),
TIEPOLO (17), TINTORETTO (5), TITIAN (7), TURNER
(3), VELÁSQUEZ (10), VERMEER (4), VERONESE (4),
WATTEAU (4). Also: Jan Bruegel (the Elder), Géricault,
Hoppner, Ingres, Kalf, Magnasco, Morland, van der Weyden,
others.

New York Historical Society, 170 Central Park West. Founded
1804. Voluntary admission $1.50 since 1/1/79, free for mem-
bers. 11 to 5 Tues. thru Fri.; 10 to 5 on Sat.; 1 to 5 on Sun.
Closed Mondays and holidays.

RUBENS.

POUGHKEEPSIE
Vassar College Art Gallery, Raymond Ave. Open free during
the academic year, 9 to 5; 1 to 5 on Sun.

CLAUDE, COROT (2), DELACROIX (5), TIEPOLO (2),
TINTORETTO, TURNER. Also: Hoppner, Le Nain.

ROCHESTER
Memorial Art Gallery of the University of Rochester, 490
University Ave. Founded 1913. Open 2 to 9 on Tues.; 10 to 5
Wed. thru Sat.; 1 to 5 Sun. Closed Mondays and major holi-
days. Admission: free Tuesdays 5 to 9. At other times: adults
$1.00; senior citizens 50¢; unaccompanied children 25¢; free to
members, full-time college students with ID, and children
accompanied by an adult.

CONSTABLE, COROT, COURBET, VAN DYCK, GAINS-
BOROUGH (2), EL GRECO, HALS, LAWRENCE, RAEBURN
(2), REMBRANDT, REYNOLDS, RUBENS, TINTORETTO.
Also: Hoppner, Ingres, Corneille de Lyon, Magnasco, De Mom-
per, Snyder, Domenico Tintoretto, others.

North Carolina
RALEIGH
North Carolina Museum of Art, 107 East Morgan St. Founded
1956. Open free 10 to 5 Tues. thru Sat.; 2 to 6 on Sun. Closed
Mondays, Thanksgiving, Christmas, New Year's Day, and
state holidays.

CANALETTO, CHARDIN, CLAUDE, CONSTABLE, J.-L.
DAVID, VAN DYCK (4), FRAGONARD, GAINSBOROUGH
(4), GIOTTO, GOYA, GUARDI, DE HOOCH (2), LAW-
RENCE (4), MEMLING, MURILLO (3), RAEBURN (4),
RAPHAEL, REMBRANDT, REYNOLDS (2), RUBENS (6),
RUISDAEL, TINTORETTO (2), TITIAN, VERONESE.
Also: Boucher, Cuyp, Hoppner, Maes, Magnasco, Morland,
Romney, others.

Ohio
CINCINNATI
The Cincinnati Art Museum, Eden Park. Founded 1881. Open
10 to 5 Tues. thru Sat.; 1 to 5 on Sun. Closed Mondays and
holidays. Admission: adults over 18 $1.00; ages 12 thru 18
50¢; Free to Museum members, children under 12, sched-
uled tour groups thru grade 12. Admission is free to everyone
on Saturdays.

BOTTICELLI, CANALETTO, CLAUDE, CONSTABLE,
COROT (16), COURBET (3), CRANACH, DAUMIER, DELA-
CROIX, VAN DYCK, FRAGONARD, GAINSBOROUGH
(12), EL GRECO, HALS (2), HOBBEMA, DE HOOCH, LAW-
RENCE (3), MEMLING (2), MURILLO, RAEBURN (3),
REMBRANDT, REYNOLDS (6), RUBENS, RUISDAEL (2),
TIEPOLO, TINTORETTO, TITIAN, VELASQUEZ. Also:
Bronzino, Hoppner, Ingres.

The Taft Museum, 316 Pike St. Founded 1932. Open free
10 to 5 Mon. thru Sat.; 2 to 5 on Sun. and holidays. Closed
Thanksgiving and Christmas.

BONINGTON, CONSTABLE, COROT (5), VAN DYCK,
GAINSBOROUGH (4), GOYA (2), HALS (4), HOBBEMA,
DE HOOCH, RAEBURN (2), REMBRANDT (3), REYNOLDS
(2), RUISDAEL, TURNER (3).

CLEVELAND
The Cleveland Museum of Art, 11150 East Boulevard at Uni-

versity Circle. Founded 1913. Open free 10 to 6 Tues., Thurs., Fri.; 10 to 10 on Wed.; 1 to 5 on Sat.; 1 to 6 on Sun. Closed Mondays, July 4, Thanksgiving, Christmas, and New Year's Day.

FRA ANGELICO, BONINGTON, BOTTICELLI, CANALETTO, CHARDIN, CLAUDE (2), CONSTABLE, COROT (3), COURBET (2), CRANACH, DAUMIER, Gerard DAVID. J.-L. DAVID, DELACROIX, VAN DYCK, FRAGONARD, GAINSBOROUGH, GOYA (3), VAN GOYEN, EL GRECO (2), GUARDI (2), HALS, HOBBEMA, DE HOOCH, LAWRENCE (2), MURILLO (2), POUSSIN, RAEBURN, REMBRANDT (4), REYNOLDS, RUBENS (3), RUISDAEL (4), TIEPOLO (4), TINTORETTO, TITIAN, TURNER, VELÁSQUEZ, VERONESE (2). Also: Bronzino, Caravaggio, Ingres, Kalf, Magnasco, M. Le Nain, Salomon van Ruysdael.

COLUMBUS
Columbus Museum of Art, 480 East Broad St. Founded 1878. Open free 11 to 5 Tues., Thurs., Fri., Sun.; 11 to 8:30 on Wed.; 10 to 5 on Sat. Closed Mondays, July 4, Thanksgiving, Christmas, and New Year's Day.

CONSTABLE, COROT (2), COURBET (2), CRANACH, DELACROIX (3), VAN DYCK (3), FRAGONARD (2), GAINSBOROUGH, HOGARTH (2), LAWRENCE (2), RAEBURN, REMBRANDT, REYNOLDS, RUBENS, RUISDAEL, TIEPOLO, TINTORETTO, TURNER.Also: Jan Bruegel (the Elder), Géricault, Hoppner, Ingres, Jordaens.

DAYTON
The Dayton Art Institute, Forest and Riverview Avenues. Founded 1919. Open free 12 to 5 Tues. thru Fri.; 9 to 5 Sat.; 12 to 5 Sun. Closed Mondays.

CANALETTO, RAEBURN, REYNOLDS (4), RUBENS (2), RUISDAEL. Also: Jan Bruegel (the Elder, with Van Balen), Magnasco, others.

OBERLIN
The Allen Memorial Art Museum, Oberlin College. Founded 1917. Open free 11 to 8 Tues.; 11 to 5 Wed. thru Fri.; 2 to 5 Sat., Sun. Closed Mondays. Vacation hours: 2 to 5 Wed. thru Sun.

CHARDIN, CLAUDE, COURBET, DELACROIX, VAN DYCK, VAN GOYEN, HOBBEMA, HOGARTH, REYNOLDS, RUBENS, TURNER. Also: Magnasco, others.

TOLEDO
The Toledo Museum of Art, Monroe Street at Scottwood Avenue. Founded 1901. Open free 1 to 5 Sun., Mon.; 9 to 5 Tues. thru Sat. Closed all legal holidays.

BELLINI, CANALETTO, CLAUDE, CONSTABLE, COROT, COURBET (2), CRANACH, DAUMIER, Gerard DAVID, J.-L. DAVID, DELACROIX, VAN DYCK, FRAGONARD, GAINSBOROUGH (3), GOYA (2), VAN GOYEN (2), EL GRECO (2), GUARDI (2), HOBBEMA, HOGARTH, HOLBEIN, DE HOOCH (2), LAWRENCE (4), MURILLO, POUSSIN (2), RAEBURN (3), REMBRANDT (2), REYNOLDS (4), RUBENS, RUISDAEL, TINTORETTO, TURNER, VELÁSQUEZ, VERONESE, WATTEAU. Also: Jan Bruegel (the Elder), Bronzino, Claesz, Cuyp, Hoppner, Maes, M. Le Nain, Nattier, van Ostade, Salomon van Ruysdael, Terborch, others.

ZANESVILLE
Zanesville Art Center, 620 Military Road. Founded 1936. Open free 1 to 5 Sat. thru Thurs. Closed Fridays and major holidays.

VAN DYCK, GAINSBOROUGH, RUBENS, TIEPOLO. Also: Ghirlandaio (with Granacci), Greuze, Moroni, others.

Oklahoma
TULSA
The Philbrook Art Center, 2727 South Rockford Road. Founded 1938. Open 10 to 5 weekdays; 1 to 5 Sunday. Admission: adults $1.50; senior citizens and college students with ID 75¢; members, children and students grades 1-12 free.

BELLINI, CANALETTO, GAINSBOROUGH, LAWRENCE (2), MURILLO, RAEBURN, REYNOLDS (2). Also: Hoppner, others.

Oregon
PORTLAND
Portland Art Museum, Southwest Park and Madison. Founded 1892. Open 12 to 5 Tues. thru Sun; Fridays 12 to 10 p.m. Closed Mondays and holidays. Admission: contribution requested. Suggested amount: adults $1.00; students 50¢. Free to members, senior citizens, and children under 12.

BONINGTON, BOTTICELLI, COROT (2), COURBET (3), CRANACH, DELACROIX (2), FRAGONARD (2), MURILLO, RAEBURN, REYNOLDS, TURNER. Also: Kalf, Morland.

Pennsylvania
PHILADELPHIA
The Pennsylvania Academy of the Fine Arts, Broad and Cherry Streets. Founded 1805. Open 10 to 5 Tues. thru Sat.; 1 to 5 Sun. Closed Mondays, Christmas, and New Year's Day. Admission: adults $1.00; students, children under 12 and senior citizens 50¢.

COROT (2), COURBET (2), FRAGONARD.

Philadelphia Museum of Art, Benjamin Franklin Parkway. Founded 1876. Open 9 to 5 daily. Admission: $1.50. Houses the John G. Johnson Collection. Other major collections: Elkins, McFadden, Wilstach.

BELLINI, BOSCH (3), BOTTICELLI (2), BRUEGEL, CHARDIN, CLAUDE, CONSTABLE (5), COROT (19), COURBET (14), DAUMIER (2), GERARD DAVID (2), DELACROIX (5), VAN EYCK, GAINSBOROUGH (9), GOYA, EL GRECO (3), GUARDI (2), HOGARTH (2), DE HOOCH, POUSSIN (2), RAEBURN (3), REMBRANDT (2), REYNOLDS, RUBENS (9), RUISDAEL (4), TIEPOLO, TITIAN, TURNER, VERONESE (2). Also: Bronzino, Le Nain, others.

PITTSBURGH
The Frick Art Museum, 7227 Reynolds Street at South Homewood Avenue. Founded 1970. Open free 10 to 5:30 Wed. thru Sat.; 12:00 noon to 6 Sunday. Closed Good Friday, Memorial Day, July 4, Labor Day, Thanksgiving, Christmas, and New Year's Day.

FRAGONARD (3), RUBENS, TINTORETTO. Also: Boucher, Hoppner, A. Le Nain, Nattier, others.

READING
The Reading Public Museum and Art Gallery, 500 Museum Road. Founded 1904. Open free 9 to 5 Mon. thru Fri.; 9 to 12 Sat.; 2 to 5 Sun.

COROT (2), COURBET, RAEBURN, RUBENS, RUISDAEL.

Rhode Island
PROVIDENCE
Museum of Art, Rhode Island School of Design, 224 Benefit Street. Founded 1877. Winter hours: Open 11 to 5 Tues., Wed., Fri., Sat.; 1 to 7 Thurs; 2 to 5 Sun. June and July hours: 11 to 4:30 Tues. thru Sat. Closed Mondays, July 4, the month of August, Thanksgiving, Christmas, and New Year's Day.

BONINGTON (2), CANALETTO, CONSTABLE (7),

COROT (5), COURBET (3), DAUMIER (4), DELACROIX (8), DÜRER, VAN DYCK (3), GAINSBOROUGH (2), GOYA (3), EL GRECO, GUARDI (3), LAWRENCE (3), MURILLO, POUSSIN (3), RAEBURN, REMBRANDT, REYNOLDS, RUISDAEL (2), TIEPOLO (8), TINTORETTO (2), TURNER (13). Also: Jan Bruegel (the Elder), Géricault, Hoppner, Ingres, Magnasco, Morland.

South Carolina

COLUMBIA

Columbia Museums of Art and Science, Senate and Bull Streets. Founded 1950. Open free 10 to 5 Tues. thru Sat.; 2 to 6 Sun. Closed Mondays.

BONINGTON, BOTTICELLI, CANALETTO, CONSTABLE, GUARDI, LAWRENCE, MURILLO, REYNOLDS, RUBENS, RUISDAEL, TINTORETTO (2), others.

GREENVILLE

Bob Jones University Art Gallery and Museum, Bob Jones University. Founded 1951. Open free 2 to 5 Tues. thru Sun. Closed Mondays, July 4, Christmas Eve, Christmas, New Year's Eve, and New Year's Day. Children under six not admitted.

BOTTICELLI, CRANACH (2), Gerard DAVID (2), VAN DYCK (3), MEMLING, MURILLO (2), POUSSIN (2), REMBRANDT, RUBENS (3), TIEPOLO (2), TINTORETTO, TITIAN (2), VERONESE (2). Also: Fra Bartolommeo, Guercino, van Orley, Signorelli, Sodoma, others.

Tennessee

MEMPHIS

Brooks Memorial Art Gallery, Overton Park. Founded 1913. Open free 10 to 5 Tues. thru Sat.; 1 to 5 on Sun. Closed Mondays.

CANALETTO, COROT, VAN DYCK, GAINSBOROUGH (3), VAN GOYEN, HOBBEMA, HOGARTH, LAWRENCE, RAEBURN (3), REYNOLDS (4), RUBENS. Also: Hoppner, van der Weyden.

Texas

DALLAS

Dallas Museum of Fine Arts, Fair Park. Founded 1909. Open free 10 to 5 Tues. thru Sat.; 1 to 5 on Sun. Closed Mondays, Christmas.

COROT, COURBET, J.-L. DAVID, VAN DYCK, EL GRECO, LAWRENCE. Also: Morland, Dürer and Rembrandt prints.

FORT WORTH

Kimbell Art Museum, Will Rogers Road West. Founded 1972. Open free 10 to 5 Tues. thru Sat.; 1 to 5 on Sun. Closed Mondays, July 4, Thanksgiving, Christmas, and New Year's Day.

BELLINI (2), BONINGTON, CANALETTO (2), CLAUDE, COROT (2), COURBET (2), VAN DYCK (2), FRAGONARD, GAINSBOROUGH (4), GOYA (2), VAN GOYEN, EL GRECO (2), GUARDI, HALS, LAWRENCE (2), MURILLO, RAEBURN (2), REMBRANDT, REYNOLDS (3), RUBENS (2), RUISDAEL, TINTORETTO, TURNER. Also: Boucher, Géricault, Hoppner, others.

HOUSTON

The Museum of Fine Arts, 1001 Bissonnet. Founded 1900. Open free 10 to 5 Tues. thru Sat.; 12 to 6 on Sun. Closed Mondays. Major collections: Blaffer Memorial, Samuel H. Kress, Edith A. and Percy S. Straus, John A. and Audrey Jones Beck.

BELLINI, CANALETTO (2), CLAUDE, DAUMIER, VAN DYCK (2), GUARDI, HALS, HOLBEIN, MEMLING, MURIL-

LO, RAEBURN, REMBRANDT. Also: Bol, Lucas Cranach (the Younger), Magnasco, Pannini, di Paolo, Bartolommeo Veneto, van der Weyden, others.

SAN ANTONIO

Marion Koogler McNay Art Institute, 6000 N. New Braunfels. Founded 1950. Open free 9 to 5 Tues. thru Sat.; 2 to 5 on Sun. Closed Mondays, July 4, Thanksgiving, Christmas, and New Year's Day.

EL GRECO.

San Antonio Museum Association, Witte Memorial Museum, 3801 Broadway. Founded 1926. Open 9 to 5 Mon. thru Fri.; 10 to 6 Sat. and Sun. Admission: voluntary donation, suggest adults 50¢; children under 12 25¢.

COROT. Also: di Bartolommeo, Bugiardini, others.

Utah

SALT LAKE CITY

Utah Museum of Fine Arts, University of Utah, 104 Art and Architecture Center. Founded 1951. Open free 10 to 5 Mon. thru Fri.; 2 to 5 Sat. and Sun.

RAEBURN, RUBENS. Also: Ambrosius Benson, Kneller, Magnasco, di Pietro.

Virginia

NORFOLK

Chrysler Museum at Norfolk, Olney Rd. and Mowbray Arch. Founded 1924. Open 10 to 4 Tues. thru Sat.; 12 to 5 on Sun. Closed Mondays. Admission: voluntary fee.

BOSCH, CHARDIN, COROT, COURBET, DAUMIER, Gerard DAVID, DELACROIX (2), VAN DYCK, FRAGONARD, GAINSBOROUGH, EL GRECO, GUARDI, HOGARTH, LAWRENCE (2), RAEBURN, REMBRANDT, RUBENS (2), TIEPOLO, TINTORETTO (2), TITIAL, VELASQUEZ, VERONESE. Also: Boucher, Géricault, Hoppner, Ingres, Magnasco, Morland, Teniers, de la Tour, others.

RICHMOND

Virginia Museum, Boulevard and Grove Ave. Founded 1934. Open 11 to 5 Tues. thru Sat.; 1 to 5 on Sun. Closed Mondays. Admission: voluntary donation with suggested minimum; members, senior citizens, children under 16 admitted free.

BONINGTON, CLAUDE, CONSTABLE, COROT (3), COURBET, DELACROIX, VAN DYCK (2), GAINSBOROUGH (2), GOYA, VAN GOYEN, GUARDI, HALS (2), HOBBEMA, HOGARTH, LAWRENCE (3), MURILLO, POUSSIN, RAEBURN, REMBRANDT (3), RUBENS (2), TIEPOLO, WATTEAU. Also: Jan Bruegel (the Elder), Géricault, Hoppner, Magnasco.

Washington

SEATTLE

Charles and Emma Frye Art Museum, 704 Terry Ave. Founded 1952. Open free 10 to 5 Mon. thru Sat.; 12 to 6 Sun. and holidays. Closed Thanksgiving and Christmas.

COROT.

Seattle Art Museum, Volunteer Park. Founded 1917. Open 10 to 5 Mon., Tues., Wed., Fri., Sat.; 10 to 5 and 7 to 10 p.m. on Thurs.; 12 to 5 on Sun. Admission: adults $1.00; students and senior citizens 50¢; children under 12 admitted free when accompanied by an adult; open free to members; Thurs. free to general public.

BRUEGEL, CANALETTO, CRANACH, DELACROIX (2), DURER, GAINSBOROUGH, GOYA, GUARDI, RUBENS, TIEPOLO (2), TINTORETTO, VERONESE.

Wisconsin

MILWAUKEE

Milwaukee Art Center, 750 North Lincoln Memorial Dr. Founded 1888. Open 10 to 5 Tues. thru Sun. Closed Mondays. Admission: adults $1.00; children 50¢.

COROT, COURBET, DELACROIX, VAN DYCK, FRAGONARD. Also: Magnasco.

Canada

British Columbia

VANCOUVER

Vancouver Art Gallery, 1145 West Georgia. Founded 1931. Open free 10 to 5 Tues. thru Thurs. and Sat.; 10 to 10 on Fri.; 1 to 5 on Sun. Closed Mondays.

CONSTABLE, GAINSBOROUGH, HOGARTH, LAWRENCE. Also: Morland.

Ontario

OTTAWA

The National Gallery of Canada, Elgin St. Founded 1880. Open free 10 to 6 Tues., Wed., Fri., Sat.; 10 to 10 on Thurs.; 2 to 6 Sun. and public holidays. Closed Mondays.

BELLINI (2), BONINGTON, BOTTICELLI, CANALETTO (2), CHARDIN (2), CLAUDE (5), CONSTABLE (6), COROT (6), COURBET (4), DAUMIER (3), DELACROIX (3), DÜRER, VAN DYCK (2), GAINSBOROUGH (5), GOYA (4), EL GRECO, GUARDI (6), HALS, HOGARTH (2), MEMLING, MURILLO (3), POUSSIN (3), RAEBURN, RAPHAEL, REM-

BRANDT (3), REYNOLDS (2), RUBENS (4), RUISDAEL, TIEPOLO (9), TINTORETTO (3), TITIAN, TURNER (2), VERONESE (6), WATTEAU (2). Also: Baldung, Bronzino, Carracci, Champaigne, Lorenzo Lotto, Simone Martini, Bartolommeo Veneto.

TORONTO

Art Gallery of Ontario, Grange Park. Founded 1900. Open 11 to 9 Tues. thru Thurs.; 11 to 5:30 Fri. thru Sun. Closed Mondays. Admission: adults $1.00; students 50¢; members, Ontario Privilege Card holders, accompanied children under 12 admitted free.

BONINGTON, CANALETTO, CHARDIN, CLAUDE, CONSTABLE, COURBET (2), DELACROIX, VAN DYCK (2), GAINSBOROUGH, VAN GOYEN, HALS (2), LAWRENCE, POUSSIN, RAEBURN, REMBRANDT, REYNOLDS (2), RUBENS, TINTORETTO, TURNER (3), WATTEAU. Also: Arentsz, Boucher, Cuyp, Hoppner, Magnasco, Morland, Salomon van Ruysdael, others.

Quebec

MONTREAL

Montreal Museum of Fine Arts, 3400 avenue du Musée. Founded 1860. Open 11 to 5 Tues. thru Sun. Closed Mondays. Admission: general fee $1.00.

BONINGTON, COROT, COURBET, DAUMIER (3), GAINSBOROUGH (2), GOYA, EL GRECO, GUARDI, HOGARTH, LAWRENCE (3), POUSSIN, RAEBURN (6), REMBRANDT (2), REYNOLDS (3), RUBENS, RUISDAEL, TIEPOLO, TINTORETTO, TURNER (2). Also: Hoppner, others.